SEARCHING
FOR SAFE
SPACES

Afro-Caribbean
Women Writers
in Exile

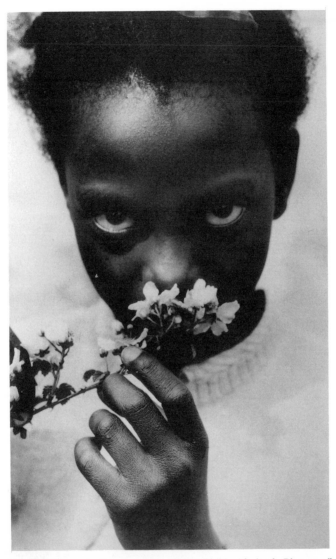

Photo by Consuelo Kanaga, 1894–1978: "Child with Apple Blossoms," 1948. Brooklyn Museum of Art, 82.65.378. Gift of Wallace B. Putnam from the Estate of Consuelo Kanaga.

SEARCHING for SAFE SPACES

Afro-Caribbean Women Writers in Exile

Myriam J. A. Chancy

Temple University Press
Philadelphia

TEMPLE UNIVERSITY PRESS, PHILADELPHIA 19122

Printed in the United States of America

⊗ The paper used in this book meets the requirements of the
American National Standard for Information Sciences—
Permanence of Paper for Printed Library Materials,
ANSI Z39.48-1984

Text design by Gary Gore

Library of Congress Cataloging-in-Publication Data

Chancy, Myriam J. A., 1970–
 Searching for safe spaces : Afro-Caribbean women writers in exile /
Myriam J. A. Chancy.
 p. cm.
 Includes bibliographical references and index.
 ISBN 1-56639-539-9 (cloth : alk. paper). — ISBN 1-56639-540-2
(pbk. : alk. paper)
 1. Caribbean literature (English)—Women authors—History and
criticism. 2. Caribbean literature (English)—Foreign countries—
History and criticism. 3. English literature—20th century—
History and criticism. 4. Alienation (Social psychology) in literature.
5. Women and literature—History—20th century. 6. Minorities in
literature. 7. Outsiders in literature. 8. Exiles in literature. I. Title.
PR9205.05.C48 1997
820.9'9287'089960729—DC21 96-46236

 The excerpt on p. 52 is from Lucille Clifton: "Who Is There to Protect Her" (Shapeshifter Poems, 2), copyright © 1987 by Lucille Clifton. Reprinted from *Next: New Poems,* by Lucille Clifton, with the permission of BOA Editions, Ltd., 260 East Ave., Rochester, NY 14604.
 Permission to quote from *She Tries Her Tongue: Her Silence Softly Breaks* (Charlottetown, Prince Edward Island: Ragweed Press, 1989) and *Looking for Livingstone: An Odyssey of Silence* (Stratford, Ontario: Mercury Press, 1991), on pp. 103–107, 111, 113–116, and 140, courtesy of the author, M. Nourbese Philip.
 The excerpt on p. 132 is from "Monkeyman," copyright © 1992, 1975 by Audre Lorde, from *Undersong: Chosen Poems Old and New* by Audre Lorde. Reprinted by permission of W. W. Norton & Company, Inc.
 The excerpts on pp. 133–136 are from "Between Ourselves," "Dahomey," "125th Street and Abomey," and "The Women of Dan," from *The Black Unicorn* by Audre Lorde. Copyright © 1978 by Audre Lorde. Reprinted by permission of W. W. Norton & Company, Inc.
 Permission to quote from *Claiming an Identity They Taught Me to Despise,* on pp. 137–140 and 142–143, granted by the author, Michelle Cliff.

This work is dedicated to the women
who are no longer in this world but whose lives
have made my own possible: my great-grandmothers,
Aricie César Lamour and Euphosia Vilmé Chancy,
as well as my grandmothers, Séphora Lilavois Lamour,
Carmen Jérome Chancy, and Alice Limousin Chancy.

Il ne s'agit pas de faire attention, de ne pas en dire trop, il faut au contraire que je dise trop, trouver le moyen de transmettre cet ordre à mes doigts, c'est une question de survie, je n'en peux plus de me taire. Je sais que je parle, seule, à voix haute parfois, plus souvent au fond de moi, mais j'ai besoin d'écrire ce texte, tant pis pour la prudence, il y aura toujours quelqu'un pour m'empêcher de commettre les erreurs impardonnables, si j'arrive réellement à perdre mes habitudes d'auto-censure.

—Jan J. Dominique, *Mémoire d'une amnésique*

The existence and validity of human rights are not written in the stars.

—Albert Einstein, *Opinions and Ideas*

Contents

Prologue

"Natif-Natal"

Living "In-Between"

Somehow, the road home is always longer and harder than one expects. This has been true to my experience, as I continuously attempt to ease myself into a life of "in-between"—living between races, cultures, languages, and nations—with the knowledge that existing in this way is counter to the norms established for survival in a mainstream society, where power is determined primarily by sex and race. Here, in the United States and Canada, women like me must camouflage our differences and blend in with surroundings that are all too often alien to where we have come from or who we know ourselves to be. We learn all too early that to be different, whether because of our race, our sex, our sexuality, or our class, is to lose easy access to surviving with grace and dignity in a society that prefers to advocate our invisibility in every arena of social interaction. In that invisibility, we, as women of color, are made to deny the specificity of our origins. For Afro-Caribbean emigrant women who may not have the support of an established community within their adoptive countries, such forced denial often produces a sense of acute alienation. While we are blocked from forming useful political coalitions and affiliations because of cultural and linguistic barriers, which are actively used to ghettoize immigrant women as a subclass of the working class, the struggle to survive takes on the added weight of the pressures of living in exile from one's home country. Home, then, paradoxically becomes both the site of self-recovery and the point of no return.

The decision to emigrate was not my own. As a child, I emigrated from Haiti to Canada with my parents in the early 1970s. Their decision

was based on the knowledge that they could not ensure their young family the benefits of a safe life-journey in Haiti in the ways they could abroad: opportunities were scarce, terror an everyday reality, the country the poorest (at the time) in the world. Success in Haiti, I realize now, was unavoidably a measure of the degree to which one was willing to live in ignorance of that poverty at the same time as one exploited it in order to maintain a standard of living equal to that of middle-class individuals in the First World, where the poorest of the poor are, apparently, more easily hidden from view and thus betrayed by a willed forgetfulness. Those unwilling to play the game suffer the consequences: political and economic persecution, marginalization, and, ultimately, life in exile. The decision to emigrate to Canada was based on foreknowledge of the difficulties of surviving in a country still struggling to remove from itself the yoke of colonial and neocolonial domination. Still, in the process of moving from one country to the next, something was being lost at the same time as the hope for freedom and better choices was gained.

It was made very clear to me as I arrived in new school after new school that I had become an "other" in Canada. I did not know the right songs, the right games, the right language. It did not matter that I knew many other things. There was a cultural gulf between me and most of the Canadian children I met in the playgrounds of my childhood. One thing seemed to stand between us then, my color or, more accurately, my race. As a child of African descent and as an emigrant, I was doubly suspect, but racism neutralized me singly and simply on both fronts. I was labeled a "nigger" from circle to circle, and there was no way that I would be allowed into any center. It did not take me long to give up on confronting my aggressors and rebel in passive ways. I refused to sing "O Canada!" in French once I realized that the second line (*terre de mes aieux*) would make me claim this alien land as that of "my ancestors." My ancestors were lying miles and miles away across a vast and unwelcoming continent, and it seemed to me then that there was little I could do to reclaim that alter-reality. I fumbled through my English language classes in a refusal to become assimilated along with everyone else. I associated English with all that remained to be lost: my native tongue and the fragments of *créole* that, I hoped, were still clinging to the deep recesses of my memory. Without language, without song, what would I have except for summer vacations, pictures, and the odd, tortured long-distance phone calls to connect me to the place of my birth? My early experiences

with prejudice in Canada marked for me the beginning of the journey back home. That alienation forced me to come to terms with what I was rather than what I was not.

Alienation is, of course, the defining feature of the *négritude* movement articulated by mostly French African and Caribbean male writers. As Rowland Smith summarizes in his introduction to *Exile and Tradition: Studies in African and Caribbean Literature,* contemporary African and Caribbean critics who owe a debt to the philosophy of *négritude* focus on two basic issues, that of "the traditions peculiar to African cultures and the sense of alienation which has so frequently resulted from the imposition of Western codes on those formerly organic cultures" (1976, 1); exile, in this context, is manifested through an alienated consciousness as well as physical remove. Haitian literary critic Max Dorsinville concurs, as in his account of Chinua Achebe's *Things Fall Apart* of 1959, "One must recognize that the world which is falling apart is Africa and the Third World in general: societies turned upside down, condemned henceforth to a state of exile within which they are to redefine themselves" (1976, 62). According to Dorsinville, the *négritude* sensibility was one informed by the need to "return to the sources" (*le retour aux sources*); those who articulated its tenets recognized, even among their differences, that they belonged "to a common culture relegated to the depths of a deliberately forgetful consciousness in an everyday existence officially sealed by the look of the Other, and the growing awareness that the world was once theirs." Theirs was "an exile which became part of their consciousness" (64). Their struggle was to become that of finding the tools by which to communicate that sense of alienation. Dorsinville continues: "But how is the exile in the metropolis to circumscribe, sing, translate that authentic world which he (*sic*) feels instinctively and wishes to measure and appraise?" He concludes that "it is memory which must break through the walls of black isolation," "the word of . . . collective memory—the speech of the griot—ancestors and spirits" (65). Perhaps it is because I am Haitian that the sensibility of *négritude* (which was, in fact, an outgrowth of the preceding Haitian movement of *indigénisme*) informs my own outlook on exile. Physical and psychic alienation have been a part of my daily existence since early childhood, and it is memory, both individual and collective, that has enabled me to sustain my cultural roots.

The function of memory has been central to my own understanding

of the ins and outs of living in exile. It has been through memory—my own and that of family members—that I have been able to keep a vital link to Haiti. I have remembered: the heat that enveloped the tropical summers of my early childhood; the walks on dust-laden mountain roads leading past the street vendors (selling tortoiseshell bracelets, woven and dyed straw baskets, baubles for the tourist dollars); lizards escaping the swift broom of the housekeeper as they slithered across clammy linoleum floors of an aunt's house; the weekend escapes to grey sand-covered beaches to wallow in the aquamarine depths of the sea; the fruits—sweet and orange flesh encased in pliant green shells—growing on my great-grandmother's *quenêpiers* trees, that I have never tasted anywhere else since. These are the fragments of a life lived without full knowledge of home: home was always the place to escape to, not the place where I resided from day to day. Such memories, I realize now, are all anchored in a middle-working-class identity, in which I was allowed to forget the housekeeper's name or the fact that her taking care of me and the other children in the house kept her from her own family. The cycle of oppression was already being repeated: I knew nothing then of the relative luxuries of my existence. It was in Canada, where my marginalization was guaranteed by never allowing me to forget any part of my nonwhite, non-Anglo identity, least of all the contempt felt nationally (and internationally) for Haitians and our curious impulse to drown at sea, that I came to realize the fullness of the exploitation of Haitians under North American patronage. This is not easy to describe: imperialism, colonialism, and neocolonialism have brought to the Caribbean a tenuous legacy bound in racist and capitalist ideologies through which large populations are suppressed while a few are allowed (or use force) to access the higher ground of class privilege. None of this is "black" and "white." The conditions that have made Caribbean countries like Haiti the poorest among the poor are complex and continuous. Growing up in Canada, an emigrant in pursuit of opportunity and the myth of equality, how does a child mourning the loss of things as simple as the fruits growing on the trees in her great-grandmother's front yard come to terms with this reality? Figuratively speaking, I began by looking for those trees.

In 1980, "mainstreamed" in an all-English school, my avenues for advancement were few. I was Black and my first language was French: I was not expected to do well scholastically, although both my parents were educators. And, I was a girl, and girls were discouraged from excell-

ing in areas that could not be defined as properly feminine (such as sports and woodshop). The only things I could do well without succumbing to the pressures of racism, xenophobia, and sexism were religious and superficially bookish: I could recite ten Hail Mary's in the blink of an eye; I could read ten young adult Scholastic paperbacks within a week; and I could write one short story per homeroom period. Prayers, however, could not endear me to my fellow ten-year-olds.

I was inferior, they thought, and on the basis of my visible differences of skin and language, nothing I earned on their turf could be deserved. My Haitianness, in this context, confirmed their impressions since, then (as now), Haiti, well-known for its poverty and manifestations of ancient African rituals, stood as a symbol of African degeneracy in the New World. I learned this lesson well and turned to the world of writing and make-believe for solace. I remember well writing a story in which I imagined myself elsewhere, in a place where everything was ideal and nothing could make me unhappy: I disguised my classroom traumas with a tale of sorcerers and magic in which only my heroine could win. Remembering that this story would be graded and that my English was still shaky, I looked up every word in my Webster's dictionary and handed in what I thought was a pretty good imagining of good winning over bad. It was never returned to me. Instead, at a parent–teacher interview, my mother was accused of having written the story for me! Since my mother had no recollection of even seeing the story, there was little she could say. The teacher could not prove her case, but nonetheless applied her version of elementary-school justice: I received no grade and a reprimand. After this, I refrained from writing but held on nonetheless to my world of books and the magic of the written word.

Education was important to my newly emigrated parents. They were both teachers, after all, and they knew that the obstacles that would face their children could be overcome only with knowledge. Ignorance of the true nature of the world at large would only keep us at a further disadvantage. And though my initial experiences in Canadian elementary schools were less than encouraging,[1] I had learned a valuable lesson from those who sought to impede my progress: the degree to which my attempts to survive were opposed within the educational system demonstrated that I was not so inferior—a fact my fellow students and teachers, given the intensity of their attacks, must have realized. I thus came to understand that my mastery of basic intellectual facts and skills would

prove to be unsettling. Although I found myself avoiding everyone in order to survive within academia, in high school, college, and graduate school, and thus perpetuated one facet of my marginalization in these institutional settings, I had also found one useful key to ending that cycle.

My struggle to overcome adversity through education had two components. On a primary level, I was seeking to reach a site of safety from which to form my own ideas and to stand my own ground without having to fight off every detractor. I was attempting to learn something about myself that could secure this site for me, and I did not realize for a very long time that I could not easily do so within the academic system I was struggling to master. In everything I was taught, I was moved farther and farther away from my origins: the more I advanced in school, the more I found that my personal and communal histories had been expunged from the official records. I did not exist and, furthermore, no one like me had ever existed before. Or so I was led to believe. Knowing all the obscure historical facts of Canadian history won me prizes and approval from those in authority, but I would have failed miserably if anyone had even thought to ask me about the history of people of African descent in Canada and elsewhere. I was unconnected to others like myself and this disconnection served a purpose: I did not threaten the status quo and earned a place closer to the center of academia. I earned that place without true knowledge of self: I was as invisible to myself as other women of color had been made to me. As I proceeded to rack up credits for my bachelor's degree, the message was clear: if I chose to master Chaucer, Milton, Shakespeare and Keats, I could be an honorary member of the inner circle. I chose instead to seek out the voices of Black authors and to write about them whenever I could—but only in American Literature classes, where the voices emerging from the Harlem Renaissance had been recognized and canonized in Norton anthologies. Although Countee Cullen, Langston Hughes, and Zora Neale Hurston, and earlier writers such as Frederick Douglass were not being taught, I persuaded professors to let me analyze their works in comparison with the literary standards of the late 1980s—Twain, Fitzgerald, Hemingway, Faulkner, and Chopin. Paradoxically, I learned more from researching on my own than in the classroom. Decidedly, there were secrets to be unearthed which could lead me closer to the Haiti that I had seen for the last time some ten years earlier.

The need to recover my history drove me to attain as much knowledge as I could. I finally saw that the marginalization I had endured as a

Black girl and woman personally was reflected in the institutions in which I now freely circulated. The next stage of my struggle, then, was to discover how to insert my own voice in academia along with that of other Black women who had done so before me. I had, of course, to find those voices that had preceded mine. Because I had been taught that there were no Black Canadian voices to be heard in the Canadian literary landscape, I had turned to African American literature for answers. I found myself drawn to the writings of James Baldwin, who himself had led most of his writing life in exile, in France. It was at this point in my tutelage that I realized that the fact of Baldwin's expatriateness had a moving impact on my own life.

I understood easily the necessities of survival that had led Baldwin away from the United States in order to write his novels, which would starkly illustrate the realities of racism, classism, and homophobia during his writing life, and which spanned more than three decades (1953–1987). Initially, I was struck by Baldwin's attention to the presence of multiple oppression in the lives of African Americans. In *The Souls of Black Folk*, W.E.B. Du Bois had written that "the problem of the Twentieth Century is the problem of the color line" (1903/1965, 209). Baldwin had gone beyond confronting the accuracy of this statement by exploring not only the nature of prejudice but also its diverse configurations; although race was always at the center of his writings, especially in his essays, in fiction Baldwin explored issues of religion, sex, sexuality, and class across racial and cultural lines and demonstrated the kinds of exile that could result from prejudice on any one of those fronts. I had found an ally in the writer, Baldwin, and I decided to write my master's thesis on his work. I did not realize as I attempted to do so that my only ally would be Baldwin. Very little attention was being paid then in Canada to Baldwin and other African American writers. As a result, I exiled myself once again, this time to the United States. Reading for my thesis, I had entered more deeply into the field of African American women's literature—Toni Morrison, Alice Walker, Gloria Naylor—and I endeavored to work specifically on women writers of African descent. By this time, by chance, I had met two Afro-Caribbean women writers in Nova Scotia—Dionne Brand and Marlene Nourbese Philip—but they were not recognized as "real" writers on the campus I was then attending. And so, barely existing myself, I still believed that there were very few Afro-Caribbean women writers to read and explore.

I came to the United States because I thought that here I could more

easily find my cultural and historical roots and, with that knowledge, continue to write myself into existence. There was, and is, a recognized African American community with its own literary tradition, and I could specialize in the area of African American literature rather safely if I stuck to those writers who had been canonized or were close to becoming canonized. Very few of them, however, were women and very few of them, other than Baldwin, spoke to me in ways that paralleled specifically my own life experience as an Afro-Caribbean woman. I needed to gain knowledge about the history of the Caribbean, about women writers from the Caribbean, or remain content with parallels rather than similarity and accuracy. I discovered by reading more African American women writers that there were strong cross-cultural ties between the African American and Afro-Caribbean communities. Writers such as Audre Lorde, Paule Marshall, and June Jordan traced their heritages back to the Caribbean and wrote about it. And what they wrote was so similar to what was being written in Canada by Afro-Caribbean women such as Dionne Brand, M. Nourbese Philip, Makeda Silvera, and Afua Cooper that I began to see that what had been rendered invisible in all my university classes, which could have heeded issues of race and sex, was at its base a history of emigration and displacement, which contributed to the denial of literary achievements by women of African descent from the Caribbean.

When I undertook doctoral work and officially declared that I intended to specialize in the literature of Afro-Caribbean women, especially that written by noncanonized writers, I was asked where I intended to find such writers. Again, I was presented with the myth of the nonexistence of Afro-Caribbean women writers. This myth exists, as it does for the study of literature by people of color generally, in order to legitimize their exclusion from various Euro-centered canons of literature. Undaunted, I researched the area by visiting feminist bookstores in Canada and the United States, where I soon discovered that the women for whom I had been searching for most of my life were indeed alive, writing, and being published.

Discovering Afro-Caribbean Women's Voices

A number of the first Afro-Caribbean women writers whom I read were being published by British presses: Heinemann Educational Books

publishes an African and Caribbean Writers Series, which includes women writers such as South African Bessie Head and Afro-Caribbean Beryl Gilroy; the press also initially published M. Nourbese Philip's novel *Harriet's Daughter*, which Canadian presses refused to publish on the false assumption that Black children in Canada "did not read."[2] The Women's Press in Britain publishes the novels of Afro-Caribbean writers Joan Riley and Velma Pollard. By reading through recent anthologies and collections of Afro-Caribbean women writers, I found many more names that I had never heard mentioned seriously in academic circles: Louise Bennett, Opal Palmer Adisa, Rosemary Brown, Lorna Goodison, Rosa Guy, Claire Harris, Makeda Silvera, Afua Cooper, Merle Hodge, Marie Chauvet. I had evidently been in the wrong circles, for these books, which include *Creation Fire: A Cafra Anthology of Caribbean Women's Poetry*,[3] *Wild Women in the Whirlwind: Afra-American Culture and the Contemporary Literary Renaissance*,[4] and *Watchers and Seekers: Creative Writing by Black Women in Britain*,[5] all stress the strong presence of Afro-Caribbean women writers. Although these writers do not form a "cohesive" community, in the sense that they are not all from the same island or reside in the same country of exile, they do speak from similar vantage points and express the same concerns for the necessity of preserving Black women's ancestral and contemporary voices, as they emerge from the Caribbean and other nations where descendants of the African diaspora remain. As a group we are neither invisible nor voiceless.

In fact, women writers from the Caribbean have a long history. Early-twentieth-century writers include Jean Rhys (Dominica) and Una Marson (Jamaica). By mid-century, writers such as Phyllis Shand Allfrey (Dominica), Marie Chauvet (Haiti), and Rosa Guy (Trinidad) were gaining recognition. They were soon followed by the many writers I have mentioned above, but texts by Afro-Caribbean women writers remained excluded from classrooms and elite literary circles. This is why the writings of women from the Caribbean are often labeled the result of a "recent 'explosion'" and referred to as "postcolonial," rather than as an extension of an established Caribbean literary tradition. The writing that is now appearing from the feminine Caribbean has a history, but that history is still largely obscured and ignored. Elaine Campbell, in "The Unpublished Short Stories of Phyllis Shand Allfrey," recounts how the writings of Caribbean women have taken a backseat to those of male writers of the Caribbean. For instance, she invokes the research of Pierrette Frickey,

who in her essay "Caribbean Women Writers and the Publishing Market" "has identified 405 published Haitian male writers compared to 15 female" (1990, 119). Women remain underpublished in the majority of the Caribbean islands, but they have nonetheless always taken part in writing, of necessity. Campbell writes of the fact that many women participated in writing pieces for small local journals and collections designed for use in the classroom (120)—this precisely in order to present students with reflections of their own lives, which was all too often not possible in schools fashioned to emulate British and French curricula. These sorts of publications, of course, have gone unrecognized. Though a number of women managed to publish within the Caribbean, most of those writing in English appear to be predominantly published in exile—in Britain, in Canada, and in the United States.

It is because of my identity as a displaced Haitian woman that I have chosen to provide literary analyses of various texts by Afro-Caribbean women writers within the contexts of their critical, historical, and sociocultural frameworks. As a literary critic, I do not believe in divorcing literature from its wider social context: texts by minority writers in general must be explored within their own historical, cultural, social, and philosophical structures. An interdisciplinary approach to literature is instrumental to making visible the marginalized in various aspects of Western societies. As I show in the first chapter, it is feminist criticism and ideology that provide me with the tools to explore this literature from a variety of perspectives, with the purpose of revealing the tenor of Afro-Caribbean women's experiences in the context of exile.

The sociocultural contexts in which Afro-Caribbean women writers in exile in Canada, the United States, and Britain write are complex and thus necessitate interdisciplinary investigation on the part of critics concerned with the wider field of Caribbean literature. Afro-Caribbean women's writing should be read as a part of the literature of the African diaspora. Within this frame, attention must be paid to the fact that the Caribbean is influenced not only by African culture but also by the cultures of those who dominated the region from the mid–fifteenth century on through imperialism and colonialism. The French, English, Spanish, and Dutch have left their imprint on the psyche of the Caribbean, and this is reflected in the writings that have emerged from the region over the last several decades. But because such cultural fusions differ markedly from one linguistic cultural group to another, I here focus primarily on

the writings of Anglophone Afro-Caribbean women. This is not to say that there is a cultural cohesion among the English-speaking islands, but only that the experience of British imperialism has given islands like Jamaica, Antigua, and Trinidad-Tobago (to name but a few) a common base of experience. Though some of that experience with imperialism and colonialism is similar throughout the islands whatever their language use, it carries its own particularities in the context of British cultural imperialism.

Searching for Safe Spaces is thus a work in which I focus on the writing by Afro-Caribbean women writers in the context of their exile from home islands. Specifically, I look at the significant themes of race, sex, sexuality, and class, in addition to age and nationality, as expressed in the works of Joan Riley, Beryl Gilroy, Makeda Silvera, M. Nourbese Philip, Dionne Brand, Audre Lorde, Michelle Cliff, Rosa Guy, and Marie Chauvet. All these writers articulate, from differing geographies of exile, strategies of resistance against imperialist, neocolonial, and patriarchal ideological and social structures, which actively suppress, oppress, marginalize, and silence Afro-Caribbean women and women of color globally. These strategies are enacted through the recording of oral history and through literary genres such as poetry (in my findings, Afro-Caribbean women reformulate this particular genre through what I have termed "poelitics," that is, a dynamic fusion of poetics and women-centered politics), short stories, novels, and essays, as well as films, by which the authors re-present aspects of the history of the African diaspora from a specifically female point of view. In so doing, the silence that surrounds the issue of the sexualization and exploitation of Black women transhistorically is broken and replaced with particularly feminist visions of the plausibility and possibility of also breaking the cycle of that oppression and its diverse manifestations.

As my analysis of particular texts shows, I see these visions as describing a particular process many Afro-Caribbean women are forced to confront within their exile. This process has four distinguishing features: *alienation, self-definition, recuperation, and return.* Each of the authors I have listed above illustrates how various forms of prejudice contribute to their female characters' sense of alienation from the mainstream of society within their adopted countries and how these characters attempt to end this alienation by first recuperating the history, on both a micro- and macrolevel, of Black women's survival and resistance to oppression across the African diaspora; this recuperation leads to the self-definition neces-

sary for obtaining and maintaining a sense of autonomy from oppressive powers (colonial or otherwise). Depending on how the characters presented in the literature fare with recuperation and self-definition, the authors explore what it might mean to "return" homeward: for some characters, the return is an actual return to the Caribbean; for others, the return is symbolically or metaphorically achieved through the affirmation of an alternative history to that presented by various colonial powers at work in the Caribbean. In any case, it is clear that Afro-Caribbean writers are intent on validating their origins as well as those of the characters they create: home is not only a place but also a state of self-understanding to which we return time and time again in order to see and know ourselves for who we are as we prevail against the erasure implicit in the process of assimilation we are forced to endure in Western societies, which openly violate and denigrate Black women as a class.

As a Haitian woman whose life has also been lived in exile, I could not, as the words I have written above demonstrate, undertake this project without personal investment, or without foregrounding my own identity in ways similar to those expressed by the aforementioned women. Failure to do so would betray their very efforts at liberating Afro-Caribbean women from their marginalized existence in their home islands and abroad. For, as I show, the politics of empowerment, as articulated by these writers, is based on an explicit awareness of the interior life of the oppressed—that is, of the alienating effects of oppression upon personal lives—and not only on a broad acknowledgment of sociopolitical ideologies that suppress formerly enslaved peoples (women particularly within such groups) in order to carve new paths from within the wilderness of invisibility. I hope, then, that this text will serve as a resource for those of us whose real-life experiences are continually masked or obscured in societies that attempt to pacify us by professing themselves multicultural and, as such, tolerant of every difference, racial or otherwise, of the rainbow of human existence.

Above all, I aim to remain faithful to the visions of the Afro-Caribbean women writers at the heart of this work; I am committed to join in their efforts to resist recent trends to coopt and commodify the experiences of women of color with token inclusions in current mainstream literary scholarship. My main purpose is to use this forum to uncover the suppressed history of Afro-Caribbean women and to connect that history to the experiences of Afro-Caribbean women surviving in

exile under multiple forms of oppression as expressed through their literature. My task, therefore, as a writer and critic is to clarify connections rather than to obscure them. Although the text has been considerably revised since its first writing in 1993 and bears the mark of that age somewhat, I have endeavored to preserve the sense of the cultural forces that brought into being the texts produced by Afro-Caribbean women in the late 1980s to early 1990s, when I first undertook the journey that brought me to write this book. In the end, whatever the inconsistencies or lapses in topicality, this work is an offering to my women ancestors. I would like to believe that, were my grandmothers alive and able (across their linguistic differences) to read what follows, they would approve of, if not all aspects of the content, its attempt to be faithful to the fabric of their lives. In a way, I have found my way home, and this work is to reflect the process of that journey as I have found it expressed in the works of other exiled Afro-Caribbean women writers.

Acknowledgments

I wish to thank those who earnestly contributed to shaping the present text in its earliest incarnations in 1993: Florence S. Boos, Peter Nazareth, Fred Woodard, Anne Donadey, and Roseanne L. Quinn. I thank Gay Wilentz for providing further commentary on a revised version of the initial text, which enabled me to reshape and refocus the study. I am also grateful to the editors of *Canadian Woman Studies/Les Cahiers de la femme* for publishing an excerpt from Chapter Three on M. Nourbese Philip's *She Tries Her Tongue, Her Silence Softly Breaks* in 1993, and to the editors of the *Journal of Caribbean Studies* for publishing an excerpt from Chapter Five on the works of Marie Chauvet and Michelle Cliff in 1993/94.

In addition, I would like to acknowledge the professors who encouraged me to discover myself through literature and express myself through writing as an undergraduate at the University of Manitoba from 1986 through 1989: Deborah Schnitzer, Evelyn J. Hinz, and John Rempel. Thanks also go to Ronald Huebert, who continued that encouragement as I worked on my master's degree at Dalhousie University in 1989.

Finally, I thank the only grandmother I had the fortune to know in my lifetime, Alice Limousin Chancy, who taught me the promises of unconditional love and inspired me to say "yes" when others would say no to my dreams; she passed away, prematurely, in 1995, of breast cancer. I hope that what follows will enable other women to reach for their own dreams as she enabled me to reach for mine.

One

Productive Contradictions

Afro-Caribbean Diasporic Feminism and the Question of Exile

This island's mine, by Sycorax my mother,
Which thou tak'st from me.
—William Shakespeare, *The Tempest*

How difficult and time-consuming it is to have to reinvent the
pencil every time you want to send a message.
—Audre Lorde, *Sister/Outsider*

Exile: An Afro-Caribbean Women's Perspective

The condition of exile has been dissected at length in literature as it has
been in criticism. It is one which, even if not experienced directly, each of
us has come to know intimately as synonymous with an alienation more
complex than the philosophical quest of coming to terms with one's indi-
vidual self. The condition of exile crosses the boundaries of self and
other, of citizenship and nationality, of home and homeland; it is the
condition of consistent, continual displacement; it is the radical uproot-
ing of all that one is and stands for, in a communal context, without loss
of the knowledge of those roots. It is, in fact, this knowledge that renders
the experience of exile so cruelly painful, for what one has lost is carried
in this forced nomadism from one geographical space to another; all that
one has lost remains "over there," in that place once known as home,

now a distant vague shape on the world map, no longer the place in which we, the exiles, find ourselves.

To begin to define exile, then, is to acknowledge its irrevocability. That is to say, that exile brings with it an irreparable fissuring of self from homeland. And yet, as I envisage exile throughout this work, it cannot be defined simply as the expulsion of individuals through overt, political, governmental force from one's homeland with all the flourishes of a Shakespearean tragedy. Exile, in my heart and mind, is more basic than this, more banal, perhaps. It is what makes remaining in one's homeland unbearable or untenable: the threat of governmental/political persecution or state terrorism; poverty enmeshed through exploitative labor practices that overwork and underpay; social persecution resulting from one's dehumanization because of color, gender, sexuality, class standing; the forever of lack of choice in one's profession; the impossibility of imagining moments of leisure, moments for the nurturance of the soul; the flickering wick of hope extinguished through despair. Such indignities lead to suicide, violence, more poverty, a vicious cycle of hopelessness, or, finally, self-imposed exile, that is, emigration.

I am speaking of exile in the Afro-Caribbean context and, more specifically, as it pertains to Afro-Caribbean women, as a process of forced migration equivalent to the image of the banished, deposed nobles of yesteryear, or of mass expulsions of entire populations in times of war or civil strife on the African continent or the Middle East, or, even, of members of the literati who, because of their political convictions, are stripped of their citizenships but spared their lives through expulsion. Not only is the migration undertaken by the majority of Caribbean people—an individual or small trickle at any given time—equivalent to those expulsions, it is often compounded with the semblance of having been undertaken for capitalist or material accruement. It is this "appearance," real only to those in whose self-interest it is to look no deeper for the causes of such migrations, which has been used over and over again to deny Haitians, for example, asylum in countries such as the United States over the last several decades, both pre- and post-Duvalier. Haitians, living in a country that remains the poorest in the Western hemisphere, because it provides the hemisphere with its cheapest labor pool, have been considered economic rather than political refugees, even as Duvalieran terrorism reigned supreme, and even after the departure of Baby Doc Duvalier, violence remained an everyday facet of life. Should we be more sympathetic to-

ward the expulsion of famed Haitian writer René Depestre, who fled to Cuba and then to France during the Duvalier years, or toward a Haitian mother who wants to ensure not only that her children will have something to eat, every day and more than once a day, but simply that her children will remain alive on dry land? Should we not be equally sympathetic? Should we not be able to discern the added plight of a woman who cannot leave the island unless she first works her fingers to the bone in the hope of buying that ticket out or, if she cannot find work that pays, would rather take her children to sea than see them die on shore? It is this qualitative difference in how exile can be experienced that concerns me here, not only by class, but by gender. For if we have come to know the condition of exile through literature, we have come to know it primarily through a male prism.

We have come to think of those in exile as "novelists, chess players, political activists, and intellectuals" because of their mobility, according to Edward Said (1990, 363). Said also writes that "the exile lives an anomalous and miserable life, with the stigma of being an outsider" (362); the exile is aware of his/her condition and suffers through that consciousness of difference. And yet, Said asserts that different forms of exile must be noted, that "although it is true that anyone prevented from returning home is an exile, some distinctions can be made between exiles, refugees, expatriates and émigrés" (362). For Said, the exile's condition is the most aberrant, for refugees are for him "large herds of innocent and bewildered people requiring urgent international assistance," "expatriates voluntarily live in an alien country for personal or social reasons," while émigrés are those who "enjoy an ambiguous status" through their choice to emigrate (362–363). In Said's litany, émigrés are barely distinguishable from expatriates, neither group departing from their homeland through political motivations, while refugees lack the intellectual acumen deserving of investigation. Said's exile is a nostalgic incarnation of a poet–figure, an idealized insurgent. Hence he writes: " 'Exile' carries with it, I think, a touch of solitude and spirituality" (362). Again, I am concerned here that the exile is in fact a *privileged* individual whose privilege goes unrecognized by Said: his/her solitude and spirituality is gained from not having to be concerned with mere survival; she or he lives in a contemplative state not unlike that reserved for the upper class in the Victorian age.

We have also come to think of exile in the Caribbean context as "the

colonial . . . slowly and ultimately separated from the original ground where the coloniser found him" (Lamming 1959/1960, 159), as "Caliban's" colonized self, speaking the language forced upon him by his colonizer. Here, in Lamming's invocation of the tragedy of exile (which I return to at greater length later in this chapter), Shakespeare's Caliban functions as the image of the West Indian who is alienated from himself (and Lamming does intend Caliban and the West Indian to be figured as male) through the very tools he has at his disposal to disrupt that exile, his modes of communication, words, language, writing. But what writing? The words of Afro-Caribbean women who themselves survive and live at a remove from their home islands betray both Said and Lamming's points of view in the sense that these women foreground what it means to be dispossessed of one's homeland in every facet of one's identity and to have had little or no choice in one's state of exile.

A consciousness of difference appears to be the only marker of what differentiates the true exiles from those whom Said does not consider "exiles," although they, too, cannot return to their homelands whatever the reason. That awareness is for Said "contrapuntal" (1990, 366), an ability not only to have a sense of the doubleness of one's existence (where one is from as opposed to where one lives, the home culture as opposed to the one negotiated in the country of adoption), but even to be able to combine these cultural disparities with elegance, as in music when two or more melodies are combined to harmonize with one another in simultaneity. This ability to counterpoint cultures is rendered all the more complex if we grant Said's non-exile exiles the possibility of achieving this "contrapuntality." If we deromanticize the condition of exile from this idea of spiritualized aloneness, we might be able to acknowledge that within this sea of exiles there are those who do not achieve the harmony inherent in the contrapuntal, but whose lives are a constant balancing act between more than two conflicting cultural codes.

I want to go back to the space in which Afro-Caribbean women in exile reside, that space in which the balances struck are, in fact, a question of life or death in the most complex of forms. Because Afro-Caribbean women are not only forced to strike a balance between the land of their exile, which is usually also that of a colonizing force, and their homeland, any number of Caribbean islands, they must also overcome the negation of their identities as women in a world that defines itself as male. Our bodies form the very nexus of the battle that begins at

home and carries into exile. For those Afro-Caribbean women whose bodies are literally abused, physically or sexually, in order to strip them of their autonomy, class becomes an all-important dimension of their consciousness of the ways in which they are multiply disadvantaged; their response, then, must be one that speaks to class imbalance without themselves, however, repeating or inverting those imbalances. For other Afro-Caribbean women, the body becomes a representation of who they ought to be (wives, mothers, mammys, sapphires, and the rest) rather than who they know themselves to be; for such women, their Black and female bodies become the source of their fulfillment. And it is in exile that such awareness of the limitations imposed upon the body becomes much clearer; for "out there" women have the opportunity to speak out against their marginalization in a culture which is not theirs and which is not likely to punish for speaking out against the emigrants' culture that it feels the less threatened by. Women within the Caribbean are also speaking out, but their voices are often lent to the cause of nationalism (more or less male-defined) or coopted to service male versions of women's identity. In exile, Caribbean women can ironically politicize their discourse and be heard in more than one culture simultaneously, making their consciousness and those they reach "contrapuntal" at once. In so doing, they nonetheless resist assimilation, for their goal is not, in fact, to harmonize with the country of adoption which is also a target for their criticism. Their vision is informed by the various ways in which their bodies or the representation of their bodies has led to the limiting of their aspirations, as well as those of their children, especially their female children.

Afro-Caribbean women's literature speaks to all of these issues, and more, from within a politized consciousness of how exile functions at the level of the corporeal, of the nation–state, of the homeland, of the adoptive culture/nation, of the psychological, of the social, of the generational, of the spiritual. This spirituality of exiles is not invoked in the form of nostalgia for the home country but in the form of a centering in the self, in the Black female body recovered through women's language, relationships to one another, and through women's writing and words. Afro-Caribbean women's condition of exile is not so much contrapuntal, then, as it is decisively *selective* in its assertion of a recuperated and rearticulated identity that is both individual and communal, here and there, of self and of other, in ways which reaffirm the roots of origin while the

self always remains cognizant of the fissuring, the inability to return to one's homeland.

For me, Afro-Caribbean women's description of the state of exile in their fiction, poetry, personal narratives, essays, and oral testimonies, is the product of painful insight into their dispossession; this insightfulness is rendered productive through an acceptance of the contradictions inherent in the state of exile. Afro-Caribbean women's expressions of exile in literature are thus, to extend Said's musical analogy further, not unlike the "fugue," which Webster's defines as "a musical composition in which a melody (the subject) is taken up by successive 'voices' in imitation, so that the original melody seems to be pursued by its counterparts. . . . In its full elaboration the fugue has further subjects introduced into its structure, and the themes may be elaborated, inverted or otherwise varied." Afro-Caribbean women's literature has for its main "melody," or subject, the condition of Afro-Caribbean women at home and in exile; its writers attempt to represent them as accurately a possible but in a variety of formats, which lead them to reformulate the genres in which they write to suit that primary subject. Their writing can be understood, then, as imitating dominant literary conventions, but always in such a way as to buoy the "original melody." On another level, since the writers' task is undertaken in exile, the representations they offer are often imitations of their former lives, an attempt to recapture all that has been lost; this is an exercise that lends itself well to fiction, which is, by its very nature, fabulous, imitative, a simulacrum of reality. As in the fugue, these representations (fictive or otherwise) are structured through multiple themes: those of race, gender, class, sexuality, nationality, and flight. The "fugue," from the Italian *fuga*, meaning flight, thus accurately speaks to Afro-Caribbean women's plight before and after exile, the necessity of fleeing conditions that adversely affect their lives and their futures (along with those of their families or loved ones): poverty, lack of jobs and health care, sexual abuse, physical abuse and neglect, in old age, sexism, racial oppression abroad, intolerance of sexual choices including bisexuality and lesbianism, the silencing of political points of view—to name only the most salient. These issues serve to construct the most elaborate of fugues, intertwining themselves like jazz riffs upon the main melody of women's oppression, to provide the eager listener with a tapestry of sounds and perspectives on what it has meant for Afro-Caribbean women to take control of their bodies, their lives, and, in order to do so, to have re-

moved themselves from their roots. Those roots are, in effect, of a dual nature, nurturing the songs they sing but also supplying the source of their melancholy; for, if the Caribbean islands represent for most the site of home, the origin for the music of their individual fugue, they also represent in part what they have had to flee. Finally, when viewed as a whole, the literary voices of Afro-Caribbean women can also be seen as constructing a fugue, as each of their voices complements the others while still remaining focused on the main subject at hand, Afro-Caribbean women's lives. Ultimately, their words form the metaphorical bridge of song that leads homeward and that bridge leads to many paths.

In Search of Our Own Tongue(s)

The struggle for recognition, whether in academic, social, or political arenas, is a difficult one for those of us who, as "minorities," do not benefit from equal or even adequate representation in any of these settings. How do we reclaim ourselves, our home islands, without a firm presence in the very circles that keep us perpetually on their peripheries, looking in? How do we affirm our existence, even in those margins, without a language of our own making, especially when language has become an arena of perpetual struggle for so many of us who have had to function with imposed, European languages as a result of colonization and deplacement? Reclamation can only occur effectively when we take stock of the ways in which we, as Black women, have been able to lay claim to a language of our own making and placed ourselves at the center of that discourse in ways that have forced our excluders to take notice. That language, as I show in this chapter, is the critical, political, socially conscious, and theoretical discourse of Black feminism in its diverse configurations in the United States, Canada, Great Britain, the Caribbean, and Africa itself. Armed with this apparatus, which lays the groundwork for understanding Black women's unique ways of seeing and understanding the world about them, it provides us with the words to measure and analyze the literature produced by Black women in a variety of contexts.

It would seem, however, that despite the increased attention being paid to a small group of Black feminist intellectuals (such as Barbara Christian, bell hooks, Michele Wallace, and others), after years of struggle to have their voices counted in academe, this has not resulted in the *ongoing inclusion* of their theoretical perspectives in traditional areas of

study such as literary criticism. Efforts on the part of Black women to formulate their own approach to feminist ideology have often been curtailed by the Eurocentricity and elitism of a number of white feminists who appear to think as well that theory and the identity of Black femaleness are "naturally" contradictory.[1] As Deborah McDowell has noted in her book *The Changing Same* (1995): "Although Black feminist criticism can be marked at one point on an as yet unfinished trajectory, it is consigned to the status of the permanent underclass" (175). Yet it remains true, as Carol Boyce Davies writes, that "if we take any feminist issue and run it up the scale to its most radical possibility, its most clarifying illustration will be the experience of Black women" (1994, 29); given that Black women's experience of oppression is more than one pronged, encompassing as it does all variety of denigrations known to humanity, it stands to reason that feminist endeavors should be cognizant of the knowledge that Black women bring to bear on such issues.

The aim of Black feminist theory and criticism is to reveal this knowledge and to broaden the scope of what is conceived of as "feminism." In other words, the visions of women of African descent across the diaspora resist their positioning as theoretical critics: they turn this imposed contradiction into positive fodder for the articulation of a feminist ideology that is productive in its deployment, which will instruct us in the ways by which Black women's oppressions might, in some future time, be brought to an end. It also avoids the solipsism Karla F. C. Holloway has noted in the work of most white, Anglophone, feminist theorists, of which she writes: "Even though the feminine Other seems to be its subject, its objective effort, the decentering of male androcentrism, has in effect fixed the critical inquiry to a dialectic that does not include itself" (1992, 69). Critical and central to Black feminist thought is the impulse to include, to make visibly present, the vibrant words, thoughts, and images of Black women.

As Barbara Christian has written in her important essay, "The Race for Theory," "We need to read the works of our writers in our various ways and remain open to the intricacies of the intersection of language, class, race, and gender in the literature. And it would help if we share our process, that is, our practice, as much as possible because, finally, our work *is* a collective endeavor" (1988, 69). In fact, it is the principle of *collectivity* that differentiates Black feminist criticism from other current modes of criticism (feminist or otherwise), which address isues of race,

sex, and class as separate and socially constructed categories that are no more than fictions waiting to be dispelled. I would also suggest that Black feminist critics have formed a distinct and recognizable theoretical practice which effectively resists "monolithism" and makes possible the application of its tenets within an area of recognition and respect for the many differences which exist between and among Black women, encompassing diverse backgrounds and identities, across geographies and time.

The Struggle for Self-Definition:
The Tenets of Black Feminism Diasporically

Black feminist criticism has its foundation in the collective organization of African American women who sought to validate their existence as well as transform its terms. The writers of what is often considered the pivotal statement of a collective self-definition of Black feminism, "A Black Feminist Statement," by the Combahee River Collective (1977/1982) root their own political manifesto in the past accomplishments of other Black women: "There have always been Black women activists— some known, like Sojourner Truth, Harriet Tubman, Frances E. W. Harper, Ida B. Wells Barnett, and Mary Church Terrell, and thousands upon thousands unknown—who have had a shared awareness of how their sexual identity combined with their racial identity to make their whole life situation and the focus of their political struggles unique" (273). What is important to note about this statement is that feminism for African American women has been a question of uniting both racial and sexual equality agendas. Black feminists no longer speak of themselves simply, as Michele Wallace succinctly stated in her essay, "A Black Feminist's Search for Sisterhood," as "women who are Black who are feminists" (1975/1982, 12), but as Black feminist women who adopt very clearly defined political points of view. In the complete vision of the "Statement," the women of the collective do in fact examine this multilayered texture and give it voice. But their aim is not only to give voice to the fact of multiple oppression for Black women, but also to connect their political statement to political acts of resistance against it. They are, or intend to become, active participants in working with other oppressed women of color on picket lines to obtain basic rights, such as good working conditions, fair wages, and health services. They organize workshops, readings within academia, and challenge white feminists to become ac-

countable for their own internalization or perpetuation of racism and classism within their own political agendas. In this, they establish their own Black feminist voice and differentiate it from mainstream, white feminism.

Along these lines, Barbara Smith, a coauthor of the Combahee River Collective "Statement," continued to explore the need for a Black feminist method of criticism in her essay of 1977/1982, "Toward a Black Feminist Criticism." There, Smith asserts the need for Black women scholars to adopt a feminist approach to the literature of Black women, which would encompass a serious consideration of the manifestation of what Deborah King has more recently termed "multiple jeopardy," that is, the interlocking oppressions of race, sex, class, and sexuality within that literature (1988). The need for such an approach is necessitated, says Smith, by the fact that Black women and Black lesbian writers are virtually ignored not only by white male critics, Black male critics, and white female critics, but by Black women critics as well. The principles of Black feminism appear threefold to Smith: *a recognition of Black women's literary tradition, self-reflexivity, and validation of lesbian relationships.* Smith believes that the application of these principles will lead Black feminist critics to make the lives of Black and lesbian women visible for those who have not recognized their existence. At the same time, by utilizing these principles as the basis for a Black feminist movement as well as for the creation of a Black feminist mode of theorizing, Smith hopes that the isolation of so many Black feminist writers attempting to do just this will be relieved.

Smith's essay is only the beginning formulation of a literary model for Black feminist criticism in the United States. In true "call and response" fashion,[2] other Black feminist critics have responded to Smith's essay and reformulated its initial concepts. Deborah E. McDowell (1980) and Hazel Carby (1987) have both articulated thorough criticisms of Smith's position at the same time that they have put forth their own agendas for the future of Black feminist criticism. They criticized, primarily, Smith's expansive use of the term "lesbian" in connection with Black women's literature. Yet, since the appearance of Smith's 1977 essay, white and Black lesbian feminist scholars, such as Audre Lorde in "Uses of the Erotic: The Erotic as Power" (1978/1984) and Adrienne Rich in her theorem of the "lesbian continuum" in "Compulsory Heterosexuality and Lesbian Existence" (1980/1986)—both of which I return to in

Chapter Four—have, like Smith, established a working definition of the term lesbianism, which in this discourse can include nonsexual but women-centered interactions; this makes possible the inclusion of heterosexually defined women under the rubric "lesbian." Although this widening of the definition of the term "lesbian" has its own set of problematics (see the responses, published along with Rich's essay, by Ann Snitow, Christine Stansell, and Sharon Thompson), these do not refute the necessity for broadening the current use of Black feminist tenets to be inclusive of the lesbian presence in our communities. Thus, Smith's bold redefinition of the category "lesbian" has not led to the delimiting of every Black women's text as "lesbian" (as McDowell appears to have implicitly suggested in her initial response to Smith's 1977 essay), but to a continued reformulation of the term as well as an insistence on paying particular attention to Black women's *overall* sexuality. *Black women attempt to assert their control over lesbian, transsexual, bisexual, and heterosexual identities at the same time as they emphasize that their responses to issues of sexual abuse and harassment at home and in the workplace must be part of a sustained Black feminist ideology.*

Addressing class issues has also increasingly become central to Black feminist criticism, as is exemplified by Deborah K. King's essay, "Multiple Jeopardy, Multiple Consciousness: The Context of a Black Feminist Ideology" (1988), which demonstrates that Black women at the turn of the century were ill-equipped to make economic advances because they were often excluded from the union organizations that arose in the United States in the late nineteenth century. Following this lead, Patricia Hill Collins has written (1990) of the ways in which Black women's "concrete experience" forms "a criterion of meaning," so that valuable knowledge may be passed on to others in order to ensure their own survival as well as that of other oppressed people. We do this, declares Hill Collins, by *evoking oral traditions, in engaging in dialogues with one another either directly or indirectly, and by making our language the conduit for the validation of our experiences.* This forms what Hill Collins has called an "Afrocentric feminist epistemology," which also includes the "ethic-of-care," that is, the ability of Black women not only to make their views known but to relate their knowledge and wisdom to the oppressions suffered by others, and the "ethic of accountability," which is the necessity of credibly linking critiques of institutionalized or academic oppressions with knowledge based on personal experience (1990, 201–

238). These form an alternative way of assessing knowledge from a Black feminist point of view that does not rely on white/male ways of validating the experiences of those of us who may lack the power necessary to be heard and considered within academia. Thus, the evolution of alternative ways of expressing theoretical and critical explorations of Black women's literature in particular will, used by many, become an accepted part of academic endeavors and will make Black women visible not only to the white/male elite but also to ourselves.[3]

Audre Lorde, in her poetry and essays, has been by far one of the most vocal adherents of Black feminism as she stresses the concurrent need for feminist activism along with feminist criticism. In her essays and speeches collected in *Sister/Outsider* (1984), Lorde speaks out of both an Afro-Caribbean and an African American sensibility. Born of Grenadian emigrant parents in the United States, Lorde's vision of the Americas is one with an African diasporic sensibility. For these reasons, her writings remain an important model for me in understanding and applying Black feminist theory to the writings of Afro-Caribbean women writers in exile. In these writings, Lorde asserts that, *"for Black women as well as Black men, it is axiomatic that if we do not define ourselves for ourselves, we will be defined by others—for their use and to our detriment"* (45; my emphasis).

The issue of self-definition, is for Lorde, as it is for me, crucial to a politics of empowerment for Black people struggling to survive in countries, such as the United States, Canada, Britain, and Caribbean nation-states, still wed to their imperial and colonial pasts. Lorde writes:

> Black women who define ourselves and our goals beyond the sphere of a sexual relationship can bring to any endeavor the realized focus of completed and therefore empowered individuals. Black women and Black men who recognize that the development of their particular strengths and interests does not diminish the other do not need to diffuse their energies fighting for control over each other. (46)

For Lorde, the acknowledgment of Black women's self-definitions within the Black community will only serve to strengthen it. Otherwise, Black women and men will be subject to the open warfare for their allegiance to white/male oppression that only divides our strength in numbers and

fragments our energies into "endless kitchen wars" (1984, 48), rather than against the combined forces of racial, sex, sexuality, and class oppression amid and beyond our communities.

How do we sustain an ideology of resistance in the face of daily abuses? What power do we have to effect change in societies which advocate for our subordination? In "The Master's Tools Will Never Dismantle the Master's House" (1984), Lorde speaks to the need to make the voices of Black feminists and lesbian feminists heard within mainstream feminist theory in academe. Our voices need to reflect the differences that exist between women, as well as between women and men, and affirm their existence. As Lorde puts it:

> Difference must be not merely tolerated, but seen as a fund of necessary polarities between which our creativity can spark like a dialectic. Only then does the necessity for interdependency become unthreatening. Only within that interdependency of different strengths, acknowledged and equal, can the power to seek new ways of being in the world generate, as well as the courage and sustenance to act where there are no charters. (1984, 111)

In the affirmation of difference, Black feminist criticism illuminates a readily available solution to multiple oppression, for, prejudice, in its various forms, exists only through the intolerance of difference. As Lorde suggests, patriarchal oppression cannot be dismantled by using the principles that sustain it. A transformation must take place in which we refuse to categorize and codify one another into impossible social clubs or ghettos; this will allow us the opportunity of defining the parameters of our own lives with a language that speaks to and of ourselves.

In this vein, I utilize a modified form of Black feminist criticism, which I term "Afro-Caribbean diasporic feminism," to take into consideration theoretical paradigms articulated in geographical locations other than the United States, in order to analyze the ways in which Afro-Caribbean women writers in Western societies work at self-definition as they recuperate their histories of lost African cultures, enslavement, and exploitation through neocolonization in the countries to which they have emigrated. For, as Karla Holloway has written in *Moorings and Metaphors: Figures of Culture and Gender in Black Women's Literature:* "In

beliefs and value systems, religion and language, echoes of the original culture persist" (1992, 167). This is not to say that the culture of origin to which women of the African diaspora refer is stagnant or simply bygone, but that they draw on an African legacy from which they have been severed through the force of colonial domination; yet along with their affirmation of that heritage, we would do well to acknowledge the active presence of contemporary African women writers and scholars who are also speaking out of a Black feminist ideology that reflects similar concerns with the limitations imposed upon African women's lives. Such an exercise will make clear that women of African descent in countries other than the United States have enlarged the scope of Black feminist criticism and made it a theoretical apparatus truly diasporic in its ideological underpinnings. Like Carol Boyce Davies, I advocate what she has termed "critical relationality," when that relationality is not simply a taking and leaving of other theoretical paradigms that may be useful to our analysis of texts by Black women writers. Rather, this relationality is most useful when it "argues for the synchronic, multiply articulated discourses, which operate braid-like or web-like as a series of strands are woven" (Boyce Davies 1994, 56). In this way, each voice of a woman of African descent speaking from her own space and place in the world is incorporated into the braid, which makes the theory which shapes our understanding of that voice. Like the music of the fugue, which I invoked in the Prologue, these voices come together and intertwine around the main melody of centralizing the Black woman's experience across the diaspora in ways that remove her from her place of marginalization in a variety of cultures. What becomes further evident in the following chapters is that exile is, paradoxically, the source from which various Afro-Caribbean women find the strength to counter their multiple points of oppression and generate their own sense of self as they move homeward. This is, once more, a "productive contradiction," for the very mechanism of alienation becomes the mechanism for liberation.

Recuperating Our Lives: Cross-Cultural Connections from Within the African Diaspora

My use of the phrase "Black feminism" warrants some explanation, given that I intend to use it throughout this study as the designation for the theorizing accomplished by women of African descent cross-

culturally; it is not meant to refer to the use of Black feminist criticism as defined and articulated by African American women, by women of the African diaspora, nor is it meant to be reflective only of African American modes of feminist thinking. It stands to reason, however, that non–African American Black women might object to the label "Black" in reference to themselves and their feminism. African feminist theorist, Molara Ogundipe-Leslie, for one, has well-articulated her objections to the term "Black" in the African context. She writes:

> Some social scientists like to speak of "Black Africa" or "Africa south of the Sahara," but, what does "Black" mean in relation to, say, Libyans, or Egyptians or Moroccans who are white in Africa but are as black as people designated "black" in the United States [and, I might add, in the Caribbean basin]. Again, North Africans who are considered white in America are darker than some high-colored African-Americans who can pass for white but are considered black in affirmative action forms. Obviously, being "black" is a political metaphor and importantly, skin color is not a useful, necessary and sufficient way to taxonomize Africans. (1994, 215)

The same holds true for people of African descent residing outside the African continent. Yet, beyond those shores, "being 'black'" as Ogundipe-Leslie puts it, has accrued political significance and, by extension, social resonance. Ogundipe-Leslie is correct in noting that in the West "the first and constant variable for [her] is race" (219). Given that racial politics determine the class mobility and social welfare of those designated as "minorities" and, as such, as products of colonial expeditions conducted across the globe, it stands to reason that the racial labels that have been used to circumscribe the existence of those "othered" in Western European societies have also come to be used as emblematic of postimperial identity.

In this context, the use of the term "Black" has come to designate cross-cultural, racial, and linguistic connections for many women of the Third World residing uneasily in the First World, that is, the world of their colonizers. Andrée Nicola McLaughlin, in "Black Women, Identity, and the Quest for Humanhood and Wholeness: Wild Women in the Whirlwind," presents the ways in which racial identity—blackness—is

utilized by people of varying racial groups as a "political-class identifica-
tion" (1990, 153). McLaughlin writes further, "As a social class, Black
people are among the world's disfranchised whose plight is characterized
by a condition of poverty, violence, misery, and inequality. A Black politi-
cal class exists when the oppressed—self-defined as 'Black'—act in behalf
of their social class to oppose the prevailing socio-economic interests of
the dominant group" (155). This process of self-definition is linked to
geographical and class identities. Thus, in some areas of Europe, "women
of Asian, Middle Eastern, and Pacific as well as African ancestries" (154)
consider themselves Black and use that racial label as a means by which
to unify their efforts for class liberation cross-culturally. This is done in an
attempt to counter the pejorative use of the word "Black" to signify the
perceived inferiority of those marginalized from the mainstream by color
and class in Western societies. In many North African countries, however,
McLaughlin suggests that Black identity is not recognized; instead, po-
litical affiliations are made along lines of Arabic unity. According to
Ogundipe-Leslie, although "Black" identity is not recognized as per the
color of a person's skin, African identity is, indeed, acknowledged (1994,
207). In Canada, the United States, and Britain, the term "Black" most
often refers to women who trace all or part of their ancestry to Africa: for
this reason only, my use of "Black" throughout the text will reflect this
particular geographically situated political reality. The phrase "women of
color" will refer to those women who, along with women of African
descent, have formed political coalitions to work at dismantling their op-
pression within white (meaning, primarily, Anglo-Saxon in origin or deri-
vation) mainstream society as Asian, Middle Eastern, Pacific Islander, Na-
tive American/Aboriginal, and Latina women.

Furthermore, the necessity of utilizing Black feminism as a critical
frame for this study is affirmed by statements made by Black women and
women of color in Britain, Canada, the United States and the Caribbean;
and although the word "Black" may not be current in Africa, feminism is
also affirmed in this part of the world. Although women of African de-
scent in all of these geopolitical locations have shown the need for a
greater production of Black feminist scholarship from their own points of
view, most have referred to the catalytic role of Black feminist scholarship
from the United States on that production. They have also, in many
cases, adopted the methodology of U.S.-based Black feminism while
foregrounding their own self-definitions and cultural/political concerns.

In her 1987 article "Rainbow Feminism," Canadian feminist, Daiva K. Stasiulis, investigates the various theoretical writings of Black feminists in the United States to evaluate the extent to which Black feminist criticism can be of relevance in the Canadian context. She summarizes Black feminism as "problematiz[ing] and reject[ing] the central categories and assumptions of mainstream feminist theory" by, primarily, pointing out "a double standard implicit in white feminist writings whereby the entry into waged labour is regarded as emancipatory for Third World, migrant and native women, but subjugating for white, non-migrant women." For Stasiulis, a Black feminist analysis of women's racial, sexual, and class oppressions is crucial for the development of "anti-racism in Canadian feminist analysis and politics" (5). As I shall show further here and in the following chapters, Afro-Caribbean women continue to adopt Black feminism as the basis for their own creation of feminist theories applicable to particular geopolitical situations, which contribute to their oppression. Black feminism, in this sense, has thus become a critical method serving the needs of Black women scholars cross-culturally and cross-nationally.

Similarly, the writers of *The Heart of the Race: Black Women's Lives in Britain* place their own efforts within the context of Black women's historical resistance in Great Britain (Bryan, Dadzie & Scafe 1985). They note in particular the contributions of Claudia Jones, an activist in 1960s Britain who founded the *West Indian Gazette* with Amy Garvey in 1958, and Olive Morris, who, although she died of leukemia at age twenty-six in 1979, remains an important figure of Black women's political organizing in the 1970s as a founder of the Brixton Black Women's group (BBW) and a launcher of what came to be the Organisation of Women of Asian and African Descent (OWAAD) in the 1980s. In Canada, Black women historians remember the courage of Marie-Josèphe Angélique, who in 1743 began one of the first known revolts in the "New World" against her own enslavement and that of other Africans in Canada. Though such women are remembered today by Black feminist scholars, they remain marginal in mainstream history, as they were during their lives. It remains for Black women to make the evidence of our resistance visible, but such efforts are complicated by the sexism and racism with which we are faced both in our communities and in white, mainstream feminist communities.

Black feminism, then, is in keeping with the dialogues on feminism presently occurring in the context of Afro-Caribbean women writers in

exile.[4] Afro-Caribbean women in exile, however, not only adopt Black feminism but transform it to take into consideration the *diasporic* dimensions of the activism, literature, and scholarship produced by women of African descent in resistance to their oppression. Out of necessity, then, exiled Afro-Caribbean women apply the tenets of Black feminism to the context of Black women's survival within the Caribbean as well as in the countries of their exile. As displaced emigrants, Afro-Caribbean scholar–activists remain conscious of the diasporic dimensions of their work, as they are forced to overcome various oppressions as well as a certain "homelessness" made visible by the foregrounding of exile as a central feature of self-definition.

As a result of being shut out from any positions of power within Black community movements and the white women's movement during suffrage and later in the 1970s, many African American women questioned their ability to address questions of race and sex simultaneously within either group. This ostracism took place also in Britain and Canada, where Black feminists have also attempted to organize themselves to battle issues of race, sex, and class simultaneously. For some, this has led to the rejection of the term "feminism." Black women organizing in Britain, for instance, actively worked against racist, sexist, and classist oppression but hesitated at labeling themselves feminists. The writers of *The Heart of the Race* (Bryan, Dadzie & Scafe 1985) speak of the OWAAD in the 1980s, which brought women of Asian and African backgrounds together to provide a supportive network through which they could organize and mobilize a large group of women for a campaign against enforced sterilizations of Black women, police brutality, and racist immigration practices, among other class and race-related issues (168). The authors state: "OWAAD was built on the long-standing tradition among Black women of organising together within our community. The basis of that organisation, however, was not necessarily a feminist one" (173). Some shrank from the identification with feminism because they believed that feminism was inherently "anti-male" and associated that sentiment with both the pejorative collapsing of lesbianism with feminism and the inability of many white feminists to make connections between their own oppression and the oppression of Black women, that is, between racial oppression and sexist oppression. Others, recognizing that "sexism and reactionary male attitudes towards women have worked to keep us down . . . have set about the task of redefining the term and claiming it for ourselves. This has meant developing a way of organising which not only takes account

of our race and our class, but also makes our struggles against women's oppression central to our practice" (176). Thus, feminist practice and the formulation of feminist theory for Black British women includes an awareness of the limitations of "sisterhood" (in the mainstream feminist sense) across racial lines. This awareness is rooted in the historical reality of Black women's silencing within (or exclusion from) white feminist organizing in Britain.[5]

In the African context, Awa Thiam and Molara Ogundipe-Leslie have also asserted the necessity of feminism for understanding and resolving the uncertain existential parameters of African women's assigned position in this world. Thiam writes unequivocally in *Black Sisters, Speak Out: Feminism and Oppression in Black Africa*, "Time to take the floor in confrontation. Time to take the floor in revolt and say, 'No!' To give to speech the power of action. Active speech. Subversive speech. Act, linking theoretical practice with working practice" (13). For those who had thought African women too "backward" to articulate a revolutionary agenda, Thiam's words here can only disabuse the ignorant of such views. The African woman has a voice, and she is using it to the full extent of its powers and in a feminist context.[6] Thiam's analysis of African women's position is also diasporic in its scope, acknowledging that any act of feminist intervention taken on by African women will necessarily affect their sisters in other far-flung countries. She writes in terms strikingly similar to her Western counterparts' of Black women's burdens in the present African economy:

> In the former colonies, be they French, Belgian, or other, the situation of the Black woman today is the same as that of her sisters in Zimbabwe or Latin America. Like her Black brother, she suffers from the damaging aftermath of colonialism and the crimes of the colonials. But her sufferings are greater than those of the men, for she is not only faced with White racism, the exploitation of her race by the colonial, but also the dominations that men, Black as well as White, exercise over her, by virtue of the patriarchal system in which both live. (1986, 116)

Molara Ogundipe-Leslie, in *Re-creating Ourselves: African Women and Critical Tranformations* (1994), echoes these words and goes beyond them in asserting yet another form of Black feminism, "stiwanism."

"Stiwanism" is Ogundipe-Leslie's neologism for contemporary African feminism; it is an acronym for "Social Transformation Including Women in Africa" (229). For Ogundipe-Leslie, African feminism provides a holistic approach toward change for present-day Africa. She writes that "the ideology of women has to be cast in the context of the race and class struggles which bedevil the continent of Africa today; that is, in the context of the liberation of the total continent." And she continues: "It is this generally holistic attitude of African women to feminism which often separates them from their Western sisters" (226). Ogundipe-Leslie also recognizes the multiple pressures put on African women and defines these as the "six mountains on her back," a phrase borrowed from Mao Tse Tung, who described Chinese women as bearing the weight of four mountains; in addition to the mountains of colonization, traditional mores, lack of her own consciousness, and the sexism suffered at the hands of men from her own cultural group, the African woman endures also the stigma of her race (or color, depending on her place of residence) and her own self-hatred or internalization of her oppression. African feminism, like Black feminist thought in the United States and elsewhere, then, focuses on toppling those mountains from African women's backs and, in so doing, providing an egalitarian base between the sexes, which will work toward the liberation of all from the imposed strictures of colonial ideologies. Ogundipe-Leslie concedes that "African female writers like to declare that they are not feminists, as if it were a crime to be a feminist" (64), but that their written words productively contradict their spoken disclaimers, for "nothing could be more feminist than the writings of these women writers [including Bessie Head, Buchi Emecheta, Mariama Bâ, Ama Ata Aidoo, and Micere Mugo], in their concern for and deep understanding of the experiences and fates of women in society" (64). In the African context, then, the pressures of racial and national politics have had the same effect on women whose writing reflects feminist politics: they have attempted to negate their feminist perspectives at the same time that they have advanced their feminist politics through literature, a mirror upheld to reflect the trials of women in Africa yesterday and today in an effort to transform what that reflection might look like tomorrow.

Carole Boyce Davies and Elaine Savory Fido, in their introductory dialogue to their anthology of criticism on the literature of Caribbean women (1990), debate the question of how to develop a feminist criti-

cism within the Caribbean itself. Says Fido: "The point is still that male writers in the Caribbean have a tradition of debate, women need to develop one consciously now" (xi).[7] Davies and Fido thus debate the sort of labels that might best describe this precisely female Caribbean consciousness. Kathleen M. Balutansky, in her noteworthy review-essay of texts on or about Afro-Caribbean women writers (1990), refers to Davies' and Fido's dialogue as "in the Caribbean context, an articulation of a dilemma that has afflicted black feminism: whether or not to give precedence to the 'race variable' and racial oppression over sexism" (543). In fact, Fido and Davies do not debate whether or not to hierarchize oppressions; they debate the suitability of particular women-centered labels to women of the Caribbean who, whether or not they identify as feminists, struggle against the combined forces of racial and sexual oppression. For Fido and Davies, the terms up for negotiation are "feminist," "womanist," and "international feminist."

For many Black feminists, the term "womanist," as coined by African American writer, Alice Walker, is a means by which to remain true to the feminist ideals of women's equality to men and of personal freedom without association with white women's mainstream feminism.[8] For this reason of separatism, Fido, who identifies as a white woman, prefers to define womanism as the "cultural manifestation" of Black women's feminism (Davies and Fido 1990, xii). For Davies, an Afro-Caribbean woman, the term "womanist" serves as "an important redefinition of the term feminism for other experiences than those of Western and white women" (xiii). The two come to the conclusion that the two labels work differently depending on cultural context; thus, "womanism" becomes a closed label demarcating a community of Black women working toward self-affirmation and rootedness in a "positive cultural expression of a particular experience," according to Fido (xi), while "feminist" remains an active political label "necessary as protection, as groundbreaking work, as our best route to a new landscape of gender relations" (xv), and a means by which to garner the womanist residing in each Black woman. Davies writes of her return to the Caribbean after a period of emigration: "I am able to look back critically on the Caribbean woman's experience and draw conclusions, comparing it with the experience of women elsewhere. I also bring to this evaluation a feminist focus that I may not have had without my experience of migration" (xiii). As articulated here, Davies's feminist vision is tied to an understanding of the ways in which various

forms of oppression manifest themselves in other geographical locations and leads her to adopt the idea of "an 'international feminism,' a term that gained credence at the Nairobi Women's Conference (1985) and that divorces it from a Western/European or American context and instead addresses women's struggles globally" (xiii). For many Afro-Caribbean women scholars still residing in exile in Western contexts, the assertion of Black feminist identities, along with the application of Black feminist criticism, is necessary both for survival and self-definition, for our efforts toward self-determination are still devalued in Western societies.

Black feminism, then, is the theory that gives Black women's realities in changing contexts a complete articulation within academia. In the context of Afro-Caribbean women's exile, it functions as the language with which to repair the pyschic damage of geographic and cultural alienation, provides the base by which to establish self-definition, the net by which to catch and gather Black women as they struggle to recuperate or recognize their ancestral, African heritage in their day-to-day life, and the bridge over which to cross, after having accomplished all of the above, on the long walk home.

"Uprooting Sound": The Journey Home

Wholeness can only be achieved by rediscovering the ways in which Black women have been able to overcome adversity transhistorically. My appeal to "transhistoricity" here should not be taken as a sign of a leaning toward ahistoricism; to the contrary, I am calling for an awareness of the ways in which women of African descent have contributed to the emancipation of Black men and women through time and, in effect, brought us to where we are. Black feminism provides the analytical tools for revovering this buried and half-forgotten legacy of courageous insurrection in action and in writing. But that analysis must be brought to bear in a way that makes evident the *presence* of Black women *in time as well as through language*. In other words, the analyses to follow will focus on what Deborah McDowell has termed "the body in the text" (1995, 20), with reference to the use of the word "Black" to denote women of African descent in theoretical parlance. For my purposes here, I am most concerned with *representations of the Black female body*, as they are imaged by Afro-Caribbean women writers in response to, or defiance of, their objectification and denigration in the European and colonial soci-

eties to which they find themselves exiled. So, as "Blackness" operates as a marker of racial and/or color identification in a context of political consciousness and affiliation, representations of the Black female body in these works function as markers of the ways in which women of the African diaspora reconcile themselves to their exile by reclaiming their bodies and the images of those bodies which circulate in the societies which demonize what they have been made to stand for—in two words: perverse sexuality. Attention to the body is a means to making visible issues of multiple jeopardy and their immediate consequences for Black women. As Ogundipe-Leslie has written of African feminism, my vision for Afro-Caribbean diasporic feminism must "include issues around the woman's body, her person, her immediate family, her society, her nation, her continent and their locations within the international economic order because those realities in the international economic order determine African [and Afro-Caribbean] politics and impact on the women" (1994, 228). Finally, even with such diverse support for the use of feminism to undertake such a critical study of Afro-Caribbean women's literature in exile, and most precisely, in exile from the Anglophone Caribbean nation–states, it must be noted that there is still little support for such a position within Caribbean (*read:* male) studies as a whole; it is thus necessary for me to end this chapter with a note toward rectifying that reality. For, if what can be termed a "discourse of exile" has been central to the construction of male Caribbean and African perspectives on the condition of the estrangement of people of African descent from their own roots, that discourse has by and large failed to encompass the realities of women of African descent.

George Lamming's *The Pleasures of Exile* (1959/1960) is perhaps the best known work by an Anglophone Afro-Caribbean male that focuses on the plight of the Caribbean person exiled from his African roots through colonialism, and exiled from his Caribbean heritage through expatriation, emigration, or forcible expulsion. In it, Lamming uses two "texts" to illustrate the position of the Caribbean exile, Shakespeare's play *The Tempest*, and the Haitian "ceremony of the Souls." Interestingly, although the Caliban/Caribbean diad has been invoked since by other writers and critics from Edward Said to Michelle Cliff, much less attention has been paid to Lamming's interest in Haiti and his *disinterest* in the connections that can easily be made between the presence (or absence) of women of African descent in both *The Tempest* and his invo-

cations of Haitian lore and heroes (such as Toussaint L'Ouverture). I conclude this chapter on feminist perspectives in the Afro-Caribbean context, then, with a brief analysis of Lamming's presentation of exile and his exclusion of the female Caribbean exile from his theorization on that state of alienation. What that analysis reveals is the extent to which consciousness of the African women's experience of imperial and colonial oppression underscores the need for a sharply delimited feminist ideology, which truly speaks to our experiences of exile as women.

Lamming's text (1959/1960) begins, not with reference to *The Tempest* but with reference to the Republic of Haiti, wherein, he says, "a native religion [*vodou*] sometimes forces the official Law to negotiate with peasants who have retained a racial, and historic, desire to worship their original gods." Lamming continues by sharing with his readers his witnessing of what he calls a "ceremony of the Souls," that is, one of the many death rituals through which the spirit of a deceased member of the community is put to rest. Lamming interprets the "ceremony of the Souls," performed without state authorization, as a parallel to the relationship between Prospero (the Law) and Caliban (the "Haitian" peasant) in *The Tempest*. Lamming feels that the ritual he observes is that of the peasants' conduit to the gods of death who will whisper their secrets to the mortals before returning to the watery depths. He thus concludes: "Like Prospero identified with his privilege, the Haitian peasant exercises a magic that vanishes and returns according to the contingencies of the moment" (10). The parallel is here compromised, as it would transmute the "Haitian peasant" into the very figure of Prospero, the law-maker who would otherwise annihilate their "magic." Death rituals are not, in fact, an assertion of a despotic power over the dead, nor are they meant to provide easy access to the spirits of the dead; they are practiced, most often, to return the "two 'compartments' of a person's spirit," as Leslie Desmangles puts it (1992), to *Ginen* (the land of the ancestors, often believed to reside beneath the floor of the sea), and to the community itself for rebirth. These two parts of the spirit, stresses Desmangles, coexist without dualism: "the two parts constitute an organic process, a dynamism which comprises divinity, authority, influence, morality, and wisdom" (1992, 68; readers should note here that Lamming is drawing on the findings of anthropologist Maya Deren). This dynamism suggests a power far different from Prospero's, a spiritual language that will not be silenced or disrupted by imperial might. Given that at issue for Lamming

is Caliban's need for language, it is interesting to note that a "solution" to this absence of tongue does not reveal itself in *The Pleasures of Exile*.

It is clear that Lamming is inspired by Shakespeare's depiction of Caliban as an enslaved bestial man, whose worse tragedy appears to be his loss of the island on which he was born and the imposition of the conqueror's tongue. In the play, Caliban says to Prospero: "You taught me language, and my profit on't / Is, I know how to curse. The red plague rid you / For learning me your language!" (Act I, ii, 363–365). Lamming thus writes: "Caliban is [Prospero's] convert, colonised by language, and excluded by language. It is precisely this gift of language, this attempt at transformation which has brought about the pleasure and paradox of Caliban's exile. Exiled from his gods, exiled from his nature, exiled from his own name!" (1959/1960, 15). And yet, Caliban is but a figment of Shakespeare's comedic play, a play that does not self-consciously set out to disparage the imperial project begun in the fifteenth century. Caliban's alter egos, Caribbean men and women, did, in fact, have their own languages, gods, traditions, and names, which were not utterly lost in the Middle Passage. These were not, like the Haitian dead, buried beneath the bottom of the sea, but were kept alive through the will of those who survived the Middle Passage, though adapted, through ritual, orality, and memory.

Even for those of us intent on reclaiming Caliban as "one of us," it must be remembered that Caliban had a mother, Sycorax, who represents one of these survivors. In the play, she is conveniently killed before the curtain opens. In her and her memory resides a potential for the transformation that Caliban, in his desperate attempt to master his master through an imposed language, is doomed to lose. It is in the loss of Sycorax, and the repetition of her silencing in Lamming's text, that Lamming's own approach to exile belies transformation. For, as Caliban spitefully revels in his subordination rather than celebrating his mother's extinguished wisdom, Lamming, as Wilfred Cartey writes in his *Whispers from the Caribbean: I Going Away, I Going Home* (1991), participates in maintaining the hegemonic status quo: "The colonial condition as presented in *The Pleasures of Exile* is functional and unresolved, and much of the argumentation itself seems to remain rooted in the colonial condition" (1991, 239). But even Lamming acknowledges that Caliban has had "the advantage—regrettable as he makes it sound—of having known the meaning and power of his mother" (1959/1960, 111). Although he

goes no further in exploring what that power might be, I would suggest that Sycorax's power is what Lamming found encoded in the Haitian "magic" of the "ceremony of the Souls."

One of the rites involved in the Haitian death ceremonies is the "rite of passage" called *desounen,* which Leslie Desmangles defines as "'uprooting of the sound'; hence, removal of life from a person's body" (1992, 69). This ritual returns the spirits of the departed to their sources: the ancestors and the earth from which they will be reborn. Sycorax, in her silent cloak of death awaits just such a resurrection in current criticism of the condition of Caribbean exile; symbolically, she represents one of the "productive contradictions" I have been outlining throughout this chapter. She exists in Shakespeare's play as a shadow person, a ghost whose invocation is laden with evil associations; she is, in fact, the opposite, the source of life, regeneration, the spiritual center that Caliban, in his quest for revenge against Prospero, abdicates. Northrop Frye suggests, in an introduction to the play, that "the traditional conception of the magician was of one who could control the moon: this power is attributed to Sycorax, but it is a sinister power and is not associated with Prospero, whose magic and music belong to the sublunary world" (1969, 1370). Frye's observation is rich with suggestion, from an African–Caribbean feminist point of view, for the association of Sycorax with the moon is invocative of the Dahomean Mawu-Lisa, the god/dess of sun and moon so poignantly recalled in the poetry of Audre Lorde, and her "sinister" magic is suggestive also of the phrase that has come to be associated with lesbian identity and the journal of the same name, "sinister wisdom." Sycorax, then, is a figure that recalls both African and women's spirituality, and she holds the key to the power that will free the "Calibans" roaming the Caribbean and in exile from those islands. By plumbing the contradiction between Shakespeare's representation of Sycorax as a negligible, forgotten, evil, bodiless "North African" woman and what she might stand for if transposed to the present-day reality of Afro-Caribbean women's lives and social positioning (as Lamming has done in making Caliban the emblem for Caribbean men), we are left with a productive symbol of the need to un-silence and liberate the theoretical potential implicit in Black women's knowledge base. In so doing, Sycorax herself becomes "sound uprooted," not in the sense of being cut off from her roots but in the sense of having her spirit liberated from the death-bind imposed upon her body. Though she is within the play up-

rooted by Prospero's magic, which is, as his language, rootless, tied as it is to neither the cycles of the moon nor the cycle of human life upon the earth, by working against the play to release her from Prospero's spell, we uproot her silenced language and allow it to breathe new life.

As I suggest throughout the following chapters, it is by resurrecting, not Sycorax the character, but what she stands for—the lost heritage of the Black woman—by returning her spirit to the living so that it may assume new life, that we can begin to see how the condition of exile can be transformative. If it is not rendered as a nostalgic search for access to the very power that has produced exile, but turned into a politicized search for that which will free both women and men of African descent from the physical and psychological chains of imperialism, colonialism, and, more recently, neocolonialism, that search becomes powerfully transformative. I would also suggest that, for this journey to be successful, we must abandon a model of "Black" womanhood fabricated by a European male writer such as Shakespeare and, as a corollary, must replace her with that real or imagined model produced by Black women historically and in literature. In so doing, we can better affirm the legacy provided us by women of African descent in ways divorced from the politically empty impetus to revise history out of empty nostalgia.

For instance, when Lamming moves from using *The Tempest* and the Haitian "ceremony of the Souls" to celebrating the achievements of Toussaint L'Ouverture during the Haitian Revolution, he does so by defining those achievements by European standards as the historical manifestation of Caliban's potential to produce his own "tempest" in the Caribbean isles. Largely recounting L'Ouverture's exploits as detailed in C.L.R. James's *The Black Jacobins,* Lamming insists on recasting L'Ouverture's shortcomings in a heroic light from his nostalgic need for historical affirmation of Caribbean subversiveness within a colonial (and still neocolonial) frame of reference. He writes of L'Ouverture's death, "Deprived of food, he was left to the rigours of this new [French] winter; an old man, in exile and alone, freezing to death in the Jura mountains. But his spirit now resided in the blade of Dessalines' sword carving its way to the Haitian freedom that has remained to this day" (Lamming 1959/1960, 150).

Certainly, Toussaint L'Ouverture stands as one of the great heros of Haitian history and as a hero to other peoples of African descent who see in him a symbol of Black power in the New World. But Toussaint, in his

drive to outdo or match the military might of Napoleon Bonaparte (his "Prospero"), did not live to see the advent of Haitian independence. And, as a Haitian woman, I can attest to the fact that, though Haiti is now almost two hundred years old, it is nominally free, its independence retained at an immeasurable cost. Finally, what this passage brings to my mind is our lack of knowledge of those who refused to ally themselves with European powers (as did L'Ouverture's predecessor Boukman) or of women who themselves took up arms in the Revolution. It also brings to mind one Saartje Baartman (otherwise known as the "Hottentot Venus") who died in similar circumstances, of exposure to cold, as she was held as a nude exhibit in a French museum for casual observation; like Toussaint, she was captive to French and European powers and yet she is not remembered now as one of our heroines. My aim is not to deify but to reclaim lives such as Saartje's, which have made our own existence (male and female) possible. By remembering them, we honor their trials, the difficulties they encountered in times much more cruel than our own, and the triumphs they must have achieved in having been able to leave their mark upon this world for us to recover.

Part of this effort is focused on making visible in our literature, our very language, the existence of those foremothers, these ancestral voices. This is made more difficult for those women who have had to exile themselves from their home islands; there is always the possibility of becoming spellbound by the powers of the conquerors or entranced in the "contrapuntal" play between tradition and assimilation. The task at hand, then, is one which can transform exile into a source of self-integrity in order to move toward the reclamation of the Caribbean homelands from which we have been alienated. As Wilfred Cartey writes, "For exile assumes the putting on of different clothes, the assumption of another landscape, which, in its essence, has different rhythms, cultural resonances distinct from those of the Caribbean. To divest oneself of this acquired clothing is, perhaps, to begin the process of going home, to begin the process of investiture in one's own still-evolving heritage" (1991, 277). With respect to Afro-Caribbean women's experience of exile, the divestment Cartey speaks of must center on an investment in foregrounding women's lives and voices.

Acts of language (and thus of literature) are therefore central to the cohesion of an Afro-Caribbean diasporic perspective. As will become evident in the chapters that follow, although for some Black women, per-

sonal experience is one way of retrieving the traditions of our ancestors, the use of Black English, *patois,* or *créole,* is another. The act of using alternative languages to standard English has become paramount in making ourselves visible within creative and critical writings, which themselves undergo a metamorphosis in form and content. These acts of language have been courageous, for alternative languages have long been used against oppressed peoples in order to denigrate their origins as well as their potential for self-empowerment through other avenues than those offered by various colonizers. Hence, Barbara Christian writes in her introduction to Opal Palmer Adisa's *Bake-Face and Other Guava Stories* (1986):

> When I was a girl growing up in the Caribbean, I was amazed by the verbal skill of even the most lowly market women. Like Paule Marshall, I was stunned by these "talking women," among whom were my mother and aunts. In spite of my greedy consumption of books, I never met one such woman in any book. And I was told by my teachers that it was quite clear that these women's language (my language as well) was not even a language, since it never appeared in print. In other words, we were as discredited as our language. (xii)

Whereas language may once have been a considerable oppression for those people who were forced to consume the values, customs, and tongues of waves of European conquerors, Afro-Caribbean women writers, along with other Black women writers in the United States and elsewhere, have made our languages visible in print in order to be discredited no longer.

Much has been said about the limits of language in terms of the patriarchal legacies inherent in most, but much more is to be discovered in the exploration of the uses of language, and by extension, of literature, to inform, transform, and define those oppressed as much by the limits of language and literary conventions as by our silence within those limits. I believe, as Audre Lorde writes, that "in the transformation of silence into language and action, it is vitally necessary for each one of us to establish or examine her function in that transformation and to recognize her role as vital within that transformation" (1984, 43). As a native–French speaker, English has become the language with which I have accessed

higher education, but I also identify it (even more than French) as the colonizer's language, because the more I explore issues of oppression with this tongue, the more distanced I grow from my origins. Writing of difference(s) thus becomes a double bind: at the same time as I find myself and theorize for others about the effects of prejudice on my life and the lives of women like myself, I drift away from that which can only be communicated in the language(s) learned at a grandmother's hearth. Yet, in the tenets of Black feminism I have found a theory conducive to regaining lost connections and exploring avenues toward change and self-empowerment. Again, I take inspiration from Audre Lorde: "We have been socialized to respect fear more than our own needs for language and definition" (1984, 44). In applying Black feminist criticism to Afro-Caribbean women's literature produced in North American and Western contexts, it should not be necessary to "reinvent" the pencil, but only to observe which pencil has already been put to use. Thus, I choose and sharpen a tool that has proven time and again to be faithful to our survival.

Two

Exiled in the "Fatherland"

Joan Riley and Beryl Gilroy Voice
Afro-Caribbean Women in Britain

In Search of Our Foremothers

In an all-girl Catholic junior high school, where the day begins with the singing of the national anthem followed by the recitation of the Lord's Prayer or the recitation of a Hail Mary, traditions rule the days. At the same time that the school is organized to give young girls the chance to form social bonds with one another and to encourage self-esteem by isolating them from the sanctioned competitiveness of boys, certain choices are made that deny girls the opportunity to explore the full range of their capabilities. I soon discovered, for instance, as I attended such a school, that home economics was composed only of cooking and sewing classes, not classes in carpentry and woodwork. Disgruntled, I pondered whether to sew a shirt or an apron and soon learned that I had no aptitude for such work. I had failed before ever having begun at what was presented to me as quintessential "women's work." At some level, I did not want to learn it. I wanted to be able to apply myself to a skill of my own choosing, a skill that would not be determined by the expectation that as a good Catholic girl I would grow up to marry a good Catholic man, and then cook balanced meals while darning for our nuclear family. It was not that I was rejecting this possibility, but that it was a role prescribed for me because of my sex and not one of my own choosing; furthermore, as a Black girl, I was made to feel that mastery of these basic skills would get

31

me further than mastery of English or art. My avenues for success were presented to me as marginal.

Still, I knew myself to be lucky, growing up in a time of relative liberty and choice, regardless of the fact that I was continually told that I had few liberties and even fewer choices. My reality, then, had come to be only because women of African descent before me had had nothing more than the ascribed and prescribed in order to survive in their own time.

One such woman was my maternal grandmother, a Haitian woman who made a living from the labor of her hands. She is spoken of with respect and admiration, and I wonder at times if she became a seamstress by choice. Did it matter then? Does it matter now? Perhaps she had had no choice and still had managed to do her work with dignity and love. Perhaps she had chosen to work with needle and thread to leave some mark upon the fabric of this world. With her work, she provided for four children, one of whom was my mother. My grandmother was widowed and went on to guide her life and those of her children. She is teaching me lessons from beyond the grave, even though I have only known her through stories and a picture in my family album in which her smiling face harbors the secrets of many generations of self-subsisting women—women who were taught "women's work" to service men but who shirked the lessons they had been taught in order to survive with or without men in cultures that did not openly support the single or the widowed woman, especially one with children, whatever her class. Such women are somehow lost from our collective consciousness or devalued for having led untraditional lives.

I am learning that there is some truth in the cliché, "The more things change, the more they stay the same." Black women today are still struggling to survive through traditional or untraditional means. As a group, we still exist on the margins of society or we are invisible as we toil in its center. Within this peripheral existence, the very young and the very old are at particular risks for added exploitation, based not only on their sex and race but on their age and class status. In the Caribbean context, the particular and short-term consequences of emigration have resulted in the physical, psychological, and emotional alienation of young girls from older women. Such alienation is compounded by the mistreatment that both groups endure in societies, which openly advocate their denigration through the trivialization and oversexualization of the Black female body;

as a consequence, young Black girls become victims of sexual abuse, while elderly Black women are physically abused and ultimately discarded as if they have nothing left to contribute to others. In response to this reality, women writers of the African diaspora have sought to express not only the multiple facets of the oppression endured by Black girls and women but also the necessity of remembering our foremothers in poetry, fiction, and personal writings. This act of remembrance is one of the few means by which a reparation of the rift between the younger and older generations of Black women might still be achieved. Still, Afro-Caribbean women writers struggle to be published, read, heard: remaining invisible except perhaps to each other.

Paradoxically, invisibility appears to define many Afro-Caribbean women's lives. By extension, silence is a recurring motif in the literature by Afro-Caribbean women who bring themselves into visibility by speaking out on issues that are normally taboo subjects in Western societies generally—issues such as racial discrimination, abuse of the elderly, sexual abuse, and incest. It is noteworthy that Afro-Caribbean women writers have had the courage to speak out against the abuse inflicted upon Black girls and women from within their own communities. As they do so, they underscore the truth that it is the legacy of imperialism and colonialism, which finds its full expression in the condition of exile, that has produced the familial dysfunction we are presently struggling to overcome.

By and large, West Indians who have emigrated to Britain in search of better fortunes have been greeted with a deeply entrenched racism on both these fronts, which closes the door to all but few opportunities for socioeconomic advancement. Thus, the movement for civil rights in Britain has been focused on the enfranchisement of visible minorities as working-class people seeking to eliminate discrimination in the work force as well as in the hierarchical system of British education. The writings by Afro-Caribbean women in Britain reflect such concerns with class and access to education (the means by which to mobilize within the deeply entrenched class hierarchies in Britain). What is all the more poignant about these writings is that they are situated at the nexus of the imperial project: writing out of the "fatherland" of Britain, writers like Joan Riley and Beryl Gilroy claim the space of their conquerors at the same time that they look critically homeward to the Caribbean. Their writings do not, to borrow a phrase from Bill Ashcroft, Gareth Griffiths, and Helen Tiffin, "write back to the empire," but write *from within the*

empire back to their home islands, in an effort to clarify the forces that
have propelled them to that center in which they can but uncomfortably
coexist with their oppressors. These writers' vision is one of coming to
terms with the effects of having been the product of the British imperial
project and still at its mercy in the context of emigration; for to reside in
this "center" is to be confronted, without intermediary, with the most
insidious evidence of the alterity, or "othering" of women of African de-
scent in the ideology and everyday social manners of the inhabitants of
one of the countries that has subjugated Black women transhistorically,
by force.

In this chapter, I focus on works by both Beryl Gilroy and Joan Riley,
for their texts present working-class West Indian characters who must
confront the history of British racism in order, literally, to survive. Their
characters are eventually drawn back to their home islands in the hopes
of reestablishing continuity with a past they were forced to leave behind
because of economic straits. This chasm between preservation of Carib-
bean identity and assimilation into British society is presented as almost
unbridgeable by both authors. By focusing on the effects of a legacy of
British colonialism and concurrent racial discrimination and marginaliza-
tion in the lives of the elderly (in Gilroy's work) and the young (in
Riley's work), it becomes apparent that a crucial facet of West Indian life
in Britain is (as it is for all Afro-Caribbeans in exile) the rupture of cross-
generational bonds. This rupture adds yet another barrier to securing
racial equity in Western contexts. Within the cultural groups Gilroy and
Riley describe, the splintering off of the young from the old contributes
to their ongoing victimization as already (racially) marginalized girls and
women.

My aim, then, is to take a close look at Gilroy and Riley's literary
visions of Afro-Caribbean women in the British context (in connection
with those of African American women writers) to uncover the ways in
which elderly Black women continue to be forgotten or mistreated in the
endless cycle of emigration, while Black girls are subject to "falling be-
tween the cracks," as they grow up separated from their grandmothers
and/or othermothers[1] as well as from their home islands. In this respect,
exile assumes yet another dimension, that is, of alienation from one's
family and one's cultural roots. Beryl Gilroy's novels present us with the
hope for community rebuilding as residing in the acknowledgment of the
role of elders in preserving the lessons of the past for future generations,

while Joan Riley's work is a warning of what may come to pass if we do not restore the nurturing connections between the generations. Ageism is an oppression suffered by both the very young and the very old; the abuses endured by both groups are shrouded in silence or altogether ignored in deference to those who perpetuate crimes against the young and the elderly. A chasm, itself a form of exile, is therefore created between the two groups—a chasm that threatens not only the well-being of members of both, but the survival of an entire community, which, in this case, is itself already marginal, silenced, and ignored.

The Black Female Body as Popular Icon

It is common knowledge that throughout times of enslavement in Britain, the United States, and elsewhere, women of African descent were subject to all forms of sexual exploitation from rape to "concubinage" as an everyday condition of their lives. Black women resisted such violence by whatever means available within the strict confines of enslavement; lacking personal autonomy, Black women nonetheless sought to end the cycle of their oppression as sexual vessels and as "breeders" for a system of enslavement that was dependent on their reproduction for its survival, after the end of the cross-Atlantic slave trade.

Historian Paula Giddings, in *When and Where I Enter* (1984), writes, "Some slave women, perhaps a significant number, did not bear offspring for the system at all. They used contraceptives and abortives in an attempt to resist the system, and to gain control over their bodies. . . . When contraception failed, slave women took more extreme measures" (46). These "extreme measures" took the form of infanticide.[2] Black women used such means to avoid the enslavement of their offspring and to protect their female children explicitly from rape—an institutionalized feature of slavery—from childhood into adulthood. Darlene Clark Hine writes: "The most common, and certainly the most compelling, motive for running, fleeing, migrating, was a desire to retain or claim some control and ownership of their own sexual beings and the children they bore" (1989, 914). Under slavery, Black girls were raped before the onset of puberty and as soon as puberty was reached (in some cases this would have been as early as nine to twelve years old), they would have been expected to become mistresses to white slave owners and future mothers of the owners' illegitimate offspring, who, in turn, would be sold for

profit or used as laborers, house servants, and as outlets for illicit sexual activity on the part of their "fathers."

Furthermore, the implications of the sexualization of Black women meant that they were held accountable for both their perceived wantonness and the perceived sexual aggressiveness of Black men (which led to their systematic lynching), especially in the antebellum southern United States. This harkens back to the Victorians' "Hottentot Venus," whose sexual "anomalies" were made representative not only of all Black women (and outcast white women), but eventually of all Africans, male and female. Sander L. Gilman draws a similar conclusion from the available historical record of the Hottentots of the nineteenth century: "When one turns to the description of the autopsies of black males from approximately the same period, the absence of any discussion of the male genitalia whatsoever is striking. . . . The uniqueness of the genitalia and buttocks of the black is thus associated primarily with the female and is taken to a be a sign solely of an anomalous *female* sexuality" (1985, 218). At this point, then, the sexuality of Black men had not been constructed as an anomaly, but it will become so eventually as an extension of Black women's sexualized "otherness." Paula Giddings remarks: "Even the Black man's alleged impulse to rape [white women] was the Black woman's fault. Historically, the stereotype of the sexually potent Black male was largely based on that of the promiscuous Black female. He would have to be potent, the thinking went, to satisfy such hot-natured women" (1984, 31). Black children were not exempt from such sexual stereotyping and violence, since they, too, were property and were considered no less primitive and lascivious than their enslaved mothers.

Ida B. Wells, who launched the first antilynching campaign in the United States, was well aware of the connections between the sexualization of Black men, Black women, and that of Black girls. As she fought against the lynching of Black men and researched such acts of violence, she discovered that Black women and children were also being lynched in the southern United States. And, while Black men were being lynched under false accusations of raping southern belles, Wells stated that, "the rape of helpless Negro girls, which began in slavery days, still continues without reproof from church, state or press" (quoted in Giddings 1984, 31). In fact, the lesser attention given to the sexual exploitation of Black women in abolitionist, antilynching, and civil rights movements from the

late nineteenth century into the late twentieth century, has served to perpetuate that exploitation rather than redress it.

A hundred years later, Ida B. Wells's words still ring true. Sexism within movements to redress racial inequity has perpetuated the sexual inequity of Black women; the resultant subordination of Black women to Black men has rested largely on the rhetoric of Black male "emasculation." Just as plantation owners had used sexuality as a device for obscuring the economic motivation behind their lynching and raping of Black men, women, and children, at the height of the civil rights movement, Black male civil rights leaders espoused sexism in order to obscure their bid to acquire and maintain patriarchal power in their own communities. Black power was the dominion of Black men, and while Black women were expected to benefit from that power, they were, nonetheless, according to sexual stereotypes, seen as a hindrance to acquiring full civil rights. Writes Paula Giddings: "Sociologists, psychiatrists, and the male literati accused Black women of castrating not only their men but their sons; of having low self-esteem; of faring badly when compared to the virtues of White women. Black women were unfeminine, they said; how could they expect the unflagging loyalty and protection of Black men?" (1984, 319).[3] As can be expected, few received it unless they were willing to subordinate themselves to their fathers, brothers, and/or husbands. Black girls, then, were also subject to this lack of protection.

Although I have found no comprehensive studies or statistics that break down reported child sexual abuse cases according to the racial identities of those abused, it is clear to me that the sexual abuse of Black girls today has its historical roots in the sexualization of Black women and their daughters during times of slavery, and that it has not yet been eradicated from our modern, racialized consciousness. Hill Collins finds similarly that:

> Rape and other acts of overt violence that Black women have
> experienced, such as physical assault during slavery, domestic
> abuse, incest and sexual extortion, accompany Black women's
> subordination in a system of race, class, and gender oppres-
> sion. These violent acts are the visible dimensions of a more
> generalized, routinized system of oppression. Violence against
> Black women tends to be legitimized and therefore condoned

> while the same acts visited on other groups may remain non-
> legitimated and nonexcusable. (1990, 177)

Violence against Black women and Black girls remains "legitimized" pre-
cisely because it has not been systematically denounced in the same ways
as violence committed against Black men in lynching.

As Darlene Clark Hine has noted, acts of violence against Black
women were more often than not analyzed or understood in terms of the
effects such violence had on "the Black male's sense of esteem and re-
spect." Thus, Black women's violations were discussed and continue to
be discussed not as a harm done to us but to Black men. Adds Hine:
"Few scholars probed the effect that rape, the threat of rape, and domes-
tic violence had on the psychic development of the female victims. In the
late nineteenth and early twentieth centuries, as [Hazel] Carby has indi-
cated, lynching, not rape, became the most powerful and compelling
symbol of Black oppression" (1989, 917). And since the stereotyping of
Black women and girls continues, as does the negation of their own vio-
lations, Black women and girls have been forced into an underclass sus-
ceptible to overt instances of emotional, physical, and sexual abuses di-
rected at them from all sectors of society. This systemic victimization of
Black women is not only the result of imperial domination, it has come
to be codified in literature, as in art, in such a way that the oversexualiza-
tion of the Black female has become an accepted artistic image. Though
Black women's literature is filled with responses to the abuses we endure,
I would like to suggest that this literary output is as much a response to
real-life occurences as it is a response to the *visualization* of this stereo-
type. Indeed, the codification of the Black female body as an object for
sexual exploitation in the nineteenth century, when the racialization as a
"science" was at its peak, has severely impacted Western ideology.

This truism was brought home to me as I planned a trip to Europe—
to France, to be precise—in order to escape my everyday struggles with
reclaiming the past. I was then under the misapprehension that, some-
how, going back to the land of my oppressors could bring me a better
understanding of those who have consistently viewed me as their "other."
For several years, I carried pictures in my mind of myself at the Champs
Élysées, at the foot of the Eiffel Tower, and I planned my tour of Parisian
museums in order to see at firsthand the *Venus de Milo,* the *Mona Lisa,*
and Rodin's sculptures. Little did I know that my daydreams would soon

merge with real life, as I proceeded with the research for this book. A visit to the Musée de l'Homme in Paris would bring me face to face with the remains of a nineteenth-century Black woman, Saartje Baartman. Her remains, however, would not be a skull, or a skeleton, or tattered pieces of clothing. I would have to stand before her genitalia and buttocks, which have remained on exhibit behind closed glass since Saartje's death in 1815. These two biological parts have come to represent, in whole for me, the official history of Black women in Europe during the nineteenth century, and in whole the life of one Black woman, a South African "indentured servant," a slave, who was better known during the last five years of her life, during which she constituted a traveling exhibit for European patrons of cultural diversity, as the "Hottentot Venus."

The overt sexual exploitation and voyeurism that enveloped the life of Saartje Baartman in pre-Victorian England and France has its roots in the history of Africa's colonization by various European nations back in the sixteenth century, when the Portuguese first explored the African continent, soon followed by the envoys of France, England, and Holland who depleted Africa's natural resources and enslaved its indigenous population. She was twenty-five at the time of her death. Her death ushered into existence what was to become a normative component of European art and culture exhibits. By 1889, the Universal Exhibition held in France "was composed of simulacra of native habitations, imported native inhabitants and tribal objects" (Solomon-Godeau 1989, 125). Human beings from colonized countries were reduced to the status of living objects for scientific and artistic curiosity (an offense that Afro-Caribbean Canadian writer M. Nourbese Philip has taken to task in her own poetry, which I discuss in the following chapter).

Hence, the cause of Saartje Baartman's death in 1815, was treated with little care or compassion by those who conducted autopsies on her cadaver. As Sander Gilman tells us in his 1985 essay, "Black Bodies, White Bodies: Toward an Iconography of Female Sexuality in Late Nineteenth-Century Art, Medicine, and Literature": "When one turns to the autopsies of Hottentot females in the nineteenth century, their description centers about the sexual parts." Of Saartje, Gilman says: "The audience which had paid to see her buttocks and had fantasized about the uniqueness of her genitalia when she was alive could, after her death and dissection, examine both" (216). George Cuvier's nineteenth-century autopsy of Saartje, which resulted in the preservation and exhibition of her

sexual and sexualized body parts, stressed nature in order to link medical observances with a racialized pseudoscientific discourse by which the "abnormalities" of Black women were used to sanction their ongoing sexual exploitation. This pseudoscientific discourse was created in order to legitimate the oppression of African women, as Gilman contends:

> To meet their [the radical empiricists of late eighteenth- and early nineteenth-century Europe] scientific standards, a paradigm was needed which would technically place both the sexuality and the beauty of the black in an antithetical position to that of the white. This paradigm would have to be rooted in some type of unique and observable physical difference; they found that difference in the distinction they drew between the pathological and the normal in the medical model. . . . It was in the work of J. S. Virey that this alteration of the mode of discourse . . . took place. . . . Virey cites the Hottentot woman as the epitome of . . . sexual lasciviousness and stresses the relationship between her physiology and her physiognomy (her "hideous form" and her "horribly flattened nose"). (1985, 212–213)

The sexualization of women of African descent in the nineteenth century runs a parallel course in art. Art, as Gilman's essay demonstrates, presents a fairly accurate historical record of the ways in which people of African descent, in particular women and children, were exploited. Thus, as prefigured by representations of Africans in seventeenth-century European art, Gilman states that "one of the black servant's central functions in the visual arts of the eighteenth and nineteenth centuries was to sexualize the society in which he or she is found," and in eighteenth-century "narrative art" (Gilman cites Hogarth's two series, *A Harlot's Progress* [1731] and *A Rake's Progress* [1733–34]), "The figures of . . . black servants mark the presence of illicit sexual activity" (209). By the nineteenth century, Gilman shows that figures of Black children and Black women served as sexual codes by which to sexualize the white female nudes central to many masterpieces, such as Edouard Manet's *Olympia* (1863) and Franz von Bayros's *The Servant* (1890).[4]

In the late nineteenth century, the focus of representations of Black women and/or of colonized women of color in art shifted to that of their overt sexualization. Griselda Pollock explains, in *Avant-Garde Gambits*

(1888–1893): Gender and the Colour of Art History, that avant-garde painters of the period were involved in a form of artistic game-playing, which in part involved the reinvention of the function of white and Black female nudes. Pollock defines this game-playing as composed of three elements: reference, deference, and difference. Avant-garde artists incorporated references to current artistic practices in their works to be recognized as part of the avant-garde community; artists alluded to the existing, acknowledged master or masterwork of the moment, while boldly attempting to displace their predecessors (1992, 14). The sexualization of Black women and women of color formed an integral part of this process of displacement. Pollock illustrates how this sexualization occurred in her broad analysis of Manet's *Olympia* and Gauguin's subsequent subversion of the painting in his *Manao Tupapau* (1892). Pollock describes how Manet transformed his reference to Titian's *Venus of Urbino* (1538), in which a white female nude dominates the foreground, by placing a clothed Black female in the foreground next to the requisite nude. *Olympia* inscribes the figure of the Black female in pictorial art in a markedly different way from before. No longer the foil to the desirable, the Black female embodies both the desirable and the disdained. Pollock points out that Manet's Black female figure is the likeness of an Afro-Caribbean model whose name was Laure. Too often dismissed in discussions of Manet's painting, or reduced to a negative space in a composition of lights and darks, Pollock retrieves Manet's Laure by giving her back her origins and her name.

But would such details have been of interest to viewers of *Olympia* in 1863? Pollock states:

> The painting's negation of orientalism emerges from its assertive modernity, a here and now-ness of the working woman hired to model as a courtesan attended by another working-class woman, displaced from her African home through colonial slavery and now in wage slavery. This fact of displacement is signified above all by the overlarge, ill-fitting European dress which clothes a body which, in orientalist art, would have been both exposed and represented as the foil to the plum white woman's brilliant, and desired, flesh. (21–22)

The fact that the Black woman is clothed overturns these earlier, orientalist associations. The Black woman's desired body is hidden from view,

directing our gaze to the white, female body, whose nudity, by negation of the exoticized other, we are now invited to desire, even to possess, *as she in turn possesses the Black woman at her feet*. Pollock, invoking the artistic milieu of 1860s France, states that "*Olympia* is a representation of the spaces of bourgeois masculinity where working women's bodies are bought and sold, where money mediates even the most intimate bodily contacts" (35). It is clear to me, however, that such a reading should not lead us to conclude that the figures in the painting are rendered equal by their "working-class" status. The Black female figure remains at the service of both the male gaze and of the female figure she is attending: objectively and sexually she is possessed by both. She alone defines the meaning of the "bodily contacts" Pollock invokes, as she is made to assume a sexualized and servile role.

Gauguin pushes the concept of the Black female as the exotic "other" a step farther as he displaces Manet's painting by replacing the white nude with a rendering of his Tahitian, pubescent "wife" and by replacing the Afro-Caribbean female figure with a sexless, shrouded form now called "Death." Says Pollock: "The painting references the modernity of *Olympia* only to erase it with a racist fiction about the fascinating and desirable difference of a pre-modern work of simple, superstitious Tahitian women afraid of the spirits of the dead" (40–41). Gauguin's artistic "gambit" —to use Pollock's term—was to situate the colonized female subject in the foreground of European sexual decadence. His model, his young "wife," is stripped of her marital status and reduced, by reference to *Olympia* to the role of prostitute: she no longer mediates between demonized Black sexuality and the reprehensible but "necessary" white female prostitutes, she becomes the thing desired itself. And, as a "Black" woman, a woman of the tropics, she does not need a mediating figure herself since she is by history and by law an object already claimable through colonial dominance.

The figure of "Death" in the painting is placed there, as Pollock suggests (20–23, 40–41), to mediate only against these elements of the painting, to undermine through religious iconography the explicit sexuality Gauguin ascribes to the Tahitian girl. Her age is also indicative of a shift in sex roles prescribed for Black females at this turn of the century.[5] Pollock suggests that "she is thus made the sign of a culture which is distanced and subdued, put in its place like a native child—wild, primitive and superstitious, but desirable" (68). *The fact that the painting is*

part of the discourse of the exotization of racial difference also serves to transform the body of a "Black" child, a child of color, into the locus for the expression of colonial white male power and desire. The cross-generational divisions Joan Riley and Beryl Gilroy attempt to repair in their fiction have their root in just this sort of cultural "exchange," whereby art is produced by disabling colonized cultures. Gauguin's model, Teha'amana, loses her connection to her culture and to her family through marriage. Her image, to viewers like myself, thus comes to represent her isolation in a Eurocentric discourse that strips her of all but her color.

With this historical overview in mind, then, it is clear that Saartje's private parts, pickled and shelved for viewing in the early nineteenth century, served as the public basis for confirming and solidifying the white European (or Eurocentric) attribution of a primitive sexual lasciviousness—which had to be guarded against or taken advantage of—to Black women and Black girls during the late nineteenth century. Thereafter, the perceived inferiority of Black, female slave/servants supplanted (at the same time as it affirmed) that of white, female prostitutes and/or working-class, white, European women: the "Hottentot Venus," that is, the African woman, became the symbol for "perverse" female sexuality.[6] Ironically, previous to the disruption of African societies such as ancient Ethiopia, African women "had rights equal to that of men, and equal power." This, according to John Henrik Clarke, who notes in his review essay of Cheikh Anta Diop's *The Cultural Unity of Negro Africa* of 1959, "In Africa the woman's 'place' was not only with her family; she often ruled nations with unquestionable authority. Many African women were great militarists, and on occasion led their armies in battle. The Africans had produced a civilization where men were secure enough to let women advance as far as their talent, royal lineage and prerogatives would take them" (1975, 15). Furthermore, as is evidenced by the prevalent worldwide iconography of the Black Madonna, there is reason to believe that previous to the colonization and enslavement of Africans, the image of the Black woman was a far cry from the one that evolved from the matrix of (white) racial superiority. As Clarke notes: "In the looking at the Black woman as a figure in world history, it should be remembered that the universal symbol of womanhood and purity was originally considered by many early Christians to be a Black woman" (1975, 20). With the rise of colonialism and the imposition of Western European models of womanhood amid which women were treated as second-class citizens,

African women were dethroned from their seats of power because rather than in spite of their gender. As recipients of this legacy, women of African descent in the present day are left to struggle with the denigration of their history, a denigration made manifest in the abuse heaped upon their very bodies.

Given the lack of attention the violation of Black women receives in Western society, it is not surprising that our victimization begins at an early age. Consequently, child sexual abuse is a recurrent theme in the writings of women of the African diaspora who have had to contend with the legacy of their position in the white European imagination as they break the silence imposed upon their violation. The representations of child sexual abuse to be found in the writings of those women reflect differing aspects of the history that has made the sexualization of Black girls and women an all too common experience. In the following section, I contrast what is perhaps the best-known novel by a Black woman to deal with the subject of child sexual abuse, Toni Morrison's *The Bluest Eye* (1970), with a somewhat less well-known novel by an Afro-Caribbean woman writer that deals with similar issues, Joan Riley's *The Unbelonging* (1985). Both novels foreground stories of incest against the entwined issues of race, gender, and class. Interestingly, these novels counteract much of current psychotherapy discourse which, although it is inclusive of socioeconomic differences among survivors, often ignores the ways in which differences of race, gender, and class impact on how survivors, already marginalized by one or more oppressions, experience and recover from the acts of sexual violence perpetrated on them. Morrison and Riley portray their female characters differently, however, and this divergence between the texts is suggestive of an experiential gap.

This is to say that the Caribbean exile considers herself to be in exile, yes, from her Afrocentric roots, but her roots also lay in the Caribbean islands, while "exile" in the African American context is complicated by the fact that U.S. society still operates so as to marginalize people of African descent who are also American. The Caribbean exile, then, experiences that exile against the backdrop of a predominantly Black culture (even inasmuch as those cultures remain "colonial" in many respects) and that knowledge produces a different set of responses to her state of oppression in her adopted culture, which is not (as "America" is for African Americans) her own. This diasporic difference inhibits the ways in which Black women are able to speak out against the injustices they suffer in

their own communities, especially when that abuse takes the forms of incest. Thus, in Morrison's text, her victimized female characters are by and large silenced in reflection of their minority status in the United States, while in Riley's text the female protagonist is given an active part in the telling of her story, in defiance of the British culture that cannot deign to see her. The gap between these two author's perspectives on child sexual abuse is indicative of the ways in which Black women have had to cope with the reality of their sexual violations.

"Who Will Protect Her?"

In her essay on Black women's responses to rape, Darlene Clark Hine contends that the lack of historical attention given to the abuse of Black women generally has resulted in what she calls a "culture of dissemblance." Hine's concept of dissemblance is characterized by "the behavior and attitudes of Black women that created the appearance of openness and disclosure but actually shielded the truth of their inner lives and selves from their oppressors" (1989, 912). By extension, I would suggest that the forces that necessitated such secrecy as a tool for survival also resulted in Black women's shielding the truth from themselves and each other. In this light, it becomes more apparent that *The Bluest Eye* in particular can be defined as a novel that illustrates Hine's "culture of dissemblance" among Black women, as the lives of abused Black females within it are obscured by a deceptive and sometimes inaccurate language.

The Bluest Eye is an important novel to discuss in this context, because it is perhaps the best-known work of literature by a woman of African descent that addresses the stark brutality of incest as mediated by the forces of race, sex, and class. As such, it provides readers unfamiliar with Afro-Caribbean women's literature and perhaps more "at home" with African American women's literature an entrée into the world of the former. Morrison presents her story from shifting points of view, alternating the voice of Pecola's childhood friend Claudine with that of her mother and father. Pecola is depicted as having gone "mad" as a result of her father's incest and therefore is unable to comment on her life except from a limited third-person point of view, which at times attributes to her an impossible sexual consciousness. The rape itself is communicated through the father's perspective as he commits the crime. These elements make this a story in which all women's lives are shown to be a component of

Black-male oppression. Though *The Bluest Eye* breaks the taboo, the si-
lence, which surrounds the issue of incest in the Black population (in-
deed, in all sectors of Western society), it is not and does not pretend to
be a feminist novel. In fact, the novel reinscribes the sorts of stereotypes
that have made the sexualization of Black girls and women permissible—
even acceptable. In what way, then, does this novel speak to the particu-
lar horrors faced by Black girls sexualized and violated since childhood in
and out of their families and communities? In the following, brief analysis
of the novel, the answer to this question is my main concern.

What has concerned most literary critics in analyzing *The Bluest Eye*
has not been the issue of incest presented by the novel. Avowed Black
feminists, such as Barbara Christian and Claudia Tate, in their brief de-
scriptions of the novel, completely sidestep the issue. Tate, for one, states
only that Pecola "surmises that the reason she is despised and ridiculed is
that she is black and, therefore, ugly" and, that "unable to endure the
brutality toward her *frail self-image,* Pecola quietly goes insane" (1988,
117; emphasis mine). Christian in turn states, in respect to *The Bluest
Eye,* that "Toni Morrison finds the language to describe the psychic
trauma experienced by so many black girls growing up in a culture where
blue eyes and blond hair are the culmination of beauty" (1985, 25).
Morrison's use of language in the novel betrays a lack of control over her
subject matter, which is not so much about the search for white accept-
ability, but more the failure of her characters to confront their alienation
and end it by valuing themselves; this failure is epitomized by Pecola's
rape, which neither Tate nor Christian can articulate. Their silence on the
subject of incest in the novel is not surprising, given Pecola's lack of
voice in it. More recent criticisms of the novel have attempted to redress
this lack of acknowledgment but they participate in, rather than illumi-
nate the cause of, the sexualization of the Black girl represented in the
text. These critics fail to reveal a substantive awareness of the fact that
Black girls, like Pecola, are not women, nor do they become "women" as
a result of sexual abuse or violence.[7]

The inability of critics to speak accurately of the source of Pecola's
own silence reflects what June Jordan has written in her essay of 1982,
"Problems of Language in a Democratic State," in which she points out
that there is no democratic state or democratic language for African
Americans and that the citizens of the United States, whether benefiting
from or victim of the illusion of U.S. democracy, "frequently validate the

passive voice of a powerful state that seeks to conceal the truth from us, the people" (1982/1985, 33). This, then, becomes tactile in language, says Jordan: "As in: 'I was raped.' What should we conclude from that most sadly passive use of language? By definition, nobody in her right mind can say that, and mean it. For rape to occur, somebody real has to rape somebody else, equally real. Rape presupposes a rapist and his victim. The victim must learn to make language tell her own truth: He raped me" (33). So too, must we who denounce acts of rape, of incest, of various sexual victimizations, state unequivocably: "He raped her" and not "She was raped." So, too, must we acknowledge that Pecola's father raped her.

The difficulty of articulating the obvious arises from the fact that Morrison buttresses the central story of the father–daughter incest with the reality of the racism all her characters must endure in U.S. society. Pecola's family, the Breedloves, live in poverty: "They lived [in a storefront] because they were poor and black, and they stayed there because they believed they were ugly" (1970, 34). The Breedloves have internalized the hatred imposed upon them by mainstream U.S. society because of their racial identity; they live on the margins of society without the hope of a better life. It is no coincidence, then, that Morrison has chosen to name the family "Breedlove": Madame C. J. Walker, of hair-products fame, was born Sarah Breedlove, and her hair products, during the late nineteenth and early twentieth century, were associated with "her clients' desire for straight, Caucasian-type hair" (Giddings 1984, 188). Pecola's desire to be "white" runs deeper than such cosmetic alterations, "she prayed for blue eyes" (Morrison 1970, 40). She survives only by attempting to shed her identity as Black, which she sees as responsible for her abuse. Pecola requests blue eyes from the community minister/witch doctor so she can emulate the inviolable Shirley Temple of the movie screen.

In this way, the tragic life of Pecola Breedlove is shown to be the result of a lack of positive representations of Black people in the popular culture of the 1940s: perfection is presented as white and middle class, neither of which Pecola can become, however much she attempts to appropriate both those markers of mainstream existence. What images of Black women Pecola could have accessed only maintain her sense of low self-worth. In films such as *Imitation of Life* (1934), and *It's a Wonderful Life* (1946), Black women were allowed to play only the role of "Aunt

Jemima," the kindly, matronly, family cook and wet nurse—there were no other positive depictions of Black women or Black girls not tied to service and subordination. As a young girl trying to survive in the 1940s, the images of Black women available in popular culture offer no alternative to the Shirley Temples and Scarlet O'Haras of mainstream U.S. culture. The women to be desired, like the female nude of Manet's *Olympia,* are white, and, in this context, upper class.

Thus, when she is mistreated by a white storekeeper, Pecola seeks solace in her purchase of Mary Jane candies:

> Each pale yellow wrapper has a picture on it. A picture of little Mary Jane, for whom the candy is named. Smiling white face. Blond hair in gentle disarray, blue eyes looking at her out of a world of clean comfort. The eyes are petulant, mischievous. To Pecola they are simply pretty. She eats the candy, and its sweetness is good. To eat the candy is somehow to eat the eyes, eat Mary Jane. Love Mary Jane. Be Mary Jane. (1970, 43)

Pecola swallows whole the image she has been told to emulate but can never be. At this point in the novel, *Pecola's eventual rape is foreshadowed by sexualizing her racial desires.* Morrison writes of Pecola's thoughts in the store: "Three pennies had bought her nine lovely *orgasms* with Mary Jane" (43; emphasis mine). Morrison's use of language here points to an inevitable outcome: Pecola's thoughts are age-inappropriate, but the slippage in language that occurs here is replicated at other key points in the novel, which leads us, as readers, to make sense of the incest as part of an intricate pattern of racial and sexual oppression to which both she and her father are equally subject.

Morrison has since written her own appraisal of her first novel. She writes of her attempt to break out of the "culture of dissemblance" by having Pecola's now grown-up girlfriends look back at the events of their childhood to decipher the root cause of Pecola's peculiar alienation. She says of *The Bluest Eye* that it "is a terrible story about things one would rather not know anything about" (1989, 21), but also that she failed to illuminate the fury in the eye of the storm brewing in her narrative. Morrison writes:

The shattered world I built (to complement what is happen-
ing to Pecola), its pieces held together by seasons in childtime
and commenting at every turn on the incompatible and bar-
ren white-family primer, does not in its present form handle
effectively the silence at its center. The void that is Pecola's
"unbeing." It should have had a shape—like the emptiness
left by a boom or a cry. It required a sophistication unavail-
able to me, and some deft manipulation of the voices around
her. . . . Although I was pressing for a female expressiveness
. . . it eluded me for the most part, and I had to content
myself with female personae because I was not able to secure
throughout the work the feminine subtext that is present in
the opening sentence (the women gossiping, eager and aghast
in "Quiet as it's kept"). (22–23)

Morrison finds that her one triumph in feminizing her novel lies in her
ability to describe the intimidation of Cholly at a young age in a way that
connects forward to the incest with Pecola. She writes: "It is interesting
to me now that where I thought I would have the most difficulty sub-
verting the language to a feminine mode, I had the least: connecting
Cholly's 'rape' by the white men to his own of his daughter" (1989, 22–
23). In fact, the result of this artistic triumph is the justification of
Cholly's behavior: his life experiences are conveyed as running parallel to
those of his daughter.

Readers are given a fairly sympathetic account of Cholly's life history;
his violence is shown to be the result of his racial marginalization in the
United States. Cholly's life begins in rejection as his mother abandons
him by the railroad tracks, and his adult life begins with rejection by his
father whom he seeks after the defining episode of his life—at age thir-
teen, a group of white men attempt to force Cholly to rape his girlfriend.
The words Morrison uses to describe the incident point to a metaphori-
cal rape, that is, to his emasculation: "Cholly, moving faster, looked at
Darlene. He hated her. He almost wished he could do it—hard, long,
and painfully, he hated her so much. *The flashlight wormed its way into his
guts and turned the sweet taste of muscadine into rotten fetid bile.* He
stared at Darlene's hands covering her face in the moon and lamplight.
They looked like baby claws" (1970, 117; emphasis mine). Feeling that
he is powerless to retaliate against the white men, Cholly identifies Dar-

lene as less powerful than himself, as a Black woman, and despises her for her socially prescribed powerlessness.

The sentence I have italicized in the passage above is echoed in Cholly's version of his rape of Pecola. Cholly watches his daughter washing dishes and thinks, "The clear statement of her misery was an accusation. He wanted to break her neck—but tenderly. *Guilt and impotence rose in a bilious duet.* What could he do for her—ever? What give her? What say to her? What could a burned-out black man say to the hunched back of his eleven-year-old daughter?" (127; emphasis mine). Cholly's despair finds root in the discourse of Black male organizing in the 1960s, in which the "castration theme" (Giddings 1984, 319) was prominent; it is not countered by Morrison. The linking of Cholly's "rape" to the rape of Pecola is couched in the memory of his emasculation: where once Cholly was unable to defend himself and Darlene from the flashlights of three white men and unable at their insistence to rape her, Cholly vindicates himself by raping another girl in a different time and space, his daughter. His violent response to his daughter's powerlessness is a by-product of his own self-hatred, but also a feature of the sexism the novel reinscribes: Darlene's "rape" earlier in the novel remains as silenced an event as Pecola's actual rape, which is only as real as conveyed through Cholly's characterization since Pecola has no voice of her own.

The rape in *The Bluest Eye* is told from the perpetrator's point of view: "He wanted to fuck her—tenderly. But the tenderness would not hold. The tightness of her vagina was more than he could bear. His soul seemed to slip down to his guts and fly out into her, and the gigantic thrust he made into her then provoked the only sound she made—a hollow suck of air in the back of her throat. . . . Removing himself from her was so painful *to him* he cut it short" (1970, 128; my emphasis). There would seem to be no way to entertain an analysis of this scene that could excuse this father's behavior; Morrison's strategic use of expletives also mediates against the dismissal or acceptance of Cholly's behavior. Still, we must endure Pecola's rape as a painful experience in Cholly's life rather than in Pecola's (even though we may imagine her pain at this precise moment outside the text, it remains outside the text). The last half-page of the novel begs readers to surrender some shred of sympathy, if not compassion, for the circumstances that have led up to the brutal moment of incest: "Cholly . . . was the one who loved her enough to

touch her, envelop her, give something of himself to her. But his touch was fatal, and the something he gave her filled the matrix of her agony with death. Love is never any better than the lover" (159). Acts of sexual violence are simply never motivated by love. Ever.

Recovering Sexual Autonomy: Joan Riley's *The Unbelonging*

Pain, shame, betrayal, these are the feelings usually associated with sexual abuse by survivors, whether male or female. Statistics reveal, however, that more women than men will have been subject to sexual abuse before they reach adulthood. Beverly Engel, in her book, *The Right to Innocence,* refers to studies which reveal what has become common knowledge, that "one in every three women and one in every seven men are sexually abused by the time they reach the age of eighteen" (1989, 1). E. Sue Blume, in *Secret Survivors,* states that at least 38 percent of (U.S.) women were sexually abused as children, but hypothesizes that "more than half of all women are survivors of childhood sexual trauma" (1990, xxii), because current studies can simply not account for the unquantified numbers of women who remain silent about their abuse or do not remember it. As Blume says: "What is not remembered cannot be reported" (xxii). Of this 38 percent, at least 35 percent of reported instances of sex abuse involved girls under the age of six. Blume also tells us that, "according to the FBI, most rape victims are between ages 10 and 19 [while] one quarter are under 12" (1990, 10). The fact that women and children are often seen or treated as the property of husbands and fathers makes possible their continued exploitation (36). Male perpetrators use a system that supports unequal power relationships between men and women as well as between children and adults in order to victimize those they recognize as powerless. Sex, race, age, and class are thus socially constructed markers of powerlessness that act as codes by which perpetrators justify their sexual violence.

Sexual abuse crosses all lines. Ellen Bass and Laura Davis write, as do most authors of current psychotherapeutic texts on this subject, that "sexual abuse happens to children of every class, culture, race, religion, and gender." And further: "it is possible to heal. It is even possible to thrive" (1988, 20). But what do such words, however true, mean to the child who suffers her sexual abuse at the same time as she suffers other abuses because of racism, sexism, or classism? What do they mean to the

child who experiences her sexual abuse out of the combined forces of racism and sexism?

Absent from most textual analyses of *The Bluest Eye* is an informed discussion of the effects of rape and child sexual abuse on female victims. When someone who has power over a child—an older sibling, a parent, a caretaker, a doctor—uses that power in order to "satisfy" his (or her) own emotional/physical/sexual shortcomings and justifies abusive behavior toward children because of the child's sex, race, and actual or perceived class, the recovery of that child will require that psychotherapists be aware of the impact of the combined forces of multiple oppression on the child in question. But such awareness can only be achieved if the current therapeutic discourse on the issue of sexual abuse goes beyond describing how sexual abuse permeates all facets of society to focus on how multiple oppressions contribute to the sexual abuse and exploitation of nonwhite, nonmiddle or upper-class, female children. The same is true of literary criticism in confronting such issues. This, of course, is not to say that male children and children of privileged backgrounds do not experience sexual abuse but only that the abuse experienced by those who have few or no privileges is disproportionate before and after their sexual violation, because of the stereotypes imposed upon them by their differences in race, class, and sex.

When a young Black girl suffers sexual abuse and asks "Why?" she must be told more than "this-is-the-way-the-world-is." And it is simply not enough to respond only by reassuring her that she has not caused her own violation. Perpetrators must be held accountable for their acts of violence against children and for the combined forces of racism, sexism, ageism, and classism they utilize as justification for such violence. Still, I must wonder, as Lucille Clifton writes in her "Shapeshifter" poem #2:

> who is there to protect her
> from the hands of the father
> not the windows which see and
> say nothing not the moon
> that awful eye not the woman
> she will become with her
> scarred tongue who who who the owl
> laments into the evening who
> will protect her this prettylittlegirl. (1987, 78)

The owl, symbolizing for me in this context the Black female child's isolation and despair, speaks out against the secrets of the night, but its question remains unanswered if not unanswerable.

In *The Unbelonging* (1985), Riley responds to the question raised in Clifton's poem ("who is there to protect her?"), as she tells a story of incest in which she combines an awareness of the impact of multiple oppression with the necessity of giving her female protagonist a voice. Riley's intention, say Jacqui Roach and Petal Felix, in their essay "Black Looks," was to write the novel "as an expression of a black female point of view" (1989, 133). Her protagonist, Hyacinth, is a young Afro-Caribbean girl, also of working-class background, who is sexually abused by her father as both attempt to survive in racially hostile England. *The Unbelonging* is as much a story about racism as it is about the ways in which the condition of exile works in tandem with racism and sexism to further silence and marginalize Hyacinth's attempts to recover from her sexual abuse.

Nonetheless, as with *The Bluest Eye,* most critics of the novel sidestep the issue of child sexual abuse and the proper attribution of responsibility to the perpetrator of that abuse, as does Isabel Carrera Suárez in her essay, "Absent Mother(Land)s: Joan Riley's Fiction." She says, for example, of *The Unbelonging*'s protagonist: "Hyacinth *bathes* in her father's presence, conscious of (though only half-understanding yet) the 'lump in his trousers'" (1992, 297; my emphasis). Hyacinth does not "bathe" in her father's physical presence and sexuality; she is terrified of the implications of his violent and sexualized behavior toward her. This terror finds expression in the novel in "the sheer recurrence in the text of the word 'fear' or semantically related terms" (Corhay-Ledent 1990, 508). Even though Riley, like Morrison, conveys the father in her story as having experienced and suffered under British racism, she does not hold him the less responsible for his visiting violence upon Hyacinth.

Riley drives home to her readers the inexcusability of his sexual violence by presenting the molestation and attempted rape of Hyacinth from the eleven-year-old girl's perspective. Her violation is therefore not filtered through the violator's eyes, but through her Black and female eyes. There is no room left for excuses and motivations:

> His rough hands were fumbling with her blue school skirt,
> while his whole body seemed to be shivering, his breathing
> rasping and obscene in her ears. She could feel his hand pull-

ing at her panties, while his breath, rancid with stale liquor, was in her mouth, in her nose, travelling down her throat, making her retch, her stomach churn in protest. Now she could feel the lump rubbing against her belly, and she heaved, the sickness bubbling up, salt liquid pouring into her mouth. . . . The tears were burning furrows down her cheeks as she felt him move above her, his weight pinning her, pushing the breath from her body, suffocating her. She felt the lump moving, and she pushed and struggled, clawing out at him, her head singing as he slapped it about in annoyance. (1985, 62–63)

Riley's foregrounding Hyacinth's perspective underscores the fact that her sexual abuse occurs because she is a girl, a child subject to the whims of the father, and because she is Black.

The violence inflicted upon Hyacinth at the hands of her own Black father is a result of his internalized self-hatred and overt sexism. As Hill Collins states: "The unfortunate current reality is that many Black men have internalized the controlling images of the sex/gender hierarchy and condone either Black women's rape by other Black men or their own behavior as rapists" (1990, 179). We need look no further than the representations of Black women in the majority of rap music videos shown on BET and MTV to acknowledge that this internalization is socially acceptable. The bulk of Riley's novel, however, seeks to illustrate how Hyacinth struggles to gain her own sense of self-worth after her father's molestation and attempted rape.

Bénédicte Corhay-Ledent points out, in "Between Conflicting Worlds" (1990), that Hyacinth's response is to "resist . . . male oppression" by using "a resistance to it [which] is very similar to a form of resistance Caribbean slaves opposed to slavery: mental maroonage" (508). This resistance is also common among survivors of child sexual abuse. E. Sue Blume, in cataloguing the wide range of reactions incest survivors have to their abuse, asserts: "The survivor's responses to the incest are natural and even meritorious, given the reality of her early life. . . . *She* is not crazy—incest is crazy" (1990, 76). Survivors develop strategies of resistance and survival such as post-traumatic stress disorder, amnesia, dissociation, alternative realities (including, in severe cases, schizophrenia and multiple-personality disorder—both of which are not

the result of psychosis), depression, and sometimes, suicide. In Hyacinth, Riley portrays a true-to-life survivor of incest in that her character's coping mechanisms include symptoms of post-traumatic stress disorder—dissociation, the creation of a new identity, and depression. But all of these coping mechanisms are also a product of Hyacinth's awareness of the roles racism and sexism have played in her violation and ongoing marginalization from British culture.

After one of her best friends dies in an accidental fire in Jamaica, Riley's protagonist is brought to live in England by a father she hardly knows. Presumably, his renewed interest in his daughter stems from the recognition that Hyacinth needs to be given access to higher education in order to escape her friend's fate or a life of possible poverty in her aunt's home. Hyacinth, however, wants only to return home where she felt she had safety and happiness:

> That night she dreamt she was already home. First she was in the plane above the clouds that stretched motionless like bits of suspended cottonwool all around her. Then the pilot was announcing their arrival at Kingston Palisados. The rest was a blur of movement until Aunt Joyce folded her into her large, warm embrace. Hyacinth pinched herself to make sure she was there, that this was not another cruel dream. There was no pain, but who would expect it when she was so happy? (1985, 32)

She soon realizes that she has only dreamed and returns to her present life in her father's house, where she is also subject to the tyranny of her stepmother. For Hyacinth, the move to England has been a move toward complete alienation. Although there is the hope of accessing middle- or upper-classness through education, her father's home, filled as it is with violence, causes her to isolate herself from others. Hyacinth makes no friends but cultivates an interior life of daydreams (31) through which she hopes to return to Jamaica.

Hyacinth's molestation, which begins as soon as her father discovers that she has begun to menstruate, evokes the ultimate alienation. Hyacinth is able to physically resist her father as he attempts to rape her and flees his house, but she has nowhere to turn: her father has taught her to trust no one, and his words return to haunt her: " 'They don't like neaga

in this country. All them white people smile up them face with them plastic smile, and then when you trust them, them kill you'" (51). Hyacinth does not want to have fled her father's violence only to be killed! Mercifully, Hyacinth is no longer subject to physical and sexual violence in the foster home she is sent to after the police discover her shivering in a phone booth, but she is subject to overt racism and its attendant ostracization.

In the relative security of her new foster home, Hyacinth hopes to continue her education. Her foster mother's reaction is to belittle her efforts: "'What college will take you?' the woman sneered. 'Can't you blacks see there isn't any place for you in education? You had your chance and failed. Why don't you give up and stop wasting everybody's time?'" (80). The point of view presented by Hyacinth's foster mother is representative of the ways in which Black girls are perceived in British society. Hazel Carby writes in "Schooling in Babylon": "In the careers service West Indian young women are thought to be most suitable for occupations as orderlies in the National Health Service and thus are encouraged to train for such jobs. . . . Black youth are associated with low-paid, low-skilled jobs, jobs that their parents were encouraged to migrate to Britain to do" (1982, 202). Riley brings this reality to life in *The Unbelonging,* but not without redress: Hyacinth refuses to be limited by her foster mother's racism and works her way through college where she begins to make friends with other people of color.

Her father's words ringing in her ears, Hyacinth does not trust any white person, but she is also unable to trust people of African descent, having learned through her father's and stepmother's behavior that she cannot assume that others who are similarly oppressed will not, in turn, oppress her. Having absorbed the tenets of British racism, Hyacinth first approaches East Indian students because, though "they were not white, . . . they had long hair, and their noses were straight, their lips nice and thin" (1985, 81). When a Black male student accosts Hyacinth in the student cafeteria while she is lunching with an Indian friend, Hyacinth is forced to face the complex nature of racism. The Black student insults her friend with racial slurs as he attempts to get her attention. He accuses her, "'Do you just prefer coolies to your own kind?'" But when Hyacinth attempts to protect her friendship with the Indian girl, the Indian student reacts with hostility and prejudice. She asks, "'Are your people always like this?'" (82). As a result, Hyacinth rejects all attempts on the

part of other displaced Africans in England to befriend her in order not to be associated with the stereotypes of inferiority forced upon people of African descent.

As an adult, Hyacinth says of her African counterparts: "They just seemed so ignorant, and she felt uncomfortable when several of them kept smiling encouragingly at her. She hoped none of them would approach her, hating the thought of being associated with them" (81). In Hyacinth's mind, to be associated with other Black people would result in the endless repetition of her abuse. She does not for a minute believe that she could entrust others with her shame when her own father could not love her for who she was, an alienated Black girl in a foreign and hostile land.

Hyacinth is confused as to how she can affirm the various parts of her identity. Knowing that her white, foster-care "mother" hates her because she is a Black girl (the foster mother is, somehow, more tolerant of the Black boys in her care), Hyacinth has an uncharacteristic longing to be among Black people (73). But when she does find herself with Black friends in college, both African and Jamaican, she attempts to deny her past by adopting a fabricated, upper-class identity: "Hyacinth had given herself a new identity since coming to Aston, mindful of the shameful secrets in her past, and had deliberately created an image she thought other people would envy. It made her confident to come from a good background, to know that none of them could look at her with pity, or guess the secret she carried in her heart" (109). Hyacinth, however, has no sense, aside from distant childhood memories, of the realities of her Jamaican background and dissociates as completely as she can her experiences with racism and sexism. She knows nothing of civil rights movements and people's revolutions among the youth of the African diaspora.

Invited to a talk by her Jamaican friend, Perlene, on racism in Britain and the Caribbean, Hyacinth reacts with disbelief: "Hyacinth bristled. There was no racism in the Caribbean, and anyway a man who taught in Africa was hardly qualified to talk on the British situation. She was getting fed up of these endless lectures, feeling saturated with all this business of black achievements. As far as she could see, that was in the past and it was certainly not helping much with the present" (115). With her fabricated identity, Hyacinth is able to forge superficial connections with other Black students, but she is unable to connect, ultimately, with herself. This alienation is a feature of her condition of exile in Britain, where

the history of modern racism in the West can be said to have some of its deepest roots; she is unable, therefore, to move toward self-definition within a Caribbean context. Hyacinth, says Corhay-Ledent, "is very much a product of English racism against coloured immigrants who, as a consequence of racial hostility, are made to reject and despise their own racial group and finally their own selves as well" (1990, 508). Riley uses the period of her story, the 1970s to early 1980s, to emphasize the degree to which Hyacinth has dissociated herself from the Black community in Britain.

Hyacinth is attending college at a time of political and social unrest among British Black youth. The authors of *Heart of the Race* (1985) write of the rebellions in 1981:

> Young people, both Black and white, rose up in anger across the country at their treatment by police, politicians and society. Their uprising posed the severest challenge and the most explosive youth response to the system we have ever witnessed. It was the direct threat of their potential to bring about radical social changes which forced the government to seek out ways of containing and regimenting working-class youth. The governmental response to young Black women in particular was to further compartmentalize them in "Youth Training Programs" which only continued to propagate the idea that Black women could only fill low-paying, low-skilled jobs. (Bryan, Dadzie & Scafe 1985, 54, 55)

Hyacinth, due to the trauma of her early childhood abuse and subsequent maltreatment in group homes and schools, has no concept of what awaits her beyond college, although her few friends are at pains to open her eyes to the youth movements taking place all around her.

Riley portrays Hyacinth as hiding in her world of make-believe. Her character cannot face the reality of the losses suffered by the people of the African diaspora, because she cannot confront her own losses of heritage, family, and community. Thus, Riley writes from Hyacinth's perspective: "Everyone seemed to be in the business of reclaiming their history, and she found the idea of Africans having civilisations too farfetched to believe" (1985, 113). When Hyacinth agrees to attend a lecture by Walter Rodney and hears him speak on the dependence of racism on capital-

ism, she begins to place her life in the context of her exile from her Caribbean home:

> She found herself sitting forward as he talked about discrimination in schools and housing, remembering the squalor of her father's house with fresh understanding. It brought back other memories too. The teachers turning a blind eye to her misery, the abuse and assaults at the children's home and, even more painful, her stay in the hostel for young offenders. They were raw wounds that he exposed, the fear and frustration of having nowhere to turn as fresh as if it had been yesterday. (116)

Given what social scientists have written about the British educational system in regard to Black girls, it is not surprising that Riley should portray her protagonist as having nowhere to turn within social institutions: those very institutions perpetuate the prejudices she has had to live with and survive since her emigration.

In "Absent Again? No Excuses!: Black Girls and the Swann Report," Heidi Safia Mirza discusses the 1985 Swann Report, which concentrates on the underachievement of Black girls in the British educational system despite evidence to the contrary. In fact, only 18 pages of the 806-page report make any reference to girls! The isssues of racism and sexism that face Black girls in British schools are completely sidestepped in order to assert that efforts are being made to bring multiculturalism into the school system (Mirza 1986, 247–248). Mirza interprets the Swann Report as symptomatic of how Black girls are ignored and oppressed simultaneously. She writes: "The concept of the self-fulfilling prophecy, as it is commonly called, resulted in programmes aimed at redressing negative self-esteem and away from challenging the institutional racism inherent within the education system" (248). That racism has resulted in the *othering* of West Indian students on the basis of cultural *deviations*, which were taken "as a sign of stupidity" (Bryan, Dadzie & Scafe 1985, 64), rather than as a manifestation of the very multiculturalism touted by government reports and educational reforms.

Paired with sexism, racist attitudes on the part of teachers could easily turn to the overt denigration of Black girls on both fronts. Hazel Carby writes: "Attempts to transform the behaviour and attitudes of black youth

is a part of the rejection of their culture as a whole. Young adolescent West Indian women, for example, are frequently regarded by teachers as 'unfeminine.' Accused of being 'too loud,' of 'flaunting' their sexuality as opposed to being demure but tempting, and of 'talking back' when they are being repressed, they 'fail' to reach Western standards of femininity" (1982, 203). The stereotypes of Black girls in British society, as exposed by Mirza and Carby, provide the context for much of Riley's *The Unbelonging*: it is for reasons such as these that Hyacinth, violated by her father and taken over by the state can be treated as if she has caused her own abuse. Hyacinth is placed in a home for young offenders, not because she has committed a crime, but because there is no other place for her in social systems that, for the most part, ignore the presence of Black girls, but when faced with a homeless, abused Black girl can only treat her like an undesirable member of society: Hyacinth is treated like an "offender" because her race and sex mark her as one, regardless of guilt or innocence.

Hyacinth's alienation occurs on multiple levels, least of which is her inability as a young woman to form romantic and sexual relationships. Like many survivors of sexual abuse, she fears the repetition of her past abuse and therefore avoids relationships with men in general, and with Black men specifically. The one time she does come close to trusting a Black male friend she suffers from flashbacks and fear: "When he kissed her, fear ran along her veins, making it hard to breathe. She pulled herself away, and stumbling to her feet, eyed him with distrust and revulsion" (Riley 1985, 105). Although her friend guesses at her past violation, Hyacinth's fear is enough to keep her from revealing her secret: she is trapped in her shame. Again, she feels as if she has nowhere to turn. Her response is to turn shame inward and to have for outlet only her dreams, some of which are reflected in the romantic pulp fiction she reads (79).

By the novel's end, then, Hyacinth has only one source of hope: still to return to Jamaica. This look forward to that past signals the major difference between Riley's portrayal of the effects of sexual abuse and Morrison's: for Hyacinth, there is a home to look to, while, for Pecola, home is where her abuse takes place; for the latter, there is nowhere to turn, while for the former, the "elsewhereness" of Jamaica signals the possibility of restructuring the home place her father has all but destroyed. Yet, Riley does not sentimentalize the possibility of repatriation, of community rebuilding. In that return, Hyacinth will be forced to con-

front the realities of her past life: internalization of British racism, the cycle of oppression itself, poverty. Corhay-Ledent comments: "The shock of seeing the squalor of Jamaica makes her understand that she first has to come to terms with her childhood before growing up" (1990, 510). In a cave where she played as a child, Hyacinth finds refuge from the shock of seeing the poverty in which her childhood friends remain, from the shock of realizing that her beloved aunt had died years ago. As much as she tries, there can be no real return to the years she knew in Jamaica before her father summoned her to Britain. In this light, the ending of the novel appears bleak, but it is possible to believe that Hyacinth has yet another chance to break the cycle of racism, sexism, and classism that has shaped her life and process of survival. The ending, says Corhay-Ledent, "can also be seen as a first attempt at exorcizing the past by going back to it with the enhanced knowledge that the exposure of her dream world has brought to her" (510).

The novel is open-ended in the sense that we, as readers, have no way of knowing whether or not Hyacinth will move toward an acceptance of her past. It is clear, however, that her experiences have resulted in her survival between worlds. For those she has left behind in Jamaica, she is only a ghost of the past and belongs to the British middle class; in Britain, she is an outcast who has had to depend on a fabricated identity in order to get by, one which is neither completely affiliated with the white middle classes or the Black students who ultimately befriend her. Still, Riley has succeeded in conveying Hyacinth's plight by locating the narrative within her protagonist's point of view and, in so doing, provides readers with a feminist text intent on mirroring the realities of multiple oppression for a young Caribbean girl in exile.

Children whose abuse is not only ignored but condoned by society, because of their age, race, gender, and class, find in silence a potent but limited ally. As Afro-Caribbean, Canadian writer Makeda Silvera states, there is a "difference between 'being silent' and 'being silenced' (1989, 3). It should, therefore, not be up only to survivors of sexual abuse to make visible the site of their multiple oppressions. I do not intend to allow one more black girl to suffer sexual abuse, if these words can help it. Still, what weight do good intentions carry in the face of systemized and institutionalized marginalization and oppression? Words, language, can only enable transformation if they carry with them the weight of their history. Without knowledge or access to the enabling history of the Afri-

can woman (and this is no call to a nostalgic revisionism), there can be little hope of bringing such abuse to an end in the near future. In my opinion, this reclamation can most feasibly be accessed by honoring elderly Black women who are in themselves the repositor for such knowledge. Afro-Caribbean women's literature in exile points to this solution at the same time that it reveals that elderly Black women have had to suffer other forms of abuse as a result of their neglect.

Black Elderly Women Today and Yesterday

Postslavery emigration patterns have perhaps been the primary contributing factor in the continuing disruption of intergenerational bonds. For a large portion of the Caribbean underclasses, emigration to North America and Europe has been a means securing job opportunities never available within the Caribbean. As the exploitation of the labor force in the islands increased in response to demands for cheap labor from so-called developed countries of the West, so did emigration numbers. Emigration, of course, had begun very early. "The islands," says David Lowenthal in his "West Indian Emigrants Overseas," "have long had larger populations than can be supported at a decent standard of living" (1978, 82), as a result of the negative relationship between the depletion of natural resources and the importation of slaves to "maximize production" (82) during slavery and colonization. Emigration, then, was an attempt to secure decent wages and work conditions from those who had impoverished the Caribbean beyond recovery. Before the adoption of domestic schemes in both Britain and Canada, Caribbean men were more likely than women to leave the islands. To women, then, fell the task of raising children, keeping house, and working as they waited (if they were dependent on men) for wages to be sent back from abroad.

Women of African descent, however, have always had a primary role in the heart of their families. Women-centered families in the African diaspora took their model from remnants of West African cultures (Andersen 1988, 137; Hill Collins 1990, 119), but conditions under slavery, which separated families as a matter of course for the economic benefit of slave owners, made the centrality of women's familial roles an explicit rather than culturally determined necessity. According to John Henrik Clarke [1975], and Ogundipe-Leslie [1994], matrilineality—not to be confused with matriarchy, in which women have the power awarded men

under patriarchy—was the common organizing factor in most preco-
lonial African societies.) Postslavery, the continuation of women-centered
families in African cultures diasporically has given rise to the myth of the
African matriarch. The label of "matriarch" in the United States has root
in the 1965 Moynihan Report, which "contends that slavery destroyed
Black families by creating reversed roles for men and women" (Hill Col-
lins 1990, 75); by extension, this "role reversal" was seen as abnormal,
and Black women who had been put in the position of holding together
what they could of their families were seen as failed women. Says Hill
Collins, "The source of the matriarch's failure is her inability to model
appropriate gender behavior" (75). On the other hand, within Black
communities, the matriarch myth took on another configuration, that of
the "strong, Black mother," who, because of her perceived indomi-
tability, could survive anything without the necessary support from her
male counterparts. Again, Hill Collins states: "Glorifying the strong
Black mother represents Black men's attempts to replace negative white
male interpretations with positive Black male ones" (117). From either,
the result of imposing such stereotypes on Black women has been to
define their roles as extensions of Black (and white) male standards of
womanhood and, in so doing, to limit their mobility and options for self-
empowerment.

Black women have provided care for generations of Black children,
unwelcome in a white and male-dominated power structure, from the
advent of slavery until this day: "Children orphaned by sale or death of
their parents under slavery, children conceived through rape, children of
young mothers, children born into extreme poverty or to alcoholic or
drug-addicted mothers, or children who for other reasons cannot remain
with their bloodmothers, have all been supported by othermothers" (Hill
Collins 1990, 120). Elderly Black women, however, are especially suscep-
tible to being oppressed by social expectations of unending strength, for
they are and have been an essential part of the ongoing network of "oth-
ermothers." Hill Collins notes that, during times of slavery, older women
took on the role of primary caregivers: "While older women served as
nurses and midwives, their most common occupation was caring for the
children of parents who worked" (121). Elder women not only took care
of the children whose parents worked, they more often than not worked
themselves. They continued, despite age, to survive the hostilities inher-
ent in living under colonization but were often forgotten or ignored;

they struggled in virtual anonymity even as they undertook the upbringing of new generations of Black children, many times the children of the children they themselves had raised some twenty or thirty years in the past. This pattern continues today in the Caribbean and Britain as well as in the United States.

Ambassador Julia Tavares de Alvarez, in her 1989 keynote address to the United Nations, "Empowering Older Women: An Agenda for the '90s," projects that "by the year 2025, 70% of all persons over 60 years of age would be living in developing countries, which are precisely the ones least prepared to meet the economic and social consequences of this drastic shift in population structure" (1989, 137). She notes that "as societies are becoming older, they are becoming increasingly female and poor," at the same time that "midlife and elderly women play a key role in the developing world" (138). Her address stresses the need for the United Nations community to respond to these alarming demographic trends. Speaking primarily as a representative from the Dominican Republic, Tavares de Alvarez notes the involvement of Caribbean governments in formulating agendas that would support in comprehensive and direct ways the needs of elderly women in the Third World community. For example, she states: "It is the intention of the Government of the Dominican Republic to include midlife and elderly women in the Forty-third General Assembly's resolution on the implementation of the Plan of Action on Aging, and to urge the Commission for the Status of Women to pay particular attention to the specific concerns of midlife and elderly women" (141). Such governmental concern has not, however, resulted in the implementation of short-term plans to respond to the needs of an aging, female Caribbean population.

In fact, many governments in the Caribbean contribute, whether intentionally or because of economic circumstances, to the dearth of resources made available to the elderly. Gloria L. N. Scott declares in "The Aging Female Population in the Caribbean Area: Some Economic Issues": "Governments have demonstrated an apparent lack of concern about the conditions of women workers in all economic sectors" (1989, 379). Women in general have little leveraging power to obtain public funds, but elderly women have even less control over their futures without governmental support (377). Furthermore, economic recessions have resulted in cutbacks in systems already established for the care of the elderly in the Caribbean, which are staffed mostly by women; hence, at

the same time that younger women are losing their positions as health care workers, older women are losing access to much-needed services (376). Scott points out that, since the Caribbean region is economically depressed and many inhabitants therefore live in poverty, women, who have been deprived of "access to high-income, high-prestige occupations" (378), are still made to shoulder an unfair burden for the welfare and survival of families. As they attempt to survive from day to day, older women are discriminated against on the basis of their age (380). They will, therefore, earn lower wages than younger women, who, in turn, make far less than men working in the same jobs—which are usually what Scott calls "low paying, low-status jobs" (378). Elderly women are thus discriminated against by sex and age and, because of their low class status, are subject to all sorts of occupational hazards without long-term health benefits or pensions. Scott demonstrates that, although these conditions may be similar to those endured by elderly women in other countries, the survival of elderly women in the Caribbean is affected by the North to South patterns of neocolonial exploitation, which prey upon the work force of the Caribbean in order to support failed markets elsewhere, as in the exportation of insecticides and household products banned in the United States or in the employment of older women in unregulated factory work (378–380). Even for older women who have not been abandoned by the missing generation of emigrated Caribbeans (usually their children), recessions in colonizing countries have affected "the flow of remittances, as many of those who migrated now find their costs of living increased and their earnings reduced" (381).

In *The Heart of the Race*, Beverly Bryan, Stella Dadzie, and Suzanne Scafe expose the continuing exploitation of Black women in Britain as low-wage workers. They also link the poor working conditions of Afro-Caribbean women in Britain to their poverty, ill-health, and dispossession in old age. They write:

> So despite our years of hard labour for Britain, as we approach old age, we cannot expect to reap many of the rewards. The number of elderly Black women is growing daily, and . . . our chances of escaping the consequences of a lifetime of stress and hard work are slim. Our problems are often compounded by the fact that we may not have worked here long enough to qualify for a full state pension, meaning that our income is

likely to be less than that of the poorest white pensioner. (1985, 93)

Immigrant, Afro-Caribbean women in Britain are unlikely to be financially able to retire in order to enjoy their "twilight" years; more likely is the possibility of their being laid off (Bryan, Dadzie & Scafe 1985, 94), since Black women often hold low-skilled jobs for which they can easily be replaced by a younger, healthier, workforce. Black women thus find themselves "trapped within a cycle of poverty" (94), which disrupts the possibility of advancement as younger women are forced to fill their mothers' and grandmothers' shoes.

The oppression of elderly Black women has many aspects. As a group, they not only suffer the consequences of racism and sexism, but the combined oppression of age-specific economic marginalization and imposed maternal roles. On the one hand, the extension of motherhood into advanced age may benefit both the young and the old in that it provides an opportunity for the transmission of cultural knowledge and values from elder to child. John Stokes and Joan Greenstone, in their 1981 study of support groups founded for Black grandparents raising young children, have found that such arrangements are common, for "to place a child in either foster care or adoption outside of the family violates the values of many black families to such an extent that it occurs only when there is no other alternative" (692). On the other hand, economic and other pressures on elderly women conspire to keep them from capitalizing on this preferred role in nurturing cultural awareness. Elderly women are systematically discriminated against, so that they themselves are not looked after in ways that would reward their long years of work and self-effacement on behalf of younger generations. They become lost links to the past, as generations of children, unable, because of their own struggles against multiple oppressions, to return the care and attention their grandmothers provided, leave them to fend for themselves.

Forgotten Wisdom: Retrieving the Lives of Afro-Caribbean Elders

In *Frangipani House* (1986) and *Boy-Sandwich* (1989), Beryl Gilroy depicts what happens when the elderly can no longer work and have no pensions, and their children are no longer present to support them in life-sustaining ways. They are forced to suffer what Lucy Wilson has termed

"another kind of exile. . . the separation and alienation that results from the inevitable and inexorable process of aging" (1989, 189). In both her novels, Gilroy pays particular attention to the ways in which racism continues to play a significant role in marginalizations that are enforced through ageism. Exile from cultural and personal homes is another factor in this alienation, and Gilroy speaks to both by using the Caribbean setting of Guyana in *Frangipani House* and of Britain in *Boy-Sandwich*. Readers are confronted with the isolation imposed on the elderly in group homes in both settings, an isolation which contributes to their silencing and robs them of connections to their once productive lives. In both novels, Gilroy's protagonists revolt against their marginalization. Gilroy then highlights the responses of the younger generations who, in the end, are the only possible source of hope for their elders to regain vital connections to their communities. Both novels, thus, are constructed in a way that corresponds to the process of exile I have described in the Prologue, that is, as a cycle that progresses through alienation, self-affirmation or self-definition, and recuperation to a return "home."

Frangipani House is the story of Mama King who, after a series of life-threatening illnesses, is placed by her daughters in a group home in Guyana. As soon as Mama King enters Frangipani House, her physical health improves but her emotional and psychological health deteriorates. She eventually devises a plan to break out of the home and survives with a group of street children until she is brutally robbed and left to die by a couple of thugs. After this incident, her daughters return from New York and attempt to decide what to do for their mother; they struggle over how to take care of their mother while, at the same time, continuing their escape from Guyana.

Although *Boy-Sandwich* does not focus specifically on the experiences of elderly Black women—the story unfolds from a grandson's point of view—it accurately depicts the generational rift between Afro-Caribbean elders and their youth. The protagonist, Tyrone, observes the deterioration of his grandparents who are forced to move from their own home to a group home, where they are the only two visible people of African descent. As Tyrone struggles to maintain his lifelong relationship with his grandparents, he also attempts to come to terms with his own marginalized identity in Britain. Connecting the racial and ageist abuses suffered by his grandparents to his harassment by the police and a racially motivated accident involving his girlfriend, Tyrone journeys back to

Guyana with his family in an effort to reclaim his and his grandparents' origins. In both novels, the need to reclaim the past motivates the younger generations to confront the impact of race and age on the formation of their identities and the necessity of preserving the wisdom of their elders in order to survive that confrontation successfully.

The initial alienation of Mama King and of Tyrone's grandparents in their respective group homes is tied explicitly to their experiences with racism. Mama King's daughters, Cyclette and Token, call to instruct the matron of Frangipani House to let her know that they will pay five hundred dollars a month for her care and specify: "'We will pay. But we want white people care for her'" (1986, 3). They not only decide for their mother that she can no longer take of herself but that she cannot be taken care of adequately by Black health-care workers; in their exile, they have absorbed the racism that labels the Caribbean as inferior and will accept only white caretakers, even though Frangipani House is mostly staffed by Black women from the surrounding area. Mama King experiences this racism indirectly, but her life is directly affected by her daughters' inability to make more than long-distance arrangements; again, both her daughters have left the Caribbean in order to make better lives for themselves but have lost any true sense of their identities.

In *Boy-Sandwich,* the racism suffered by Tyrone's grandparents is direct. They are evicted from their home by land developers who have bought their land and that of their neighbors in order to "make room for town houses which only the rich could afford" (1989, 1). But this eviction is not based solely on the bottom line. It is clearly racially motivated as a mob awaits the departure of the grandparents from their home; they have been the last to hold out and thus the last to leave. Tyrone observes the crowd: "Clutching their Union Jacks, they thumped their chests as they chanted, 'Nigs out!' 'Schwartzers out!' We stopped close to the front door. The racists booed and held their flags high. My grandparents, dressed and waiting, had heard it all before. Those days would never return but they would always live in memory" (2). The police refuse to protect the Grainger family as they clutch their belongings on their way to the group home. One sergeant appeals to Tyrone's grandfather to calm down because he is, after all, old and should reconcile himself to that fact. He also points out about the crowd: "You may not like what they're saying but free speech is what we British are all about" (2).

This kind of free speech, however, reflects the overt nature of the

racism Tyrone's grandparents have endured since their arrival in Britain. His grandfather tells him of their struggles as newly arriving emigrants to Britain:

"Some white people was hostileish to us. . . . Nobody offer friendship after work, Dey eyes never smile. Only dey mouth make a little move. Dey is never welcomin'. No peace within. It better if you pretend you don't notice. One time we go on a visit to Southend. I tek Auntie Gracia two girl wid us. At de beach dey never see black children, so people stop dem and tek dey photograph. When we come back we have de whole carriage to ourself. Nobody come inside to sit down near by us. Only a parson come in and den a bend-foot man—you know, handicap—and his wife. So it was we, de parson wid his dog-collar and de bend-foot man and his wife in de carriage. Dey disable by God, we disable by colour and de priest by religion." (21)

Here, Tyrone's grandfather relates how he and his wife were made to feel like outsiders in Britain on the basis of their race, but the hostility they endured as West Indian immigrants is entrenched in English history and immigration policies, which, by the early 1960s, "made entry contingent upon employment" (Lindsay 1988, 180). Since West Indian immigrants were seen as a foreign labor force, they were not treated as equals within British society, but rather as descendants of slaves whose place it was to look after the base needs of the mother country. West Indian women in particular were treated as—to paraphrase Zora Neale Hurston—"the mules of the world," and as Linda Lindsay has written, given jobs "deemed too harsh for English women" (187). Lindsay, in comparing interracial relationships between Black men and white women and white men and Black women in Britain, also observes that Black women "continuously had to prove their adherence to western morality" (186) by avoiding interracial relationships and concentrating on their roles in the workplace. Gilroy's novel unearths the racial prejudice commonly suffered by both Black men and Black women, but stresses, through the retelling of family history, the necessity of remembering these realities. Both of Tyrone's grandparents had made a point of giving him the gift of

their memories in order to open his eyes early to the racism he would have to confront in Britain for the remainder of his life.

The transferral of memory Gilroy depicts is in keeping with Patricia Hill Collins's concept of "othermothers" in that the relationship Tyrone enjoys with his grandparents provides him access to the past through their parenting. From his earliest days, Tyrone feels safe in the sanctuary of his grandparents' home. As he helps them to settle into their new dwelling, he recalls his childhood:

> When she met me from school and took me home to tea, I felt a deep pleasure. The colours of the fabrics piled up every-where in her rooms made me pretend I was in some rainbow country that I had conquered. Grandma would let me feel the silks, the satins, the cottons and the crêpes and she would tell me their names; and when Grandpa came in from the garden we would take tea together. (1989, 12)

He also remembers being protected by them when he encountered racism in the neighborhood streets. The same sergeant who had refused to disperse the crowd in front of his grandparents' home had harassed him as a twelve-year-old child, calling him names, and searching him for illegal substances in front of his non-Black friends. Tyrone's grandfather "took matters in hand and telephoned a representative of the West Indian Standing Conference. Together they visited the police station" (48), and the harassment came to an end. Faced with that same sergeant and the powerlessness of his grandparents as West Indians and as aged people, Tyrone wishes he could return the favor. Powerless himself, he can only watch as his grandparents are robbed of their dignity.

Tyrone's grandmother carries all of her important mementos with her to the group home, as she attempts to stay linked with the independent life she has been forced to abandon. Tyrone sees her there, "clutching her bag, which is stuffed like a pregnant capybara with her possessions." A seamstress by trade, her bag is filled with "thimbles of all sizes, pinking shears, scissors, tape-measures, boxes of pins, scraps of jewelry" (11), old coins from Guyana and dance shoes; she refuses to put her bag down, even for tea, for fear that she will lose her identity without those belong-ings. She insulates herself against the workers at the home who begrudge her this need for tangible remnants of her past and is silenced by their

reproaches. Tyrone remarks: "Her voice is her most personal possession but, like a tap that has been turned off, she has been silenced by the unyielding routine of things and she disappears into her room" (13).

Likewise, Tyrone's grandfather, a tailor, prizes the clothes he wears since he has made them himself, but in the home they begin to disappear. Tyrone discovers that the place is run to exploit its elderly inhabitants: their clothes and valuables are often taken and sold; those who have pensions have them confiscated or are charged for services (like baths), which they never receive (17–18). As soon as Tyrone reports these irregularities, the house matron attempts to prevent him from visiting his grandparents. His grandfather, meanwhile, has become as silent as his wife, with the loss of his autonomy, belongings, and pension. Tyrone tells us: "Grandpa's lucid language never failed to give me pleasure. He had his own diction, his own imagery and words flowed from him like water. Today I wonder where those words have gone" (20). Gilroy's portrayal of an elderly Afro-Caribbean couple in *Boy-Sandwich* emphasizes silence as a feature of her characters' responses to racial discrimination within their exile. Tyrone's grandparents are rendered mute in their marginalization, and the loss of their identities is deeply felt by their grandson. Tyrone says: "This place, where my grandparents are, will destroy what is left of their bodies and even dash their spirits into the ground and they will forget just who they are and what they were in their long span of years" (30).

Gilroy's protagonist in *Frangipani House,* Mama King, without a vital connection to her family or community, experiences life primarily through memory. She listens to the nurses as they work in the house and is brought back into the past by their "domestic sounds" and her feelings of separateness and isolation: "The film of memory unwound itself revealing moments of pleasure and other things dear to her" (1986, 6). Mama King remembers her youth and the boys who courted her. She remembers her husband Danny, who had deserted her before the birth of her second child. She remembers how Token fell in love with a man who repeated the past, leaving her stranded in the United States with two children, and she remembers Cyclette's loss of a son to drowning. At the moment of her ultimate loss of contact with those she has loved, Mama King is left to remember only a life of losses. She is trapped at Frangipani House and wishes for the independence she once knew: "More than anything else she wanted work. She always had a special relationship with

work. Her body needed it as it needed food and clothes. And now, time and life, her daughters and the matron had all conspired to deprive her of her faithful friends, work and hardship. She felt as though they had punched and kicked her and given her many terrible blows" (19). But it is not until Mama King suffers punches, kicks, and blows from strangers that her extended family takes on its responsibility for the quality of her life in old age. Until then, Mama King is defined and defines herself in terms of the work that has taken the place of family.

Faced only with the prospect of her death, Mama King decides to flee from the home. Afraid of what changes may have occurred outside Frangipani House since she came to live there, she nonetheless searches for all possible means of escape (55). She eventually decides to wait for the visit of beggars to the home—mostly children—and leave among their numbers. The beggars keep her and accept her in their community even though they have little means with which to take care of one more member. Mama King makes some money by reading hands at the market and is soon robbed by two young men who see her buying a bottle of mauby. They target her as a beggar, as a poor woman, and with no compassion for the frailty of age, they beat her without realizing that she has no other money in her pockets.

Comatose in a hospital, Mama King is reclaimed by the caretakers at Frangipani House, who are at pains to explain to her daughters how they could have lost her in the first place. But even though Cyclette and Token have almost lost their mother, they still struggle to take on the responsibility for her care. Neither daughter wants to accept that Mama King's identity is one with Guyana and the independence she fostered there all of her life. In the hospital room, while Mama King's breathing "asserted her right to the life that had always been her own," Token resists the implications of that right and says: "'I am going back to where I am—to where the life that is mine exists. This place is the past—the painful past.'" Cyclette adds: "'There is nothing here for me either. . . . 'Nothing, nothing. Just pain and hatred of poverty, hardship and useless mud and dung, pain, mosquitoes and old age'" (98). Unable to face their roots, they abandon their mother to her fate.

In *Boy-Sandwich,* Tyrone is unable to separate his own experiences with marginalization from that of his grandparents. After reporting "The Birches" for its abuse of the elders in its care, Tyrone understands that the matron is involved in the irregularities he has observed, because she

actively abuses the differences of race and age to oppress his grandparents and to hold on to her power over the inhabitants of the home. Tyrone says then: "I consider this woman. She does not acknowledge difference. To be different is to fail. She makes a political stew of every little thing" (25). He refuses to be intimidated by her and asserts his right to visit during the set hours. The self-esteem his grandparents have imbued in him provide him with the confidence to defy the matron. But beyond "The Birches," Tyrone continues to contend with racism. His girlfriend, Adijah, is caught in a fire motivated by racial hatred. Tyrone is set reeling by the realization of the intensity of this hate crime:

> I had glimpsed their hard, eager faces as they watched the ordeal of these people who to them were unbelonging and had to be destroyed. I ask myself again and again, why, nearly forty years after the coming of my grandparents to this land that was the source of their beliefs about life and civilised living, people burn others, deny others' capacity to feel and applaud their terror and their death. (76)

A return to Guyana becomes the only source of hope for relief from such hatred in Britain.

Ironically, the discovery of a painting by a famous Spanish colonizer among Tyrone's grandparents' belongings finances the return of the family to Guyana. To Tyrone's delight, his grandparents are transformed by the return to their homeland. He notes: "What a contrast they are to the fumbling, confused couple that resided at The Birches. They have found other strands of security. They have come home" (104). Tyrone, however, soon discovers that *he* has not come home; the return to Guyana has not solved his problems with an identity that fluctuates between assimilation and otherness.

The exile in which Tyrone has lived in Britain is a central component of his identity. He says:

> Within myself I feel the resonance of some unspoken need. It isn't my desire to read or my love of books; nor do I miss the press and indifference of people. I conclude that it is my need for anonymity. In London I am of no particular importance to anyone. I am unknown except to my family and friends. . . .

> In Picktown I am trapped—in my family identity, the identity
> of community and the identity of my opportunity. In London
> I have lived another life, grown other feelings. . . . I know
> how and where I am vulnerable. I understand my difference.
> (110)

Unable to reconcile his life as a displaced West Indian with the possibility
of reconstituting his identity in the harbor of his original home country
and community, Tyrone chooses to live again in exile. In this choice,
Tyrone realizes that the exile he has felt in Britain is due to the racism he
has endured there rather than alienation from his Guyanese ancestry; he
has benefited from growing up with his grandparents and parents at his
side. His challenge, then, is to bring together the lessons his elders have
taught him with an awareness of the ways in which exile from his home-
land have shaped his identity.

In contradistinction, Mama King's grandchildren have never known
her. Their lives have been led at a distance and they have never had the
chance to absorb her memories and life experiences. In the end, it is her
grandchildren who choose to cherish Mama King, for they realize that
she holds the key to their erased West Indian identities. For Chuck and
Cindy, Token's son-in-law and daughter, alienation from their grand-
mother is made synonymous with the alienation they feel from their
Afro-Caribbean roots. At the same time that their parents abandon
Mama King in the hospital, Chuck and Cindy dedicate themselves to
overseeing her recovery: "Each day they visited her in the hospital and
found her a mine of information and fun" (101). They adopt her and
hope to bring her back with them to the United States, where Cindy
plans to give birth to her child. Fate brings a twist to their plans, as
Chuck and Cindy's twins are born in Mama King's house under the care
of a midwife. At the end of this novel, the alienation of age has been
repaired as three generations of Mama King's family are gathered to-
gether under one roof.

Frangipani House and *Boy-Sandwich* are hopeful novels. In each,
Beryl Gilroy remedies the alienation confronted by her elderly Black char-
acters by depicting younger members of the Afro-Caribbean community
in exile as receptive to both knowledge and acceptance of their elders. In
reality, such an embracement of grandparents as a connection to the past,
to the recuperation of Caribbean identity, is more often than not impos-

sible. It has been difficult, in my own case, to reestablish vital links to my heritage. What memories have been shared with me of my familial past are few and narrow.

For instance, I have known for years that there is a link between my father's family and that of Toussaint L'Ouverture. It is not often spoken about, yet is affirmed without ceremony. Surely there is some pride invested in passing down this remnant of a link to what is often historicized as the first successful slave revolt in the New World. Toussaint became a hero of that revolution, which liberated (superficially) Haiti from French domination in 1804. In 1988, proof finally appeared in our mailbox in the form of a photocopied article from a Haitian newspaper,[8] in which the descendants of Toussaint were enumerated. There are in fact no direct descendants of Toussaint: he had two sons who had no children of their own, and thus genealogists trace his primary descendants through his siblings. I was finally able to see how the past is so often restructured in order to highlight patriarchal descent over matriarchal descent. My connection to the sacred memory of Toussaint is through his sister, Geneviève Affiba. The historical record that remains of Geneviève states only that she was bought as a slave by a Monsieur de la Fontaine and that she then gave birth to nine sons and three daughters as the concubine of another French colonist whose name I now bear. Nothing else is known. There is no record of her involvement in the revolution in the early nineteenth century, no record of her means of subsistence other than her title of "concubine." Although I am *her* descendant, she is remembered only as a *link* to Toussaint: her own existence erased in favor of the visibly heroic. Perhaps she had sewn Toussaint's tunic as he headed off to war. Perhaps her own children, young but fearless, had joined their uncle on the battlefields for a new Haiti. Her mark, and that of other women, on the revolution is lost, as are most of the mundane, everyday revolutionary acts committed by women as a way of life and survival.

Growing up, I had only one living grandmother, and the things she could teach me were lost in the ocean that separates us. Survival in this New World demands that we leave each other behind again and again in order to escape endless cycles of missed opportunities in the Caribbean. History has kept us from knowing each other fully as Black women and as survivors. As Beryl Gilroy demonstrates, this is a connection to be weighed against the necessity of emigration.

Without tangible connections to our community elders, and in light

of the paucity of historical records pertaining to the lost cultures of en-
slaved peoples and especially of enslaved women, it seems that recuperat-
ing a sense of our cultural roots as Afro-Caribbean women is seriously at
risk. This recuperation can only come about by our arming ourselves
with the knowledge of Black women's history under imperialism and co-
lonialism.

What is clear in the narratives I have analyzed is that the absence of
intergenerational bonds contributes to the victimization of Black girls
and elderly Black women. This suggests that the *presence* of intergenera-
tional connections would work toward the preservation and appreciation
of cultural markers that are denigrated by mainstream society and thus
toward the validation of the elders and the building of positive self-
images for the youth in Black communities. Since, for Anglophone Ca-
ribbean women writers, Britain is considered the "fatherland," which has
imposed its language, its racist ideologies of white superiority and African
degeneracy, its systemic exploitation and marginalization of immigrant
Caribbean workers, it is striking that Afro-Caribbean women writers who
have written from within the very center that oppresses them have been
able to do so with a critical eye. In their works, it is apparent that Britain
holds them captive due to the imperial history that binds the displaced
African cultures and the colonizing British cultures together in an uneasy
hegemonic relationship. And yet, they have not been fascinated by that
center, rather, they are critical of it to the extent that, without denying
the economic factors that have brought West Indians to the European
continent, they continue to regard their Caribbean nation–states as
"home." The "return," for these characters, is thus not back to Africa,
but to the African roots of Caribbeanness.

In the homeplace imaged by Afro-Caribbean women in Britain
(which for some of their characters remains actualizable only in the imag-
ination), the elderly Black woman holds a place of much importance, for
she holds the key to that buried past, to the heritage that young Black
girls will need to overcome or avoid their victimization in societies that
have not yet learned the lessons of their own history books, that is, that
the African woman is still (to paraphrase John Henrik Clarke) a symbol
of pure womanhood that must be treasured. Following in these foot-
steps, Afro-Caribbean women writers exiled in Canada (another British
culture in the Americas) have sought out and recorded the histories of
Black elderly women in an effort to demonstrate that our past is alive and

with us, if only we would care enough to open our eyes and ears. In the following chapter, then, I show how writers such as Dionne Brand and M. Nourbese Philip have foregrounded the lives of elderly and ancestral Black women at the same time that they have more closely challenged the very means by which this knowledge has come to be recorded, through visual media (film and photography) and language itself.

Three

"Good Enough to Work, Good Enough to Stay"

M. Nourbese Philip, Dionne Brand,
and Makeda Silvera and Women's Dignity in
Canadian Exile

"La Survivance": Surviving the Rigors of Canada

Given the obscured history of Black people's experiences with racism and discrimination in Canada, it is not surprising to find that Afro-Caribbean women writers exiled there would deal in their various works with issues of racial and sexist oppression as well as with the silence that surrounds such oppression. This silence is made all the more difficult to disrupt in that, unlike Afro-Caribbean writers in Britain, displaced Afro-Caribbean writers in Canada must negotiate over finding themselves in a country that in many ways replicates the mores of its founding nations (Britain and France), while, at the same time, it counterasserts an "American" identity bent on distinguishing itself from those nations as far more liberatory and inclusive in its politics. Such a counter-identity makes the assertion of one's alienated identity far more difficult, because Canadian society presents itself as a safe harbor from the kinds of alienation suffered both in Europe by those oppressed or marginalized by virtue of their class status or religious convictions and in those nations colonized by European powers. The presence of continued dispossession and alienation is thereby obscured by the rhetoric of New World civilities, which are said to incorporate rather than annihilate difference. Consequently,

Afro-Caribbean women writers exiled in Canada have taken to task that very liberal humanist discourse, the underpinnings of everyday language itself, in order to convey effectively the impact of the North–South relationship on Caribbean economic solvency. Dionne Brand, M. Nourbese Philip, and Makeda Silvera call in question, in particular, the use of imposed European languages (in this case, English) to communicate Black women's resistance to their commodification and forced assimilation in Canadian society. Some of this interrogation takes place at the level of honoring and preserving oral history in the medium of documentary film for Dionne Brand and in sociological texts recording the histories of elderly women for both Brand and Silvera. Like their counterparts in Britain, then, these women underscore the importance of preserving the memory of elderly Black women and understanding the contexts (historical, social, cultural, and otherwise) in which they survived and, ultimately, lived. They extend the efforts of writers like Beryl Gilroy and Joan Riley by recuperating the threads of those lives and intertwining those histories with those of younger generations, particularly through the understanding of their own experience with exile and its attendant alienation. Along with the poetry of M. Nourbese Philip, which moves us toward a vigorous re-evaluation of the very terms of our existence and the ways in which we make our existence intelligible linguistically, Brand's and Silvera's works serve to add a building block to the road toward home. Theirs is a vision of recuperation by which the true-life conditions of Afro-Caribbean women in Canada are truthfully laid bare and possessed as a tool of affirmation. Moving beyond the concept of alienation in a foreign land, then, Brand, Nourbese Philip, and Silvera argue for a more accurate rendering of the ways in which Canada replicates imperial ideology in its historical treatment of people of color and Afro-Caribbean women in particular. They negotiate that neocolonialism through oral history and challenge the veneer of liberal humanism, which shields Canadian consciousness from acknowledging its role in North–South exploitation dynamics, by revealing their own Afro-Caribbean feminist consciousness and its calls for the preservation of a productive difference along the lines of race, sex, sexuality, and class not only in Canadian society but also in displaced Afro-Caribbean communities themselves.

Canada has for many decades enjoyed a reputation for a generosity and political neutrality said to be unparalleled in the Western hemisphere. As a nation, Canada is widely considered an unthreatening military

power, a harbor for those seeking refuge from around the world, and, above all, a place free of the racism associated with its mother country, England, or with its neighbor to the south, the United States of America. It is this vision of Canada, actively advertised by the Canadian government Bureau of Multiculturalism on the Canadian Broadcasting Corporation (CBC), which Afro-Caribbean women writers seek to put into question. Communal diversity and tolerance are touted as Canada's trump cards, differentiating it from the United States and other leading First World countries as a place where true democracy (including socialist practices such as a comprehensive national health care system) has taken root and flourished. History of the unofficial variety, however, reveals a much different picture.

When in school, my Canadian history books concentrated on the early formation of Canada as a nation. The only mention of minorities centered on the struggles of the Acadians, of the Métis—with Louis Riel as hero[1]—and later, of the arrival of African slaves from the United States by way of the "Underground Railroad." These texts presented Canadian students with a happy ending, that immigrant subgroups were accommodated, subsequent to their historical struggles for equality, within the Canadian mainstream. I was surprised, then, having finished my formal education in Manitoba and finding myself in Nova Scotia at age nineteen, to discover that the Black population in Halifax, clustered in the economically depressed Northeast End, was not an extension of the Black population in the United States, but was composed of descendants of the very first immigrants to arrive in Canada.

In her 1991 essay, "Institutionalized Racism and Canadian History," Adrienne Shadd clarifies this forgotten point of history. She writes: "10% of the Loyalists who migrated to British North America after the American Revolution were Black. Their descendants, particularly in the Maritimes, have been living in quasi-segregated communities for over 200 years" (3). Initially, these communities were self-supporting and self-defined by the Black community: in Nova Scotia, on the outskirts of Halifax, Black Canadians formed a settlement known as Africville. It was later destroyed when the Nova Scotian government decided to move the community into a segregated section of Halifax in order, primarily, to obtain their land for business developments on the waterfront, without recognizing their legal ownership of the land on which they had lived for several generations with reasonable compensation.

Today, very little of the history of these settlements remains and even less remains of Black women's presence in Canada in its early days as a nation. Shadd corrects this latter oversight in her essay: "Standard textbooks never mention that, in 1734, part of the city of Montreal was burned down by Marie-Josèphe Angélique, a black female slave, when she learned of her impending sale by her slave mistress. Most Canadians are not even aware that slavery existed in this country" (1991, 3). As a colony, Canada shared the laws of its mother country, England, which owned most of Canada after the Seven Years War (1756–1763) and did not abolish slavery until 1839. The "forgotten" story of Marie-Josèphe Angélique not only contributes to the dissimulation over Canada's historical participation in slavery, but also over the fact that the activism of Black women in Canada has a lengthy history. In truth, the first newspaperwoman in Canada was a Black woman, Mary Ann Shadd, an editor for the *Provincial Freeman* of Toronto from 1853 to 1859 (Shadd 1991, 3; Thornhill 1983, 81). The presence of Black people in Canada has been manipulated to such a degree that historical facts such as these have been left out of mainstream historical texts and what has been rendered is a vision of Canada as the ultimate safe space in which visible minorities could survive and even flourish. Thus, when people of African descent began to emigrate from the Caribbean, it has generally been assumed that, like their African American counterparts, they were able to lead better lives in Canada than in their home islands.

Mainstream history does not reveal, however, that African Americans were not treated with decency and humanity upon their entry into Canada during the slave era. Many "fugitives from slavery [who] had settled in southwestern Ontario returned to the U.S. after Emancipation was proclaimed in the U.S. in 1867," writes Dionne Brand in *No Burden to Carry* (1991a, 158). Although this return can be attributed in large part to the fact that the fugitives had been forced to leave their place of birth and that Emancipation brought with it the hope of reuniting Black families, it is also true that many may have preferred to face racism with those families than endure the same injustices in a foreign country. Following Emancipation, when new groups of African American immigrants "lured by Canadian government advertisements in their local newspapers," entered Canada to homestead (Shepard 1991, 17), Canadian racism was in plain evidence in the press of the day: "Blacks were the butt of jokes and cartoons which regularly appeared in western journals. Blacks were also

negatively pictured in numerous advertisements. Minstrel shows were very popular at the time, and were frequently advertised" (18). In addition, the immigration of Black families was seen as a threat to Canada's peace—they could only bring crime and a decline in "quality of life," thought those white Canadians who complained to immigration authorities (25). As a result of these complaints, an immigration order was passed in 1911, barring "any immigrants belonging to the Negro race"—this was the first time in Canadian history that a racially designated group had been barred (30, 31); the order was repealed a few months later. In that same year, the first wave of domestic workers from the Caribbean arrived in Québec.

Recent efforts by Black scholars in Canada have revealed that Caribbean immigrants—predominantly women—suffered various abuses under what was then known as the Canadian Immigration Bureau's "Domestic Scheme." But to understand the far-reaching implications of the racism and sexism explicit in that Domestic Scheme, it is necessary to remember that the insidious presence of racism in Canada predates the anti-Black racism of the late nineteenth and early twentieth century. In her essay "Racism Runs Through Canadian Society," published initially in the *Winnipeg Free Press,* Aboriginal writer and poet Emma Larocque decries the reduction of discussions about racism in Canada to what she calls the "black–white conflict," which ignores the fact that "stereotypes have an important function in the maintenance of racism. Between 1500 and 1800 A.D., the stereotype of Indians as savage served to justify the dispossession of Indian lands." She states that these early stereotypes shape today's power inequity between the government of Canada and the Aboriginal people who are still seeking self-government and a share in the molding of Canada's future (1991, 74).

Canada's Aboriginal community remains a vocal and active force battling racism. This was made clear in June 1990 when Manitoba representative Elijah Harper, in the legislative court, blocked passage of the Meech Lake Accord, which would have granted Québec's Francophone community broader political rights like those First Nations people had demanded since the settling of North America. Preventing passage of the accord was a measure toward ensuring that the Canadian government took up its responsibility for its Aboriginal population by working to guarantee their long-denied rights. As Harper states:

We're not some savages who are not to be treated well. . . .
We need to be recognized for the great contribution we've
made to this country. We shared our land and resources with
those who came here; we cared about these people. But we're
not recognized in the Canadian Constitution. We're not even
mentioned in the supreme law of this land. I cannot fathom
the mentality that exists in this country, that might is right.
(quoted in Davies 1990, 50)

"Might is right" is a phrase more closely associated today with U.S. inter-
vention in the politics of Third World countries, but Canada's treatment
of its Aboriginal population demonstrates a similar and basic disrespect
for minority rights. One might say that the oppression of the First Na-
tions people is as emblematic of Canada as the Maple Leaf.

Racism in Canada exists on many fronts. Beyond the deeply en-
trenched racism leveled against Aboriginals, early immigrants were sub-
ject to minority status and the governmentally sanctioned racism and
discriminatory practices that accompanied it. Jewish Canadians were pro-
tected under Canadian law in 1932 (Glickman 1991, 46) from socio-
political oppression, but the history of anti-Semitism in Canada is stark.
Catholics in Québec were at the forefront of religious persecution of
Jewish immigrants at the turn of the century, while "racialism," the belief
that races are biologically superior or inferior to one another, also served
to oppress Jews in English Canada. Yaacov Glickman cites S. A. Speisman
in stating that "during the 1920's, in Toronto and in other parts of Can-
ada, Jews were facing occupational discrimination, residential restrictions,
and quotas imposed on Jews seeking employment in the public school
system" (49). Anti-Semitism had increased after World War I, when Jew-
ish people sought to emigrate from Eastern Europe to Canada.

Immigration, in fact, appears to be a salient feature by which Cana-
dian racism surfaces transhistorically. Asian Canadians, too, from the time
they were "imported" (Creese 1991, 34) as indentured labor to build the
Canadian Pacific Railway, have been the object of unfair governmental
practices. "Restrictive immigration policies," Creese declares, "the denial
of the political franchise, and other legislation that discriminated against
Chinese in Canada were instrumental in entrenching lower wages and
restricted employment opportunities for Chinese workers" (35). Chinese

immigrants were not then seen as potential Canadian citizens but only as a stable source of cheap labor, while incoming African Americans were construed as lazy and criminal. Xenophobia and the remains of a racist, colonial mindset, reaching from one end of Canada to the other, worked in combination to maintain the disenfranchisement of large numbers of non-Anglo, non-French,[2] and nonwhite immigrants.

Exploiting new generations of immigrants continued with the "Domestic Scheme," which sought, over a hundred-year period, to compensate for the lack of European immigrants (Brand 1991a, 27) to the Americas (exacerbated at times to the First and Second World Wars) by allowing persons from the Caribbean to immigrate—but only to fill low-wage and domestic employment. In her essay, "Canada's Immigration Policy and Domestics from the Caribbean: The Second Domestic Scheme," Agnes Calliste charts the history of Black women's immigration from the Caribbean as domestic workers from 1910 to 1966. Calliste labels 1910 and 1911 as the period of the first Caribbean Domestic Scheme, when Guadeloupean women were brought to Québec as domestics (1989, 137). Although the first scheme was discontinued by the Canadian government, because "of rumours that some of the women were single parents" (137), the importation of Caribbean women was to continue intermittently to fill low-income and domestic positions deemed undesirable by the (white) resident Canadian community, ensuring also that Black women would fill only menial jobs.

Dionne Brand points out, in *No Burden to Carry*, that after World War II, Black Canadian women who had found employment in war-related industries "were reluctant to go back to domestic work," while Afro-Caribbean women, "fleeing the bust of Caribbean economies in the 1950's, . . . came to Canada to fill the shortages of domestic workers" (1991a, 27). Afro-Caribbean women were therefore targeted by immigration policies to replace the Black labor force already present in Canada but no longer willing to take menial employment after working in the war industries. Indigenous Black Canadians would thus be compelled to compete for jobs they no longer wanted or be forced out of the labor market altogether. Calliste also points out that Canada had "more trading and investment interests in the Caribbean than in any other Third World country" (1989, 140) after World War II, making its targeting of a Black labor force for immigration that much easier.

Canada's "investment interests" included what I can only term a "commodification" of Black women—a covert, modern equivalent to the historical enslavement of Africans—whose importation was a by-product of Canada's neocolonization of the region. This commodification took place *with* the participation of the Caribbean governments. The motives of these governments may have been to better the image of Caribbean workers abroad, as Calliste suggests (for the governments did participate in screening those women who were to emigrate), but the Canadian government's scheme was clearly based on racist stereotypes of Afro-Caribbean women and Black women generally (143). Since Black women had been forced to take care of white children or to clean up after white families for hundreds of years, the Canadian government appeared to believe that such jobs were a natural extension of Black women's lives upon which to capitalize. As a result, Afro-Caribbean emigrants who entered Canada under the Domestic Scheme "were to be young (ages 21 to 35), single and without children" to encourage their dependence on their Canadian employers (137) and, certainly, to ensure that they would not bring family members into Canada who, it was presumed, might become burdens to the state. Black women were therefore divorced from their families, and the scheme contributed to their cultural and racial alienation not only from mainstream Canadian life, but also from each other.

Afro-Caribbean women writers in Canada have sought to repair this alienation by preserving Black women's attempts to break out of their isolation and move toward self-definition in their writings. In so doing, they follow in the footsteps of Black Canadian women, such as Marie-Josèphe Angélique and Mary Ann Shadd, who faced great odds in their own lifetimes but succeeded in affirming their rights as women of African descent to end their oppression and that of other Black people in Canada. Their dedication to addressing the issues that face Black women in Canada today takes shape in activist work combined with their fiction and poetry. I discuss the works of Makeda Silvera, Dionne Brand, and M. Nourbese Philip in terms of their use of diverse media to make visible the lives of Afro-Caribbean women. Their efforts as Black feminist artists are not limited to literary texts only but are also directed to the creation of an Afro-Caribbean diasporic feminist context for their fiction, poetry, essays, and films, all of which have their roots in oral narratives.

Valuing Oral History as Methodology

In her documentary films, Dionne Brand underscores the necessity for communal cohesion in and among Afro-Caribbean women and among women generally in the Canadian context. Her films exemplify the ways in which we might potentially defy barriers of race, class, sexuality, and nationality among ourselves through their presentation of candid interviews with Black women that reveal their struggles against multiple oppression in this alien landscape. Brand seeks, as she does in *No Burden to Carry*, to preserve the marginalized histories of Black women in Canada as well as those of Black women in the Caribbean at the same time she inserts her own life experiences in the public record. For Brand, it is clear that the personal, the political, and the historical are inextricably linked. She says:

> I believe that history, and the history of the people that I come from, is important, and that it is important to rewrite that history in a way that saves our humanity. Black people and women have to make their humanity every goddamned day, because every day we are faced with the unmaking of us. Sometimes any words I throw at this feel like pebbles. But the purpose in throwing them is to keep, to save, my humanity, and that is my responsibility. And also as a woman, as a lesbian, I have to redeem my life every day, in a society that thinks I should lead an existence that's second class. Every day I get to say, no way. (Daurio interview 1990, 14)

In her films, *Older, Stronger, Wiser* and *Sisters in the Struggle*, Brand does just this by providing other Black women with a forum to declare their experiences of oppression and to be heard by a wide public.

Older, Stronger, Wiser (1989) is a short film, which showcases the lives of five Black women in Ontario. Each of these women has had to survive by working in various jobs, from domestic work, to farming, to politics. They have striven to better the lives of younger generations of Black women by involving themselves in the struggle for Black rights in Canada and creating opportunities for change. Says Brand, in her narration, "If labor outside the home took the measure of these women's lives, leadership in the community was imperative." Grace, one of the women inter-

viewed for the film, survived in the 1940s by farming with her husband and in her later years became involved in politics as a union activist with the New Democratic Party (NDP). Grace explains her involvement thus: "The working man needs all the help he can get 'cause he's carrying this country." Her statement takes into account the struggles of all working-class people, but in particular the struggles of her husband, a former porter on the Canadian National Railroad, and of her own, a former domestic worker who, unemployed, pounded the pavement in Metro Toronto during the Depression in the face of overt racism.

Brand interviews one of the first female ministers in Canada who devoted her life to a small Black church in an effort to preserve a sense of spiritual life for the beleaguered community. She also interviews Gwen Johnson who, with her husband, has owned and operated the Third World Bookstore in downtown Toronto since the 1960s. Gwen describes her own experience with education in Canada, "When we were going to school, here in Canada, there was nothing. We didn't come across any Black books until we were in our late teens, early twenties, really. . . . It's very important that our children, our young people, be introduced to their history and culture, which was lost to us for so long." The Johnsons' bookstore attempts to fill the gap between the Euro-centered history and literature taught in Canadian schools and the history and literature of people of African descent, which remains at best marginalized, and at worst, erased from formal education. Brand turns her camera eye on a middle-aged educator who is attempting to instill pride and self-knowledge in the lives of her young, Black students. She tells all of them: "When you go walking down the corridor, you are a Black child. They don't stop to ask whether you are in 'Advanced' [classes], whether you're from Jamaica, whether you're from Trinidad, or whether you are a Canadian. You are all in the same boat. Therefore, what hurt one of us, hurt all of us." Of course, this Black woman speaks to the blindness of Canadian racism, which erases the particularities of each Black child's identity and, in so doing, destroys the self-esteem of those children in a way that separates them from one another and from the possibility of coming together to work against institutionalized racism. Her object—as is Brand's—is to instill in these young Black children a sense of their interconnectedness as people of African descent, among whom many are first-generation emigrants to Canada from the Caribbean. In doing so, she builds community in and among them that does not, in fact, erase their

distinct heritages, as Canadian society does, but uses those heritages as building blocks toward social cohesion.

In bringing together these women's voices in her film, Brand makes a similar statement: she points out that each Black woman featured has had to overcome similar struggles with racism and sexism and provides them the access, formerly denied them, to the means of communicating their individually distinct life stories, through print and audiovisual media, and of making those points of connection visible and politically viable. Furthermore, her efforts in bringing together various Black women's voices demonstrate that, as a filmmaker, Brand is attempting to remove herself from the margins of the Canada Film Board and making central her identity and that of other Black Canadian women, whether they are immigrants or were born in Canada.[3]

Dionne Brand's first film had a great impact in Black Canadian communities, as I noted when I attended a special screening of *Older, Stronger, Wiser* in Halifax, Nova Scotia in 1990. After Brand's brief introduction, a packed room of predominantly Black Haligonians viewed the film.[4] I was surprised that so many of us had gathered to see a short film, a documentary at that, and that three generations of Nova Scotians were in attendance—the elderly, the middle-aged, the very young. As the film played, I heard many sighs of recognition, saw nods of approval, and the absorption of the engaged. I sat at the back of the room, not wanting to be too close to the screen in order to avoid showing disappointment, if I should feel any. But I was far from being disappointed and observed both the success of Brand's vision of rewriting history with our own words and the eagerness of the audience members to share their own experiences with Brand as well as with one another following the screening. Some women in the audience spoke of how they found the images of the Black women on the screen representative of their own life experiences; women behind me and in front of me leaned toward younger women and children to say, "Yes, I was in service and that was how it was." The experience for me was overwhelming.

The screening was held in the main room of the North End's public library, and, for the first time, I found myself among others like myself whose lives had been erased from the classes being taught only a few bus stops away at the second-oldest university in the nation, Dalhousie. Although I felt that I was intruding on a community evening, that, as a young, first-generation immigrant, I was not "home," something happened that night in my viewing of the film and of its audience, which

conveyed to me the possibility of being an important part of this submerged community, albeit still a visitor or an outsider—I could go on in my everyday struggles with the knowledge that my road had been walked before by other Black women whose own determination had made that road easier to travel.

I was surprised to find out, years later, when reading "Bread Out of Stone" (1990a), that the story behind the making of Brand's film was as heartbreaking as the Black women's stories she showcased. She writes in this essay of editing her film, "By now it's going on three years and it is actually torture, and I ask myself why did I start all this at all. Something about recovering history, history only important to me and women like me, so I couldn't just drop it, no matter how long it took" (45). Of course, I should not have been surprised.

Brand's essay recounts the arduous process of turning the oral histories of Black women into a film and of how affected she was by her experiences with racism/sexism and with the homophobia that surrounded her as she brought the film into being. She remembers being asked by a white woman whether she thought of herself as "Black or woman," as if for a Black woman, the two identities could be separable. Brand says, "She asks me this because she only sees my skin, my race and not my sex. She asks me this because she sees her sex and takes her race as normal. On the Playas del Este, near Guanabo, I bend closely to edit the oral histories of older Black women as I remember this encounter. I put the sun outside at the back of my head" (1990a, 46). Such memories compel Brand to set herself to the task of preserving the history of Black women who before her would have been asked the same or similar questions, or, who would not have been asked but would nonetheless be made to abandon one identity for the other, as they were exploited in function of both their race and sex. As she goes about her work as an oral historian, writer, and poet, her efforts are continual undermined by mainstream critics who cannot fathom the necessity of a Black woman's making her racial and sexual identity central to her art. Says Brand, "An interviewer on the CBC asks me: Isn't it a burden to have to write about being Black? What else would I write about? What would be more important? Since these things are inseparable, and since I do not wish to be separated from them, I own them and take on the responsibility of defending them. I have a choice in this" (47). Brand chooses to foreground her life and the lives of Black women.

Brand's essay poignantly describes the choices that face a variety of

Afro-Caribbean women in Canada struggling to affirm their own identities against the usual racial and sexist stereotypes that dominate their existence. She describes the resistance she encounters in areas where Black people, and Black women in particular, have been told they have no right to create a revolution, especially out of words and strips of film. Black women in Canada are continually told, as has been my experience as well, that they have no right to their own voices at the same time they are forced to survive by making the world habitable for others as cleaning women, child caretakers, office workers, cooks, and so on. For Brand, *Older, Stronger, Wiser* is a visionary film—she has dreamed its existence:

> I'm working on a film. It is a film about women in my community. I've dreamt this film as a book, dreamt it as a face, dreamt it at a window. I am editing it on the Playas del Este; a woman's face, old and a little tired, deep brown and black, creased with everything that can be lived, and calm, a woman's face that will fade if I do not dream it, write it, put it in a film. I write it, try to make everyone else dream it, too; if they dream it, they will know something more, love this woman's face, this woman I will become, this woman they will become. I will sacrifice something for this dream: safety. (1990a, 47–48)

The identity of the filmmaker is always a component of the film made: Brand is aware that through the film she will make a statement about her own identity and its political implications.

As a lesbian, as a feminist, Brand recognizes—for she is made to feel it—that she is exiled from her coworkers, from other Black women, from Black men, from non-Black women, whose lives she could touch with the words of elderly Black women in Canada. Her identity is rendered suspect through homophobia:

> To dream about a woman, even an old woman, is dangerous; to dream about a Black woman, even an old Black woman, is dangerous even in a Black dream, an old dream, a Black woman's dream, even a dream where you are the dreamer. Even in a Black dream, where I, too, am a dreamer, a lesbian

is suspect; a woman is suspect even to other women, especially if she dreams of women. (48)

This "suspicion" has two components: first, Brand is suspect simply because she is a woman making a film about women. "Women are taught to abandon each other to the suffering of their sex, most of all Black women who have the hard white world in front of us so much the tyranny of sex is a small price, or so we think," writes Brand (48). For the Black woman, survival in a world that places our race before our sex while exploiting both often results in the decay of bonds between us: as women, we do not trust each other because we are told daily to pretend that we have no sex, or that we are "superwomen," or that being Black means that we can only hold allegiances to Black men who (we are told) are far more oppressed than we are as (Black) women. Second, homophobia surfaces from this divisive distrust. Brand continues: "To prove that they are good women the conversation singes the borders of lesbian hate . . . plays at the burned edges, firing each other to the one point of unity between Black and white women—fear, contempt for women who love women" (49). Taught to fear each other, the women Brand describes form bridges out of contempt. Brand, like Lorde in her "The Uses of Anger," suggests that bridges can alternatively be built out of understanding for the dis-similarities in our lives, as each of us struggles to survive in the face of a mysogynistic, racist, and homophobic patriarchal world order. By recuperating the lives of the Black women who created the paths on which we now wander, by affirming the experiences of our own individual travels, and by working together to define our own identities, we move closer to the bridge that will take us home. In this process, we enact the principles of Afro-Caribbean diasporic feminism in paying attention to those markers of status (race, sex, class, sexuality, and so on), which delimit the quality of our existence in this world, and move more swiftly toward a transformative progress that will better the condition of Black women's lives and of all others concurrently. By focusing on our personal existence and politicizing the parameters of that existence, we actively transform the terms of our exile and bring our alienation to an end.

The elderly women Brand interviews know that the necessity of asserting the relationship between the personal and the political is tantamount to securing the quality of Black women's survival in Canada. Ac-

cording to Brand, "These old women need us to do something different, that is why they're telling us this story. This story is not an object of art, they did not live some huge mistake, they are not old and cute and useless, they're showing us the art of something, and it is not perfect, and they know it. They do not want us to repeat it" (49). Brand's film sets out to preserve the lessons of the past for her generation and those to come. But, in addition to making this link, by preserving the voices of Black women all too often forgotten even in Black history, Brand takes a Black feminist stance about the importance of making visible the intersection of race and sex discrimination. The exposure of the exploitation of Black women is not presented here as a metaphor for the "rape of Africa," but as a reflection of reality. In so doing, Brand inserts her own identity into the film by refusing to deny her love of women—Black women—who have endured every imaginable indignity. For, at the risk of proclaiming a utopian idealism, it must be said that it is love that will heal the wounds of our dispossession. Only love has the strength to overcome the tyranny of the continued forces of colonialism.

Although lesbianism is not an explicit issue exposed in her first film, it is in her second, *Sisters in the Struggle* (1991b),which demonstrates the importance of making connections among ourselves, across differences of sexuality, class, and nationality. Says Brand, "I am a woman and a Black and lesbian, the evidence of this is inescapable and interesting" (1990a, 51). In the second film, Brand presents interviews with numerous Afro-Caribbean and Black Canadian women speaking on the subject of their personal experiences of articulating and positioning themselves within Black feminist identities. Rosemary Brown, who emigrated as a young woman in 1950 from Jamaica to Canada, speaks of her politicization in the context of the U.S. civil rights movement:

> [The] connection between myself as a Black person having to deal with racism and myself as a woman having to deal with sexism [came] largely through following the statements of Black men involved in the civil rights movement. . . . Stokely Carmichael . . . people like that who made comments about Black women's role as being simply there to serve really jolted me because I knew we had an important place to play in the struggle for equality as Black people. And then to realize that even after that's won, we still have to deal with an unequal

status within the Black community as a woman was a jolt for me. . . . Feminism helped me to understand that the things that were happening to me weren't just happening to me . . . we're socialized, even before birth . . . to run this race which we could never win under any circumstances and . . . women, not just here, but everywhere, in their own cultures, were confronting the same thing—this incredible no-win situation. (1991b)

With that awareness, Brown involved herself in politics to better the socioeconomic conditions of Black women. She worked to make the issue of Black women's oppression central to Black Canadian organizations such as the National Black Coalition and the Negro Women's Organization of Ontario.

In 1972, Brown decided to run for office in the province of British Columbia on the New Democratic Party (NDP) ticket. She says of this decision in her memoir, *Being Brown,* that she and her husband "had a good chuckle over that at home that evening, because we knew that no Vancouver riding would choose a person who was Black, female and an immigrant to be its elected representative" (1989, 93). Spurred on by her own experiences with racism and sexism and those she observed in her community, Brown became the first Black woman ever to be elected in a Canadian provincial election, and, along with one other candidate headed for a post in the NDP provincial government, turned the page in British Columbian politics, where a Black person had not been elected for any public office since 1858 (115–116, 120).

Sisters in the Struggle celebrates the voices of a number of Black women who have entered politics or who have become activists in response to the racism, sexism, and homophobia they have encountered in Canada. Women of the Black Women's Collective speak of the danger of asserting their multiple identities, and in particular their lesbian identities, in much the same way as Brand does in her essay, "Bread Out of Stone." One member, Angela Robertson, states: "organizing yourself as a Black woman and labelling yourself a feminist you put yourself in the position of being isolated and being labelled as lesbian and, usually, lesbianism is seen as something derogatory because once you're labelled as lesbian [by Black men and by Black, heterosexual women] your difference has no political validity" (1991b). Another member continues, "I happen to be

a lesbian, so what am I going to do—deny that part so that I can work within the Black community?" (1991b) Simply put, there is no possibility of advancing equality in society for Black women if our identities are separated out, or racial identity is made to dominate other points of oppression. Says one member, Grace Channer:

> The Black community experiences serious oppression, but if we don't recognize the full extent of what that oppression is—which isn't just the colour of our skin, it *is* our sexuality, it *is* our gender, it's all of those things—we're never going to really have a cohesive forum that is . . . going to eradicate all those things [racism, sexism, homophobia, classism, ageism] which we are all here to eradicate. (1991b)

Sisters in the Struggle presents viewers with the collective voices of women who experience multiple oppressions and who, in experiencing those marginalizations, recognize that prejudice must be battled on more than one front. Though certainly not all of the women in the flim are lesbians, each of the women interviewed recognizes the need to combat homophobia as strenuously as racism, sexism, or classism.

Brand also includes an interview with a Franco-Caribbean Black woman to demonstrate that Black women in French Canada also battle the same oppressions as Black women in English Canada. In presenting this woman's voice, Brand uses subtitles rather than a voice-over translation, which allows the woman's own voice to be heard rather than camouflaged; the effect of using the subtitles is significant, because the result is to refuse to marginalize the woman's linguistic difference by foregrounding the similarity of her lived experience in her own voice and words. She states, "Nous allons être avec eux comme francophones qui avons étudié le Français. Nous allons être avec eux pour les aider à défendre la langue française. Mais, ils [ne] peuvent pas faire alliance avec nous, même pour défendre leur langue, parce qu'ils nous considèrent pas comme des 'intégrables.' C'est juste la couleur qui fait la grande différence." This woman observes that, although Franco-Black Canadians will always have a stake in supporting French Canadians in their fight for linguistic autonomy and the preservation of French culture, Black Canadians whose primary language is French will not have that support re-

turned. Racism is used to marginalize Black people in French Canada for they are continually seen as "others."

Thus, the survival of any woman depends upon the support of *all* women: it is not enough to work at ending racism if, once racism is eliminated, a Black woman is sexually harassed, just as it is not enough to eliminate sexism if, once sexism is eliminated, a Black woman is denied housing because she is a lesbian, a job, because of her age, a college education, because of her class. Eliminating multiple oppression is a task that demands the recognition of differences and collective action across those differences among women. The Black women Brand presents in her films are thus forging bonds among themselves, but they are also making sure that their presence is felt in white feminist communities; the condition of exile demands such coalition, for the alienation attendant to exile can only be alleviated and terminated through vital connections to others. And futher, those connections need to be made not only with those with whom we share that exile, but also with those who, in part, contribute to our sense of alienation. This is so, for it is only through a radical transformation of consciousness on both sides of the colonial experience (that is, the descendants of the colonized on one side and the descendants of the colonizers on the other) that the dehumanization of Black people and Black women specifically will come to an end. This movement toward cross-cultural coalition building is nonetheless buoyed by the necessity of articulating and affirming Black women's identities transhistorically; this affirmation empowers us to work for change as our foremothers did.

Oral History as Methodology

No Burden to Carry, edited by Dionne Brand, and *Silenced,* edited by Makeda Silvera, expose the hardships endured by Black women in Canada in an effort to recuperate the reality of their lives in the historical context of exile to Canada in the twentieth century. In both texts, Brand and Silvera make use of oral history as a means to uncover and discover Canada's deeply embedded racism and sexism. Brand states of her project: "I decided to use the method of oral history to bring into relief the terrain of Black women's lives" (1991a, 30). Silvera likewise states: "Oral historians can learn from these testimonies because the document[s] bring into the forefront the lived experience of the voiceless" (1989, viii).

For Silvera, oral history provides the means to access Black women's erased history in Canada, that is, "a methodology to chart the experiences of Caribbean domestic workers" (v). Brand records the memories of fifteen Black women and Silvera of ten. By bringing oral history into the realm of literature in their collections, Silvera and Brand also emphasize the connections between storytelling and the production of historical texts. The stories they bring into relief are otherwise mute in the annals of Canadian history.

The women Silvera and Brand interview give testament to the harsh conditions they were forced to endure as domestic workers in Canada. In their first-person narratives, Viola, Myrtle, Noreen, Irma, and Hyacinth, women of different ages but of similar backgrounds, describe their oppression at the hands of employers who exploited their physical labor and sexuality in ways that mirror the slavery of the past, which each of these women had hoped to have put behind her. Were neocolonization not a condition of Canada's modern involvement in the Caribbean, these women would not have been forced to leave home and family in order to survive in an alien and hostile land. They also provide us with insights as to the reasons they were forced to leave their home islands in the first place, as each tells a specific story. One woman, Myrtle, aged fifty-four, interviewed by Silvera in *Silenced,* states, "It was hard to find work [in Dominica] and when I did work, the money wasn't enough to support my family. I have eight children back home in Dominica, and I am the only one looking after them. My youngest is ten years old. The last time I see her she was twelve months old" (1989, 74). Lack of opportunities in the Caribbean forced Myrtle, in effect, to abandon the possibility of raising her children herself. Immigration policies denied her the opportunity to support her children financially as well as physically. The absence of family life and isolation are for many such women conditions of living in exile. Domestics from the Caribbean were not only separated from their families in the Islands; they were also discouraged from forming familial bonds within Canada. In fact, mixed-race marriages were illegal until the late 1940s (Calliste 1989, 137)—most likely in order to facilitate deportations, which were as common as importations of Caribbean women.

Nonetheless, many Caribbean women sought to work the Domestic Scheme to their advantage. "Skilled and semi-skilled workers (e.g., civil servants, nurses and teachers) used the Scheme to immigrate to Canada

in order to further their education and to seek other fields of employment," writes Calliste (143). Restrictions in their everyday lives, from racism to low-wages, made economic and class improvement nearly impossible as late as the 1970s and early 1980s. In *No Burden to Carry*, Dionne Brand thus records the historical experiences of Black women who, often for the first time, spoke of their exploitation as they lived "in service":

> If you lived in, you were lucky to make thirty dollars a month; you started seven in the morning and you still weren't through at seven in the evening—it depended on the size of the family. One job I had, I stayed not quite the month. She took the thirty dollars so that I wouldn't get my full pay. There was nine people in that family. I can remember cooking a fifteen-pound roast and putting it on a silver tray to bring into the dining room—the dining room was over sixteen feet long.
> —Testimony of Viola Berry Aylestock on conditions in 1910 in Ontario (1991a, 94)

Viola's experience of being underpaid and undervalued reflects the reality of most Black domestic workers in the early twentieth century. Little changed over the next decades since Black women's income in 1979 remained less than half that of white men's; among women, Black women found themselves at the bottom of the wage-earning scale (Brand 1984, 34).[5]

In the charting of Afro-Caribbean women's experiences in Canada, the year 1979 is historically significant. This was when a group of Afro-Caribbean women faced deportation, because it was found that they had children in the Caribbean (it was common practice for women not to declare their children in order to immigrate successfully [Silvera 1989, vi]). Their case, "dubbed The Seven Jamaican Mothers" (vi), spurred a national protest on the part of women of color and working-class women. Says Dionne Brand: "Raising the slogan 'Good Enough to Work, Good Enough to Stay,' several groups, including the International Committee Against Racism and the Committee Against the Deportation of Immigrant Women, fought a successful campaign to have the women remain in Canada" (1984, 40). The women eventually won their fight and were allowed to remain (Silvera 1989, vii). Unfortunately, the case of

the Seven Jamaican Mothers did not bring an end to the exploitation and oppression of immigrant domestics from the Caribbean, which continues to this day.

Since the 1970s, immigrants have been admitted primarily on work permits (rather than on visas) in order to further limit the mobility (economic and otherwise) of Caribbean women. Afro-Caribbean domestic workers were thus forced to pin all their hopes on the whims of an immigration process that shamelessly discriminated against them. Says Noreen, one of Silvera's interviewees, "I just hope that landed [immigrant status] come through soon. You know sometimes I feel like *a slave,* sometimes I dream of freedom. You know, I wish I could move where I want to, work in whichever job I want, and have a little apartment on my own" (1989, 20; emphasis mine). Women on work permits were denied the opportunity to change their occupations from domestic work to more lucrative employment and could be deported at a moment's notice (Calliste 1989, 151). Another Afro-Caribbean domestic worker, Irma, relates in her oral history, "When I made up my mind to leave [the job] I felt that Immigration might deport me, but it was a chance I had to take. That woman was driving me like *a slave.* Is a lot of times when I was supposed to be on my days off that she would send me over to her friend house to wash clothes for them" (Silvera, 1989, 83; emphasis mine) Afro-Caribbean women forced to live in exile without their husbands, children, or other significant relatives and friends found themselves exploited by the employers on whom they counted, in order to receive the pittance that they sent on to the Caribbean; few were able to leave their jobs and get another, without the fear of deportation or with any guarantee that past events would not repeat themselves in new work situations.

In numerous cases, Black domestic workers were subject to overt acts of sexual harassment and sexual abuse. This occurred with few or no avenues for recourse by which Afro-Caribbean emigrants could denounce their abusers—to have done so would more than likely have resulted in the loss of what little money they made to support themselves, their children, and extended families left behind, of necessity, in their home islands. Doubtless, the youth of many of the women imported by the Canadian government made them more susceptible to this sort of exploitation. In Silvera's *Silenced,* Hyacinth speaks of her sexual abuse and racially motivated rape in domestic service at age twenty-four: "He ask me if I was going shout, I shake my head and say no, so he let go of my

mouth, I remember him telling me that if I had sex with him he would raise my pay. I tell him that I couldn't do that because he was married and his wife was upstairs. I didn't know if she was but I just say that. He laugh and ask me what Black girls know about marriage" (1989, 56). The degrading conditions under which Afro-Caribbean women are forced to subsist in North America has produced a code of silence, largely unbroken, which in part sustains the vicious cycle of exploitation that Canada and the United States count on in order to preserve their colonial–economic power.

Oral histories like Silvera's and Brand's are, therefore, of the utmost importance, for they can enable younger generations of Black and Afro-Caribbean women to terminate their forced complicity with the institutions that have marginalized and subjugated them. It also allows older women to enter their stories into the nation's historical record. One of Makeda Silvera's interviewees points out, however, that such books are necessary not simply to educate potential oppressors but to forewarn those Caribbean women who might still hope to find in Canada the answer to their prayers: "These books like what you are doing need to be written, but they need to be sent down there in the Caribbean, so that before other women come up as domestics, they know what they are getting themselves into. When you are down there, you tend to think that Canada is great, until you really come up and realise that what you really coming up to be is somebody's servant" (1989, 98). In both *No Burden to Carry* and *Silenced,* the authors provide a forum for those Silvera has called "the voiceless." The stories of the Black women told in each collection reflect the diversity of Black women's experiences as well as the need to forge a new tradition of Black feminist expression within literature, which knows no strict frontiers of nation, time, or age.

Uses of Language

Afro-Caribbean women writers in Canada have made clear that their works of fiction cannot be divorced from either oral history or the lived experiences of Black women. The particular works of prose and poetry produced by Dionne Brand, M. Nourbese Philip, and Makeda Silvera have their context within each author's own dedication to activism on behalf of Black Canadian communities. Hence, the history of Black people and the confrontation of the difficulties facing emigrant Afro-

Caribbean women in Canada are instrumental for understanding the fictional literature produced by each of the three writers. In their fiction and poetry, language takes on added importance. In some cases, *patois* is used in order to mark the identity of the characters the writers create as spokespersons for generations of Anglophone Afro-Caribbean emigrants who were forcibly exiled from their home islands through political or economic circumstance. M. Nourbese Philip, for one, presents the effects of colonization and neocolonization on the descendants of African slaves through the use of Caribbean dialect and the active dismantling of standard English in her epic poetry collections.

As an exiled writer from Trinidad and Tobago, Philip sees Canada as a space in which a revolutionary Caribbean tradition can be forged, which will dispel the myth of the Prosperian "gift" of the English tongue. She feels that either in England or the United States, she would have had somehow to fit into already formed Black literary traditions. Canada, which is largely unpopulated beyond its urban centers, presents her with a challenge to "[push] against some kind of margin, beyond which I don't know what there is" (Carey interview 1991, 19). At the same time, the sense of Canada's vast wilderness, which forms part of her exiled consciousness, connects to her sense of alienation from both her Caribbean and her African origins, the latter of which are not clearly identifiable or recuperable.

Canada, as I have shown, has had an uncomfortable history of denial and erasure when it comes to the history of Black people (and Black women in particular). That shadowed history has resulted in the erasure of literary voices from the mainstream, so that it appears, for Philip, "there was nothing there" (Carey interview 1991, 19). Philip's sense of Canada's forbidding landscape is not new: Canadian literature is by and large populated by writers who sought to break with the old (England) in order to bring in the new (Canada). Margaret Atwood states, in her 1971 text, *Survival: A Thematic Guide to Canadian Literature,* that "the central symbol for Canada—and this is based on numerous instances of its occurrence in both English and French Canadian literature—is undoubtedly Survival, la Survivance. . . . The survivor has no triumph or victory but the fact of his[/her] survival; [s/]he has little after his[/her] ordeal that [s/]he did not have before, except gratitude for having escaped with his[/her] life" (32–33; my brackets). The theme of survival is evident in both of Philip's poetic texts, and in both, Canada is the back-

drop for many of the struggles her characters take on; in this sense, Philip's work—as with most writers of the African diaspora writing in Canada—belongs to an expressly Canadian tradition of alienation from struggle with the landscape. It is markedly different, however, from texts produced by "white" Canadians in that alienation from the land is more than simply physical. It is a psychic and spriritual disconnection, which makes the landscape all the more inaccessible, since that land has come to be defined through the eyes and tongues of the dominant British and French cultures, which invaded it and then founded Canada; furthermore, Afro-Caribbean people who have come to that land in search of better futures have done so, as I outlined above, through exploitative channels that have forced them to survive on the margins—forever looking in.

In a larger context, Philip's work belongs to a Caribbean tradition that defies national borders, in that survival, for the Afro-Caribbean woman, is not a question of simply making it back "from the awful experience—the North, the snowstorm, the sinking ship—that killed everyone else" (Atwood 1971, 33), but of recognizing that the process of conquering the great North American frontier resulted in the genocide of indigenous peoples in both North America and in Africa. Survival, then, in this context, is part of a global, collective effort to struggle, not against the elements, but against man-made destruction from one generation to the next.

Philip's "Caribbean demotic" is thus a concept that defines for her the reclamation of lost African dialects and cultures. She says, "What I'm struggling to do is find a written form of that spoken language that the people on the street nurtured—what used to be called 'bad English.' Just as with standard English, the way you speak it is not how you write it. There's a transformational process that happens. And that's what I'm trying to find—you could say the deep structures of that oral language" (Carey interview 1991, 19). Philip's explorations also incorporate the interrogation of "standard English" by revealing the depths to which language contributes to the oppression of the formerly and continually oppressed: "Because even though I appreciate English as the wonderful tool it is, with all its resources, historically its underpinnings are tied to colonialism, to exploitation, to being forced upon African peoples who were not allowed to function in their own language" (Carey interview 1991 19). In *She Tries Her Tongue, Her Silence Softly Breaks* and *Looking for*

Livingstone: An Odyssey of Silence, Philip alternately deconstructs standard English and reconstructs the Caribbean demotic by unveiling the points of intersection between the violence of imperialism and colonialism and the efforts of the enslaved to maintain cultural and linguistic integrity despite that devastation.

Because of this attention to the links between contemporary language use and the historical plundering of African cultures, *She Tries Her Tongue, Her Silence Softly Breaks* received mixed reviews on its Canadian publication in 1989. Some reviewers, like Erin Mouré, attempted to universalize Philip's poetry and in so doing disassociated her work from its source. Mouré has written:

> Without words, one's own words, can there be history? How to speak, when you must speak in a foreign tongue, a tongue that has continually disparaged you?
>
> Such questions reverberate in the work of Nourbese Philip—especially but not just for Black and Native peoples colonized by Western European language and culture: they also echo for others on the margins of dominant culture, and, yes, for everyone disenfranchised by the language of politics, advertising, management, and the law. Within which we all risk being people without history. (1990b, 40)

Mouré, in her aptly titled review, "Insisting on the Questions," appears to bypass some of the answers Philip provides in her collection of intertwined poems.

In asserting Philip's universal appeal and in connecting her to the writings of Québec women writers who Mouré believes, are equally "affected by colonial and, yes, racist attitudes of the dominant society" (41), Mouré participates in neocolonizing Afro-Caribbean women's experiences from a literary standpoint. Philip's interrogation of language as a tool of oppression is vastly different from that of Acadian writer Antonine Maillet in *Les Cordes-de-Bois,* or that of Québec writer Anne Hébert in *Kamouraska,* who portrayed the difficulties faced by Acadian and French communities in terms of class disenfranchisement and the struggles of assimilation. Both the French and the English have left their colonial imprints on the Caribbean islands, and this colonialism continues in Canada. Still, Black people in Canada were subject to further exploitation at

the hands of both French and English, and though there may be parallels in the depiction of marginalization offered by both Maillet and Hébert to that offered by Brand, Silvera, and Philip, those parallels fail to account for the discrimination experienced by Black Canadians within French communities, most specifically that endured by Haitians in Québec.

Philip illustrates the degree to which African and Afro-Caribbean cultures have been disrupted by colonialism in her opening section of poems, "And Over Every Land and Sea," in which a mother and daughter scour every corner of the earth to find each other. The Mother in the poem "Questions! Questions!" speaking in the Caribbean demotic, summons her Daughter; her questioning voice is full of desperation:

> Where she, where she, where she
> be, where she gone?
> Where high and low meet I search,
> find can't, way down the island's way
> I gone—south:
>
> grief gone mad with crazy—so them say.
> Before the questions too late,
> before I forget how they stay,
> crazy or no crazy I must find she. (1989, 28)

The "crazyness" the Mother speaks of is a by-product of the alienation the Daughter suffers as a result of being forced to survive without her Mother, that is, without her cultural roots. On the Daughter's side, there is a struggle not to give into "crazyness," which would only result in further alienation from her past. Philip makes clear that the search both figures undertake is symptomatic of the legacy of familial and cultural divisions brought about by colonization. Reading this part of the poem, I have asked myself: how many times did one of our foremothers have to battle being labeled "crazy," as she resisted her oppressions as a Black woman, in Canada, in the Caribbean, around the globe? How many times did I think *I* was crazy for wanting to know the truth of my origins?

Mother and Daughter in Philip's poem survive in exile, and it is not clear whether either of them knows the face of the woman she looks for,

just as it is true that we often attempt to reclaim the past with little
knowledge of the shape of those people and cultural markers that were
taken from us, destroyed, or manipulated to fit new, colonial contexts. In
"Clues," again, the Mother speaks:

> She gone—gone to where and don't know
> looking for me looking for she;
> is pinch somebody pinch and tell me,
> up where north marry cold I could find she—
> Stateside. England. Canada—somewhere about (30)

By the end of the series of poems, the Daughter sits in the "Adoption
Bureau" with a sense of being searched for as she herself searches:

> Something! Anything! of her.
> She came, you say, from where
> she went—to her loss:
> "the need of your need"
> in her groin (36)

The only hope for these women is to find one another in the annals of
history—annals from which they have been cut out and forgotten. The
opening poems lead into the heart of Philip's *She Tries Her Tongue,*
where history is reconstructed and myths made flesh. As Philip says in her
introduction, "For the many like me, black and female, it is imperative
that our writing begin to recreate our histories and our myths, as well as
integrate that most painful of experiences—loss of our history and our
word" (25). The Mother and the Daughter Philip brings to life in the
first poems of the collection are representative of all Black women living
suspended between the past and present, as the quality of their lives is
determined, not by themselves, but by their oppressors.

Philip's use of the Mother–Daughter bond is a metaphor for the gen-
erational disruption of that bond through racist and sexist oppression. It
is no surprise that the Mother invokes the Daughter for she, too, has
been a Daughter kept from her matriarchal roots; in fact, the Daughter
invokes the Mother in a reciprocal attempt to regain what has been lost
to the both of them: language, history, freedom. These opening poems,
then, are symbolic of a counterdiscourse, an alternative language, which

Philip attempts to formulate against the oppression she uncovers in standard English, her "father" tongue.

Thus, in "Discourse on the Logic of Language," Philip moves from stating that English is her "mother tongue" to being tongue-tied by the language itself:

> What is my mother
> tongue
> my mammy tongue
> my mummy tongue
> my momsy tongue
> my modder tongue
> my ma tongue?
>
> I have no mother
> tongue
> no mother to tongue
> no tongue to mother . . .
>
> I must therefore be tongue
> dumb
> dumb-tongued
> dub-tongued
> damn dumb
> tongue (56)

This section of the poem resonates with the opening Mother–Daughter poems in that there is a clear realization that there is no connection to African culture through English, and further, no connection to a matriarchal ancestry. This is why on the same page, Philip offers a first-person narrative running lengthwise down the page, next to the stanzas quoted, which recounts the birth of a child who begins to access language through her mother's tongue, cleaning her of "the creamy white substance covering its body."[6]

Alternately, competing for its linguistic space on the page is an edict aimed at disrupting this fragile but necessary bond. The edict states in part that "every owner of slaves shall . . . ensure that his slaves belong to as many ethno-linguistic groups as possible" to discourage "rebellion and revolution" (56). One leaf over, edict number two states: "Every slave

caught speaking his native language shall be severely punished. Where necessary, removal of the tongue is recommended" (58). For the African, then, English becomes "a foreign anguish," and readers must turn the poem on its side to discover the mother with her newborn child attempting to defy the edicts by blowing into her daughter's mouth: "WORDS —HER WORDS, HER MOTHER'S WORDS, THOSE OF HER MOTHER'S MOTHER, AND ALL THEIR MOTHERS BEFORE— INTO HER DAUGHTER'S MOUTH" (58). The physical act required on the part of the reader to absorb these words is a symbolic link to the manipulation of English on the part of those Africans colonized by the British to free themselves by forming new ways of speaking in the New World. This, of course, is the language that saturates the opening poems of the collection and binds the lost mothers and daughters of this colonial legacy together:

> stop looking for don't see and can't—
> you bind she up tight tight with hope,
> she own and yours know up in together;
> although she tight with nowhere and gone
> she going find you, if you keep looking (30)

That language, however, a somewhat standardized version of Anglophone *patois*, seems to disappear as Philip progresses through her exploration of English.

The emphasis in the subsequent sections of *She Tries Her Tongue* is on how to shed imposed language. Philip therefore moves to making connections between the imposition of English and the imposition of other European languages upon enslaved Africans. She emphasizes the need to "lose a language" (67), which legitimates acts of violence against women of color. For example, Philip writes of the language used to describe sexual violence against women in poetic terms: "raped—regular, active, used transitively　　the again and again　　against / women participled into the passive voice as, 'to get raped'" (66). Thus, the recognition of the reinscription of violence against women within language is countered by the centering of the female voice both upon the page and in the construction of "The Question of Language Is the Answer to Power," "Testimony Stoops to Mother Tongue," and "She Tries Her Tongue;

Her Silence Softly Breaks," the last three poems of the collection. The voice here, female, is defiant:

> forgive me this dumbness
> *but thou art the same Lord, whose property*
> this lack of tongue forgive
> *is always to have mercy* (94)

It is also in search of her history:

> each word creates a centre
> circumscribed by memory . . . and history
> waits at rest always
> still at the centre (96)

Here, there is no return to the Caribbean demotic, to bad English, *patois,* dialect: Philip moves her poetry unto the brink of nothingness, of "pure utterance" (98), that is, toward a confrontation of that history which remains obscured. This marks, perhaps, the possibility of re-birth in the forgotten past, which remains within our grasp. But can history possibly be regained outside of speech? Is the return to the absence of language, that is, to silence, an option by which freedom can be attained?

The last poems of *She Tries Her Tongue, Her Silence Softly Breaks* resonate for me on a level removed from the adaptation of language for survival. I recall here Philip's words from her introduction: "loss of our history and our word." The last three poems of the collection reconstruct those losses and illustrate the process of breaking silence only to reclaim that silence as a ritual of resistance. Philip says of writing *She Tries Her Tongue,* "When I was done with it I found that silence—the concept of silence—confronted me. Was silence always something negative—could there be a positive aspect to it?" (Carey interview 1991, 19). These poems lead me to confront my own silences. For me, silence has been a space in which to reevaluate the political implications of standard language usage to resist the continued cooptation of my cultural heritages and personal experiences. Living as I have between two "father tongues," French and English, and with limited access to my "mother tongue" of Haitian *créole,* it has been difficult for me to articulate the losses Philip brings to life in her mythical creation of the African Mother and Daugh-

ter flying the globe in search of each other. In what language can I seek such connections when, divided through enslavement and colonization, so many of us have been forced to acquire languages that could only serve to wedge us farther apart? Language affects my ability to find affirmation for both myself and my place of origin. Language is a way by which we proclaim our "sameness," as Canadians or Americans, and deny each other's specific cultural backgrounds. This is the sort of reality I find reflected in Philip's poetry, that is, the pull between speaking the language that provides access to Canadian "equality" while denying Canadian multiculturality. Philip accurately describes the effect the imposition of Western languages has had on those of us who have roots elsewhere, in other languages and other lands.

One reviewer of *She Tries Her Tongue* sees Philip's depiction of the struggle between self-affirmation and assimilation as strained. He points out, "On the one hand she questions the very existence of 'Standard English'; on the other, a sentence such as, 'it is *in the continuum of expression* from standard to Caribbean English that the veracity of the experience lies' (Philip's emphasis), seems to presume that it does indeed exist" (Barratt 1990, 103). Interpretations such as this one refuse to recognize that Philip's use of both the Caribbean demotic and standard English is a function of a legacy of forced assimilation; the relationship between Philip's use of standard English alongside her Caribbean demotic is therefore necessarily strained. The reason Philip questions "standard English" is, of course, the fact that its social correctness has been historically constructed in order to suppress the cultural codes and languages of "others." Variations on that English are then labeled "substandard" in order to discourage rebellion against those who maintain the status quo by refusing to recognize that other forms of communication are vital to the survival of non-Anglo or nonmainstream cultures. Philip is negotiating as a writer between expressing her own Afro-Caribbean identity through dialect and staying within accepted mainstream modes of communication. The reviewer I have quoted above maintains that "Philip tends to slide over the persistence in the New World of African musical forms, notwithstanding serious efforts to destroy them" (Barratt 1990, 104). Again, such an interpretation refuses to accept that Philip is working in more than one tradition and presenting how those traditions, of assimilation and of resistance, coexist at the same time they are conflicting. In keeping with what I have termed the productive contradictions of

Afro-Caribbean diasporic feminism in the opening chapter, Philip demonstrates that "Black" identity is more than any one fact, as she incorporates the most obvious markers of Blackness ("musicality," for instance) in the very structures of her poems which work with the tonalities of words and the music they make when thrown into new combinations. Along theoretical lines, she also creates works that are not unlike the fugue (that is, more than simply contrapuntal, to recall here Said's figure of the exile), providing variations on a central melody: the liberation of colonized peoples from the stereotypes that box them in. Clearly, Philip's effort to tackle the issue of language as a point of oppression and cooptation for exiled Afro-Caribbean people is seen as threatening, because she does not fit into the narrow enclave of artistic expression expected of all Black artists in Canada's insidiously racist culture.

Similarly, controversy directed at Philip's subject matter erupted soon after the launching of her last book of poetry, *Looking for Livingstone: An Odyssey of Silence* (1991). Language only masks the deeper realities of our identities as Canadian emigrants, and Philip has managed to convey the extent of those realities despite the constraints of language she exposed previously in *She Tries Her Tongue*. In response to an interview with Philip in which she spoke of rewriting history with respect to the "explorations" of the famed Doctor Livingstone, a now infamous Letter to the Editor appeared in the literary magazine *Books in Canada* in November 1991. The letter, which includes a directive issued to Philip on how to lead her life (for example, "She can migrate to any English-speaking country in Africa, practice law, and write about her discovery of her motherland"), rebuts Philip's revision of history from the point of view of a woman of African descent: "Dr. David Livingstone . . . did not silence her people; he opened their country to medical missionaries, teachers, and engineers and exposed her people to stimulating change. To sneer at his accomplishments is absurd" (Parkes 1991, 7). Statements such as these provoked a small-scale debate in the Letters to the Editor section of *Books in Canada,* whose editors chose not to provide their own editorial comments on an interview that had been commissioned and published by them in the first place.

Some months later, Philip herself responded in her own Letter to the Editor: "[The] letter not only demonstrates but proves the existence of that bedrock racism that surfaces as soon as there is any attempt to present a fuller and more detailed picture of what has been a thoroughly

Eurocentric *and* inaccurate view of Africa." She continues: "The entire letter is nothing but a more polite, less exciting, albeit more articulate version of 'Nigger go home!' which I have seen scrawled as graffiti around Canada" (1992b, 5). Unfortunately, Philip's perception of the letter's indictment of her right to reconsider the historical record as it has been handed down by European conquerors is confirmed by another letter writer who responds, two issues of *Books in Canada* later, that he found in the initial letter "a style considerably less inflated than Nourbese Philip's own . . . a succinct summary of the many rights and opportunities that well-educated Canadians like Nourbese Philip enjoy" (Sanger 1992, 6). This response to Philip's defense of her own work (along with her assertion of the right to choose to lead her own life as she sees fit), which appears in the required "correct" English, only goes to show the extent to which imperialism and colonialism remain an integral part of Canadian society.

In *Looking for Livingstone: An Odyssey of Silence,* Philip thus turns to the suppressed currents of Afro-Caribbean women's experiences rendered inaudible in contemporary Canadian society, in order to counter the oppression they suffer through racism and sexism. Her protagonist, The Traveller, confronts the ghost of Livingstone and "challenges him about his role as silencer," says Philip. She continues, "What I wanted to suggest was that when the European went overseas, whether to North America or Africa, he assumed that the people he encountered were silent in the sense that they didn't have a history" (Carey interview 1991, 19). Philip counters this assumption by illustrating the uses of silence to resist colonization and to preserve a sense of history. Silence exists as a marker of loss as well as resistance in Philip's work. At the same time, she points out, there are different sorts of silences, that is, there is also the silence that remains once indigenous or aboriginal cultures are robbed of their singularity. For her, silence appears to be symbolic of the marginalization of the history of revolution on the part of the formerly enslaved, whether we trace those revolutions back to Africa or to the Caribbean. Says Philip:

> We weren't taught Caribbean history until my fifth year of high school. We learned about King Arthur and daffodils and nightingales, while surrounded by hummingbirds, hibiscus, and a silenced tradition of insurrection by groups such as the maroons. It's quite amusing on one level and quite pathetic

on another. . . . So what I'm doing is taking the texts and putting us into the centre of them—and the texts have to change as a result. (20)

Looking for Livingstone rewrites history through fiction and poetry. The Traveller, a descendant of enslaved Africans, journeys to Africa in order to confront Dr. Livingstone with the destruction his imperialist behavior has brought to the cultures of African peoples.

Perhaps the most successful section of the text is "The Museum of Silence," in which Philip's Traveller makes connections between tribal silences, her own silence, and the silences imposed by colonizers. In this section, The Traveller rages against the fact that museums around the world hold captive treasures stolen from African people and demands the return of those treasures, of those silences:

It was ours after all, I told them, and upon it *their* speech, *their* language, and *their* talk was built—solid as the punning Petros upon which the early church, harbinger of silence, had been erected. Ours to do with as we pleased, I repeated, to nourish, care for, or neglect; to let rot, or wither away to dust, chewed upon by vermin. "Ours! Ours! Ours!" I screamed, "to do with as we choose," I dropped my voice, "to break, banish, destroy—to negotiate with—." They laughed—how they laughed, and said nothing, which was not the same as silence. They said nothing and laughed. (1991, 58)

Philip's assertion that the artifacts of silence must be returned to their rightful owners reflects life outside her text. In 1989, Philip protested, along with other Black Torontonians, the Royal Ontario Museum's exhibition, "Into the Heart of Africa," on the basis that the ROM was participating in the continued colonization of Africa and its descendants by presenting their African art collection as an extension, not of African cultures, but of British Canadian history.

Philip states in her article, "Museum Could Have Avoided Culture Clash":

For Africans, the museum has always been a significant site of their racial oppression. Within its walls reasons could be found

for their being placed at the foot of the hierarchical ladder of human evolution designed by the European. Proof could also be found there of the "bizarre" nature and "primitive" anatomy of the African. Where else could you find the preserved genitalia of the black South African woman, Saartjie Baartman, known as the "Hottentot Venus," but in the Musée de l'Homme in Paris? (1992a, 104)

Positioning herself as an African Canadian reader of the exhibition (105), Philip objects to the Royal Ontario Museum perpetuating the stereotypes of Africans in their exhibition. This stereotyping, though seemingly not obvious to the curator of the exhibition, was observed by non-African Canadians as well.

Susan Crean, a descendant of one of the British soldiers honored in the exhibition, writes in her essay, "Taking the Misssionary Position":

As I walk along I find myself growing increasingly disturbed by the roll call of former owners, the detailed label explanations of whose estate gave what and how it passed along from one person to another and eventually to the museum. The names parade along like a nagging subtext, casting the artefacts as misappropriated by products of all that religious and military fervour. The lives of the white folks are featured, their stories personalized and connected to the larger stream of history while beside them, in photos and in absentia, the Africans with whom they lived remain silent. And, with a couple of rare exceptions, nameless. (1991, 121)

Crean analyzes the installation of the exhibit, which begins with a slide show, "In Livingstone's Footsteps," and ends in the *back room* with a collection of African artifacts—textiles and musical instruments (122–123). The curator, Jeanne Cannizzo, has maintained her own and the museum's innocence by claiming good intentions as well as the absence of Black Canadian "experts" to help them avoid the racism implicit in the final formulation of the African exhibit. Crean points out that, despite this claim to innocence, Cannizzo is able to refer to Livingstone as a "British hero" in one of her explanatory plaques without questioning the honor she bestows upon Livingstone and others, like Crean's "Great-uncle." Says Crean: "Cannizzo creates a context in which that history is

claimed rather than criticized and rejected, showcased even while she tut-tuts from between the lines. 'Well, Greatuncle certainly was a scoundrel, and who knows what he got up to in Africa; but, well, you can't blame the old boy for being a product of his time.' That seems to be the sentiment" (121).

Like Philip, Crean sees a danger in the appropriation of relics of African culture to continue to sustain the myth that British imperialism must be honored rather than presented as a major force of genocide in modern history. In case of the ROM exhibition, the words of the colonizers were also foregrounded as the fundraising speeches of missionaries and explorers were piped into the first section of the exhibition and permeated the remainder; the African voices are effectively rendered mute. In addition, pictures of African women and men in the exhibition are presented from the viewpoint of the colonizers: a Zulu warrior is shown stabbed by a soldier, while African women wash clothes as "a white woman in voluminous skirts looks on, smiling approvingly" (1991, 122). The exhibit never redresses those images, leaving only an empty space where the voices of Africans should have been presented or made audible.

Philip is thus compelled to have the Traveller in *Looking for Livingstone* encounter the African kinship groups—whose names are various anagrams of the word silence—Livingstone has plundered and learn from them the significance of silence as a mode of resistance and as a tool to preserve culture. From an elder, a woman named Arwhal, of the African kinship group NEECLIS, she learns: "there were two separate strands or threads—word and silence—each as important as the other. To weave anything I first had to make the separation, and before I could do that, I needed to find my own Silence" (1991, 54). This realization comes after Arwhal's story of a sister who must save her six brothers (who had defied her words of wisdom and were turned into roosters as a consequence) by silently creating shirts for each out of African violets over a period of six years. The Traveller is left in a room to create something for the African kinship group as a thank-you for their hospitality. It is in this room that she finally comes to understand that the African kinship group has preserved its culture, not by pursuing those like Livingstone who are intent on destroying them, but by concentrating on the preservation of what has not been destroyed and is yet-to-be-made. In their everyday lives, they counter the presumption that they and the continent of Africa have been "discovered" and/or remain to be "tamed."

It is the meeting with Arwhal that makes it possible for the Traveller

to reach Livingstone with something other than anger. She learns to make of herself the center of her quest:

> I clung to my anger for a long time—it was very hard to let go of it—but when I began to give it up to the Silence around me, my fingers, as if of their own accord, began to weave. Like the girl in the story Arwhal had told me, in finding my own Silence I was finding my own power—of transformation. . . . And then I wove some more and came to understand how Silence could speak and be silent—how Silence could be filled with noise and also be still. (54)

It is with the strength of her own identity, that is, with having come to terms with the legacy of imperialism and colonialism as well as with the survival of African cultures despite that legacy, that the Traveller is able to confront Livingstone with the fallacies of history. Livingstone, however, demands proof of her newly acquired identity. The Traveller resists his demands: "a fact is whatever anyone, having the power to enforce it, says is a fact. Power—that is the distinguishing mark of a fact" (67). Since the Traveller has no power in her relationship with Livingstone, the power of her Silence is also invalidated.

It is only in a dream that the Traveller is able to use her Silence powerfully. In her dream, Livingstone attempts to trade his words for the Traveller's silence. The Traveller tells Livingstone the story of her dream: "He was offering me words, Livingstone—if I had words, he said, I could be a witness to all that had gone wrong. I could speak out, condemn—I could even blame them. I couldn't do that with silence, he told me. I was just silent with silence. At that point in my dream, I came awake, and I remember thinking that if he wanted my silence so much, there had to be some value in it" (65). The heroine's silence is meant to highlight the fact that the use of Livingstone's language for resistance would be only the same as being permitted, within constructs of oppression, to resist patriarchal domination: resistance is sanctioned and therefore, neutralized. In reality, Livingstone sees little value in her silence. "But you're so much more powerful with words, aren't you," he responds (65). Philip uses the Traveller's silence here as a metaphor for those cultural markers, which colonizers such as Livingstone chose to label as "backward" or "insignificant," at the same time they claimed those markers as their "discoveries" and attached their names to each.

The irony in the Traveller's journey is that she credits Livingstone with her wholeness: "I told him how indispensable he had been to this, that were it not for him, I would never have set out on my travels to find my interior—the source of my silence—which was he perhaps" (63). I find this statement ironic, because it seems clear to me that it is in the relationship with Arwhal that the Traveller comes to understand that Livingstone is not the source of her silence, but the true betrayer of that silence, a disturber of her peace.

Initially, the Traveller believes that Arwhal has betrayed her by forcing her to make the journey within herself into silence alone. The Traveller feels more anger toward Arwhal than she does toward Livingstone at the moment she is forced to seek her own identity: "How long I yelled and screamed I don't know, and what I yelled I don't care to remember—but I traced her ancestors back to a mule and a jackass and threatened to kill her and hang her out to dry" (51). The Traveller has absorbed the racist and sexist rhetoric of the man she pursues to exact her justice and turns it on her nurturer. Again: "How I loved her—the beautiful Arwhal—bitch! And she had left me" (51). Once the Traveller learns what Arwhal has been trying to teach her, the inner source of her own power, she leaves *her:* "In pursuit once again of Livingstone" (51) and "The absolute/ in Virgin/ Whole" (52). Still, she has learned her lesson, for the significance of the dream she recounts to Livingstone lies in her experience with Arwhal, who responded only with Silence when berated by the Traveller for her "betrayal." Philip, however, appears to position the significance of the dream squarely in the relationship of language to power between the Traveller and Livingstone and continues to prioritize that relationship rather than the significant bond she has created between the Traveller and Arwhal.

The latter relationship is presented as an intense mother–daughter connection, in which Arwhal represents ancient tribal knowledge and nurtures the Traveller with that knowledge through the telling of stories that "entertained and delighted" (49). Arwhal provides her with a sense of community within the African kinship group and a sense of her own value despite the existence of "Livingtones." Their relationship is described as follows:

> Reading to each other as we lay naked at the water's edge . . .
> watching the noon-day sun play hide-and-go-seek with water-
> damp bodies—first a flank then a nipple. . . . the soft sur-

round of navel, soon the long, swift curve of back . . . tufted,
secret triangles of crinkly pleasure . . . braiding each other's
hair, elaborately trying to outdo the other, how we laughed
and talked our way into each other's silence. . . . We had
shared time and space and bodies—our Silences—with each
other—and how I loved her (53)

It seems that in loving one another fully the two are able to communi-
cate the fullness of their identities as African women. In the above pas-
sage it appears also that the two are able to bridge the gap between
stolen history and the future, but only as lovers. Despite the erotic over-
tones in the above description, the relationship between Arwhal and the
Traveller does not otherwise appear to be constructed as a lesbian one by
Philip. This is in keeping with Philip's discussion of lesbianism in her
collected essays, *Frontiers: Essays and Writings on Racism and Culture,* as
a choice or fact that appears to remain at the periphery of Black women's
experiences. In *Frontiers,* Philip makes connections between oppressions
suffered by women in differing marginalized groups in the following
manner: "The Canadian-born Black artist, artist of colour, or the white
lesbian artist, for example, all face dilemmas over audience similar to that
of the artist who has more recently—relatively speaking—arrived in this
country" (1992a, 28). It would seem that, in making these fleeting
connections, Philip excludes the possibility that Black and/or Afro-
Caribbean women, and other women of color, can also be lesbians and
thereby suffer homophobia in addition to racism, sexism, and xenophobia.

Thus, at the end of *Looking for Livingstone,* there is no sense of the
possibilities of the Traveller's return to the African kinship groups she
encountered on her travels, much less a return to Arwhal. The Traveller,
holding Livingstone's hand as he dies, surrenders "to the SILENCE
within" (1991, 75), unconnected to others like herself. In one sense, this
reflects the reality of many Afro-Caribbean women in exile who can
never sever the ties to Canada's past, to its connection with British impe-
rialism. Yet, had Philip committed herself to illustrating the growth of an
explicitly lesbian relationship, she would have made valuable connections
between the presence of racist, sexist, and homophobic oppression in the
lives of Afro-Caribbean women in addition to illustrating the difficulties
of surviving between the memory of "home" (as embodied by Africa or
the Caribbean) and the imposition of assimilation in English cultures,

which owe their existence to the colonial explorers of the not too distant past.

Politics of Inclusivity

The Afro-Caribbean diasporic feminist vision of Dionne Brand, as presented through her poetry, steadfastly foregrounds and defines the oppression of Afro-Caribbean women as being comprised of homophobia in addition to racism, sexism, and classism. The result of such a vision is her refusal to participate in the further alienation of Black women whose lesbianism (or bisexuality) remains invisible or silenced in Black communities. Brand's representation of Black women in poetry is thus complex, as it progresses from the remembrance of elder Black women to the impact of their past struggles on the survival of Black women today. Brand links her rewriting of traditional history, with respect to both the Caribbean and Canadian landscape, to her own identity as an exiled Afro-Caribbean, Black feminist, lesbian, historian, filmmaker, and poet.

As a writer, Brand does not see herself, as Philip has, on the margin of mainstream Canadian life. She says, "I don't consider myself on any 'margin,' on the margin of Canadian literature. I'm sitting right in the middle of Black literature, because that's who I read, that's who I respond to" (Daurio interview 1990, 14). And, in her most recent book of poetry, *No Language Is Neutral,* Brand writes of the forgotten women of Black history by combining her own struggles to survive as a lesbian, Afro-Caribbean woman exiled from the roots of her identity with the struggles of women incarcerated after the squelching of the Grenada People's Revolution in 1983 and Black women who have seemingly left their mark on the world only through old photographs. The effect of the collection is to force readers to recognize this lost history as well as to confront Brand's inclusion of multiple identities with respect to Afro-Caribbean women.

In "Blues Spiritual for Mammy Prater," for example, Brand eulogizes an aged Black woman, Mammy Prater (1990b, 17–18). Brand presents Mammy Prater as a shaper of her own destiny, indeed, as a shaper of history, as she describes her waiting for just the right time, the right decade, in which to leave a trace of her existence behind to be found by a younger Black woman in a forgotten photo album. The photograph becomes a cultural relic by which Brand can rediscover Mammy Prater and,

with her, legitimize Prater's personal history. That photograph preserves Mammy Prater's life experiences as an emancipated slave and is the vehicle through which she chooses to pass on her knowledge of survival. She is presented as a woman who has outlived slavery, the abuses of whatever white man owned her, a life of continuous oppression, in order to leave something of value behind: herself. The repeated symbolism of Mammy Prater's eyes in the poem underscores that her eyes, like ours, are witness to the many injustices suffered by the formerly enslaved and their descendants. The photograph, then, captures a moment, a pose which has outlasted despair.

In her story, "Photograph," Brand similarly illustrates the necessity of preserving such images. In it, a young woman remembers the death of her grandmother, by whom she was raised, in the Caribbean and recalls that she has no photographs of her to confirm her existence. Of course, the grandmother in the story lives on in the storyteller's memory, but Brand presents her protagonist's recall as missing an essential, tangible piece. The story opens with: "My grandmother had left no trace, no sign of her self." It continues, unraveling one incident after another in the young girl's life when she can remember her grandmother's attempts to give her and her siblings a safe home, an education, and love. Each of those incidents is anchored to the memory of the grandmother's trip away from her home to have her picture taken for an identity card. For the grandmother, this photograph represents something far greater than a supporting document, which will legitimize who she is; in fact, she resists having to have her picture taken because it seems to have represented for her the end of her life, too much of an encapsulation of her true identity. The storyteller says: "She had been what seemed like hours at the identity card place. My grandmother had to wait, leaning on my sister and having people stare at her, she said. All that indignity, and the pain which always appeared in her back at these moments, had made her barely able to walk back to the house" (57). In contrast to Mammy Prater, the grandmother in this story is shamed by the experience of having her picture taken, precisely because it is out of her control.

In the context of "Photograph," images of Black women taken against their will or in exile (the granddaughters receive letters from England along with photos of their mother whom they can hardly imagine to be real) leave very little for their descendants to hold on to. The significance of "Blues Spiritual for Mammy Prater" lies in a shift from appro-

priation and exploitation of the images of Black women to the exertion of control over the means of production of those images. Like the elderly women in her first film, Brand presents through Mammy Prater's image, and in the portrayal of the grandmother's refusal to be reduced to a statistic in "Photograph," a warning for readers to treasure Black women's history of survival in order to prevent the horrors of the past from being repeated in the future. Of course, such horrors are being repeated.

In the section, "No Language Is Neutral," Brand speaks of her own life lived between the Caribbean and Canada in an effort to politicize her personal sense of identity in a broader context. This is an effort that I have elsewhere termed "poelitics," which is a fusion of politics and poetry that recalls Lorde, who once wrote of the transformative power of poetry as "a revelatory distillation of experience" and as an act of fusion between "true knowledge" and "lasting action" (1984, 37).[7] Brand invokes the oral history garnered from the mouths of elders that keep her from forgetting the Caribbean's blood-soaked past (1990b, 23). Her experiences as a Black woman living in exile in Canada also force her to find strength from her own center and to make central the alienation and marginalization of other Black women. Brand thus refuses to silence herself and utilizes poetry as a vehicle for rewriting history. As well, she foregrounds an identity of her own making, which encapsulates Black women's history in Canada and in the Caribbean as well as her own history as a displaced Afro-Caribbean artist struggling to survive against the forces of racism, sexism, and homophobia.

Brand frames "Return," and "No Language Is Neutral" with "hard against the soul," a poem in which she foregrounds her lesbian identity as an essential component of her feminist politics. Brand says of "hard against the soul": "I needed to fully come out as a lesbian; I needed to say what that did in terms of how I was going to speak now as a poet. Much of my work before didn't deal with sexuality as political" (Daurio interview 1990, 16). This inclusion of sexuality as part and parcel of Black feminism (a position fully articulated by the writers of the Combahee River Collective "Statement" [1977/1982], who laid the groundwork in the late 1970s for Black feminism as it exists today) forces Brand's readers to confront and accept sexuality as a point of difference or of commonality but always as a point of oppression for lesbian women. "The poem," says Brand, "is about my first lover, but it is also about

recognizing I was a lesbian, and why. I looked at ocean and earth, and I thought, that's right, I love that, there's something about that fecundity of it, the richness, that somehow verified my love for women. . . . We live in a world that doesn't love women, and I suddenly faced the possibility of having to live that out" (Daurio interview 1990, 16). Brand celebrates her lesbian identity as a way of returning to her roots and as a defiance of the male gaze (Brand 1990b, 48).

No Language Is Neutral defies readers to separate out Brand's multiple identities; she is a Black, lesbian, woman who works to end her oppression on all these fronts. Most important, Brand's "poelitic" vision requires an understanding of her involvement in the Black communities of Canada and the realization that her foregrounding of lesbianism in her diverse works is meant to make visible Afro-Caribbean women's oppression as a function of their denied sexual identities within Canada as well as in the Caribbean.

Self-definition and affirmation are thus at the root of "hard against the soul," which begins in the foregrounding of a lesbian relationship against the backdrop of the Caribbean and continues by linking the mythic (as described by Philip in her own poetry) to the intensity of a love newly discovered in the context of exile. With this new-found knowledge, the recuperation of what eyes like Mammy Prater's have seen, and her own observation of the attempts made within the Caribbean to overthrow oppression in its diverse forms along with the neo-colonization brought about by North American capitalism in Cuba and Grenada, Brand does not give in to despair and celebrates herself.

It is in the power of her connection to another woman, in this case to another Black woman, that Brand retrieves hope when she describes the geography of their love-making as a state of war (1990b, 40). In their union, the struggles of decades of oppression are freed from the imposition of silence and denigration: the affirmation of the sexual relationship between two women as presented by Brand symbolizes the possibility for entering into new ways of seeing Black women and our passage in societies that depend on our invisibility for their own survival.

By making such a relationship visible herself, Brand presents a new vision of multiculturality for Canada and underscores the necessity for change in our future: by reinscribing those images of Black women that have been lost to us through imperialism, colonization, racism, sexism, neo-colonization, and homophobia, she asserts an alternative to the sta-

tus quo. The women of African descent Brand presents in her poetry and prose not only serve to rewrite the past but provide us with renewed options for the future in continued resistance to oppression and in the reclamation of, or return to, our own identities, which, in effect, are themselves our "homes" away from home.

The title of this chapter, "Good Enough to Work, Good Enough to Stay," foregrounds the fact that Afro-Caribbean women in Canada have been, for a large segment of Canada's history, part of the fabric of Canadian life. Because of their race, because of their sex, and because of their immigrant status, Afro-Caribbean women as a group have been exploited with the sanction of Canada's immigration policies. Our history in Canada is denied, however, in order to maintain a false image of Canada's multiculturalism.

In her essay, "Overcoming Sexism and Racism—How?" Rosemary Brown summarizes the Canadian approach to problems of racial and sex discrimination, declaring:

> If I were to write a book about Canada and its people, the title would be "Let's Pretend, Let's Deny." The first line would read, "Canadians are a tolerant and compassionate people . . . at least that is what they tell me." I might then recall the ways in which we [Canadians] discriminate against each other because of dislikes based on a person's sex, race, disability, age, sexual orientation, religion, culture, or class. (1991, 168)

The weight of discrimination upon the backs of Black women in Canada is an inescapable reality. The writings by Afro-Caribbean women in Canada reveal the multiple nature of that discrimination. All the writers I have discussed write from a position of exile from their home islands, from a sense of alienation due to that physical displacement. But each also articulates the fact that to suffer from racism, sexism, homophobia, classism, and other prejudices is to suffer other forms of exile, that is to say, exile from mainstream culture, as M. Nourbese Philip has shown us, and exile from one another, as the oral narratives of Makeda Silvera and Dionne Brand reveal. As each of these writers exposes the multiple layers of exile for Afro-Caribbean women, they recuperate the history of Black women's existence in Canada and move us toward apprehending the

means by which we might define ourselves for ourselves rather than in response to those who have stereotyped us and abused our bodies. The rewriting of history through oral history, fiction, poetry, and film is the attempt to be exiled no longer from our own identities. In the United States, this rewriting has in fact led to the movement to *define* Afro-Caribbean identity beyond the mere act of historical reclamation.

As I endeavor to show in the following chapter, writers such as Michelle Cliff, Rosa Guy, and Audre Lorde, each with varying degrees of connection to the Caribbean, argue for the necessity of building a coalition between the African American and Afro-Caribbean communities and for increased tolerance of difference among ourselves in order to achieve that coalition productively. In so doing, they build upon the work of Afro-Caribbean women writers in Britain and Canada and further distance themselves from the alienation inherent in exile to affirm the ways in which exile might be transformed into a dynamic source of political power.

$\mathcal{F}our$

Remembering Ourselves

The Power of the Erotic in Works by
Audre Lorde, Rosa Guy, and Michelle Cliff

Dangerous Writings

The power of the erotic exists in memory, forgotten history, and the articulation of identities forged from difference and self-affirmation. That power, rooted in the land and in the ancestral traditions of African women, as described in the poetry of Audre Lorde and the writings of Michelle Cliff, is recuperable by both women and men, but finds its clearest manifestation in an energy defined by women's historical and present lives. As the earlier chapters have shown, the process of decolonization entails the rediscovery of our maternal and African roots as well as the admission of the importance of our relationships to one another as Black women. The lives of Afro-Caribbean women have long been rendered invisible in mainstream history, poetry, and fiction. Here, I intend to show that in their work, U.S.-based Afro-Caribbean writers attempt to bring us closer to home, to wholeness, not only by making Black women's lives visible but also by stressing the reclamation of the Black female body as the site of our ultimate empowerment. For, inasmuch as our bodies have been the source of our commodification in art, the site of physical and sexual abuse under slavery and neocolonial "domestic schemes," it stands to reason that it would be through the body that we might regain a palpable sense of our own identities.

Thus, in ways similar to those expressed by Dionne Brand in her films, poetry, and essays, Audre Lorde in "Uses of the Erotic: The Erotic

as Power" writes of the distrust women have of their own power: "We
have come to distrust that power which rises from our deepest and non-
rational knowledge" (1984, 53). Lorde emphasizes that the reason for
such distrust among women resides in our association of power only with
male dominance and various forms of exploitative capitalism. But, she
asserts, this sort of power has its opposite, or its alternatives, that is,
woman-centered power and community-driven socialism. Lorde calls this
women's energy the power of the erotic, wherein "the erotic is not a
question only of what we do; it is a question of how acutely and fully we
can feel in the doing" (54). She adds:

> The very word *erotic* comes from the Greek work *eros,* the
> personification of love in all aspects—born of Chaos, and per-
> sonifying creative power and harmony. When I speak of the
> erotic, then, I speak of it as an assertion of the lifeforce of
> women; of that creative energy empowered, the knowledge
> and use of which we are now reclaiming in our language, our
> history, our dancing, our loving, our work, our lives. (55)

I understand this passage to mean that through the assertion of female
sexuality—meaning woman-centered, meaning lesbian—Lorde sees a
possibility for transformation. Recovering sexual autonomy as a Black
woman and as a lesbian, Lorde's concept of the erotic as power centers
on self-affirmation and the denial of "male models of power" (53).

Instead of continuing to feed the male models of misogyny and fe-
male subjugation, Black feminists (whether they are lesbian or not) have
it within their power to construct safe spaces for the nurturance of
women's lives, free of homophobia and the prejudices of racism and sex-
ism. The lesson to be garnered from the experience of lesbian lives is, of
course, from Lorde's point of view, the lesson of loving women as
women, and not as an extension of men, or of male desires.

To be able to be free within a feminist women's community to speak
of one's lesbianism in particular is to be freed to empower oneself and
others to define each one's personal identity. This freedom, in turn,
strengthens the community's dedication to the alleviation of all forms of
prejudice. It is the removal of the fear among women of which Brand
writes in her essay, "Bread Out of Stone" (1990a). Similarly, Lorde has
written:

The fear of our desires keeps them suspect and indiscriminately powerful, for to suppress any truth is to give it strength beyond endurance. The fear that we cannot grow beyond whatever distortions we find within ourselves keeps us docile and loyal and obedient, externally defined, and leads us to accept many facets of our oppression as women. (1984, 57–58)

Recognizing and verbalizing that many Black women are oppressed as lesbians is a means by which other oppressions can be faced:

For as we begin to recognize our deepest feeling, we begin to give up, of necessity, being satisfied with suffering and self-negation, and with the numbness which so often seems like their only alternative in our society. Our acts against oppression become integral with self, motivated and empowered from within. (58)

Rather than deny lesbianism in order to be accepted in the Black (male) movement, or the mainstream (white) U.S. women's movement, Brand and Lorde foreground that identity, along with the unalterable presence of their race and sex, in order to make visible what for too long has remained an invisible component of traditional calls for Black women's equality in North America.

Equality is a social concept based on the idea that all human beings deserve the right to define the direction of their own lives and the right to do so without threats of prejudice and alienation from without. To recognize that homophobia is a prejudice that threatens the lives of lesbian women and gay men in most communities in North America is to assert the necessity of making connections between the source of all marginalizations, that being, as Lorde states, "a racist, patriarchal, and anti-erotic society" (1984, 59). To recognize vital connections among women is to break away from prescribed patriarchal definitions of womanhood. And to affirm those connections is to begin to see the world in new ways and to shift our ways of dealing with that world and the oppressions that all women face, but women of color in particular. Lorde claims, "Recognizing the power of the erotic within our lives can give us the energy to

pursue genuine change within our world, rather than merely settling for a shift of characters in the same weary drama" (59).

Lorde's articulation of the potential of woman-centered power is tied to an affirmation of the complex manifestations of the power of the erotic among women who may otherwise be divided by class, race, or sexuality. Here we should recall Adrienne Rich's "Compulsory Heterosexuality and Lesbian Existence" (1980/1986), in which she sets out to "encourage heterosexual feminists to examine heterosexuality as a political institution which disempowers women" (23) by pointing out the degrees to which compulsory heterosexuality forces women to deny their own need for and desire of primary relationships with others of the same sex in order to satisfy the needs and desires of heterosexual men who use heterosexuality as a means of justifing male domination over all areas of women's lives. Compulsory heterosexuality, therefore, affects all women, whether they are lesbian, bisexual, or heterosexual, because it remains compulsory, not as a result of "nature" but as a condition of sustained male power and privilege. Rich's complex analysis of the ways in which compulsory heterosexuality impinges upon and often violates the lives of women centers on the necessity for mainstream feminism to recognize both lesbian existence—"the fact of the historical presence of lesbians and our continuing creation of the meaning of that existence"—as well as a lesbian continuum—"to embrace many more forms of primary intensity between and among women, including the sharing of a rich inner life, the bonding against male tyranny, the giving and receiving of practical and political support" (51). Thus, Rich claims: "The lesbian trapped in the 'closet,' the woman imprisoned in prescriptive ideas of the 'normal,' share the pain of blocked options, broken connections, lost access to self-definition, freely and powerfully assumed" (64). Self-definition, self-empowerment, is regained when women choose to abandon old and standard definitions of what it means to be a woman in North American society as well as what it means to be a lesbian in North American society, and what it might mean to our survival and well-being to define the basis of the power of eroticism between women as explicitly lesbian.

Ideologically, then, feminists must, "as we deepen and broaden the range of what we define as lesbian existence, as we delineate a lesbian continuum . . . begin to discover the erotic in female terms: as that which is unconfined to any single part of the body or solely to the body itself" (Rich 1980/1986, 53). Women will be liberated from the confines of

patriarchal domination only when we recognize that a wide spectrum of women-centered interactions can serve as the ground from which to negotiate our existence in a world that denies the power of women. This existence can be redefined in ways that preserve our essential differences while honoring our need for one another.

Barbara Christian, in her review of Audre Lorde's *Sister/Outsider,* states that Lorde's concept of the erotic is "also connected to the other critical concept that characterizes her thought—difference as a dynamic force. . . . The erotic is one means by which difference among people can become a source of creative dialogue, rather than a threat" (1985, 208). But difference, in a world that uses difference as a discriminator between those who maintain power over others and those who are powerless, continues to be a threat. The woman artist, the writer or poet, is often made to fear the power of her own words, that is, of breaking the web of labels, which keeps her silence contained and inaccessible to herself and to others. Thus, as important as it is for Black women specifically to reach for self-definition, to list the identities which contribute to our psychic and physical makeup, it is as crucial to question our use of words, contextually.

What does it mean, then, to be oppressed not only by race and class but by sex and sexuality, in the Caribbean context? What does it mean to be a lesbian, whether by existence or along a continuum, in the Caribbean context? For those of us who have suffered arbitrary impositions of various race- and sex-specific labels, the impulse may well be to do away with labels altogether, as an act of displacement rather than of erasure to make space for a subsumed reality: what it means to love one another and ourselves, as women, in a multicultural, multilingual context. But there are perhaps feasible ways of exploring these aspects of definition within language without suffering from the ways in which social labels overdetermine the identities of those they seek to compartmentalize and identify.

The answer to such questions has been explored by Makeda Silvera in her story "Her Head a Village," anthologized in *Voices: Canadian Writers of African Descent.*[1] In it, a Black woman writer is confronted with the many voices of home, which fill her mind and her spirit. Readying herself to produce an essay, "Writing as a Dangerous Profession," Silvera's writer is disrupted by the sounds of the village in her head, her memories of home, that is, the knowledge of how her community would

react to her words if they only knew—if they only knew that she wanted to write not only about poverty and racism but about sexism and homophobia. The story begins as follows:

> Her head was a noisy village, one filled with people, active and full of life, with many concerns and opinions. Children, including her own, ran about. Cousins twice removed bickered. A distant aunt, Maddie, decked out in two printed cotton dresses, a patched-up pair of pants and an old fuzzy sweater, marched up and down the right side of her forehead. Soon she would have a migraine. On the other side, a pack of idlers lounged around a heated domino game, slapping the pieces hard against her left forehead. Close to her neck sat the gossiping crew, passing around bad news and samples of malicious and scandalous tales. The top of her head was quiet. (1992a, 99)

The woman writer (who has no name within the story) also wants to remain faithful to the needs of her fellow villagers. As one of the voices in her heads tells her: "Many of us would like to write but can't. We have to work, find food to support our families. Put that in your essay" (102). In her story, Silvera exposes the reality of writing as a privileged art at the same time it remains a dangerous act for one whose identity is charged with seeming contradictions.

For a woman for whom writing is a means of survival, a path by which to reach wholeness through self-definition, writing can also be dangerous. One villager tells the woman writer: "Writing is not a dangerous profession, writing is a luxury!" (102). But for this writer, a Black woman, a Black woman with children to support, a Black woman who takes female lovers, a Black woman who must speak for her generation as well as for those whose generations have been left voiceless, writing is a question of life and death for her extended community as well as for herself.

Silvera's writer searches for a quiet space in which to gather her thoughts and translate them into words on the page, to move from invisibility into visibility. She surrounds herself with reminders of her many lives beyond the closed circuit of her mind:

The shed faced south. Old dirty windows ran the length of it and the ceiling's cracked blue paint threatened to fall. There she worked on an oversize ill-kept antique desk, a gift from a former lover. She had furnished the space with two chairs, a wooden crate stacked with a dictionary and a few books, a big armchair dragged from the neighbour's garbage, postcards, pasted on the walls to remind her of Africa. There were a few things from her village: coconut husks, ackee seeds, photographs of birds, flowers and her grandparents' house near the sea. (102)

Still, sentences do not flow with ease from her pen. Rather, she is invaded by the villagers who want to make sure that their concerns are voiced in her essay, but this at the the expense of silencing her own concerns. At the center of the debate that ensues between the writer and the villagers is the need for her to write of the dangers of writing "about being a black lesbian in a North American city."

With too few writers from the Black community having access to means of publication, the villagers demand that the writer efface her own identity in order to represent them as a group. They tell her, in the form of rhetorical questions, to silence herself for the "greater good," forgetting that she too is part of their group: "'What about the danger of your writing being the definitive word for all black women? What about the danger of writing in a liberal white bourgeois society and of selling out? Why don't you write about these things?'" (103). Were the writer to answer these questions, she would in fact be "selling out" to escape ridicule, marginalization, the erasure of her lesbian, Black, female identities in return for acceptance both in the Black community and the white bourgeois society, which expects nothing more from her but what has become a normative tally of economic and social ills afflicting the racially oppressed in its midst. Silvera's woman writer responds to such questions by internalizing her marginalization within her own already marginalized community. She contemplates the ultimate erasure—suicide.

Silvera writes, "The black woman writer was full of despair; she wanted to explain to the villagers, once again, that what makes writing dangerous for her was who she was—black/woman/lesbian/mother/worker" (106). The only person to reach into the woman writer's mind to pull her out of her despair is Maddie, the mad woman of the village

whom none understand but all appear to respect. Maddie is "a woman of the spirits, a mystic woman who carried a sharpened pencil behind her ear." She is associated with the forgotten past but also points to the means of survival for the future, knowledge of self. Says she: "You can't be too sure of anything but yourself" (100). As the story progresses, the woman writer finds peace only when she thinks of her grandparents and the Caribbean island from which she and they came. She is brought closer to wholeness through memory: "in another village, the tropical one where she was born. Easter lilies, powder-puff trees, dandelions and other wild flowers circled the house. She saw a red-billed Streamertail, a yellow-crowned night heron and a white-bellied Caribbean dove, their familiar voices filling her head. 'Quaart, Tlee-oo-ee, cruuuuuuuuuu,' and other short repeated calls" (101). She is afraid of losing sight of her paper, of the words she must pen, of becoming "crazy" like Maddie. But it is Maddie who saves her from the fate of nothingness—the white space of cultural erasure which M. Nourbese Philip captures so well in her poetry. As "her head blazed; her tiny tight braids . . . like coals on fire," Maddie restores her peace of mind when she declares, quite simply, that "we all have to live together in this village" (106). When the woman writer awakes from sleep, it is Maddie who is with her, holding her hand, taking her out into the fields, to set her sharpened pencil to the task for which it was destined.

As an elder, Maddie holds the key to the past, and her affirmation of the necessity of the younger woman's writing bridges a generational gap. Furthermore, a connection is made between their respective "otherness": both are considered "mad"—Maddie for her habit of wearing all her clothing at one time and carrying a pencil behind her ear without ever using it, and the woman writer for wanting to write about her existence as a Black, lesbian single-mother scholar–woman—and are ostracized because of their differences. In the end, their coming together is a move to eliminate isolation and form an alternative community *within* the village, which recognizes the necessity of making affiliations cross-generationally as well as across differences of education, occupation, and, critically, of sexuality. Maddie's story, as well as that of the woman writer, needs to be told precisely, because Silvera makes each representative of the lives of the many Black women who remain forgotten in history and who are inaccurately represented in fiction and poetry. Luxury is relative.

In her essay, "Poetry Is Not a Luxury," Audre Lorde writes:

> For women, then, poetry is not a luxury. It is a vital necessity
> of our existence. It forms the quality of the light within which
> we predicate our hopes and dreams toward survival and
> change, first made into language, then into idea, then into
> more tangible action. Poetry is the way we help give name to
> the nameless so it can be thought. The farthest horizons of
> our hopes and fears are cobbled by our poems, carved from
> the rock experiences of our daily lives. (1984, 37)

Writing, in this case poetry ("a revelatory distillation of experience"),
is the end result of an affirmation of self on the part of women whose
day-to-day experiences and emotions have been disregarded in the inter-
est of the "greater good." It is also the means by which to reach other
women who live on the margins of society, whether that society what
oppresses us as racial minorities or what forms our personal, ancestral
communities, which contribute, at times, to our oppression as women for
defining the contours of our lives against established norms, as writers, as
women alone, as lesbians, as bisexuals, as active feminists, and sometimes,
all of the above at once.

Poetry, writing, can become the seed of new revolutions where Black
women's lives, past and present, are cherished, fought for, validated. Says
Lorde, "If what we need to dream, to move our spirits most deeply and
directly toward and through promise, is discounted as a luxury, then we
give up the core—the fountain—of our power, our womanness; we give
up the future of our worlds" (1984, 39). Luxury is a relative concept. It
is no coincidence, then, that in Silvera's story, Maddie—the embodiment
of what Audre Lorde has termed "the mother within each of us—the
poet" (38)—unlocks the door for the beleaguered woman writer. Mad-
die whispers in her dreams the only words that count, that is, the impor-
tance of making bridges out of our differences in order to reclaim and
affirm the past. Our futures can be faced only when we have full and
accurate knowledge of our lost histories as Black women.

Revising Given History

Audre Lorde has emphasized the need to reach back into history for
the lives of women of African descent in both her essays and in her po-
etry. In *The Black Unicorn,* Lorde draws upon the feminine components

of Dahomean mythology in a way that subverts the current emphasis on male-centered theories of "signifyin(g)," which take up the god Esu as a symbol of Black people's transformation of English into Black English. Henry Louis Gates, Jr., writes, for instance, that "Esu is our metaphor for the uncertainties of explication, for the open-endedness of every literary text" (1988, 21). Esu, as described by Gates, is overwhelmingly male, though originally believed to be a bisexual God, both feminine and masculine. Lorde, on the other hand, foregrounds in her poetry those marginalized female deities who seemed to have dominated the original Dahomean ethos. Far from completely negating the role of Esu as interpreter, Lorde supports the concept of his linguistic utility, yet turns to the mythic mother-figures who are the life-giving forces who produce Esu, a son rather than a father. Lorde's Black lesbian feminist consciousness informs her poetry in ways that undermine the value of Esu's translating function. For instance, in a poem from her collection *Chosen Poems—Old and New,* "Monkeyman" (revised in her recent *Undersong* [1992]), Lorde expresses explicit distrust of the "signifying" monkey.

The monkey described in "Monkeyman" is first of all, male, and secondly, a burden upon the female persona's back:

> There is a strange man attached to my backbone
> who thinks he can sap me or break me
> if he bleaches out my sun my water my fire
> if he confuses my tongue by shitting his symbols
> into my words. (1992, 168)

Literally, the subversive power of the monkey within Black culture as connected to language use is not seen as a blessing but as an imposition. Monkeyman is a Black figure, but he nonetheless appears as a trickster, and also as capitalistic and implicitly Western. He "tugs at my short hairs / trying to make me look into shop windows / trying to make me buy / wigs and girdles and polyurethane pillows" (168). His intentions are to transform the speaker in order to have her enter and accept a mainstream existence. The imposition Monkeyman represents is that of assimilation in North American society. Lorde's speaker attempts, in vain, to resist being coopted by one of her own race: "I used to pretend / I did not hear him." In this respect, Lorde's poem addresses one of the conditions of life in exile: her speaker is living in between knowledge of

her African roots and how those roots have been transformed by forced assimilation. On another level, of course, resistance to Monkeyman on the part of the speaker is an act of resistance to patriarchal domination, which would have her fear her own history and her community.

In "Between Ourselves," Lorde addresses the problem of finding oneself isolated within a marginalized community as well. The poem begins:

> Once when I walked into a room
> my eyes would seek out the one or two black faces
> for contact or reassurance or a sign
> I was not alone
> now walking into rooms full of black faces
> that would destroy me for any difference
> where shall my eyes look? (1978, 112)

Lorde is speaking in complicated layers of history, of betrayals upon betrayals heaped upon the shoulders of women of African descent. For instance, she remembers the African who "sold the woman who carried / my grandmother in her belly." These are not things to be forgotten for such betrayals resonate in the present:

> . . . whenever I try to eat
> the words
> of easy blackness as salvation
> I taste the color
> of my grandmother's first betrayal. (113)

In this passage, Lorde declares that community cannot be built simply out of shared heritage: a greater commitment needs to be made to the unearthing and preservation of history as it was and not as we hope it was. Part of the history of imperialism and colonization lies dormant in the unspoken memories of the betrayals, which have occurred among us as well. Thus, later in the poem, Lorde states:

> When you impale me
> upon your lances of narrow blackness
> before you hear my heart speak

mourn your own borrowed blood
your own borrowed visions. (1978, 112)

"Between Ourselves," is a poem which also speaks to the alienation of a
woman who knows that to be Black, female, lesbian, and feminist is
grounds for rejection, not only in mainstream society but also in her own
community. In this way, ignorance of the past is connected to ignorance
of the various facets of our identities as displaced Afro-Caribbean women
today.

Lorde's poetry speaks to empowering women, as she offers readers
her own voice, and the names of the female goddesses from whom her
power is derived or can be reclaimed. In "Dahomey," Lorde "presents an
African goddess of and through whom she is empowered to speak" (De-
Shazer 1986, 183). This goddess is Seboulisa, "the goddess of Abomey
. . . a local re-presentation of Mawulisa, she is sometimes known as
Sogbo, creator of the world" (Lorde 1978, 121). She is described as
follows in the opening lines of the poem:

Seboulisa
standing with outstretched palms hip high
one breast eaten away by worms of sorrow
magic stones resting upon her fingers
dry as a cough. (10)

Brenda Carr writes of Lorde's vision in this poem: "Another way Lorde
renegotiates exclusionary signifying systems is by drawing on African
myths and traditions, specifically those from Dahomey and the Yoruba
cultures of Western Nigeria, which Lorde found transplanted to her
mother's Grenadian context" (1993, 142). Lorde not only reinscribes
this African and Afro-Caribbean mythology and ancient spirituality, she
explicitly foregrounds the female elements of these cultural heritages. Ac-
cording to anthropologist Melville Herskovits, Mawu-Lisa is a name used
to identify the Sky pantheon. Mawu is its female principle, and Lisa rep-
resents the male principle. Mawu is the moon, Lisa the sun: "in Mawu is
concentrated the wisdom of the world, and in Lisa its strength" (Hers-
kovits 1934, 101–103). Lorde brings both these qualities into the realm
of the female in this woman-centered poem. In her description of Se-
boulisa/Mawulisa she also invokes the ancient women warriors, the Ama-

zons, who were said to have removed their right breasts in order to use their bows and arrows more accurately in defending themselves.

The exclusion of male "difference" in the poem is not peculiar, for Mawu is considered the "generic symbol of deity" (Herskovits 1934, 103), and, in conversion to Catholicism, Lisa becomes second to Mawu: "The word Mawu is employed for the Christian God and Lisa as the equivalent of Jesus" (105); Lorde simply uncovers the female roots of modern and ancient usages of the terms Mawu and Lisa. Although some anthropologists record that Mawu and/or Mawu-Lisa were considered female and male, or sometimes twins (Deren 1970, 55), according to Leslie Desmangles, in the Fon mythology of Benin, Mawu was primarily regarded as female. Desmangles writes: "When Mawu arranged the universe from preexisting materials, she did so in four days, the traditional Fon week. She traveled throughout the universe, stopping at the four 'quarters of space,' which correspond to the four cardinal points of the cosmos" (Desmangles, 1992, 101). This creation myth, when transferred to Catholic or Christian myth, became the basis for the apparent adoption of the cross by colonized Africans, who saw in the symbolism of the Christian cross a reflection of Mawu's powers. Seboulisa, as Mawulisa in Lorde's poetry, thus becomes the core of elemental life forces. Drawing from this generative source, the women in Lorde's poem "Dahomey" empower themselves as they can by refusing to subjugate their own power to that of male gods:

> In the dooryard of the brass workers
> four women joined together dying cloth
> mock Eshu's iron quiver
> standing erect and flamingly familiar
> in their dooryard
> mute as a porcupine in a forest of lead (1978, 10)

They know and cherish their own power, handed down from Seboulisa. Eshu's power is illustrated in the poem as mute, producing no symbols other than phallic replications. Women's power, on the other hand, is more than sexual, it is erotic and powerful in the sense that it draws strength from women working together toward a common goal.

As expressed in the poem "125th Street and Abomey," women's power is also manifested in "the woman strength of tongue" (12), that is,

in the articulation of self-knowledge and self-definition. Similarly, in "The Women of Dan," Lorde repeats this motif:

> I do not come like a secret warrior
> with an unsheathed sword in my mouth
> hidden behind my tongue
> slicing my throat to ribbons
>
>
> I come like a woman
>
>
> who I am
>
>
> laughter and promise
>
>
> warming whatever I touch
> that is living (14)

R. B. Stepto notes that Lorde's female speaker in each of the three poems I have mentioned above "has found a voice of her own that can utter 'Whatever language is needed' (a skill allowed only to Yemanja's son [Esu-Legba]) and can even laugh" (1986, 291). This is so, because each speaker has acknowledged the existence of mythic and spriritual roots that reach back to the Caribbean and to Africa. The severed ties to these lands are salvaged in the affirmation of a culture that predates the damages inflicted on both through imperialism and colonization. The difficulty of exile is confronted in Lorde's poetry with the strength of a remembered Black women's history.

For many exiled Afro-Caribbean women, the move to affirm African origins is complicated by the legacy of colonial origins. How, then, can the power of the erotic within the context of African women's "herstory" be reclaimed and move us to empowering self-definitions? Michelle Cliff provides a complementary approach to Lorde's vision at the same time that she asserts the need to confront the colonial heritage(s), which is/(are) an important and unalterable part of the fabric of the Caribbean.

Negotiating Between Self-determination and Assimilation

Claiming an Identity They Taught Me to Despise, Michelle Cliff's early collection of prose poetry, reflects the necessity of taking up the struggle

to reclaim an identity of fragmentation—a fragmentation caused by imperialism and colonialism—through the affirmation of difference and through the power of the erotic. In the prose of *Claiming an Identity*, Cliff describes the process of coming to terms with the effects of colonization upon the Caribbean child. But, like Silvera's woman writer, there is a danger implicit in setting to the page that alter-reality. "There exists a certain danger in peeling back" (1980, 3), writes Cliff. That danger is multifaceted: it is the danger of having to face our complicity in the forgetting of the past or in the pull to assimilate or in the oppression of others like ourselves. It is also the danger of relearning to become who we have always been but have been taught to deny—purposefully, by omission, or even by mistake—mixed-blood:

> We graft the Bombay onto the common mango. The
> Valencia onto the Seville. We mix tangerines and
> oranges. We create mules. (1980, 6)

This is true not only of Jamaica but of every one of the Caribbean islands, despite the differences in our colonial and emancipated histories. But to be mixed—a *créole*, a quadroon, a *marabout*,[2] what have you—is to be different in ways unacceptable to those who colonized Africa as they did North America. The presence of "Blackness," the tainting of European blood, has long been a mark of inferiority here, as in the Caribbean, as in Europe, and therefore, must be hidden. Such secrecy marks the childhood of the colonized child of whom Cliff speaks in *Claiming an Identity*, where she writes of the lessons she was taught: "Cultivate normalcy. Stress sameness. Blend in. For God's sake, don't pile difference upon difference. It's not safe" (7).

Safety is promised the colonized child in the form of passing. Cliff writes: "Passing demands a desire to become invisible. A ghost-life. An ignorance of connections." And: "Passing demands quiet. And from that quiet—silence." And: "Passing demands you keep that knowledge to yourself" (5–6). Refusing to pass demands the rupture of imposed silence and the sharing of knowledge across wide fields of isolation among those who have survived the colonization of their childhoods. Memory plays a crucial role in the recovery of voice and, ultimately, of multiple identities. Thus, Cliff remembers schooldays in the United States:

Each year the day before school after summer vacation I sat
on my bed touching my notebooks, pencils, ruler—holding
the stern and sweet-smelling brown oxfords in my lap and
spreading my skirt and blouse and underwear and socks before
me. My mother would come in and always say the same
thing: "Free paper burn now." (5)

Educated in the colonizer's schools to emulate, if not become, the colo-
nizer him/herself, the colonized child enters another form of enslave-
ment. Here, the mother's words underline the irony of a world in which
emancipation, papers (literally, the child's summer freedom) have only
culminated in further cooptation through schooling. There is no freedom
to be gained in mastering the rules of geometry and geography, which
have composed the maps of our forefathers, making our grandmothers
(*read,* motherlands) irrelevant, border countries. Thus, at the same time
that the mother makes an American education available to her daughter,
she also provides her daughter with the memory of what has been denied
to others of their Caribbean background.

The mother's presence and words serve to activate the memory of the
privileges historically denied those who live under Third World condi-
tions by way of colonization and racism. Cliff tells her readers:

Such words conspire to make a past.
Such words conjure a knowledge.
Such words make assimilation impossible. They stay
with you for years. They puzzle but you sense a
significance. I need these words. (5)

Passing is thus a double bind, for it requires not only resistance to main-
stream ideology but complicity with its modes of oppression. The mother
Cliff presents us with renders the double bind visible, so that even as she
participates in aiding her daughter to "pass," she makes visible for both
of them the connections between past and present, oppression and privi-
lege, invisibility and visibility, thus making "assimilation impossible." For
the Afro-Caribbean woman caught between such poles, seeing them for
what they are is a tool she can use to liberate herself from remaining both
colonized and privileged, a shadow of her true self.

The experience of colonization for children of indigenous (and dis-

placed indigenous) populations is remarkably similar across geographies. Carl Beam, First Nations/Aboriginal Canadian artist, confronts the same tyranny of Euro-centered education for Aboriginals in Canada in his multimedia work, *Burying the Ruler* (1991),[3] in which he illustrates a three-part development in the process of colonization and decolonization. In the first frame, feathers hang from geometrical white outlines of a circle and a triangle against a stark black background: the indigenous collides with the European in a first, hesitant meeting. In the second frame, the faded figure of a Native man holding a ruler at his side like an unnatural growth protruding from his hand can be made out: feathers have been replaced by Western garb. In the final frame, a ruler is pasted to a white sheet of paper: white paint drips over it, covering it in a sacred burial into the whiteness from which it first appeared. Small objects can leave lasting impressions. Beam's artwork renders visually the experience of receiving and ultimately rejecting the imposition of a colonial education. The last frame calls our attention to the need to renounce what the ruler signifies for too many colonized children in Canada, the United States, the Caribbean: whiteness and the loss of indigenous heritages.

"The question of my identity," writes Cliff, "is partly a question of color: of my right to name myself. That is what I have felt—all along" (1980, 8). Refusing the possibilities of passing as a light-skinned, Jamaican woman, Cliff repossesses her identity and works to bring into the foreground those parts of her ancestry that have been made almost invisible to the unaccustomed or disbelieving eye (4), which seeks to affirm whiteness over all. Camouflage or costume, the habit of becoming someone other than who we are, is a central image in *Claiming an Identity They Taught Me to Despise*. From the opening pages, Cliff voices the need to shed the false image of a mainstream (noncolored) identity and evokes vital links to those differences that privilege (of color and class) has obscured. Food is one: "rice or yam or green banana cooked in dried salt-fish. / In America this food became a secret—and a link. Shopping under the bridge with my mother for cho-cho and cassava and breadfruit. And the New Home Bakery for hard-dough bread. Finding a woman who makes paradise plums" (5). Her mother is another: "A space is left where knowledge of her body should be. I fill this space with a false knowing: I mis/take my flesh and contours for hers—my voice speaks for those parts of her she cannot reach or show" (12). Both belong to another time, a split existence. Yet they remain as proof or signs of a difference worth

preserving—the daughter becomes her mother falsely until she learns the "accurate record," "dark blood of which I was not told: denied knowledge of her body and her blood" (23). Only then can she begin to remake her identity.

"I filled their silence with rapid lies," says Cliff of voicing her Jamaican nationality in an American classroom. *Claiming an Identity* is an unraveling of those lies told to the colonized child and repeated by her in the absence of knowledge of self and the forgotten traces of her history/ heritage. In the section entitled "A History of Costume," readers are walked through a museum exhibit of costumes through the ages. We follow mother and daughter as both seek a visual rapprochement—the possibility of seeing their own reflection in the costumes before them or seeing beyond them to each other. At one point, we stand and take in an etching in which women are pictured falling unless they are supported by men: a false image. Mother and daughter retrieve an alter-reality as they remember those women absent from the etching hanging on the museum wall. Cliff writes, "Together my mother and I remember women with filled market baskets; women who carry a week's wet laundry from the washing place; a woman we know who bears water on her head— each day for a half a mile. And briefly—recalling the women of our common ground—we meet" (35). Again, memory becomes the focal point for establishing the connection both women seek although they hold few memories in common (33).

The irony here for me is the setting chosen by Cliff to illustrate the chasm between mother and daughter and this reconnection: a museum. The costumes are by and large, typically European: parasols, wigs, riding habits, camisoles. The scene recalls M. Nourbese Philip's "Museum of Silence," in which the presence of every object on exhibit signals the absence of that which has not been presented or represented. Philip's "Museum of Silence" houses the relics of decimated African nations all carefully preserved by European patrons who reinterpret the meaning of these seized objects in light of their own image. The colonized thus remain silenced by their invisibility, and Philip argues for the right of the colonized to possess that silence and to do with it what they will. We can recall here that her heroine in *Looking for Livingstone* states: "It was ours after all . . . and upon it *their* speech, *their* language, and *their* talk was built" (1991, 58).

Like Philip, Cliff works to unveil the connection between heralded

early explorers of the "New World" and the ongoing marginalization of indigenous people and people of color in the present. In her essay, "If I Could Write This in Fire, I Would Write This in Fire," Cliff writes with anger of the imposition of European historical perspectives:

> Their bloody kings and their bloody queens. Their bloody peers. Their bloody generals. Admirals. Explorers.
> Livingstone. Hillary. Kitchener. All the bwanas. And all their beaters, port-ers, sherpas. Who found the source of the Nile. Victoria Falls. The top of the mountains. Their so-called discoveries reek of untruth. How many dark people died so they could misname the physical features in their blasted gazetteer. A statistic we shall never know. Dr. Livingstone, I presume you are here to rape our land and enslave our people. (1983, 23)

As Cliff notes, even after Britain's abolition of slavery in 1839, slavery continued in various forms in Britain and its "former" colonies: women of color occupy the same jobs they held before emancipation as the world's caretakers and undertakers: Black people are still shouting slogans for liberation: "Let my people go" transformed into "We are here because you were there": the past is our present.

To overcome this continued enslavement, a new way of envisioning the world must come into existence. This new vision necessitates not only the questioning of the present social order, but a new language, this being perhaps Philip's concept of "mother tongues," or simply the articulation of what has been left unsaid—especially from a female point of view. It is not surprising, then, that Cliff's coming to terms with her own identity involves picking up the threads of the lives of other women whose identities have been mislabeled and misrepresented. These women are labeled "mad," like the lone female cousins of whom Cliff writes: "The women's madness was ascribed to several causes: childlessness, celibacy, 'change'" (19). These are women who apparently did not compose their identities through their associations with men. Hence, they were deemed abnormal if not subnormal, their madness confirmed by their attention to their surroundings, talking to one another, alone, to lizards, sitting in the river (18). Labeled madwomen, they fell out of the loop of mainstream acknowledgment and survived only at its margins.

This labeling is connected for Cliff to the "notion of the lesbian as monster, marauder; the man/woman in the closet" (1991, 48), those among us some would rather forget than accept. As she writes of Charlotte Brontë's depiction of Bertha Rochester in *Jane Eyre*, Cliff attempts to reveal the depths to which the multiple facets of Bertha's identity are "othered" in an association with the invisible, the closeted, that which is dark.[4] To expand on this interpretation, I would suggest that we think of Cliff's Bertha as a new breed of the "Hottentot Venus," that is, as the product of a colonial ideology, which merges all that is unacceptable onto the image (metaphoric or real) of the Black female. Whether in the closet, in the museum, "by the roadside" (1980, 19), the real or figurative site of Black female identity is of the utmost importance, for it is these shadowed sites to which Black women are relegated in the popular imagination. Cliff works to reconnect these shadow women to Afro-Caribbean women's consciousness today by noting their presence and their collective power as women. In my view, as I show below, she thereby transforms their mislabeled madness into the power of the erotic as defined by Audre Lorde.

The recording of a shadowed history demands a new imagination—noncolonial and noncolonized. In "Against Granite," Cliff places women at the center of a world where Black women's history is remembered and recorded, "Here is where black women congregate—against granite. This is their headquarters; where they write history. Around tables they exchange facts—details of the unwritten past. Like the women who came before them—the women they are restoring to their work/space—the historians are skilled at unraveling lies; are adept at detecting the reality beneath the erasure" (1980, 29). In fact, Cliff is one of these women as she proceeds in this work to reconstruct her life (Raiskin interview 1993, 71); her vision takes a long look back to the various oppressions of Black women's movements through this world. This women's community is not a utopia, nor completely a dream, for the recollection of things past is threatened by what Cliff calls enforcers of silence: "slicers/suturers/ invaders/abusers/sterilizers/infibulators/castrators/dividers/enclosers—" (1980, 30). This list has no end for there is no end in sight to the oppressions faced by Black people. Still, the women Cliff imagines remain steadfast in their pursuit of self-definition and self-empowerment:

> And in the presence of this knowledge the historians plant,
> weed, hoe, raise houses, sew, and wash—and continue their

investigations: into the one-shot contraceptive; the slow deaths of their children; the closing-up of vulvas and the cutting-out of tongues. By opening the sutures, applying laundry soap and brown sugar, they draw out the poisons and purify the wounds. And maintain vigilance to lessen the possibility of reinfection. (31)

Says Cliff, "Most of my work has to do with revising: revising the written record, what passes as the official version of history, and inserting those lives that have been left out" (Raiskin interview 1993, 71).

In her novel *Abeng* (1990), Cliff tells the story of a Jamaican girl's coming of age in terms of facing her colonial legacy in worlds—Jamaican, American, and British—which deny her the means to bring together the fragments of her multiple identities into a sense of wholeness. Cliff infuses the novel with a revisionist history meant to highlight Clare's growing awareness, and to make us, readers, aware of her predicament, that is, of being caught between polarized worlds. In telling Clare's story, Cliff accentuates the necessity of inserting Afro-Caribbean women's stories of resistance to fragmentation and exploitation in history.

Some of the lives left out of history, out of the official record, can never be recovered. They are lost in the "Middle Passage" of the slave trade, in the wide oceans between the western coast of Africa and the North American colonies to which, to paraphrase James Baldwin, they were brought in chains, at the bottom of boats. Such a loss of life and, by extension, of heritage is illustrated in *Abeng* in Cliff's story of the coffin unearthed from an Anglican, Jamaican churchyard:

A brass plate which had been affixed to the coffin and etched with an inscription informed the vicar that the coffin contained the remains of a hundred plague victims, part of a shipload of slaves from the Gold Coast, who had contracted the plague from the rats on the vessel which brought them to Jamaica. Others, many others, would have died onboard and their bodies dropped in the sea along the Middle Passage— the route across the Atlantic from Africa—or the Windward Passage—the route from the Atlantic to the islands of the Caribbean Sea. The people in the coffin had died in a *barracoon* in Kingston—a holding pen—a stockade. (1990, 8)

This discovery follows that of Clare's finding a trilobite fossil on a beach, which her father uses to explain to her "how insignificant was man" (8). Clare's development is hindered by her father's romanticization of man's place in the universe: there exists no connection in his mind, or hers, between the fossil and the coffin. Cliff's juxtaposition of the two events draws attention to the nonending cycle of extinction through the ages.

Trilobites are remains from the second Stone Age, the Paleozoic Age, which, according to my Webster's dictionary, "began with man's first attempts to shape tools and ended (in Europe) c. 8000 B.C." Distanced by time and space, the coffered remains of enslaved Africans imaged by Cliff in *Abeng* are dumped into the sea after their startling exhumation and become fossilized, forgotten, and "insignificant." Clare's father makes no such connection. He speaks of the Caribbean rising from the sea, "the process by which flat rock becomes peaks and slopes," of "myth and natural disaster," "extraterrestrial life," and passes on his world of make-believe to Clare, who, at twelve, does not yet question his erasure of the history of colonialism and of Jamaican revolts, which filled the mountains he could see (as he did all the Caribbean islands) only as "the remains of Atlantis, the floating continent Plato had written about in the *Timaeus*" (9).

The mountains of Jamaica, however, hold stories, mythic in their own way, and true, which may save Clare from being stripped of her own identity, as some of her African ancestors had been. Cliff writes:

> Nanny, who could catch a bullet between her buttocks and render the bullet harmless, was from the empire of the Ashanti, and carried the secrets of her magic into slavery. She prepared amulets and oaths for her armies. Her Nanny Town, hidden in the crevices of the Blue Mountains, was the headquarters of the Windward Maroons—who held out against the forces of the white men longer than any rebel troops. They waged war from 1655–1740. Nanny was the magician of this revolution—she used her skill to unite her people and to consecrate their battles. (14)

Maroon societies existed in Jamaica as early as the sixteenth century, at which time slaves began their escapes into the mountains and waged war on their oppressors (Layte 1992, 8). Although women are thought to

have been few in number in early Jamaican Maroon communities (Camp-bell 1988, 4), Nanny rose to the rank of leader of the Blue Mountain Rebel Town Maroons in 1720, shortly after fleeing the estate to which she and her five Ashanti brothers had been sent (Layte 1992, 9). Nanny, as Cliff has written, soon became an important link to the preservation of West African cultures, in which resistance, in the tradition of her Ashanti tribe, formed a central part. Hollander Layte, in her article, "Women Leaders: Nanny of the Maroons," states: "In time, Nanny became known as the wise woman of her town, passing down African legends, customs, music and songs to her followers, and instilling in them confidence and pride in their cultural heritage. Her influence had such a strong hold on the Maroons that to many of them it seemed supernatural" (9). Despite the signing of a treaty between the British and another Maroon leader, Nanny's "brother" Cudjoe,[5] Nanny herself refused to sign such treaties and continued to live in the folds of her community until the mid-1750s. Her resistance to British domination becomes emblematic for the process of Clare's decolonization, as Cliff provides Clare with a link to Nanny through her family history, uncovering the presence of nameless women who continued to resist long after Nanny's death.

The exploits of Nanny are not so far removed from Clare, who is told about her great-grandfather's land holdings but not the story of his "mis-tress," Inez, a young, part-Ashanti woman. Like Nanny, Inez is captured as the result of betrayal by one of her own, a *quashee,* as she attempts to procure a rifle for her Maroon father. Brought into Judge Savage's court for sentencing, he chooses to save her for himself: "He raped her for six weeks until he left on one of his trips to London. She was eighteen" (Cliff 1990, 34). At twenty, still the property of Judge Savage and his sexual slave, Inez finds herself pregnant and seeks out the help of Mma Alli, the Amazonian slave, another Nanny. Mma Alli "represented a tradi-tion which was older than the one which had enslaved them" (34). Mma Alli is the embodiment of the power of the erotic, as Judith Raiskin sug-gests in her interview with Michelle Cliff (1993, 70). She transmits Afri-can folk traditions as part of her identity as a woman who "had never lain with a man." She teaches other Black women imprisoned on the planta-tions to "keep their bodies as their own" (Cliff 1990, 35) in acts of resistance against their enslavement. Mma Alli helps Inez to abort her pregnancy and to find freedom, doing both as she transmits her ancient knowledge:

The women came to her with their troubles, and the men with their pain. She gave of her time and her secrets. She counseled how to escape—and when. She taught the children the old ways—the knowledge she brought from Africa—and told them never to forget them and to carry them on. She described the places they had all come from, where one-breasted women were bred to fight. (34)

Mma Alli dies shortly after Inez's escape in a fire Judge Savage set in the slave cabins on his plantation. But her memories live on in those she taught, like Inez, who survive the fire and move into the interior of Jamaica, following in the footsteps of Nanny and the Maroons.[6]

Clare's knowledge of her history remains clouded by the Britified education she receives at St. Catherine's School for Girls, where she learns little about the island's indigenous and slave history because it has been replaced with the apparently well intentioned history of the British Empire. African and Maroon revolutions on the island are reduced to the level of annoying disruptions of British power. Writes Cliff: "This history was slight compared to the history of the Empire" (30). And Clare is caught between two identities—British and Jamaican—one affirmed, the other denied: "England was their mother country. Everyone there was white, her teachers told her. Jamaica was the 'prizest' possession of the Crown, she had read in her history book. And she had been told that there was a special bond between the wild island and that perfect place across the sea" (36). That bond exists only in the racist imagination of her teachers and her father, who believe that Britain's influence on the island's indigenous people and the Africans they brought there as slaves has been to their benefit. Clare is taught to deny her color and to seek her future elsewhere, in Britain or in America, and, thus, to leave the past behind. But she cannot reconcile the choice imposed upon her—to choose between her mother or her father, the black or the white. Despite efforts to the contrary, she knows herself to be "both dark and light" (36). It is through her mother and grandmother that Clare find the roots of her multiply defined identity.

As in *Claiming an Identity They Taught Me to Despise,* Cliff places the potential for a return to wholeness in her female characters and, specifically, in her maternal figures. Kitty, even as she maintains an unsurmountable aloofness from her family, attempts to pass on to Clare a love of the land, of the Jamaica beneath the colonial mansions. Cliff writes:

Kitty had a sense of Jamaica that her husband would never have. She thought that there was no other country on earth as beautiful as hers, and sometimes would take Clare into the bush with her, where they would go barefoot, and hunt for mangoes or avocadoes out of season. Kitty believed that there were certain trees hidden in the underbrush which bore the fruit as they, the trees, wished—with no respect for ordained schedules, in a pattern not as God willed it. For her, God and Jesus were but representatives of Nature, which it only made sense was female, and the ruler of all—but this she never said. (52–53)

Kitty's respect for the land, though never spoken, is tentatively relayed to Clare through such journeys; in this way, Clare is taught what books will never teach her: the power the land holds to nourish, cure, and comfort. This power is clearly linked to the power of women who willingly gave themselves over to the cycles of the plants, which they knew would see them through the hardships of every season. Kitty's respect also extends itself to the people who survive in the countryside, especially the women with whom she came of age.

In fact, although Clare's name "signifies light-skinned, which she is, and in the worlds she knows, light skin stands for privilege, civilization, erasure, proximity to the colonizer" (Cliff 1991, 44), for Kitty's mother, her name stands as a reminder of a young girl she once knew, Clary, who cared for her when Kitty as a child had to be taken to Kingston for the removal of her severely infected tonsils. Away from her mother, and in pain, Kitty is forced to rely on Clary, whom Cliff describes as "not quite right in the head" (1990, 138), to survive her hospital ordeal. Clary, though sweet and simple, responds to the child Kitty under her care with devotion and understanding, "holding her hand night after night, singing to her, jumping up to get her cool water from the well out back" (141). But Kitty never tells Clare of her namesake. The silence that exists between mother and daughter hampers the transfer of knowledge between them as Jamaican women. It ultimately threatens even Clare's acceptance of her link to land and to the disprivileged women she sees on her journeys into the bush with her mother. It is Clare's grandmother, Kitty's mother, who provides Clare with a clearer path to the past and the opportunity to experience a childhood similar to Kitty's.

Miss Mattie, as she is called throughout *Abeng,* is well respected in

the Jamaican countryside. Born of a Black father and white mother, Clare's grandmother also occupies a position of "in-betweenness," but she has chosen her identity long ago. Miss Mattie's allegiances are to those of color in her family. As a child, she worked as a cane-cutter, suffering under the exploitation of the overseers (one of whom is her cousin), and learned to take responsibility for herself (142). Married to an alcoholic who refuses to take responsibility for supporting his family, Miss Mattie takes care of her own, whether they are directly linked to her or not, having learned in the process of her own oppression the need to take care of others when possible. Cliff writes of her: "Miss Mattie shared her home with homeless children and shared her family's food with people who had nothing but the enamel cups and bowls—their 'utensils'— they held up at her back window at meal time. She filled their utensils with yam, cassava, ackee—even chicken, if there was any extra" (137). Miss Mattie's life is directed toward the service of others at the same time she consolidates her identity as a "landowner." With a foot in both the "Black" and "white" worlds, Miss Mattie has chosen to be faithful to the "darkness" in herself, but her existence between these two identities— cane-cutter yet landowner—also results in her silence. It is not until adulthood that Clare will learn of the full scope of her grandmother's dual identity in relationship to her own conceptualization of home and homeland.

The role of the grandmother is crucial to understanding Cliff's vision of the Caribbean as she presents it in both *Abeng* and *No Telephone to Heaven*. In "Caliban's Daughter: The Tempest and the Teapot," she writes, "For me, the land is redolent of my grandmother(s) and mother. The same could be said of Clare Savage, who seeks out the landscape of her grandmother's farm as she would seek out her grandmother, mother. There is nothing left at that point but the land, and it is infused with the spirit and passion of these two women" (1991, 46). Clare's return to the land of her mothers takes place in *No Telephone to Heaven* (1987) after long absences in the United States and Britain, but in *Abeng*, where she is still on the land, but not of it, Clare's struggle takes the shape of attempting to grasp what knowledge she can of her mother and grandmother through her child's eyes. Her vision is clouded by the privileges she does not yet recognize in herself, but which both her mother and grandmother work to undo by attempting to bridge the gap between themselves and those who have far less. In Clare's childhood relationship

with Zoe at her grandmother's house, Clare begins to acknowledge the presence of difference in her life and the ways in which differences of class and color, and even sexuality, contribute to her sense of alienation.

The relationship Cliff creates between Zoe and Clare in *Abeng* is telling of her approach to the issue of multiple identity in the Caribbean. In many ways, the relationship is written to 'unravel' the colonization process Clare has undergone in school. Cliff also suggests that their differences may be bridged at the one level of commonality they have that is, their femaleness. Their connection is described in the following terms:

> This was a friendship—a pairing of two girls—kept only on school vacations, and because of their games and make-believe might have seemed to some entirely removed from what was real in the girls' lives. Their lives of light and dark—which was the one overwhelming reality. But this friendship also existed close to the earth, in a place where there were no electric lights, where water was sought from a natural source, where people walked barefoot more often than not. This place was where Zoe's mother worked for her living and where Kitty Freeman came alive. To the girls, for a time, this was their real world—their true plane of existence for two months of the year when all other things fell outside. (1990, 95–96)

It is the rest of the world that becomes invisible to the girls, who recognize in each other the possibility for friendship away from their schools, which teach them too well to mistrust one another in the absence of true knowledge of their history. Zoe, through her mother, is closely identified with Kitty and Mattie in their relationship to the land outside the world of Kingston, but, the absence of silence in her relationship with Clare marks new territory for Clare's development. Not only do they speak to one another about their differences, they fight to settle their arguments (100). With Zoe, Clare bridges the aloofness that characterizes her physical and emotional relationships with her mother and grandmother. Between the girls, communication remains an open, inviting door.

The difference between Zoe and Clare is based on color and class. Although Clare attends her school on scholarship, her status as a Savage, as a light-skinned, great-granddaughter of landowners, procures her a

place in the middle class, which Zoe, as the dark-skinned daughter of a market woman, can never achieve. Clare works hard to dispute this basic but important difference in their lives, but it emerges in their play when she decides that the two of them will kill a notorious wild boar, "Cudjoe," to gain access to the privileges given only to her male cousins. Zoe is immediate in her response as she is told of the plan: "'Wunna know, wunna is truly town gal. Wunna a go back to Kingston soon now. Wunna no realize me have to stay here. Wunna no know what people dem would say if two gal dem shoot Massa Cudjoe. Dem would talk and me would have fe tek on all de contention" (117). Zoe is aware of the impact the consequences of killing Cudjoe would have on her life. They would be crossing two lines drawn according to their sex and class; by taking on the role of hunters, both would be denying the differences ascribed to their sex, becoming aggressors rather than healers. Zoe, dependent on Miss Mattie's generosity, and her mother a renter on her land, cannot afford to break established cultural codes of behavior. For her, such an involvement would be seen as a form of insubordination rather than the act of courage Clare hopes to perform.

Cliff writes of Clare's response: "Clare was having trouble taking in all that Zoe said; she didn't want to believe it. She wanted them to be the same" (118). But they cannot be the same, at least in the plan Clare has devised to make herself noticed. Zoe, on the other hand, free of the blinding quality of privilege, sees Clare as limited; their relationship begins to fail. Zoe's thoughts reflect her disappointment: "She didn't think Clare had any idea of what being poor really meant. What being dark really meant. Why these things would always come between them. She cared for her playmate but she saw she was limited. Maybe Clare would someday come to an understanding of Zoe's part of the conversation but if she did, it would take her time" (119). Clare truly does not understand the depth of her difference from Zoe, but she gives up the hunt in deference to Zoe's concerns. Still, her lack of understanding ultimately turns their day into tragedy.

Instead of going after the wild boar, Zoe and Clare go swimming in Annie's pond—a watering hole where Kitty sometimes takes Clare on their journeys in the country. They bathe naked and Clare feels that "something had been gained" (119), because, like their male playmates, they can be naked together without shame. It is in this brief moment that the two come close to bridging the gap between them as they own the

right to their bodies much as Mma Alli would have taught them had she still been alive:

> Pussy and rass—these were the two words they knew for the space-within-flesh covered now by strands and curls of hair. Under these patches were the ways into their own bodies. Their fingers could slide through the hair and deep into the pink and purple flesh and touch a corridor through which their babies would emerge and into which men would put their thing. Right now it could belong to them. (120)

Lying intimately together on the rocks by the pond, Clare and Zoe are bound together by the gold and brown of their skins as well as the sameness of their sex.

Clare vaguely links her feelings for Zoe with the possibility of a lesbian relationship between them. She remembers an Uncle Robert, whose "dearest friend" was an African American man. The two were ostracized from the Savage family because of their relationship, not only because the men were gay but because color and class lines had been broken. Robert's friend was "the wrong skin color and the wrong nationality" (125). This difference Clare can understand:

> Now Clare herself had a dearest friend who was dark, but it would not have occurred to her to place those swift and strong feelings—largely unspoken feelings—she had for Zoe in the category of "funny" or "off" or "queer." . . . If Clare felt anything was wrong with her feelings about Zoe and her concern about losing Zoe's friendship—that those feelings should be guarded from family, for example—this would have originated in what she had been taught and what she had absorbed about loving someone darker than herself. (127)

Clare has been taught by her father to preserve her lightness. This can only be done, in his mind, through marriage to a white man, thus excluding both the possibility of her marriage to a Black or nonwhite man or the possibility of choosing women lovers, especially of a "darker hue." Clare has absorbed this lesson so well that she abandons the closeness she has with Zoe in the water and on the rocks in order to assert her privi-

leged identity. Attempting to protect their nakedness from the eyes of one of Miss Mattie's male cane-cutters, Clare menaces the man with the gun she had intended for their hunt. She drops her *patois* and tells the cane-cutter to get off her grandmother's land in the language of her British schoolteachers and her almost-white father, "relying on the privilege she said she did not have" (122).

Simon Gikandi understands the relationship between Zoe and Clare as an erasure of "the material signifiers of difference" through fantasy and childish make-believe. Gikandi interprets Clare's inability to maintain equality in her relationship with Zoe as as a function of the invisibility of her privilege. Furthermore, he believes that Cliff portrays Clare as a "schizophrenic who has failed to accede fully to the realm of speech and language" (1992, 249). Schizophrenia (again, according to my Webster's) is defined as "a common mental disease whose characteristics may include separation of the intellect from the emotions, inappropriate emotional reactions, distortions in normal logical thought processes, withdrawal from social relationships, delusions and hallucinations." Even metaphorically, Clare is far from schizophrenic: she does access both sides of her identity, the light and the dark, and processes her emotions through intellectualism. With Zoe, she is able to bring together her diverse identities through language, especially in her use of *patois* in speaking with Zoe about their differences.

In *Abeng*, Cliff uses *patois* primarily between the two girls and thereby distinguishes their union from the other connections Clare attempts to make throughout her childhood with her mother, father, cousins. Clare drops her *patois* when she asserts her privilege in defending Zoe and herself on the rocks and then, with her grandmother, when she is punished for her misuse of power. Gikandi misreads this second abandonment of *patois* as Clare's abandonment of Zoe and the potential of that connection: "When she 'drops' the patois in her final conversation with Zoe, Clare seems to have judged 'the distance between them as now unbridgeable'" (1992, 251). In fact, the phrase Gikandi quotes is Clare's thought about her grandmother whose shame over her granddaughter's behavior results in Clare's banishment from Miss Mattie's home and land. Despite the fact that Clare will soon have to leave Miss Mattie's to return to Kingston, she never betrays Zoe, protecting her from the punishment and shame only she herself deserves. And although she will never see Zoe again (a fact she has not yet processed), she leaves her with

words spoken in *patois*, believing still that "by the river . . . the two of them could erase difference" (1990, 124).

In language, this remains true. Their similarity is made visible both in tongue and color in the pond, where even Kitty can own an identity she is denied (and denies herself) elsewhere. The real dreamworld exists in Kingston—as Clare herself thinks (96)—where history is denied in order to maintain power relationships as they are. Gikandi characterizes Clare's privilege of color and class as invisible: "the power of these codes depends on their invisibility" (1992, 250), but it is in fact the contrary that is true. With Zoe, Clare moves toward history rather than to its dismissal, out of invisibility toward visibility, as she is forced to realize that her privilege *is* visible and her nonprivileged identities (her African and Maroon heritage as well as her father's lack of wealth) invisible. The relationship between Zoe and Clare has no outlet for development as a result of Clare's inability to acknowledge difference. By the end of the novel, she is further exiled from her identity, having been sent away from the land she has yet to fully appreciate.

Setting the Stage for Revolution

The relationship between Zoe and Clare in Michelle Cliff's *Abeng* calls to mind another literary work by an Afro-Caribbean writer who focuses on questions of class, sex, and nationality. Rosa Guy, in her novel of adolescence, *Ruby,* presents a relationship between two Black girls, through which she explores the possibility for understanding across difficult-to-overcome differences at the same time that she confronts homophobia, which threatens to strip the girls of their courage. *Ruby,* although necessarily limited in its scope as a "young adult" novel, addresses the issue of revolution and how Black girls, as they enter adulthood, can begin to identify for themselves a place in the struggle for Black liberation in the United States as well as in the Third World.

Literary analyses of *Ruby* have tended to negate the lesbian relationship at the center of the novel. Writers such as Jerrie Norris have attempted to gloss over it by emphasizing that the love between Ruby and Daphne is only a rite of passage, which both girls will outgrow as they establish autonomy from their respective families. Ruby and Daphne's relationship is in some ways representative of the sort of union that might have taken place between Zoe and Clare had they been older and more

knowledgeable about their own capability to overcome the barriers of color and class Jamaican society put between them. Ruby is eighteen and Daphne sixteen in the novel, and their relationship does mark their passage from childhood to adulthood, but not as a passing phase or fling: it is through their relationship that both girls are forced to acknowledge their differences and, hence, to confront their identities as Black women in an intolerant world. Norris suggests that "the conflict on which Guy focuses this love story would exist no matter who, or what sex, Ruby's lover might be, for the problem arises out of the ages of the protagonists and their family relationships, cultural backgrounds, and unique personality traits" (1988, 69). If this were true, then Guy must have been foolish to make Ruby's lover female in 1976. At the time, her publishers were concerned enough about the lesbian content of the novel to market it as an adult book initially, even though *Ruby* was the second of a trilogy Guy wrote for a young-adult audience. The tensions between Ruby and Daphne may be due in part to a lack of experience attributable to their youth, but it is also clear that Guy is illustrating the function of racism, sexism, homophobia, and xenophobia in the eventual decay of the relationship between the two.

When the novel opens, the Cathy family has recently emigrated from its Caribbean home island (which goes unnamed in the novel) to New York. Ruby is lonely and virtually friendless and exists in a half-world made up of remembrances. She attempts to make her present world like the old one through cooking traditional foods and keeping close ties to her father and sister. But after the loss of her mother to breast cancer, Ruby has been unable to reenter the world, especially the world of New York, which does not seem to want to accept her as a West Indian girl. For instance, she is taunted at school and called an "Uncle Tom" for helping a racist, elderly schoolteacher with her coat and cane every morning out of respect for her age. The other students see her as "un-American" but, more specifically as un–African American; Ruby is at pains to explain that her West Indian background demands of her that she place respect for age before race or class. For Ruby, there is no safe space in which she can exist within the parameters of her identity other than in her mind, through thoughts and memory.

Interestingly, Guy also utilizes the imagery of a watering hole to communicate Ruby's tie to her homeland and to its landscape, both of which are connected to her mother. Ruby muses:

Yes, I remember. . . . Mother and I used to go to the Blue
Basin . . . that blue, Blue Basin, where the branches of the
giant trees came together to cut out the sun . . . where wild
birds sang and small animals came to drink and cool off in the
coolness of the glen . . . where bright red and yellow and
orange flowers splashed against the dark green of the sur-
rounding bush, making the bush seem darker, mysterious . . .
and where the waterfalls tumbling into the Blue Basin kept up
that constant rhythm, adding to the mystery. (1976, 8)

In the Blue Basin, Ruby shared a closeness with her mother she can never
recapture, just as she is in no way able to return to her home island in her
current circumstances. In her father's house, Ruby is prisoner of her fa-
ther's sexism. He distrusts her growth out of childhood and into adult-
hood and attempts to limit her contact with and awareness of the outside
world. It is in her relationship with Daphne that Ruby begins to define
her independence from her father at the same time that she begins to
return home, toward a safe harbor.

In Daphne, Ruby feels that she has "found herself, a likeness to her-
self, a response to her needs, her age, an answer to her loneliness" (46–
47). But, like Clare, this groping toward completeness in another person
leads her to ignore their subtle differences. Although they are of the same
class, Daphne is better educated, independent, and uses a strong sense of
African American loyalty to distance herself from Ruby. Daphne is well
aware of her identity as a Black woman in the United States and links her
identity to that of the millions wrenched from Africa in the slave trade.
"Just think, Bronzie," she says to Ruby, "of all the people who were
uprooted from Africa and brought to the Americas. Never before has
such a vast number of people been displaced. We know that hundreds of
thousands of blacks perished in the middle passage. Yet millions of black
people, with roots that inevitably lead back to Africa, people in the Amer-
icas, are indigenous to countries as far-flung as Nova Scotia and Brazil"
(57). Despite such knowledge, Daphne is able to "other" Ruby and to
treat her as if her West Indian heritage marks her as inferior in the U.S.
landscape. For Ruby, says Daphne, there should be no dreams of college
and well-paying jobs. She tells Ruby that she is "just not college mate-
rial" (89) and misinterprets Calvin's sexism and homophobia for elitism
when it comes to his plans for his daughter. She says, "Your father is an

old-fashioned, West Indian blow-top—the typical primitive who thinks
that making it from a small island automatically qualifies their children
for world rule. You should be thinking of getting a job—going into
nurses training" (89). Daphne has other plans for herself.

Soon enough, Daphne, who throughout has attempted to bully Ruby
into "coming out," so that they can have their lesbian relationship in the
open, abandons Ruby to attend Brandeis, a wealthy private college,
where she intends to make a success of herself by "going straight" (179).
Daphne's vacillation between the love and the hatred she feels for Ruby
is an extension of her acceptance and hatred of her own self. Although
she espouses the need for revolution and Black nationalism throughout
the novel, Daphne is unable to accept that there will always be people
like Ruby's father to stand in her way. She decides to pass as an upper-
class heterosexual woman in order to escape the responsibility of support-
ing Ruby's growing self-awareness.

Guy demonstrates that Ruby's acknowledgement of difference be-
tween them is slow and painstaking, because of her overidentification
with Daphne ("Nothing is written on me, until I feel for someone like I
feel for you" [120]). She also shows Ruby's steadily growing awareness
of the choice she has made in loving Daphne. At the end of the novel,
unable to cope with, on the one hand, her father's rejection of her
choice, and on the other, Daphne's abandonment (which certainly mir-
rors, in her mind, the absence of her mother), Ruby attempts suicide.
Driven to despair by her lack of knowledge—of history, of family—Ruby
is continually misunderstood, and she misunderstands herself. Guy leaves
us at the end of the novel with an ambivalent heroine who knows only
that she has risked all to love another woman and she is not yet ready to
love again. Still, in the relationship she presents between Ruby and
Daphne, Guy interrogates easy categorizations of race, class, and sexu-
ality and posits identities that are not easily collapsible.

What makes *Ruby* such an important novel is the effort Guy makes to
show how silenced Ruby is within the contours of her own life. She
defines herself and is defined by Daphne rather than by the memories of
her past island life that haunt her. The novel is interspersed with her
thoughts, but seldom does she share them with any member of her fam-
ily or even with Daphne. Ruby believes that Daphne restores her happi-
ness, but their love ends tragically because she is unable to recognize that
Daphne holds on to the only privilege that can exist between them: that

Ruby is an exoticized island girl (hence her nickname, Bronzie), but also the daughter of a working-class West Indian man, while Daphne can claim to be the daughter of a revolutionary African American Nationalist, despite her own mother's working-class (waitressing) job. Guy's novel illuminates the fact that, even between Black women, difference is not easily overcome. It remains, however, that Ruby and Daphne would never have confronted their differences or their sameness without having had their lesbian relationship. In this, Guy has succeeded in affirming the potential of women-centered interactions, while still demonstrating their limitations without the support of a community or knowledge of the history of Black women's resistance to homophobia as well as to sexism. These limitations exist because Daphne and Ruby have no female role models to speak of.

The homophobia Cliff alludes to and Guy demonstrates in their novels is an accurate reflection of today's West Indian and African American societies. Homophobia is in evidence in a number of the books I have analyzed to this point. For instance, Joan Riley, speaking of her depiction of the sexually abused Hyacinth in *The Unbelonging*, says: "She wasn't one of these cardboard blacks who at the end either becomes a lesbian or suddenly gets blackness" (Roach & Felix 1989, 133). Although it is true that sexual abuse does not usually influence the sexuality of those victimized, Riley's comment points to the underlying homophobia in evidence in her novel, in which the one lesbian who appears is a hateful white girl who tries to pick a fight with her protagonist. Hyacinth, of course, having heard "about the bad things she did with girls" (1985, 74), stays out of her way. M. Nourbese Philip, in *Looking for Livingstone,* although she comes close to depicting a positive lesbian relationship between the Traveller and Arwhal through the poetry of her text, is unable to take the same position in her prose in *Frontiers,* where she renders lesbian relationships between Black women (or women of color) invisible. Toni Morrison, in *The Bluest Eye,* transforms her only West Indian character (Soaphead) into a child molester, a classification that she erroneously equates with homosexuality and attributes to his sense of loss and the dispossession of exile. In Beryl Gilroy's *Boy-Sandwich,* Tyrone's older brother is killed in a racist attack, but his mother places the blame for his death on his "gay" appearance without connecting the homophobic and racist motivation of his attackers; she contributes to his denigration in the novel. Riley, Philip, and Morrison

each refuses to admit the presence of gay/lesbian identity within the parameters of her own culture or race. Gilroy is more inclusive but fails to give her sole gay Afro-Caribbean character real human dimensions. These authors' lack of attention to positive portrayals of lesbian and gay Black characters thus contributes to the sustained homophobic intolerance that pervades our communities as well as mainstream society.

In "Redrafting Morality: The Postcolonial State and the Sexual Offences Bill of Trinidad and Tobago," Jacqui Alexander writes about the legalization of homophobic oppression in the Caribbean. She suggests that the Sexual Offences Bill of 1986, which criminalized gay and lesbian sexual activity and made acts of marital rape permissible, sought to establish heterosexual codes of behavior that have their root in the imperial and colonial past. She states: "An Elizabethan statute of rape institutionalized and legitimated violent colonial masculinity which took the form of rape but criminalized Black masculinity, thereby solidifying the cult of true womanhood and its correlate the white Madonna and the Black whore" (1991, 134–135). The Sexual Offences Bill reemphasized these gendered and racialized divisions in order to maintain domination over Black and (as Alexander stresses) immigrant Indian women: to heterosexual Black and Indian men, however, was extended the privilege of oppressing their sisters, wives, and daughters. Gays and lesbians, as well as single women whose sexuality was not visibly defined by unions with males, were denied privilege on the basis that they threatened what Alexander terms "the heterosexual contract" (138). Her essay points out not only the intolerance toward gays and lesbians but also toward women in general and the fact that such intolerance, translated into law, threatens the lives of those who transgress compulsory heterosexuality. This intolerance exists not only in Trinidad and Tobago but also in other Caribbean islands, like Jamaica.

In her essay, "Man Royals and Sodomites: Some Thoughts on the Invisibility of Afro-Caribbean Lesbians," Makeda Silvera writes of the two-pronged role of enslavement on the sexualization and domination of Black women in Jamaica:

> Under slavery, production and reproduction were inextricably linked. Reproduction served not only to increase the labour force of slave owners but also, by "domesticating" the en-

slaved, facilitated the process of social conditions by focusing on those aspects of life in which they could express their own desires. Sex was an area in which to articulate one's humanity, but, because it was tied to attempts "to define oneself as human," gender roles, as well as the act of sex, became badges of status. To be male was to be the stud, the procreator; to be female was to be fecund, and one's femininity was measured by the ability to attract and hold a man, and to bear children. In this way, slavery and the post-emancipated colonial order defined the structures of patriarchy and heterosexuality as necessary for social mobility and acceptance. (1992b, 23)

Black men and women could in the "post-emancipated colonial order," marry and have children together, not to meet the labor needs of their colonizers but to establish their access to rights not granted them under slavery. By extension, nonheterosexual unions were seen to threaten this newly acquired privilege, especially in Christian terms. Silvera does not underestimate the impact of Christianity on the colonies. She writes: "The importance the Bible plays in Afro-Caribbean culture must be recognised in order to understand the historical and political context for the invisibility of lesbians" (16). It is crucial, in the process of recovering our history, that we also remember the place of Christianity in our oppression, for, as Silvera points out, the Bible was used effectively as a tool of domination in colonization to support racist and misogynist ideologies.

Although Silvera does not address whether gay and lesbian sex is criminalized in Jamaica, she does record through oral history the presence of criminal acts directed against women who were, or were perceived to be (because they were single, independent) lesbian. She speaks to a friend of her mother's and her mother and grandmother to establish the presence of lesbian women in Jamaica. Her mother's friend tells her:

Crimes were committed against the women. Some very violent, some very subtle. Battery was common, especially in Kingston. A group of men would suspect a woman or have it out for her because she was a "sodomite" or because she act "man-royal" and so the men would organise and gang rape whichever woman was "suspect." (18)

Though each woman denies involvement with the women of whom they speak, each remembers their presence. For Silvera, this is what matters: that lesbian women in Jamaica be remembered as members of a wider women's community in which they were recognized if not always accepted. This, too, is part of the project of revising given history. Oppression meted out to race, color, class, sex, and/or sexuality contributes to the colonial conditions under which the Caribbean remains: in the writings by Afro-Caribbean women in the United States, such as Lorde, Guy, and particularly in Cliff's work, recognition and acceptance of diversity along these lines in addition to retrieving buried histories (especially female) of resistance in the Caribbean (and elsewhere) become the cornerstones for establishing a new process of decolonization and revolution.

In a recent interview, Michelle Cliff speaks of her character Harry/Harriet as the "most whole and sane character in *No Telephone to Heaven*." She has made him so in response to the homophobic society from which she comes. She says further: "I think to live in this world as somebody like Harry, you have be courageous, and he is, and he knows who he is. And Clare learns by his example" (Raiskin interview 1993, 69). Harry/Harriet defies easy categorizations. Like Clare, he is made up of diverse parts, each of which he acknowledges and embraces. Through his own experiences as a colonized child and child of privilege—Harry/Harriet is the illegitimate son of a servant and her master—Harry/Harriet understands Clare's feeling that "she is composed of fragments" (Cliff 1987, 88) but works toward synthesizing his own fragmentation: this synthesis takes place, not at the level of denial, of passing, but in the acceptance of internal and external conflict. Harry/Harriet is dark and light, Black and white, male and female: "One old woman, one who kenned Harriet's history, called her Mawu-Lisa, moon and sun, female–male deity of some of their ancestors" (171). In this character, Cliff outlines the possibilities for Clare's own acceptance of plurality in her self. Harry/Harriet is the vessel through which Clare is able to reclaim her homeland and her foremothers.

Harry/Harriet encourages Clare to "help bring us into the present" (127) in all of his letters to her while she is in exile in England, trying to come to terms with her colonial past. In her relationship with Harry/Harriet, Clares reestablishes her connection to her homeland and to her identity within that landscape. As with Zoe, Clare speaks *patois* with

Harry/Harriet, "breaking the taboo of speaking bad" (121), and feels to some extent at home. Along lines of sexuality, their relationship is rendered parallel to that Clare begins with Zoe: between them exists the potential of both erasing difference and affirming it. Harry/Harriet questions Clare on her sexuality, asking if she has ever been tempted by "loving your own kind" (122). Clare responds with some defensiveness that she hasn't, that is, that she does not think she has been tempted to have a lesbian relationship, forgetting for the moment her thoughts about Zoe years earlier. Harry/Harriet offers her the opportunity to meet "a marvelous woman. Older. Dashing. With endless breasts. From one of the finest families of Jamaica." Clare asks, "You?" She jokingly suggests that Harry/Harriet is offering himself,[7] and it is Harry/Harriet's turn to be somewhat defensive: "Don't be bizarre . . . but thanks. . . . Besides, sweetness, we are the same age" (122). The next day, Harry/Harriet takes Clare to a beach where "they could swim as girlfriends," and difference is erased as the two frolic on the beach.

Given the parallels with Clare's relationship to Zoe in *Abeng,* it is easy to interpret Cliff's description of the interaction between Clare and Harry/Harriet as a rendering of an intimate moment between two women: "Resting from riding the breakers, warmed by their feast and the sun, they lay side by side under a sky thrilling in its brightness. Touching gently, kissing, tongues entwined, coming to, laughing" (130). And though readers may be tempted to codify Harry/Harriet as a crossdresser, as a male transvestite, as a man in drag, as a gay man, as a "battyman," his decision to become a woman, despite his inability to procure a sex change, based on self-knowledge and a refusal of gender-based labels, reinforces such an interpretation. As Harriet, he, become she, will become a nurse reminiscent of Mary Seacole (171), taking care of the ill in an effort to restore health to the failing countryside. But restoring health to Jamaica is not simply a medical or bodily task; it involves restoring to Jamaica her history, her Carib, Ashanti, Arawak, British legacies. This is a process of decolonization that echoes that described by Audre Lorde in her poetry and evokes Mawu-Lisa as the source of Black women's power and identity and "tongues" as the symbol of women's erotic power. In becoming Harriet, Harry/Harriet claims an identity he was taught to despise, his femaleness as well as his colonized self.

In her creation of a character like Harry/Harriet, Cliff illustrates the possibility of extracting wholeness from colonial fragmentation. Harry/

Harriet accepts his fragmented identity and lives with contradiction in order to reclaim his past as well as Jamaica's past. As a nurse, he becomes a true successor to Mma Alli and to Nanny. He learns African folk healing practices and embraces the wisdom of old women. But Harry/Harriet remains a part of an unflinchingly polarized community. Cliff writes:

> None of her people downtown let on if they knew a male organ swung gently under her bleached and starched skirt. Or that white powder on her brown face hid a five o'clock shadow. Had they suspected, what would they have been reduced to? For her people, but a very few, did not suffer freaks gladly—unless the freaks became characters, entertainment. Mad, unclean diversions. Had they known about Harriet, they would have indulged in elaborate name-calling, possibly stoning, in the end harrying her to the harbor—perhaps. (171)

Aside from the space Harry/Harriet has created for his own existence and Clare's—a world in which difference can be a point of strength rather than of despair—there is no safety to be found in their confirmation of plurality. At a moment's notice, either of them could be rejected or betrayed.

Harry/Harriet is particularly poised for the betrayal each of the revolutionaries suffers at the novel's end. As a gay person in the Caribbean context, he occupies a forbidden space. Realistically, there is little doubt (given Alexander's and Silvera's observations above) that the freedoms Harry/Harriet procures for himself can be sustained. Lourdes Arguelles and B. Ruby Rich have written about the difficulties of privileging (in the sense of affirmation) gay identity in the Caribbean under capitalism, revolution, and socialist communism. Their collaborative essays focus on the gay male and lesbian Cuban experience before and after the revolution that propelled the Castro régime into power. Their intent is to "advance the discussion of sexuality within immigrant, minority, and émigré communities in general" (II [1985], 120). In my opinion, some of Arguelles and Rich's observations are particularly relevant to understanding the dimensions of gay and lesbian life in the Caribbean as depicted by Cliff.

Arguelles and Rich note that gays and lesbians in prerevolution Cuba were more tolerated than accepted and that many could find employ-

ment more easily in tourist-related businesses than in other forms of employment, since homosexual activity was still relegated to the fringes of Cuban life. Garnering their information from oral histories, they state: "Cuban homosexuals had preferential hiring treatment in the Havana tourist sector in order to meet the demands of American visitors and servicemen for homoerotic experiences" (I [1984], 686–687). Gays and lesbians employed in other avenues were subject to regular sexual harassment on the job. As expected, Arguelles and Rich find that lesbians in particular suffered under the double oppression of "misogyny" and "homophobia." During the revolutionary era, gays and lesbians were attacked by leaders of the revolution under the guise that they were contributing to "the evils of capitalist vice" (688). Gays and lesbians were forced to choose between their Cuban and gay identities, as if the two were incompatible. Some emigrated to the United States. For those who remained in Cuba, Arguelles and Ruby report that "class and class interests were perceived as more elemental aspects of their identity than homosexual behavior" (689). Ironically, in the United States, gay emigrants were also forced to hide their homosexual identities in order to survive. Many remained politically active, working to provide their Cuban communities with the political liberties granted other Americans. Arguelles and Rich write that "political work within the enclaves became more important by the day and thus created a de facto separation between them and the American gay community, just as their gayness continued to endanger their roles and efficacy in Cuban-American community work" (II [1985], 128). The authors note that being "out" in both the Cuban and Cuban American contexts is a luxury afforded primarily to those with class privilege.

Such is Harry/Harriet's experience in the Jamaican landscape. Harry/Harriet embraces a female identity, which others would deny him if they had knowledge of it; he also embraces the power of the erotic in its fullness, an identification that is inclusive of the gay/lesbian identity he shares with Clare. His choice is limited by the denial of sexuality difference that contextualizes his existence in Jamaica.

At the end of the novel, Harry/Harriet finds him/herself part of a movement to abolish oppression across differences of class, color, race, and sexuality. Each individual on the "No Telephone to Heaven" truck embodies some part of the Jamaican people, and for a brief while, together, they manage to extract wholeness from their imposed fragmenta-

tion in their single-minded purpose as they travel toward the site of their armed revolt. Yet, they are betrayed. Cliff has stated:

> The problem is that all of these people on the truck represent different parts of the Jamaican society and they've been brought up to distrust one another. And so that's why the revolutionary act at the end of the book is sabotaged by somebody and you never know who's done it. Somebody betrays them because they've been colonized to be betrayers of one another and they haven't managed to deal with that. (Raiskin interview 1993, 64)

The betrayal of Clare, Harry/Harriet, and the other revolutionaries is symptomatic of a society still deeply entrenched in the colonial mind-set, which demands that the colonized turn their backs on one another in order to pledge allegiance to their European desecrators. Still, Cliff suggests that the efforts of the revolutionaries, of Clare's process of returning from her exiled existence back to her grandmother's land, of Harry/Harriet's process of abandoning a life of privilege to serve the poor, at the same time they both affirm the various parts of their identities, have not been in vain.

Clare, along with the other revolutionaries, returns to the land through her death. Cliff writes, "Her death occurs at the moment she relinquishes human language, when the cries of birds are no longer translated by her into signifiers of human history, her own and her people's, but become pure sound, the same music heard by the Arawak and Carib" (1991, 46). The sounds with which Cliff inundates the final page of *No Telephone to Heaven* rise to fill the gap between Clare's old self and her newly recovered Jamaican identity. This end is strikingly similar to M. Nourbese Philip's *She Tries Her Tongue, Her Silence Softly Breaks,* in which Philip suggests that women writers of African descent will only shed the language of their colonizers, be they French, English, Spanish, or Dutch, by dismantling it until nearly nothing is left but the wordless language a mother gives to her newborn child. It is also reminiscent of Makeda Silvera's woman writer in "Her Head a Village," who acknowledges her island identity by remembering the calls of birds circling her grandparent's home: their voices fill her head, quite literally, with the sound of another time and place (1992a). In each of these stories, Cliff,

Philip, and Silvera link the return to the land with a return to wholeness and to femaleness. But is that return possible? When we take into consideration the very real revolutions that have been waged against colonial and neocolonial oppression, both at the hands of European powers and "indigenous" Caribbean powers (as was the case with Grenada discussed earlier in connection with Brand's poetry), the return home becomes complicated by the gap between the dream of repatriation to our islands and/or cultures and the actualization of that dream. In the final chapter, then, I turn to a comparative analysis of Michelle Cliff's work and her novelized depictions of communal insurrection in Jamaica and in the early-twentieth-century United States and Marie Chauvet's trilogy, *Amour, colère, et folie* (1968), which resulted in her banishment from her home island of Haiti. Particularly striking in a comparison of these two authors' works are the ways in which exile is configured as a psychic disruption of body and soul within the home cultures themselves at the same time that disruption occurs in states of exile such as slavery. The healing of that disruption is made possible through the reclamation of women's involvement in, and responses to, regimes of oppression at home and abroad: the act of communal self-definition beyond the individual identity, and cross-cultural coalition-building toward a socialist, dehierarchized social system both in and out of the islands. Further, both writers suggest that, though women's autonomy must be preserved, Caribbean men hold as much responsibility for future transformation as Caribbean women; that responsibility, however, must be realized with an appreciation and understanding of women's struggles in the broader, diasporic context.

$\mathcal{F}ive$

Exile, Resistance, Home

Retelling History in the Writings of Michelle Cliff and Marie Chauvet

Et ceux qui conservent intacte au fond
d'eux une lueur du soleil ne peuvent être perdus.
—Marie Chauvet, *Amour, colére, et folie*

Exile and Resistance: "Memory crosses memory crosses memory"

In their texts, Anglophone Afro-Caribbean women have given voice to the shifting qualities of exile, viewed not simply as the product of political expulsion but as a complex web of intricately connected levels of alienation. As a Francophone Afro-Caribbean woman, it is important for me to connect their visions to that of women writers from the French Caribbean, particularly from Haiti, though the political climate, historically and contemporaneously, is such that there exists a deep distrust in and among the Caribbean islands. This distrust, in my opinion, is responsible for the dearth of comparative scholarship to emerge from Caribbean studies. Nonetheless, when one takes a close look at the writings of Afro-Caribbean women across the islands, the stress on Afro-Caribbean diasporic feminist ideology is clearly in evidence. Here, I compare the work of Michelle Cliff to that of Haitian writer Marie Chauvet to discover the ways in which that ideology is made evident cross-culturally within the Caribbean. By comparing and contrasting Chauvet's and Cliff's artistic visions, a more comprehensive understanding of how oppression crosses

generational, cultural, and national lines and affects Afro-Caribbean women's capacity to achieve autonomy or self-determination in the Caribbean and abroad may be achieved. Such an analysis should also make clear that the question of exile needs to be reviewed with awareness of an alienation that occurs not only as a disjunction from ancestral African culture or Caribbean cultures, which are left behind in the search for economic or other freedoms, but as a component of everyday life for women within the islands themselves. Exile, seen in this light, is an insidious part of the marginalization of women at "home" as well.

Yet Haiti and Jamaica are very different countries: one French- , the other English-speaking, but both owing their cultural and spiritual roots to ancient West African traditions. Haiti gained its independence through a massive slave-led revolution in 1804; Jamaica, despite numerous similar revolutions, only obtained its independence from England in 1962. Both countries have an extensive history of *marronage,* that is, of Maroon communities (called *marrons* in Haiti) dating back to the sixteenth century, although Maroon communities are presently more commonly associated with Jamaica. Widespread acts of revolution emerged from these rebel enclaves, but the consequences of resistance to colonial powers were very much dependent on the political climate of the particular European country in control. The threat of losing Haiti as a stronghold in North America, both as a resource for natural products and as a gateway to the mainland (what we now know as the United States and Canada), led France to temporarily abolish slavery in 1793 (Plummer 1992, 12)— some two years after revolts had begun in Haiti and eleven before those revolts led to complete capitulation on the part of the French.[1] Britain, on the other hand, benefited from the losses France incurred in its colonies to secure its position as supreme colonial power in the Americas. Britain did not abolish slavery until 1839, after years of economic repression and reforms in foreign policy in the 1820s.

Haiti and Jamaica, then, have developed on separate trajectories of self-determination and in the present day remain divided by linguistic and cultural legacies, which still echo with the experience of European colonization over several centuries. Haiti is three times the size of Jamaica in terms of geography and population (Payne and Sutton 1993, 294–295), but, as is well known, Haiti is the "poorest country in the Western Hemisphere," having a gross domestic product (GDP) of $300 U.S., per capita as compared to $1,843 U.S. in Jamaica (for Haiti, of course, the GDP has

been considerably lower since the embargo of 1992). Despite these differences, the two islands are remarkably similar in their social and class struggles. Michelle Cliff and Marie Chauvet—both writing from exile in the United States (Cliff by choice and Chauvet through expulsion), explicitly acknowledge the importance of the Caribbean homeland for their female characters, but are realistic about the conditions in which women must live whether under slavery, revolution, or dictatorship. Each focuses on the role of women in both societies and how politically conscious women negotiate sexual oppression within social and class constraints. Finally, both authors also stress the importance of African spirituality in conflict with Christianity in Jamaica and Haiti and address the conflicts that remain as a legacy of racial and class distinctions based on color, family, and land ownership. They also demonstrate the necessity of men's involvement in the transformation of contemporary Caribbean societies by creating male characters who attempt to overcome class oppression; what is telling about these particular aspects of the stories they relate is that the male experience depicted is completely focused on the nationalism/class identity problem. Chauvet and Cliff complicate the nationalism/identity paradigm by also showing these male characters struggling to regain the wisdom of their grandmothers whom they associate directly with the Haitian and Jamaican landscapes respectively. It is, in fact, from this juxtaposition to women's perspectives that the men's stories take on holistic significance: only by realizing the different relationships that women and men have to the land of their birth will there be some hope for establishing a *common* ground, one which especially recognizes the greater range of oppressions endured by Caribbean women. Finally, these texts bring us back to the works I discussed, in Chapter Two, by Afro-Caribbean women writers in Britain in that they affirm the need for reconnection to our fore/grandmothers and the ancestral Afrocentric knowledge they represent. In this pursuit, they reclaim "Sycorax" and abandon the myth of Caliban, for Afro-Caribbean women's search for freedom and dignity is focused on the reclamation of self, spirit, and body in light of a buried history rather than on appealing to oppressive powers for a recognition and affirmation that will never, in truth, be freely granted.

Interestingly, both Cliff and Chauvet have been criticized by Caribbean scholars for their realistic portrayals of women's oppression in the Caribbean and for accentuating the effects of colonization on the psyche

of men and women in societies that remain deeply governed by the languages, education, and religions of their original colonizers. Chauvet, writing mostly during and about the years of the American Occupation and the ensuing dictatorships, including the Duvalier régime (1957–1987), made little or no use of Haitian *créole* in her literary works, which led to charges of inauthenticity, of having a *"tournure d'esprit française,"* by Haitian intellectuals of the period (Gouraige 1960, 446). In my opinion, the absence of *créole* in the trilogy I discuss in this chapter, *Amour, colère, et folie,* is no indication of Chauvet's lack of Haitianness precisely because the content of her work is directed toward confronting the contradictions of Haitian identity. Her book is extremely political and addresses the plight of those politically conscious individuals in the middle classes from which she came; she also connects their ambivalent position in a society based on color and class hierarchies with the plight of the less-fortunate oppressed classes. This focus was a further point of debate for critics who charged that her attempts to reconcile racial or cultural duality in characters who could not be easily classified or categorized were utopian (Gouraige 1960, 446) and that, therefore, they had little or no basis in actual Haitian life. And although Chauvet depicted the harsh conditions under which women of varying classes lived under dictators such as Vincent in her early books, her critics charged that her work lacked "force" (Pompilus 1961, 552). In fact, most of her writings remain unpublished. Some have suggested that the political content of her works and the repercussions that her political vision could have on her family still remaining in Haiti have resulted in the suppression of her writings. Her family, however, moved to suppress even her published writings, buying back all remaining copies of *Amour* from the French publishers (Yanick Lahens, quoted in Zimra 1993, 86).[2] Only recently has Chauvet been recognized as an important Haitian writer. Exiled to New York as a result of the political content of *Amour colère, et folie,* she passed away at the premature age of fifty-seven. Nonetheless, her works that have been published are testaments to her vision in recognizing the extent to which violence, against women in particular, permeates Haiti on both a political and personal scale.

Michelle Cliff has been similarly criticized, but conversely, for her use of *patois* and depiction of middle-class conflicts in Jamaica in works such as *No Telephone to Heaven.* In their introduction to the Heinemann anthology of Caribbean women's works, *Her True-True Name,* editors

Pamela Mordecai and Betty Wilson state, "The only one of the recently published Caribbean writers who does not affirm at least aspects of being in the Caribbean place is Michelle Cliff, who along with Rhys could be regarded as being more in the alienated tradition of a 'francophone' than an anglophone consciousness" (1989, xvii). Mordecai and Wilson appear to base their observations primarily on color and class. As they do so, they perpetuate the sense that color and class in the Caribbean are not only inextricably linked but remain barriers that keep individuals from crossing class lines and making valuable coalitions for change. Cliff, like Chauvet and a number of artists included in their anthology, is not out to whitewash reality but to present the possibilities for social transformation. The Caribbean has been and continues to be a place of contradiction, fragmentation, and distrust and a place where various forms of prejudice oppress a wide spectrum of individuals. Mordecai and Wilson are also under the mistaken impression that French writers have had more access to publication than Anglophone and Spanish women writers. Haiti, in fact, has the worst female-to-male-publication ratio in the Caribbean, and this has yet to change. Furthermore, Mordecai and Wilson never substantiate their association of Cliff with the "alienated tradition of a 'francophone' . . . consciousness"—they state the contrary of the Francophone women writers they have chosen for the anthology (xvi). They perpetuate the sense of irreconcilable difference that has long existed among the Caribbean islands and particularly with respect to Haiti.

The contempt with which Haiti and Haitians are treated in everyday relationships (social, economic, and the rest) by other Caribbean people and North Americans alike stands in stark contrast to the eulogizing of the Haitian revolution in literary and historical narratives. It is perhaps due to the fact that, since its unprecendented emancipation, Haiti has suffered volatile politics and oppressive régimes, which have sunk Haitians into an impossible economic stupor unbecoming to its glorious founding as a nation at the turn of the century. The editors of *Modern Caribbean Politics* attribute the perception of Haiti among the other islands to a response to the Duvalier régime, "As for Haiti, the prevailing view, certainly in the Commonwealth Caribbean, was concerned in maintaining its isolation for fear that, somehow, the Haitian virus of authoritarianism would spread and infect healthier parts of the regional body politic" (Payne and Sutton 1993, 9). If anything, the similarities between Cliff and Chauvet, as I see them, are due to an acknowledgment of the

isolation imposed upon their characters and the fact that the rejections they suffer arise from a social milieu intolerant of diversity. This intolerance mirrors that of those who have colonized the islands since the fifteenth century. The legacies of colonialism are for Chauvet and Cliff undeniable realities, which must be confronted in the writing of history and fiction in the language or languages that reflect the imbalances of power that remain an integral part of the Caribbean.

In addition to examining the relationship between land, spirituality, history, and class oppression, Marie Chauvet and Michelle Cliff explore issues of multiple oppression in the Caribbean from explicitly female and feminist points of view. In this respect, questions of exile and resistance are more fully addressed in their depictions of women struggling to come to terms with both their nationalistic concerns and their concerns as women within those particular contexts. Furthermore, both authors present the possibilities for resistance as represented by women through history: such resistance is revelatory of women's efforts to free themselves from prescribed roles as breeders, mothers, nannys, laborers, and the like. The intent of much of Chauvet's and Cliff's writings is to highlight women's roles in recognized class struggles in Haiti and Jamaica. Women's histories in the larger context are systematically obscured; within the Caribbean, the invisibility of women's historical (and everyday) social contributions is acute. Chauvet and Cliff work to highlight Afro-Caribbean women's presence in ways that force their readers to link their storytelling, that is, the sociopolitical dimensions of fiction, to already recorded history. As they re-vision past history, both create a space in which Afro-Caribbean women can be recognized as well as recognize themselves.

In her most recent novel, *Free Enterprise* (1993), Michelle Cliff pays particular attention to the cross-cultural relationships forged among women of the Americas in order to undo the damage done to indigenous and African cultures through slavery and colonization. *Free Enterprise* tells the stories of many peoples who, at the turn of the century, took part in rebellions engineered to free the enslaved and the colonized in the Caribbean and in the United States. The novel centers on the Harper's Ferry raid of October 16, 1859, in which abolitionist John Brown and collaborators were ambushed, wounded, captured, then incarcerated and hung. Cliff revises the historical record to show that what is largely remembered as the John Brown conspiracy was only a part of an intricate network of men and women working together across class, racial, and

national lines to bring about the large-scale liberation of the enslaved in the colonies. This network, and women's roles within it, is revealed through memory and letters, indicating that much of what is buried in the past can only be found through excavation of personal archives and marginalized existences. Cliff's two central characters, the African American Mary Ellen Pleasant and the Caribbean Annie Christmas, tell their stories in retrospect. Their attempts to "look back" present readers with the opportunity to link their activism to possibilities for the liberation of oppressed peoples in the future.

Cliff describes Annie Christmas as a woman in exile. Annie has entered the United States to escape her life, both privileged and oppressed, in the islands: in order to honor her rebel roots, she refuses to hold on to the life of privilege her mother offers her as a legacy of her almost-white skin. Writes Cliff: "Like Harriet, and Ellen Craft, and other runaway women she had come to know, she began her revolting behavior with her own escape" (1993, 11). In the United States, she joins with African Americans in their struggle for emancipation, taking on the struggle as part and parcel of her own. Her experiences at Harper's Ferry, though, have left her spirit broken, and we find her at the novel's beginning, residing in Carville, Lousiana, where she attempts to forget her past. Cliff describes her in this landscape as follows: "Never settled, never at home on the continent to the north, even after a lifetime in exile there, Annie Christmas thought of her island each day of her life" (20). At Carville, and in her associations with those afflicted with Hansen's disease, then better known as leprosy, Annie retrieves her island memories and begins to reconstruct the past in ways that help her to come to terms with the consequences of the Harper's Ferry raid and her involvement in the rebellion. Carville, as Cliff describes it, becomes a space in which she can begin to tell her story.

Although the choice of the leper colony for the setting of Annie's recovery may seem unusual, it operates as a metaphor for the character's exiled state. Cliff first introduces the colony by invoking the stigma attached to the disease of leprosy. She writes:

> Like many diseases to which the word *plague* is applied, leprosy carried (carries) with it a sense of retribution, payback.
> Carriers belong in the Ninth Circle.

> No one knows exactly how, or when, leprosy entered the
> United States.
> It is safe to guess that the disease flourishes among the
> darker races.
> When you read the literature on leprosy, also known as
> Hansen's disease, the search for point of entry into the U.S.A.
> appears as crucial as the search for cure, vaccine. (35)

In this way, Cliff not only reminds her readers that leprosy is still among
us, but that the history of how those afflicted by the disease were infected
is governed by a discourse of racism and blame. That history has a strong
parallel with the current discourse surrounding AIDS patients in the
United States.[3] For me, the parallel has all the more significance in the
Haitian context.

In the early 1980s, Haitian refugees as well as Haitian Americans
were openly discriminated against, as it was discovered that a few Hai-
tians were HIV positive, but they were not thought to have contracted the
disease by "traditional" means, that is, through gay sex, transfusions, or
intravenous drug use. In 1981, the U.S. Centers for Disease Control and
Prevention declared AIDS the disease of "the 'Four-H Club,' a shorthand
reference to homosexuals, Haitians, hemophiliacs, and heroin-users"
(Farmer 1992, 211). The CDC was aware that many (if not most) individ-
uals in each of the designated groups were not infected with the disease,
but nonetheless contributed to the marginalization of individuals in each
group by labeling them "people at risk"; by extension, those associating
with members of the "Four-H Club" would also be putting themselves at
risk. In his 1992 text, *AIDS and Accusation,* Paul Farmer records how,
despite evidence to the contrary, the inclusion of Haitians in the four risk
groups resulted in the perception that AIDS had originated in Haiti.

Since no initial links could be found between cause and effect when it
came to determining how Haitian AIDS patients had contracted the dis-
ease, it was concluded that they had it because they were Haitian. The
cause? *Vodou:* "North American scientists repeatedly speculated that AIDS
might be transmitted between Haitians by voodoo rites, the ingestion of
sacrificial animal blood, the eating of cats, ritualized homosexuality, and
so on—a rich panoply of exotica" (Farmer 1992, 224). Data developed
by Haitian American researchers and physicians in 1985 laid such theo-

ries to rest, as it was revealed that the earliest cases were sexually transmitted or transmitted through blood transfusions (222). Still, Haitians continued to be discriminated against, losing jobs, housing, and access to immigration (which was never open in any case), and this discrimination was sanctioned not only by the CDC but by the Food and Drug Administration (FDA), which prior to 1990 had "stipulated that Haitians who had reached the United States after 1977 could not donate blood" (218); in 1990, all Haitians were prohibited from donating blood, even though, by this time, methods for the screening of blood for contamination had been established throughout North America. As Haitians in the United States suffered racist discrimination under the accusation of being AIDS "carriers" (a term which had apparently not been widely used until Haitians were accused of having brought the disease into the United States), Haiti itself suffered its worst economic blow as tourism came to a complete and deadly halt by 1983 (213). If Annie Christmas were a woman alive today, then Haiti might be the place to which she would run, or perhaps to the camps where Haitians have been detained along the U.S. coast, like lepers (then and now), ostracized and demeaned rather than cared for and heard.

In "Telling It Slant: Personal Narrative, Tall Tales, and the Reality of Leprosy," Marcia Gaudet writes of the importance of stories and storytelling to those individuals who led a large portion of their lives in the inpatient hospital in Carville, Louisiana before the advent of successful treatment for Hansen's disease. Established in 1894, the Louisiana Leper Home (now known as the Gillis W. Long National Hansen's Disease Center) served as a home away from home for those afflicted with the disease. Those who entered it were associated with uncleanliness and sinfulness in the minds of those outside the facility's fence. Gaudet writes of the patients as misunderstood and alienated: "While being admitted to Carville, patients were encouraged to hide their true identities. Often not even the staff knew their real names. No identification papers were necessary to enter and often the home town was kept secret so the shame and ostracism would not extend to their families" (1990, 192–193). Although the patients were given numbers to "protect" themselves and their families from the attendant shame of leprosy, among themselves, identities could be revealed. Storytelling became a means of communication and communion among persons of a variety of backgrounds and experiences.

Gaudet's essay is primarily concerned with highlighting the relationship of patients to the outside world, which scorned their very existence. She notes that storytelling was used to insulate the patients from the pain of isolation and rejection by those with whom they came into contact outside the "Home." Gaudet writes: "These personal stories show both the traditional attitudes of the community toward outsiders and the personal experience of the teller with outsiders" (196). She writes further that "these stories were usually told within the community and that some of them could not have been told openly" (197). It is easy to conclude that the parameters of storytelling within the community could not have been limited only to those of patients' experiences with the Carville community at large; the fact that stories of confrontations with nonpatients were shared among them and kept largely secret suggests that a broader tradition of storytelling existed in the community.

In Cliff's *Free Enterprise*, the inhabitants of the leper colony tell each other their stories on a day-to-day basis in order to shed their numbers and reinstate their true names, lives, and histories. Cliff imagines the atmosphere in the Louisiana Leper Home in the following passages:

> Some passed up miniature golf, tennis, Bingo!; others, after a few tries, found these distractions tiresome, and lacked the manual dexterity or interest to sustain a game.
>
> For these story-telling became the major pastime, and, once discovered, was never relinquished.
>
> Stories of the original, outside world, and their place in it, were passed from mouth to mouth.
>
> Stories of the days in La Terre Lepraux, safeguarded by some of the old-timers among them, were released. (1993, 44)

Cliff also remembers their efforts to resist their forced incarcerations as the inhabitants broke out of the home, the colony, from time to time, and appeared outside to make their presence felt and acknowledged:

> Oral histories of lepers breaking out of the landscape into the City, terrorizing innocent people; lepers looting stores, leaving behind notes: "This is the hand of a leper"; lepers disrupting the auction block—mainstay of the city's commerce—jump-

ing onto the platform and kissing the auctioneer, appalling
the paying customers. No wonder the authorities were forced
to enclose them. They threatened the common good. They
were outrageous, anarchic. (44–45)

As Cliff describes them, the inhabitants of the Carville leper colony were
themselves involved in everyday acts of rebellion, as they denied their
erasure in their confinement and disrupted the surrounding community;
their acts not only made them visible but showed them to be disdainful
of the confinement of others to similar kinds of marginalizations. At the
auction block, they showed themselves contemptuous of slavery and of
the moneyed people who strove to maintain the institution of slavery as
those people also maintained the colony. It is to this world that Annie
turns in her own time of crisis.

In Carville, Annie attempts to isolate herself from her past, to forget,
and chooses to associate only with members of the Carville colony. This
choice is indicative of her need to recover memory, however painful that
process might be. In the colony Cliff imagines, storytelling revolves
around the recovery and sharing of experiences of colonialism: each sto-
ryteller speaks from his or her own particular cultural background and
tells how that culture has been affected by colonialization. Cliff has stated
that *Free Enterprise* is "about how people connected and worked as re-
sisters and collaborators to the slave trade" (Raiskin interview 1993, 57).
For instance, a Hawaiian man tells the story of his great-grandfather's
experiences with Captain Cook, which are engraved on a thigh bone, an
amulet he wears around his neck for remembrance. He speaks of his
people's initial acceptance of Cook and his men when they first arrived
on the island of Hawaii; soon, their hospitality turned into mistrust as
they came to understand the nature of Cook's visit to their home island.
He says: "Englishmen did not simply wish to visit us, to 'discover' us, as
they put it. They wanted to own us, and the islands, tame the landscape
to their purposes" (1993, 47). The Hawaiian man tells this story in his
great-grandfather's voice (48) as if the great-grandfather's departed spirit
lives on within him—and it does; he also tells his story using the collec-
tive "we," speaking for his people as well as for himself, wanting to re-
turn to them not only in the future but in the memoried present.

A Tahitian woman tells the story of her people's encounter with Cap-
tain Bligh of the *Bounty* and others who were involved in the slave trade

to enrich themselves and exploit the Tahitians. Conjuring up the images of Gauguin's fourteen-year-old Tahitian "wife" (whom he painted in 1892–1893 while visiting the island), the storyteller says, "Fletcher Christian and his men, it is said, populated their island colony by taking Tahitian women as their, so to speak, wives. Much is made in this version of bare breasts. The pale Englishman in thrall to the brown tits of Polynesia. We become fetish, drive them mad. They collect us in the flesh, on postage stamps, in their museums" (56). She adds, "What is not said, never, as far as I can tell, is that these women had husbands already, and in some cases children by their Tahitian men. But, just like that, Christian and his cohorts enslaved the Tahitian men. At gunpoint, of course. It was astonishing how easily these sailors were transformed into the lords of all they surveyed" (56–57).

Through this character, Cliff connects the enslavement of Tahitian women in concubinage to the exploitation of Tahitian men for labor: in both cases, the fruits produced are owned by the British colonizers, who use their guns to make themselves important and obeyed in the New World landscape they believe they have invented and discovered, rather than stumbled upon and visited. The Tahitian's story with the Hawaiian's and that of others in the colony form pieces of a whole. Annie adds her own voice to this web of history when she speaks of Nanny and of Alexander Bedward, "healer, prophet, asylum inmate, early Pan-Africanist, flying African manqué" (52), but she feels some distrust for the uses of storytelling so she remains silent about what has brought her to the colony.

It is in her relationship with Rachel that Annie learns the importance of preserving connections across histories and of the need to break with silence in order to make those connections through storytelling. She learns to revise history in order to let more of the truth emerge in a space where before it was never recognized. The two women talk about the uses of storytelling. Annie says: "Sometimes . . . too much of the time, I think all we have are these stories, and they are endangered. In years to come, will anyone have heard them—our voices?" Rachel responds, "Once something is spoken . . . it is carried on the air; it does not die. It, our words, escape into the cosmos, space." (59). Annie resists Rachel's belief in transcendence; she wants "to be heard here and now" (59), and Rachel reassures her that she is, for once a story is told among them, it lives in each of their memories. The stories, as such, became part of their

communal consciousness. They are responsible for keeping them alive out of respect for their ancestors as well as to ensure that the pain inflicted in the past, which saw their histories divided from island to island and culture to culture, cannot be repeated. There is strength to be drawn from releasing the truth to the air, as Rachel says: this means that what has been kept secret or dismissed or marginal has survived.

Rachel's own story is one of survival. She speaks of herself as one of the many Spanish Jews, *marranos*, who hid their identities in order to escape the Inquisition but were often then forced to live in exile; some came to the New World colonies. Rachel describes those who did as "following at a discreet distance behind the Niña, Pinta, and Santa María, in search of a new world, but for different reasons than the Admiral of the Ocean Sea, El Señor Colonización, as some of us called him" (60). Many of these "followers" settled in Dutch-ruled Brazil in the mid-seventeenth century; struggles for dominion in the colonies among European powers forced the Brazilian Jews to relocate throughout the Caribbean after the French took control of Brazil and other Dutch-owned colonies. Some settled in Surinam because of its proximity to Brazil (Roth 1959, 292); in Surinam, they were allowed to own land, slaves, and to take part in the sugarcane industry,[4] until attacks by the French and slave insurrections forced a number to flee the colony and settle elsewhere.

Cliff depicts Rachel, a descendant of exiled Jews landed in Surinam, much as she does Annie, as a rebel. Rachel speaks of her choice to join the rebel armies, Maroons of Surinam, as "focused on one thing, the cessation of the Trade" (1993, 183). Like Annie, Rachel remembers her own history of oppression in the persecution of her people during the Inquisition and colonization, but she also takes responsibility for the privileges gained from exile to the colonies. She recognizes that those privileges were not extended to the enslaved Africans and joins them, as Annie joins the abolitionists, in the fight for liberty and equality.

Fittingly, it is to Rachel that Cliff has Annie tell her story. Rachel wants to know "what did not happen" in reference to the Harper's Ferry raid of 1859. "What did not happen" is the story of those who collaborated in the insurrection at Harper's Ferry and are no longer remembered as having taken part in resistance to slavery before the Civil War; they are lost to the amnesia of the winners who record and transform history to maintain their positions of power in society. Annie begins her story to Rachel in this way:

"What did not happen, you ask? All I know is I was captured. Some were killed. Died in action. Were hanged under the law. Some escaped back to Canada. Mary Ellen managed to escape, barely, found her way back to San Francisco. John Brown is written down in the history books as a madman, fanatic, whose last sentient act on the way to the gallows was to kiss a black baby; none of which is true." (194)

Annie contextualizes the events at Harper's Ferry in terms of the activism that surrounded it on the part of Black men and women; she especially highlights the risks women took as they disguised themselves as midwives, as men of trade (blacksmiths and the like), to enter the South to help slaves to escape the plantations where they were held captive by arming them for rebellion. She also speaks of slave women's everyday acts of resistance, such as suicide and infanticide (193). For her part, Annie went South disguised as a cooper, hiding guns for the slaves; before she could reach her destination, word traveled that someone had betrayed them. She was trapped with the others who awaited word from their leaders, and her disguise saved her from certain death as she watched the murder of the women among them: as a man, she was "judged useful" (198).

Annie tells Rachel of Mary Ellen Pleasant's successful escape from the raid to return to San Francisco, where she continued to work for the emancipation of the slaves. Annie says: "That's where we went our separate ways. She kept the faith, kept on pushing. I withdrew." She sees a fundamental difference between them: " 'She was a liberator by marriage, and by inheritance. I on the other hand walked by myself, out of the place in which I was raised, and across a foreign landscape where, in my mother's words, I should not business . . .'" (199). Their real difference lies in the story Annie does not tell, in the story she tells to no one but to Mary Ellen. It is the story of her capture, of the discovery of her sex, of the memory of being forced to copulate with her coconspirators, the men on the chain gang: the story of her final degradation and humiliation. "There is a point of no return," she writes to Mary Ellen (209). And, "This is the story I do not tell" (210). These experiences, too, even though they exist within the confines of a fictionalized text, are part of the forgotten record. In Annie's story of exile, activism, and isolation, Cliff presents aspects of Black women's involvement in resistance to slav-

ery, which are not remembered in history save by the women themselves: the taking of risks, disguised and armed, forming coalitions across race and class lines to abolish slavery, committing suicide and infanticide to bring down the institution, being killed, raped, denied their humanity for having dared to use violence as a tool of liberation. Such women, in our official history books, simply do not exist.

Slave insurrections and rebellions did not begin at Harper's Ferry, as some historians have contended; the climate of the time was such that the events that transpired at Harper's Ferry were but an extension of already organized systems of resistance established by slaves and ex-slaves themselves, like Frederick Douglass, Harriet Tubman, and Sojourner Truth. In *Free Enterprise,* Cliff also reintroduces Mary Ellen Pleasant's name in the history of African American resistance, but does so by linking it to the efforts she imagines many more Black women would have made at a time when their active involvement would have been the only choice between life and death, liberty or enslavement.

Cliff has said of *Free Enterprise* that it is "about the history that's been lost to us of people who resisted, that there was a movement in this country of armed resistance." She continues, "John Brown was financed by a black woman—she gave him thirty thousand dollars in gold to buy fifteen thousand rifles, which he did. At the Chatham convention where Harper's Ferry was being planned, the majority of people there were black and they came up with a constitution which demanded a black state within the United States" (Raiskin interview 1993, 65). What remains recorded about the Harper's Ferry raid is often attributed to the efforts of white abolitionists whose aid in the cause for slave liberation is seen as somehow divorced from Black organizing in the United States.

At least, this is the view presented in works such as Jeffery Rossbach's *Ambivalent Conspirators: John Brown, the Secret Six, and a Theory of Slave Violence* (1982). Rossbach claims that, when Brown appealed to Harriet Tubman for financial aid, she "made no commitments to his venture, although she said he might obtain aid from Martin R. Delany, the Black nationalist who was living in Chatham, Canada West" (158). He goes on to say that Delany "agreed to set up a convention in early May where Brown could outline his plan to radical abolitionists residing in Ontario and recruit interested parties" (158–159). These comments do not explain why Tubman, for one, would go to her grave struggling "to establish the John Brown Home for the Aged," selling fruit and her biography

to raise funds for the project (Giddings 1984, 73). Neither do they reveal that the Chatham convention was largely organized and attended by Black activists from both sides of the border who would have been in the habit of meeting regularly. For Rossbach, the Harper's Ferry raid is the story of John Brown, his family, and his white, pacifist, abolitionist supporters, six men who helped Brown to procure funds for the raid.

In Cliff's historiographic text, Harper's Ferry is the story of many. But, as much of history relegates the activism of women to invisibility, Cliff works to bring Black women's involvement in the rebellion to the fore. In particular, she presents Mary Ellen Pleasant as the activist who, in 1866, may have been the first Black woman to openly object to the treatment of Black people on public means of transportation when she "sued the San Francisco Trolley Company after she was prevented from riding on one of its cars" (Giddings 1984, 262). Pleasant was a millionaire at the time, owing her wealth to the gold rush (73), but she is remembered by many now as "somebody who ran a whorehouse . . . who was called 'Mammy' Pleasant and who was a voodoo queen" (Cliff, quoted in Raiskin 1993, 65). Cliff revises this image and replaces it with the image of a woman whose background and political consciousness molded her into a woman of courage who used her access to privilege to enable others—Black women, men, and children—to secure the rights denied them under slavery.

Cliff connects Pleasant's activism to memory as she tells of her inheritance. Both her father and mother are resisters and they convey their history to her through storytelling. Cliff writes: "He needed to pass his version on. He needed to protect her from the world" (1993, 113). He does so by teaching her always to resist, even in the face of great odds. Her father's stories are the remains of the life of a man who infiltrated the slave trade with his own ship, which he used to liberate Africans rather than enslave them. For example, Cliff imagines Captain Parsons landing in Jamaica, where he is captured and imprisoned for conspiring with a Carib. It is here that Cliff inserts Jamaican women's resistance. Parsons's captors tell him of the women they have captured before him, whose leader is Mesopotamia: "They say she has a hole in her ear where the overseer nailed her to a tree" (118). Nailed to a tree for passing out wild cassava (an abortant) to slave women, Mesopotamia is long gone. Later, Parsons will discover the mark she, or women like her, would have left to encourage those not yet caught to continue in their struggles: the

sign of "the four moments of the sun," which Parsons cannot recognize. Cliff's invocation of Mesopotamia inscribes the history of Jamaican women's resistance in Parsons's memory, which he then passes on to his daughter, Mary Ellen Pleasant.

In "Searching for the Invisible Woman: Slavery and Resistance in Jamaica," Stella Dadzie notes that women's role in insurrection is often denied in order to affirm the stereotype of their "sexual promiscuity and collaboration with the planter class" (1990, 21). In her essay, Dadzie plucks from historical archives the essence of women's resistance to enslavement in Jamaica, as she describes suicide, infanticide, and abortions as common means of rebellion for women who used ancient African knowledge to secure their autonomy as best they could (29). Dadzie's claims are based on the historical evidence that enslaved African women were mistreated as cruelly as were men: in either case, labor and punishment for rebellion were enforced without regard for sex difference. Women were whipped as were men, were made to suffer miscarriages because of physical punishments, and executed. Dadzie writes of a notation by a Reverend Henry Coor, in his memoirs, no doubt, of "witnessing the nailing of a house-wench's ear to a tree for having broken a plate" (26). Women also had to endure what Dadzie terms "the added physical toll of pregnancy, lactation, childcare and domestic chores" as well as rape and sexual abuse (25). With these added responsibilities and gendered exploitation, it was common for enslaved Jamaican women to "dunbar" their slavemasters,[5] to "risk all in defence of their right to self-determination" (24).

In providing a window on this history in *Free Enterprise* through Captain Parsons, Cliff is clearly linking Mary Ellen's future to the past paths of resistance her father had encountered in his voyage to Jamaica. Although he is saved, ironically by his adopted, white son, who claims him as "lost property" (Cliff 1993, 121), the women whose marks have been etched onto the prisons walls are not. They remain alive through memory only.

Cliff's Mary Ellen also draws strength from the memory of her mother, and her mother's mother, who passed on to her knowledge of the African gods through stories of Yemanya, "mother of the seas" (128), and Shángò, the sky god (129). But Mary Ellen's mother, Quasheba, who was told such stories in her childhood, soon learns that the gods seem

powerless to deliver them from natural disasters (such as storms) and unnatural ones (such as the slave trade). Cliff writes:

> In the end they became beautiful stories, dazzling imagery, the stuff of bedtime excitement and children's language, figures drawn with a pointed stick in the sand—useless. A female riding the foam, swinging low on a chariot of *abeng,* in a blue garment flowing into the waves, alive with stars, could not hold her own. Against the endless canvas of sails, the passing of cargo, the genius for detail, this pretty picture was powerless. (129)

Still, the stories inspire the necessity of keeping a link with the past and of using the knowledge from African cultures to undo the conditions under slavery and colonialism, which render the power of the gods useless. Quasheba, sent to live on the U.S. mainland by her mother, learns "to forge gunmetal; she learned to make a decent firearm" (131); she teaches Maroons there the properties of metal and explosives as they engage in rebellions against the Southern plantocracy. Although Quasheba dies when Mary Ellen is only fourteen, she has already provided her daughter with a lived example of the possibilities for a woman's role in revolution. She herself has lived by her mother's stories of African gods in the belief that in her connection to ancient customs, the power lies within her to bring about justice for her people.

Unlike Annie, Mary Ellen has the ability to draw from the legacy of both her parents to sustain her in the face of defeat. She, too, is shaken by the failure of Harper's Ferry. Cliff imagines her feelings as follows: "The failure of their enterprise haunted her. At times a bitterness burned inside her, threatening to rise in her gullet and cut off her breath. She placed the origin of the burning in October 1859, when Harriet Tubman had been disregarded and Captain Brown seized the (wrong) day" (101). Looking back on that day, some fifteen years in the past, Mary Ellen, as Cliff describes her, is "a woman who travels first-class . . . a successful business woman in San Francisco, hotel keeper in that wide-open city, entrepreneur and woman of property" (100). Rumored to be all the wrong things—a madam, mammy, *mambo*[6]—Cliff writes that "in 1874, her collaboration has gone undetected" (102). Cliff uncovers her collab-

orative involvement in the Underground Railroad, in which she made use of her hotels as covers for slaves escaping North, and took personal risks participating in the Harper's Ferry rebellion as she exchanged thirty thousand dollars of her own money for gold, and headed to Chatham to deliver her help to Brown "wearing a jockey's silks. Disguised" (107).

If *Free Enterprise* can be said to recast the past in light of the present, re-visioning given history in order to bring to the surface what has been forgotten but still survives in documents, letters, journals, and oral history, then "Amour" and "Colère," the first two stories of Marie Chauvet's trilogy, though set in a definable historical period, appear to be less accessible due to the acute absence of female names remembered in the literary and social history of Haitian women. The disconnection between Haiti and the United States, aggravated by the American Occupation in the early twentieth century, makes it nearly impossible as well for Chauvet to make the sorts of cross-cultural connections described by Cliff in her novel. Furthermore, the two texts are distanced by the authors' approach to issues of sexual violence, especially that directed toward women. Cliff's descriptions of violence, physical and sexual, are told from somewhat of a distance. This serves to preserve the sense of hope Cliff sees as possible through coalition across barriers of class and color. Nonetheless, the preservation of that hope is at some level utopic and obscures the horrors that were lived by those formerly enslaved by European colonial powers and that continue to be lived today. Chauvet, on the other hand, forces readers to read, step by step, the extent to which corruption and vengeance paired with patriarchal domination serve to wrench apart the physical and psychological bodies of her female characters in particular.

By refusing to distance readers from the horrors of such violence, Chauvet resists the interpretation of her characters' violations as a metaphor for the "rape" of Haiti: the violence she uncovers and explores is a complex presentation of the effects of internalized exploitation, and self-hatred, as a *result* of colonization. It is also a reflection of a suppressed reality. Chauvet's envisioning of Haitian women in the trilogy is certainly traceable to actual events, but to document them is virtually impossible; in my opinion, the explicit elements of Chauvet's text in themselves act as documentation of unrecoverable historical occurrences. Like Cliff, then, Chauvet's trilogy is a rewriting or re-visioning of history, but it goes

beyond the retracing of historical events to present the inner world of chaos, which inhabits those lands where colonialism has yet to be deracinated. Her work explicitly demonstrates the need for the *déchoukage*, or uprooting, of Duvalieran terrorism in Haiti and reflects a political reality that needs to be imagined in its starkest terms in order to be understood and unraveled. The abuses of power that occur under totalitarian rule are vastly different in their scope from those that operate under the guise of societal sanction. The differences I see in the literary visions of Cliff and Chauvet, as well as between Chauvet and the other authors whom I have discussed throughout this work, are thus attributable to the fact that Haiti, unlike most of the other Caribbean islands (such as Jamaica, Trinidad and Tobago), has suffered under a number of dictatorships since its emancipation in 1804.

Chauvet's female protagonists live in an insulated, horrific world in which women are denied access to the means by which to control their own destiny. In "Amour" and "Colère," her central characters, Claire and Rose, attempt to empower themselves, but each is limited in her success by her class and by the political climate of Haiti. Those scholars who have attempted to examine Chauvet's political and feminist work in terms of her female characters have bridged this gap between the knowable and unknowable by transforming her characters into incarnations of the voodoo goddess, Erzulie; although such analyses are useful, they also demonstrate the extent to which women's lives in Haiti remain invisible. Chauvet, who voices the concerns of mixed-raced, middle- to upper-class women, appeals to readers' sense of historicity; her stories are contextualized in terms of inner Haitian politics post-occupation up until the Duvalier régime (1940–1960s). In them, women's lives are given center stage without accurate records to corroborate their experiences. Historically, Haiti cannot be said to have a Maroon Nanny, nor a Harriet Tubman, nor a Mary Ellen Pleasant, although such figures must have existed. Such women are not remembered in the largely male literature of Haiti or in the historical and anthropological case studies made by visitors/ outsiders: only voodoo and the woman invoked in it are.

I am not suggesting that Erzulie is not an important figure in Haitian *vodou*; she is associated with the Virgin Mary in Catholic theology for her purity and role as mother of the world (Desmangles 1992, 138), but also represents qualities of excess, such as wealth, passion, eroticism, jealousy, rage, and despair. Erzulie has many sides and incarnations. Maya Deren

has written of her as "the divinity of the dream, the Goddess of Love, the muse of beauty" (1970, 138). Leslie Desmangles writes that she "is depicted as an astonishingly wealthy upper-class mulatto woman of luxury" and that she "is believed to be preoccupied with establishing erotic liaisons with male *lwas* [*loas,* or deities] as well as humans" (1992, 132). At first glance, it seems that Chauvet may well have drawn on the persona of Erzulie to establish the psychological and emotional parameters of her characters in "Amour" and "Colère."

Claire and Rose are by definition "pure"—Claire in her role as spinster and Rose in her role as innocent young woman—but both are eventually to be found in erotic liaisons with men. Janis A. Mayes, for one, concludes that these similarities argue for the presence of Chauvet's conscious modeling of her characters on Erzulie. Mayes suggests that, "like Erzulie Freida, Claire turns sexual rage and despair into a meaningful political act" (1989, 85) and that "Rose evolves into a woman who, like Erzulie, sees man as an animal destined to suffer" (86). Deren and Desmangles, however, both suggest that Erzulie is seen by her worshipers as the goddess of luxury, as they ignore their own needs to satisfy her whims. In this respect, it might be said that Claire and Rose, who slowly evolve into a political and feminist consciousness (and it might well be argued that Rose does not have that chance), shed whatever Erzulian characteristics Chauvet might have invested in them: they renounce luxury, eventually, rather than cling to it, as they recognize that they have benefited wrongly from too much privilege. Furthermore, it is the fact that both characters have fallen prey to the abusive long-arm of dictatorship that forces them into "erotic" relationships, which are more complicated than simply allusions to "voodooism." In fact, both characters reject the *loas* and one, Rose, is subject, not to love but to hate through rape.

Chauvet's terms are political and feminist in ways that cannot be met, it seems, through the mere association of her characters with the *loa* goddess. Her vision has a depth charged with a realism that cannot be dismissed or subsumed under an analysis that merely shifts the ground from character to god, or from story to myth. Although her female characters may embody some aspects of Erzulie, the fact that they represent countless numbers of Haitian women whose stories have not been told should also be taken seriously. In this aspect, Chauvet's characters are explicitly feminist incarnations whose purpose is to render the real lives of Haitian women more visible, without romanticization.

Along these lines, Chauvet's story "Colère" is particularly difficult for readers to process outside the Haitian context. In it, Rose, the daughter of a middle-class Haitian family makes a bargain with a lawyer who is acting on behalf of a corrupt government to oppress the people of Haiti whatever their class background. She gives up her body in return for her father's land, which has slowly been disappearing piece by piece, as men dressed in black, soldiers of the government, have begun to subdivide it, apparently for re-distribution. The family's parish priest calls for passivity on the part of the parishioners, saying: "Il nous faut apprendre à nous soumettre . . . il nous faut apprendre à nous résigner, car rien ne se fait sur terre sans la volonté de Dieu" (1968, 220).[7] Most of the members of Rose's family reject the priest's claim, but few are in a position to change their decline from the middle class; Rose's mother is fast becoming an alcoholic, her father and brother are cowards hiding behind their books, her grandfather and younger brother are too physically weak to fight against the soldiers. Rose, at twenty, attempts to buy back her family's land with her body and with her father's silent approval: she has agreed to be raped for a month for the return of land they no longer own.

Chauvet describes the first day of Rose's rapes with clarity, conveying the horror of Rose's abuse with words which cannot be minimized. Her rapist tells her: "Tu es vierge, n'est-ce pas? Tu ne m'as pas menti? Je vais te faire mal, très mal, mais tu ne diras pas un mot, tu m'as compris? Pas un mot" (284).[8] Chauvet has Rose tell her story in her own words so that her oppression is subverted within the text itself though not escaped. She tells us: "Il s'enfonça en moi d'un seul coup terrible, brutal et, aussitôt, il râla de plaisir. Je mordis mon poing, de souffrance et de dégoût" (284).[9] The next day, the lawyer tells her that he will open her until he can ram her with his fist, as he also calls her his saint. If anything, it is he who transforms Rose into Erzulie, as he wants her to be both virgin and concubine; he also equates love with material wealth as he offers her luxury and jewels (290); he wants to both possess and worship her.

Rose's reaction is to play dead; she separates herself from her body in an act of unnecessary martyrdom. She explains, "C'est ma vengeance. C'est bon, n'est ce pas? me demande-t-il avec angoisse. Et les yeux fermés, j'ai l'air d'acquiescer. Que m'importe! Un mois c'est vite passé. Je me tairai, j'accepterai tout ce qu'il voudra. Il m'a fait saigner cinq fois et je n'ai pas crié. Ma complicité n'a pas de limite" (285).[10] Rose's attempt to recover her family's land only forces her into further collusion with her

own oppressors: she in no way frees herself from her repeated sexual violations, and the land is never returned to her father. Still, Chauvet shows through Rose's experience, as Cliff attempted to with Annie Christmas's, the risks of women's attempts to revolt against their oppressions. In this case, Rose is subject to rape because of her sex but also because she has not abandoned her privileges; as opposed to Cliff's Annie, Rose has not made a choice: she resists oppression and dictatorship only to maintain her family's class status rather than to liberate the poorer, nonlandowning classes. Rose embodies the political ignorance of the middle classes who must live through the horrors of humiliation and brutality at the hands of other Haitians before they realize their role in the unfolding political drama over land rights. Rose's brother Paul expresses the dilemma best when he says: "Ce que nous vivons, pour l'instant est si révoltant que nous n'échappons à nous-mêmes qu'en ressassant des idées de vengeance" (270).[11] Remaining only at the level of dreams or unfulfilled wishes of revenge, both Rose and her brother are condemned to suffer whatever comes their way.

Paul insists that he will kill the lawyer, dubbed "le gorille," repeating over and over: "I will kill him then I will die" (271), but fear keeps him from committing this act of vengeance. On her side, Rose questions her need to restore her father's land at all cost; it is in her own oppression that she begins to see the plight of those worse off than herself. She says, again in her own words:

> Je lutte avec la conviction que la justice n'est pas de notre côté. De quel droit possédons-nous des biens? De quel droit sommes-nous des privilégiés alors que d'autres pataugent dans la misère? La misère de ceux que mon paysan de bisaïeul a bien dû exploiter, la misère des pauvres qui pillaient son jardin et qu'il faisait fouetter sans pitié, la misère des mendiants qui ont endossé l'uniforme, la misère de celui qui se venge sur moi d'avoir toute sa vie été repoussé par les femmes qu'il désirait. Si je devais mendier moi aussi, un jour, si je devais me sentir humiliée, ne serais-je pas fière de voir Paul en uniforme, une arme à la ceinture? Je ne sais pas. C'est difficile de se mettre dans la peau des autres et je suis encore trop bien nourrie pour comprendre ce que peut suggérer la misère et la faim. (293)[12]

Chauvet thus describes Rose's growing political consciousness, but reveals it to be limited. Though Rose sees more clearly that the issue of her own powerlessness is based on color and the loss of class privilege and that those denied access to the kinds of privileges her family has long enjoyed have taken them by force, brutally, she still does not see that she has succumbed to a similar level of exploitation and humiliation.

At the end of the story, Rose's grandfather and little brother are gunned down in their backyard. Rose, after another night in her private hell, comes home to die. Very little has been gained. "Colère" is as much about one family's struggles under dictatorship as it is the story of those who have come into power and misuse it: on both sides, vengeance is the catalyst for resistance. Chauvet conveys a feminist analysis of the political climate by focusing on Rose's experiences at the hands of the new dictators; she reveals Rose to be limited by her class privilege at the same time that she conveys that the atrocities committed on her young body are hateful and irreversible, setting into motion a new cycle of anger and violence, which is entrenched in old wars over power and prestige. The players change, but the stakes remain the same.

In "Amour," the story which has received the most attention of the trilogy,[13] Chauvet presents a character who also experiences political growth, as she observes the cruelties inflicted across class by the government brutes. The story is set during the final years of President Sténio Vincent's dictatorship, 1939 and 1940. Vincent, by most accounts, was a corrupt dictator whose presidency was marked by the routine incarceration of dissidents and by the creation of a secret police (Abbott 1988, 52), which no doubt was a precursor for Duvalier's *macoutes*. Chauvet describes, through Claire, the atmosphere of terror that reigned in Haiti during this time among the middle classes. Claire is the oldest of three girls and the darkest of the three; her life runs in many ways parallel to Cliff's Clare in *No Telephone to Heaven* (1987) in that she, too, is the daughter of a father who would have preferred a son and who traces his roots only to his white ancestors through whom he has obtained his landowning status and its attendant privileges. And, like Clare, Claire is brought up to deny her African heritage, even though, in her case, the color of her skin makes it impossible for her to ignore the truth of her mixed-race heritage.

In her upper-middle-class family, Claire is made to suffer for the color of her skin. As she tells her story, Claire expresses the middle ground she

is made to inhabit and remembers a childhood in which her color made her appear out of place in the social circles her parents frequented (Chauvet 1968, 10). Her father in particular tries to keep Claire from forming friendships with girls of her own color, who are most often from the lower classes. In one incident, Claire is beaten for playing with Agnès, a working-class girl who spends much of her time at the home of an older man named Tonton Mathurin. Unfounded, vicious rumors circulate about the old man and the young girl, and Claire is compelled to befriend them both. She is punished severely for wandering out of her own class. After beating her, her father says: "j'inculque des principes et j'entends être obéi. . . . C'est une race indisciplinée que la nôtre, et notre sang d'anciens esclave réclame le fouet, comme disait feu mon père" (110).[14] Claire's father acknowledges his African heritage only to demean it, except when it comes to his landownership, which he believes is protected by the offerings he makes to the *loas* his grandmother once worshiped; he expects Claire to follow in his footsteps.

Filled with self-hatred, Claire cannot accept the worship of the *vodou* gods. She tells her father that she will never serve her grandmother's *loas*, and he responds by threatening, again, to beat her, while her mother tells her to be quiet because "ce serait le scandale" (116–117). At the same time that her parents reject her dark color, naming her Claire in the hope that she will grow into her name to shed her color and providing her with a French-Catholic upbringing, her father, especially, expects her to keep some link with the ancient African customs he was taught by his grandmother. For Claire, this is an impossible position, and she becomes isolated in her own home (her sisters are younger, lighter, and therefore deemed more beautiful) and in her class, without friends or suitors, as she is convinced of her ugliness and "backwardness."

Chauvet presents Claire's isolation as the source of her ultimate power. In many respects, her isolation is a form of exile, as she suffers from racism/colorism, sexism, and the legacy of her father's classism. Claire, at age forty, is very much aware of the political climate in which she has grown up and which has now turned on her and those of her class. For eight years, they have been subject to the whims of Calédu, a particularly brutal commander who raids their homes and kills indiscriminately. Claire wonders how many people he has killed, for many have disappeared without a trace; in her is born the impulse to resist. She says: "la révolte gronde en moi. Déjà je haïssais mon père de fouetter

pour rien les fils de fermiers" (15).[15] For Claire, the inhuman treatment Haitians are made to suffer under Calédu is no different from the acts her father has committed against individuals of the lower classes. Chauvet makes clear that one major difference between Claire's father's class-motivated hatred and Calédu's lies in whom they attack. Although on the surface, Calédu has taken it upon himself to disrupt the privileges of the higher classes, he attacks women more viciously and terrorizes the dispossessed.

Protected by the blinds in her bedroom, Claire observes Calédu's cruelty firsthand. She recounts one morning's horrors:

> Ça recommence. Ce matin, Calédu a matraqué quelques paysans. Il est en rage. J'ai assisté à toute la scène derrière les persiennes de ma fenêtre. . . . J'entendais chuchoter à droite, à gauche et parmi ces chuchotements s'élevaient à intervalles presque réguliers les jurons de Calédu, les cris de protestation, de douleur des paysans. (90–91)[16]

In her own class, Claire observes the battering and mutilation of a number of women who used to be her playmates. She overhears her family doctor, who has treated them all, say to her brother-in-law: "Nous avons affaire à un sadique qui se venge peut-être de son impuissance sur les femmes . . . il est aussi un aigri qui fait payer aux autres sa condition sociale" (69).[17] Calédu's viciousness is born of his own past oppression: now risen from the lower classes to assume a role of power as a commander of the state's police, he turns on those he sees as the purveyors of class inequities.

As Chauvet illustrates, Calédu's acts of vengeance are not limited to those who formerly oppressed him. He beats the peasants in the street because they have dared to go on strike for fair wages. He targets women in the middle and upper classes because he is the product of a society that views women as objects to be possessed, and light-skinned women, especially, as trophies of privilege. Calédu is after the *power* of his oppressors, not liberty or redistribution of wealth for the masses. Like his predecessors, Calédu only attacks the powerless, whatever their class status. In this respect, Claire's darker skin and the presence of her French brother-in-law protect her from Calédu's rage. Her childhood friends, Dora

Soubiron and Jane Bavière, single and without families, have no such "protection."

Through Claire's involvement with Dora and Jane, Chauvet presents her character's growing feminist consciousness. Dora and Jane are attacked by Calédu because of their class status but also because of their politics or lack thereof; Dora has no political consciousness and is flogged for her haughty disdain for the likes of Calédu, while Jane, a seamstress, is closely watched for seeming to conspire with political dissidents. Claire seeks out both women, even though they have been shunned by members of their class. A neighbor tells Claire about Dora's misfortunes as part of class gossip:

> Il paraît qu'ils l'ont estropiée. Tu l'as vue? J'attends encore que les choses se tassent. Eugénie Duclan, elle, l'a vue. En cachette, mais elle l'a vue. Elle n'a plus rien, là. . . . Ça doit être terrible. Elle a raconté à Eugénie avoir vu sa chair voler en éclats tandis que Calédu la cravachait, couchée sur le dos, les jambes ouvertes, maintenue dans cette position par quatre prisonniers, quatre mendiants pouilleux à qui il l'a ensuite livrée. . . . J'ai soixante-quinze ans . . . jamais je n'ai senti comme aujourd'hui planer autant l'horreur et la malédiction sur cette ville. (42)[18]

Claire does not wait for time to pass, nor does she see Dora secretly. As she sees Dora stumble in the streets one day, Claire descends from her look-out post to extend a helping hand, even though Calédu is passing in the street at the same time. Dora warns her to stay away, but Claire insists that she will visit her every day. Surprised at her own daring, Claire asks herself why she feared Calédu before this moment with Dora. Claire begins to acknowledge that she has the power to take control of her own life and, through it, the ability to watch over those women whose fates have been decided by Calédu's own cowardice.

Chauvet presents the sexual crippling of Dora as a question of power. The question of power and how it comes to be used within the parameters of the text centers on who holds power and why. Calédu's internalized colonized mind-set, his misogyny, and his thirst for vengeance are all turned against the powerless: Dora is chosen as one of his victims because she is a single woman. Claire recognizes this imbalance in power

and is thus better equipped than Dora (who clings to her privilege as to a shinking ship) to bring it to an end.

Jane, on the other hand, has been ostracized from Claire's class, long before Calédu's ascension, for giving birth to a son out of wedlock. For this, Eugénie Duclan, the true gossip among them, has called her a criminal (44); others think that she is a prostitute and confirm this image they have of her because of the men they see congregating in her house late at night. As Jane grows more and more unpopular with the frightened middle class, Claire decides to befriend her. She says:

> Jane Bavière a été mon amie et j'ai décidé de rétablir nos bonnes relations. Je l'ai déjà suffisamment abandonnée. J'ai déjà suffisamment applaudi des deux mains aux sornettes de nos bon bourgeois. Je m'élève contre. Il n'y a plus rien à faire. Est-ce parce que je la crois mal favorisée par la chance elle aussi? Toujours est-il qu'en sa présence, je me détends . . . ce qu'elle m'apprend d'elle-même avec une spontanéité que j'envie constitue pour moi la leçon la plus enrichissante que j'aie jamais reçue de la vie. . . . Je croyais l'inquiétude, la méfiance et l'aigreur la rançon du scandale. (44)[19]

Claire finds in Jane a compelling ally and learns from her the courage of leading an independent life whatever the cost or consequence. Jane also warns her about Calédu and his men and asks her never to return to visit, for it puts them both in danger. Claire, despite this new alienation, gains strength from her association with both Dora and Jane. It is for these women, as well as for herself, that she will later assassinate Calédu, whose death is desired by all.

Janis Mayes interprets Chauvet's depiction of Claire's act of resistance as a feature of Claire's Erzulian character. She writes:

> Claire's recognition and acceptance of the sources of her suffering provide her with enough strength and courage to confront her oppressions. Shaped to be lucid, pitiful and dangerous in the image of Erzulie Freida, Chauvet's character is empowered to alter the course of Haitian life by an act of murder—she kills a policeman who has terrorized the entire community across class lines. It is this murderous act that

> throws the character into balance by relieving her inability to
> function outside the realm of fantasy. (1989, 84)

In my opinion, it might be more accurate to interpret Claire's killing of
Calédu as a move toward self-empowerment, which she has learned, not
from the dimensions of her own oppression, but from other women's
oppression. Those women are the catalyst for Claire's act and force her to
confront the reality of the conditions under which women especially,
poor and privileged both, must live amid the terrors of dictatorship. In
this respect, Claire is far from being an incarnation of Erzulie, who is
noted for her jealousy and hatred of other women whom she sees as
rivals for men's affections (Desmangles 1992, 133). In her relationships
with Jane and Dora, as well as the faceless, nameless women she hears
being dragged through the streets by Calédu in the middle of the night,
Claire is asserting a woman-centered consciousness.

If Chauvet patterns Claire after Erzulie, it is only in her connection to
men through dreams, since within the parameters of "Amour" she has
none of Erzulie's powers of attraction or the devotion of men. Even
then, Chauvet subverts what could be perceived as traits of Erzulie by
bringing those dreams to a brutal and irreversible end, which drives
Claire farther away from the men of her dreams, Calédu and Jean-Luze.
In *Divine Horsemen*, Maya Deren writes of Erzulie that "she is the divin-
ity of the dream, and it is in the very nature of dream to begin where
reality ends and to spin it and to send it forward in space, as the spider
spins and sends forward its own thread" (1970, 144). In "Amour,"
Chauvet shows dreams to be an integral component of Claire's psyche.

Claire dreams of making love to Jean-Luze, her sister's white French
husband, and of becoming his wife. She says of him: "Un étranger à nos
yeux a toujours représenté ce qu'il y a de plus parfait" (1968, 77).[20] She
betrays that her attraction to him is based on the fact that he is white and
married to her white-skinned sister: a privilege or possibility that has al-
ways been denied her. Thus, away in her room, Claire secretly fantasizes
and dreams about the day Jean-Luze will choose her over both her sisters
(the other has had an affair with him), but she knows full well that this
can never become reality. At the same time, Claire has eroticized dreams
about Calédu; in one particular dream she sees herself, naked, chased by
a crowd until she reaches a statue she recognizes as Calédu by the size
and erection of its phallus. She dreams that the crowd pushes Calédu to

kill her, and he does. Claire wakes from the dream to link it to others she has had as a child of her father, transformed into a lion, whipping her as she searched in vain for a key to the cage in which she was held captive (145). This dream, unlike those related to Jean-Luze, does become reality except for the fact that the crowd is hunting Calédu and it is Claire who plunges her dagger into Calédu's flesh. Claire subverts the power represented by the phallus in a way beyond Rose's abilities in "Colère." With the dagger, Claire exacts revenge for herself as well as for the greater Haitian population. In so doing, she releases herself and women like Dora and Jane from the subjugation and violence of patriarchal and colonial domination.

Both Mayes and Marie-Denise Shelton have characterized Claire's murder of Calédu as an act of revenge upon her "torturer/lover" (Shelton 1992, 774). Mayes suggests that Claire commits the murder because "she is threatened by the loss of romantic love by Jean-Luze's decision to return to France" (1989, 84). Claire thinks about murdering her sister, not Jean-Luze, to keep him at her side, but, when Jean-Luze finally is in her arms, as he congratulates her for having had the courage to kill Calédu, Claire pushes him away. Even she is surprised as she leaves him to return to her room, claiming that she is tired: "Est-ce moi qui ai prononcé ces mots? Est-ce moi qui l'ai doucement, très doucement repoussé?" (1968, 187).[21] Chauvet has brought Claire through a complete metamorphosis by the end of "Amour." Where once Claire was obsessed with the limits of her own privilege, she has forgotten herself to free others. Where once she feared authority, she has used Calédu's fear to empower her to turn her dagger from an act of revenge and jealousy to one of justice and courage. Sitting on her bed, with the blood of Calédu on her hands, Claire is brought face to face with reality, and she renounces the two men, one white and one Black, who both represent, for her, racial, sexual, and class oppression.

Home: Land and Spirits

The connection to land is of particular importance to both Chauvet and Cliff. In both Jamaica and Haiti, class privilege depends to a large extent on the ownership of land. Although the abolishment of slavery opened the doors to the possibility of landownership for all, land continued to be allotted according to race, color and class. Europeans contin-

ued to own large tracts of land (though they often became absentee land-lords), followed closely by those of mixed race—the mulatto elite as they have been called in Haiti and the "coloureds" in reference to Jamaica. Ex-slaves followed behind. Land is therefore closely associated with gradients of privilege. Chauvet and Cliff explore this association and link it also to the history that has been played out on that land in various manifestations of resistance to slavery and oppression. By doing so, both authors make an undeniably political statement about the need to restore the land to those who, forgotten by history, are most deserving of its fruits.

Two concepts may be of use in approaching the connections between home and land as expressed by Cliff and Chauvet, "ruination" and "*déchoukage.*" In her essay, "Caliban's Daughter," Cliff defines ruination as follows:

> *Ruinate,* the adjective, and *ruination,* the noun, are Jamaican inventions. Each word signifies the reclamation of land, the disruption of cultivation, civilization, by the uncontrolled, uncontrollable forest. When a landscape becomes ruinate, carefully designed aisles of cane are envined, strangled, the order of the empire is replaced by the chaotic forest. The word *ruination* (especially) signifies this immediately; it contains both the word *ruin,* and *nation.* A landscape in ruination means one in which the imposed nation is overcome by the naturalness of ruin. As individuals in this landscape, we, the colonized, are also subject to ruination, to the self reverting to the wildness of the forest. (1991, 40)

Both the opening and the closure of *No Telephone to Heaven* (1987) resonate with the implications of ruination as Cliff's characters, Clare and Christopher, emerge from their states of colonization to both claim and fall prey to the land. Christopher in particular is associated with the land in terms of religion and/or spirituality: his ruination is a reclamation of his birthright as an Afro-Caribbean man and envoy of God (as his name signifies), but it is also the source of his ultimate demise for his part in both ruin and nation.

Déchoukage is a *créole* word meaning "uprooting."[22] It has gained wide currency as a descriptive term for the uprisings that followed the fall

of Baby Doc and, along with him, the Duvalier régime. In numerous murals, which were painted around Port-au-Prince in the aftermath of the ousting of Baby Doc, *déchoukage* is a constant theme. In his essay, "Revolution on the Walls," Alan W. Barnett reviews the murals in the Haitian capital and notes: "During Dechoukaj, a pair of clasped mulatto and black hands was frequently repeated on walls, a sign calling for the healing of the sharp divisions of Haitian society" (1989, 71). Not only was there an urgent call to alleviate if not eliminate class divisions, but there was an explicit connection made between the spiritual and the social. Many of the murals depicted social messages through Catholic images. For instance, Barnett notes that scenes of the Last Supper were often connected to Haiti's lack of food and basic resources for the Haitian underclass (71).

Other murals called for the *déchoukage* of *vodou*, associating *vodou* with the notorious *Tontons Macoutes,* many of whom were killed for their involvement in the Duvalier régime. Barnett seems confused by this mixture of positive Christian references and negative *vodou* images; based on the common assumption that Haiti is defined by "voodooism" alone, Barnett is reluctant to acknowledge the pervasive influence of Catholicism in Haiti or the fact that voodoo was used extensively by the Duvaliers (père et fils) as a tool of power and oppression for the past thirty years. Consequently, the *déchoukage* of *Duvalierisme* is appropriately connected to the uprooting of the brand of voodoo that was used against the populace by the Duvaliers during their reign of terror. This connection was best illustrated on the cover of the Haitian newspaper *Le Nouvelliste* (February 7–10, 1986) by a drawing of a tree uprooted by the masses with the head of Baby Doc for roots. As Barnett himself notes of the cover: "this image reflects the widely held voodoo belief in Haiti that powerful spirits inhabit trees" (1989, 67). Thus, *déchoukage* has significant meaning in terms of the people's relationship to class concerns, which include the redistribution of land and issues of spirituality. A transformation is needed and has yet to take place.

In retrospect, Marie Chauvet's story, "Folie," illustrates why the issue of *déchoukage* has arisen recently. There, a community of impoverished writers struggles to survive amid the anarchy of Duvalierism. At the heart of the story is a concern for the role of *vodou* in opposition to Catholicism, the role of the artist as opposed to that of the landowner. In their struggle to come to terms with such dualism, the writers continue to

resist domination, but do so with the intention of preserving what they can of their cultural roots. At the same time Chauvet reveals the deep distrust of *vodou*, which has permeated the consciousness of these politically aware writers, she also demonstrates their tireless attempts to preserve a spirituality untainted by the political antecedent of *Duvalierisme*.

In *No Telephone to Heaven*, Christopher's story is symbolic of that of the Jamaican underclass. Christopher lives with his grandmother in a shantytown "built by women and children" out of discarded packing materials (1987, 33). They survive on the leftovers of the middle and upper classes: Christopher's grandmother, like the other mothers in the makeshift town, rummages through hotel garbage for food. For Christopher, and other children like him, the land is a source of pain rather than hope, as they are forced to live off the excesses of others rather than the land itself. Malnourished and sickly, these children are victim of both the upper classes and the land, turned to decay and "mountains of garbage" (32). Christopher's grandmother remains hopeful and attends the Church of the Little Jesus with her grandson. Its pastor, Brother Josephus, recognizes in Christopher an inner light: he associates him with Jamaica, with the land's true origins, and thus as a "bearer of Christ" (37) sent to show them the way back to their African roots and, ultimately, to God. Brother Josephus invokes Haiti's past as proof of Christopher's divinity and tells his congregation:

> Mek me tell you of dis Black man who carry Christ amongst de Black people of Haiti. Christophe was de pure Black man who lead de Black people of Haiti dem against de mixed-up ones who want fe controld de Africans dem. Jus' like ya so in Jamaica. Christophe know, for Lickle Jesus tell him, him know well dat de ones who mixed, de ones who talk "my white grandmother" or "my English father"—dese ones carry Satan in dem blood. (38)

The pastor wants to persuade the congregation to replace the white Christian Christ they have inherited from colonialism with a Black one in their own image. Christopher, "the darkest of the three in the room" (37), represents most concretely this connection to the African past through color and to Haiti's King Christophe through his name.

Christopher, however, has no vital connection to his own past or to

history. Unlike King Christophe in Haiti who, as the leader of Northern Haiti in the early nineteenth century, had access to land as well as to the power to distribute that land as he established his monarchy in the high Northern hills, Cliff's Christopher has no land and thus no access to power. But, like Christophe, he chooses a path of resistance in order to reclaim his share; in this instance, Christopher claims the land for his grandmother whose spirit he wants to lay to rest several years after her death with a proper burial. Christopher attempts to obtain the land of his grandmother from his employers; they, of course, refuse him. Repelled by "the fat brown man in the big fat bed looking forward to a morning of golf at Constant Spring while his wife was at mass" (47), Christopher, under the watchful eye of his grandmother's spirit, kills the man, his wife, and his daughter as well as their housekeeper, Mavis. In his anger, Christopher kills Mavis the most savagely: "He cut her like an animal, torturing her body in a way he had not tortured theirs" (48). He punishes her for her complicity in his own unmaking, for having helped to keep him at the margins of this family, which had taken him in but despised him for his poverty as well as his skin color. She is more savagely butchered because, from Christopher's point of view, she has not only been complicitous with his oppressors, but she has also betrayed him as they are both of the same class and status in Jamaican society. Christopher is motivated not by greed but by the need to avenge himself and his grandmother: his power to commit these acts is sanctioned and made possible by his grandmother.

Cliff writes later of her characters: "the grandmother of Christopher . . . inhabits the Dungle, literally a garbage heap on which people lived. Here, the grandmother is all but bereft of power, except for the power to judge, to assess the worthiness or unworthiness of others" (1991, 48). According to the narrative, that power is channeled through Christopher. Cliff defines the grandmother in her novel: "Hers is a power directly related to landscape, gardens, planting when the heavenly signs are right, carrying her tung-tung, fallback, lemongrass to market . . . burying the placenta and umbilical cord, preparing the dead for burial, singing them to sleep, making sure the duppy is at rest" (1991, 47). For the absence of a proper burial place, the murder of one oppressive family is exacted as atonement, but it does not lay Christopher's grandmother's "duppy," or spirit, to rest. Christopher himself falls into "madness" as a result of having killed. He is still without land and without family; he continues to

exist at the margins of society as its conscience or reminder of all that has yet to be reclaimed.

It is fitting, then, that Clare, in *No Telephone to Heaven,* gives over her grandmother's land to the revolutionaries whom she joins in the attempt to bring about a revolution. It is through her experience that we are given a glimpse of Christopher's preempted potential as a revolutionary. Blinded by his (justifiable) anger at his forced disconnection from the Jamaican landscape he will never be allowed to "own," he cannot connect himself to a larger community of resistance. Thus, his actions have a limited resonance. Clare, ironically, finds this larger community by giving up her hold on the land, that is, to her privilege. The group in which she finds community is made up of a cross-section of Jamaican society; its members work together to reclaim the land which has gone "ruinate." Cliff writes, "Swinging their blades against the tough bush, some of them thought about their grandparents, thought: yes, this is for them too. And for their mothers: our mothers who fathered us when the men were called away or drifted off. Although we may never be able to tell those who are still alive. They may never know who we really were" (1987, 10).

The revolutionaries discover the land as it was long before Miss Mattie's time, bearing "Cassava. Afu. Fufu. Plantain." (11) and use their soldier garb as camouflage to blend into the landscape. As Cliff describes the land, there is a sense that it has also been taken over by African spirits like the forest god, Sasabonsam, who in the opening pages of the novel is depicted as "dangl[ing] his legs from the height of a silk-cotton tree" (9). By the end of the novel, Christopher, shedding his Christian namesake, will become "Sasabonsam," albeit on a movie location, in an unconscious movement toward solidarity with the revolutionaries who risk their lives on his behalf as well as that of other marginalized Jamaicans.

In the final scene of the novel, Christopher and Clare are brought together as both die in the foiled revolution attempt. Only in death are they united with the land they sought to reclaim through armed resistance. Christopher, become Sasabonsam, fills the air with his wails: "His howls became larger, longer—for a time his noise masked other noises" (207). But even the forest god is powerless against the betrayal that leads to all their deaths. He falls silent under gunfire as does Clare. Their deaths occur because others, like Christopher's employers and the film crew, which has invaded the land for a while, insist on confirming their

power. Yet it is the love of the land and the need to resuscitate the past that leads the revolutionaries to attempt insurrection. Though the revolution has failed, the participants have died together without class and color distinctions among them. They return to the land they have fought for, and they will continue to resist along with it into a ruination haunted by their spirits.

The kind of inner betrayals Cliff portrays in her novel is nothing new on the Haitian landscape. There, history gives testament to the irreparable breakdown of solidarity among Haitians as a result of colonization and the system of hierarchization of race, color, and class Europeans firmly implanted in their colonies. Despite successful grassroots revolutions and the placement of power in the hands of leaders born from the lower and darker classes, the experience of class fragmentation as it exists today in Haiti is firmly entrenched. For though leaders such as Toussaint, Dessalines, Christophe and even Pétion (who presided over the Republic of Southern Haiti from 1807 to 1818), sought to redistribute wealth and power in the former French colony, they still looked to France for social and economic models; the result was that the redistribution of wealth was limited and class distinctions strengthened. Haiti's history of revolts and coups is the legacy of the excesses of those who gained power, seemingly forgetting the people from whom they came and from whom their power was derived in the first place.[23]

Conflicts over power within the Republic are part of what makes Haiti what it is today, but those conflicts pale in comparison to the sort of domination Haitians had to suffer in the early to mid-twentieth century, during the American Occupation (1915–1934),[24] Rafael Trujillo's reign in the Dominican Republic, and ultimately, under Duvalier. Haiti's relationship with its closest neighbor to the east has always been a strained one. Conflicts over the border (land claims) and over the migration of Haitian workers fueled animosity between the two countries.

In the 1930s, economic conditions were such in Haiti that the vast majority of individuals from the lower classes sought employment elsewhere. Many migrated to the Dominican Republic, despite a 1929 treaty that consolidated the border between the two countries in an effort to bar Haitian immigrants. General Trujillo, who ruled the Dominican Republic as President from 1930 to 1938 and 1942 to 1952, was intent on ruling Haiti as well (Fiehrer 1990, 9) or removing all Haitians from the Dominican Republic. In "Political Violence in the Periphery: The Haitian

Massacre of 1937," Thomas Fiehrer states: "The literature of Trujillo's regime is peppered with vague references to supposed 'Dominicanisation,' a euphemism concealing plans to de-Haitianise the eastern side of the island. Moreover, the Dominican people generally feared Haitian invasion: their neighbour was overpopulated . . . and naturally spilled over into unoccupied Dominican lands" (1990, 8–9). In his essay, Fiehrer also states that, in 1937, some 200,000 Haitians lived in the borderlands between the Dominican Republic and Haiti; 52,657 were counted in the 1937 census as illegal residents on the Dominican side of the border (11); between 12, 000 and 20,000 of these Haitians were massacred by Trujillo in October of the same year (Fiehrer 1990, 1; Plummer 1992, 154). In his 1987 film, *Sucre Noir,* however, Michel Régnier has provided a much larger death toll of 40,000 deaths.[25] Whatever the numbers, the massacre went almost unnoted by journalists outside Haiti and the Dominican Republic—particularly silent was the U.S. government. Haitians working on U.S.-owned sugar plantations were unharmed, and the U.S. government issued statements to clear themselves and the Trujillo régime of wrongdoing (Plummer 1992, 155, 156).

The then-president of Haiti, Sténio Vincent, also colluded with these governments in order to hold on to his own power base, and "in a letter to Trujillo, professed disbelief that the Dominican government bore any responsibility for the holocaust" (155). Animosity and the exploitation and killing of Haitians continued on a less obvious scale for decades afterward. Though the rise of Duvalier should have changed the fortunes of the Haitian peasants forced to seek work in the canefields of the Dominican Republic, conditions only worsened. In 1966, a contract was signed between the two countries for the employment of 15,000 Haitian sugarcane workers to be sent to the Dominican Republic. In return for these laborers, the Dominican government promised to pay—and did—$1,225,000 U.S. to the Duvalier government (Lemoine 1985, 14).[26]

A world in which not even your closest neighbor can be trusted is the Haiti described by Marie Chauvet in *Amour, colère, et folie.* The setting for each of her three stories spans the years of the Vincent presidency and the era of Papa Doc Duvalier, in which distrust and loathing for Haiti's roots flourished in a way they never had before. Ironically, Duvalier came to power by stressing the need to respect the Black masses and return to the African roots of Haiti. Duvalier was born in a lower-middle-class family and became a doctor, working with U.S. army medical missions in the

1940s (Ferguson 1993, 33). In 1946, at a time when the Catholic Church conducted an ardent anti-*vodou* campaign, Duvalier published, along with Lorimer Denis, an essay entitled *The Class Problem in the History of Haiti*. Their essay, writes James Ferguson:

> set out to demonstrate that the traditional supremacy of the mulatto elite was, in the first instance, an ethnic rather than an economic phenomenon. The heroes of Haitian history— Toussaint, Dessalines, Salomon, and Estimé—were, they wrote, exclusively black; yet the elite continued to exert a near monopoly in financial and political terms. The moment had come, the book concluded, for a black middle class to force its claims and destroy mulatto hegemony. (32)

Duvalier was following the doctrine of *noirisme,* or *indigénisme,* adopted by intellectuals such as Jean Price-Mars, who had articulated the same position years before.[27] Along with this reassessment of Haitian history arose the need to validate *vodou* and its importance to the Haitian people. Duvalier once wrote: "'Voodoo . . . is spiritual because it proclaims the survival of the soul in sanctifying the spirit of the Ancestors'" (quoted in Abbott 1988, 54). It seemed, by electing Duvalier, that the people would regain access to their historical and religious roots. It was not long before Duvalier turned his connection to the people as a country doctor and his knowledge of history and voodoo against the Haitian masses, making himself president-for-life in 1964. Duvalier's dictatorship was a reign of terror, under which color became a definitive marker of class distinctions, although less-dark Haitians were not necessarily rich, just as darker Haitians were not necessarily poor; this was no different from the reigns of terror under Vincent earlier.

In "Folie," Chauvet describes the life of a young mulatto who has no place in the Haiti of Vincent or Duvalier, though he considers himself a revolutionary of the people in his role as a poet. René is the illegitimate son of a Black woman. At age fifteen, René's mother had been given to a rich landowner by her poor parents in exchange for a plot of land, and René was born of his mother's rape by her owner. His mother hoped to make an educated man of him, for although poor, privilege of color could give him access to the higher classes. René, remembering his upbringing, wonders when he lost his connection to his people (1968,

372), as he continues to struggle between the Black and the white, *créole* and French. The land itself is oppressed by the militarism of omnipresent soldiers. The story opens with René's description of the tarnished landscape of Haiti: "Un coin de ciel tropical bleu indigo capta comme par dérision mon attention; bleu indigo délayé d'eau qu'un peintre austère et silencieux, armé d'un gigantesque pinceau promenait, infatigable, à l'horizon sans fin. . . . Des balles sifflant à mes oreilles me fire rapidement rentrer la tête et refermer la porte" (335).[28] René is preoccupied with the need to take part in a revolution to bring the repression of the governing powers to an end. Educated only to read and to write in French, René has little else but words to offer; he struggles between *créole* and French to express the need to recapture the diverse histories of Haiti, that is, of both the Black and the white—the legacy of colonialism.

In an important passage, René invokes the names of Haiti's forefathers and questions their own rise to power. He says:

> J'ai écrit en français des vers sur Christophe, Dessalines, Toussaint et Pétion. Je me cramponne comme un morpion à l'héritage colonial. Pourquoi pas? Dessalines a-t-il cru le déraciner en hurlant:—Coupez têtes, brûlez cailles! Ses discours sur l'Indépendance, est-ce en créole que son secrétaire Boisrond-Tonnerre les avait rédigés? Et Toussaint? En quelle langue avait-il appris à lire pour rivaliser d'intelligence avec Bonaparte? (373)[29]

Language and religion are at the crux of René's marginalization. It is through both that he understands his link to Haiti's land and people, but his experience of colonialism through education prevents him from fully recuperating his heritage.

While raising him, René's mother insists on instilling in her son a respect both for God and for the *loas*. Before her death, she tells him: "Sers les loas de la famille et prie Dieu pour que ne rien ni personne n'ait de prise sur toi" (337).[30] René, however is unsure of the necessity of the *loas*, especially because of how he is treated in the streets of Haiti where he begs for money to survive. He says: "j'ai méprisé les loas et fui l'idée de Dieu. J'avais trop souvent faim" (337).[31] Hunger and fear are incompatible realities for belief in God or the spirits. He has also been taught to prize a Christian God over the *loas* of his mother by the Catholic nuns

and priests. For René, the prayers of his teachers are hypocritical, and he ponders the possibility of returning to the *loas* along with the other poets with whom he hides from the soldiers. But *vodou* is not a simple answer to René's dilemma. René remembers the mother of one of his friends, who, suffering from nervous attacks and mental breakdowns gave a *houngan* (priest) all her money for cures and blessings for her son. At her death, the *houngan* refused to lay the mother to her rest, accusing her of having betrayed the *loas*. René thinks, "Quelle est l'utilité d'une religion si elle accable au lieu de réconforter? Si elle désespère au lieu d'aider? Si elle réduit au lieu de sauvegarder? André s'est agenouillé et prie. D'où lui vient sont mysticisme? J'ai vu ma mère servir inlassablement ses loas et j'ai reçu de ses mains, froidement, l'héritage sacré. Je prie et j'invoque les loas avec la conviction que je joue la comédie" (367).[32]

Chauvet's poet is caught between the realization that his has been a colonized upbringing and that Catholicism has stripped him of his spiritual origins, and the fact that in the present Haitian landscape, a return to African spirituality may not be possible. For him, the devotions of his friends are futile, comedies, madness, for even the *houngans* are against their people, exploiting them for their money and blind devotion. René wants to be able to serve the *loas,* to be faithful at the very least to the memory of his mother, but his marginal existence prevents him from retrieving the past. He is simply not allowed to live, to look upon the Haitian sky without fear for his life. Like Christopher in *No Telephone to Heaven,* René wants to exact vengeance for himself and for his mother— as he says, to deliver Haiti from the claws of the devils (342).

In this story, Chauvet lays bare the impossible nature of René's existence and complicates the often-quoted demographics of Haiti's population, which separate out classes according to skin color as if overlaps do not occur. Differences in class are not racially based except in the case of white Europeans who maintain land or businesses in Haiti. Otherwise, especially during the Duvalier years, which gave rise to the consolidation of a Black middle and upper class, color became less important than class itself, but the two remained linked. René has entry in neither the mulatto upper class nor the Black elite: for both, he remains a pauper undeserving of their attention, whose education was a waste of time and an abomination. René still hopes for acceptance for himself and for his dark-skinned mother.

René attempts to channel his anger and his hopes through his poetry.

But poetry, for him, is explicitly linked to the colonial, to "une langue d'emprunt" (341)—a borrowed tongue. He feels suspended between his native *créole* and his colonial French and compares his feelings to the careening of a boat on the sea. The sea also reflects his own feelings of dispossession, as it seems to him to be furiously fighting against the devils: the Haitian soldiers armed with U.S. weapons. But the sea, he feels, is also against them, the Haitian people, for being passive and resigned (341). It is the sea itself, and the sky overhead, which pushes René to question the history and language behind his poetry, and then, the utility of poetry itself in the struggle for equality.

René's only allies are his friends, all writers, all poor, but of varying backgrounds. They are trapped in their hovel not only by fear but by the decomposing corpse of one of their friends who was shot down on their doorstep. They have only a bottle of *clairin* (the Haitian equivalent of "moonshine") to sustain them and their words. Soon, they are forced to face the fact that their words are useless to their immediate survival. René argues with another poet, Simon, who refuses to take up arms against the soldiers because of his own past as a soldier in the French army during World War II. Simon says: "Je n'ai pas envie de tuer ni de me faire tuer. J'ai envie de boire, j'ai envie d'écrire et de faire l'amour avec les femmes d'Haïti" (388).[33] Simon's laissez-faire attitude stems from a distaste for violence and even for the effort of resistance. His approach to writing is classical rather than political, stressing nostalgia for Haiti rather than the need for change. René's response to his friend's comment is to accuse Simon of having no love for his country and of being blind to the devils that have invaded it; he accuses his friend of being "white," because of his conscious ignorance of the plight of his people. Simon responds: "Ne soulève pas cette absurde question de peau et de race. Je suis ton frère par l'âme et le coeur. Tu le sais bien" (389).[34] The confrontation between the two men is symbolic of the change René wants to bring to the country through his poetic vision caught as he is between what is Haitian and what is French. Chauvet, through René, states the dilemma of her own position as a middle-class Haitian woman whose writing, though devoid of *créole* and traditional in style, affirms the necessity of preserving the diverse elements of Haitian culture but within an *indigéniste* consciousness.

In René's thoughts, Chauvet encapsulates the essential dilemma of color and class hierarchies. René is neither one thing nor the other, and

though he is despised and beaten because of the color of his skin (for the *macoutes* and soldiers) links him to the white and mulatto elites who oppressed their darker-skinned counterparts, he has never risen above the class of his dark-skinned mother. In a long passage, Chauvet relates René's anguish over his social position as he speaks to the spirit of his mother:

> Le commandant a levé son gourdin et il m'a frappé. Il a levé les pieds et il m'a piétiné. Il m'a craché au visage, traité de salaud de mulâtre, moi, ton fils. Il est noir comme toi, ma négresse de mère, mais il m'a pris pour un vrai de vrai, un mulâtre de dix-huit caras comme ils appellent dans cette province les beaux messieurs à cheveux plats, prétentieux, bourrés de préjugés. Est-ce à cause de ma couleur de caca-poule qu'ils m'ont persécuté? Est-ce à cause de ma couleur de noix de coco pourrie que je ne peux trouver de place ni à droite ni à gauche? Simon dit qu'il faut oublier cette absurde question de peau et de race. . . . La question de race mise à part puisque je suis noir aux yeux des blancs pourquoi le commandant a-t-il cru m'insulter en m'appelant mulâtre? Est-ce que je l'appelle nègre, moi? (395)[35]

René observes the fragmentation of the Haitian population in the politics of power. Clearly, race and color cannot be forgotten since power struggles are determined by both. Chauvet's character wishes that he were not singled out by his color and thus alienated from his darker-skinned people. He knows that his fellow poets have been spared because they can pass for white more easily than he can, that even Simon can deny his Haitianness because he presumes, as he prepares to pen a testament to Haiti (388), that he will be spared when the time comes. René, without class privilege, cannot affirm his own dark roots without being mistrusted, ironically, by the Black Haitians in power. Through his identification with his mother, René finds it impossible to deny his Black Haitian heritage and he continues to struggle for acceptance by implicating himself in the struggle for the liberation of the lower classes. He increasingly writes less and less because words have a limited power—especially in a country where freedom of speech is strictly controlled.

At the end of "Folie," René and his friends are held prisoner by the

soldiers, the devils he says plague both his imagination and his life. They have been arrested precisely because of words, for publications by poets unknown calling the populace to bear arms against the tyranny of their imposed leaders. René admits to having taken part in a conspiracy that exists nowhere but in the minds of the soldiers and in his own hopes for change. All those captured are killed, as have been many of the poor, children and market women, in the nights preceding the arrest. René is left with nothing but God, possibly the *loas,* an impossible faith. He cries, "Ah! Christ! . . . puisqu'ils vont nous attacher au poteau commes ils t'on cloué sur la croix et puisqu'ils vont cribler notre corps de plaies, fais que notre mort serve à quelque chose et empêche nos noms de sombrer dans l'oubli" (428).[36] Much like the ending of *No Telephone,* day breaks. But in this instance, René imagines himself and the others carried away on angels' wings to the skies. Though René's only progress is to move toward his death in "Folie," it is clear that Chauvet's writing of his story is meant to counteract the notion that poetry has no power; for one thing, René would not have been sought out in particular were he not feared as a poet; for another, without Chauvet's text, he would have found no life in our imagination. In this way, René, and those he represents—the dispossessed Haitians living between worlds, both privileged and poor, Black as well as white—enter the annals of history.

But what are we to make of the return to spirituality at the story's end? Why does Chauvet show René to have overcome his mistrust of religious fealty? And, is the return a Christian one or to *vodou?* At the root of "Folie" is a description of the fragmentation of *vodou* in Haiti, like everything else, it too is subject to the entrenched differences of class and color. Duvalier sought to strike fear in the hearts of Haitians through *vodou,* but he did not reinvent it. He strove to transform *vodou* into a religion of terror, but *vodou* cannot be owned by any one man. As Laënnec Hurbon suggests in *Comprendre Haïti: Essai sur l'État, la nation, la culture,* Duvalier tried to control *vodou* practices in Haiti by setting up his own core of *houngans* and by organizing his own religious meetings, which stressed the diabolic rather than the redemptive. He also infiltrated organized secret *vodou* societies in an attempt to make their already-tarnished reputations as bastions of witchcraft reality (1987, 152–154). Hurbon stresses that this led to some confusion in the societies, but that they eventually organized together against Duvalier's influence to bring down the dictatorship (154). Such alliances are reminiscent of Haiti's

Maroon heritage as well as of the *cacos* (descendants of the Maroons) who came together to resist the U.S. marines in 1915.

We must also be mindful of the fact that *vodou* is not a "pure" religion and has never been one. Since its beginnings, *vodou* has been an amalgamation of African beliefs and the practices of various African communities united under slavery in the French colony. Later on, after forced conversions to Christianity, mostly to Catholicism, *vodou* was transformed to mesh with Christian beliefs. Haitians found refuge from Duvalier's religiopolitical tyranny by turning to the Church, which was then forced to officially recognize the existence of *vodou* and the impact of its manipulation by the government, especially in the countryside where it has had its strongest following.

The Catholic Church, protected by its European seats of power (the Pope, for example), could resist the Duvalier régime more or less openly, and through it, the people could resist in ways that could not be co-opted, as Duvalier had attempted to do with *vodou*. The Church, however, did not remain immune to *vodou*, as the members of various societies entered its portals; for many, *vodou* and Catholicism were one or nearly the same. The Church, swollen with its new converts, would not turn them away, and neither would they denounce calls by the people to eliminate the many *Tontons Macoutes* who, by virtue of the adherence of some to *vodou* as *houngans* appointed or supported by Duvalier, became known as *loup-garous*, or werewolves. Hurbon considers this acquiescence on the part of the Church an admission that it shared (however much it denied it) the belief in the existence of witchcraft (and hence in the spiritual powers of *vodou*) in Haiti (1987, 118). Chauvet's "Folie" (1968) predates such conclusions, but describes the complexities and contradictions inherent in the collision, synthesis, and fragmentation of spirituality in the Haitian context.

Both Cliff and Chauvet foreground the importance of home and land in the Caribbean for those who do not belong in the middle to upper classes because of their color and/or class. Both make an explicit link between the marginalization of their characters (Christopher in *No Telephone to Heaven* and René in "Folie") and the power politics being played out in terms of landownership and spiritual ties. Spiritual, ancestral connections are tied to mother figures, mothers and grandmothers, and are shown to be inseparable from ancient African customs, which link dignity and prosperity with respect for the land. In systems where

the vast majority of Jamaicans and Haitians are denied access to land for their basic survival and are instead exploited for their labor, a very crucial cultural connection is severed, which is only recovered through active resistance. Christopher's violence and René's poetry both reverse the status quo; their acts of resistance are linked historically to those communal acts of resistance enacted on both the Jamaican and Haitian landscapes back to the time of the earliest Maroon rebellions. Divided from community, Christopher and René come to untimely ends; it is therefore their connections, however tenuous, to their grand/mothers that bind each to spiritual, communal legacies that remain a central component of Caribbean societies. It is through this ancestral memory that resistance will continue to be enacted, and it is at the point at which that memory becomes cherished in our present communities that the empowerment necessary for the dispossessed to overcome their imposed oppressions will be gained.

In this respect, both authors demonstrate what Lamming defined as one aspect of exile, the effects of colonization, when he wrote: "The colonised is slowly and ultimately separated from the original ground where the coloniser found him" (1959/1960, 159). For Lamming, this separation expresses the relation of exile, which emerges for the colonized as a function of living in tandem with "his" colonizers; both Christopher and René are subject to this relation. They have the power to overcome and end that relation through the reclamation of their grandmothers who, in effect, represent the repressed Afrocentric roots of Jamaican and Haitian society respectively. Furthermore, both their stories show that exile, in the Caribbean context, must be understood as an extension of a primary alienation from the West African coast, even though the ways in which Afro-Caribbean women writers have expressed that exile is focused on the Caribbean landscape of the islands and projected back (for the most part) onto that site of origin. Rather, West Africa stands as the understood place of beginning, as a site of memory, as the underpinning of Caribbean cultures as a whole. And, the Middle Passage, as Lamming has himself observed, is to be understood as "that night of exile" (155), the root source of an alienation that Caribbean writers have begun to repair in various ways in their writing throughout the twentieth century.

Thus, Afro-Caribbean women writers such as Cliff and Chauvet ultimately show that the issues that arise out of the condition of exile from

the Caribbean are many and complex. Exile has not only a geographical or physical dimension; it preexists emigration for many people of the Caribbean. Afro-Caribbean women in particular survive within the Caribbean under conditions of sexism that exacerbate racism/colorism, classism, homophobia/heterosexism in ways that result in social and/or psychological exile. Emigration adds to this alienation in the form of xenophobia and differing but similar forms of prejudice leveled against Black women and women of color in predominantly white European societies. Afro-Caribbean women writers, working from a point of exile from their home islands, have found it necessary to address both marginalization within the Caribbean and marginalization at large. At the same time as there exists a longing for home, there coexists a need to confront the realities of the conditions in which most women live in the Caribbean as a result of various prejudices and forms of economic and political repression.

Given the realities of civil rights abuses, which occur in states like Haiti where colonial power is only beginning to be deracinated, it has thus been important for me to come to a close with the above analysis of Marie Chauvet's *Amour, colère, et folie*. Unfortunately, Chauvet's writings, which are, for the most part, untranslated or out of print, cannot be read in a wider context of Haitian women's writings. Too few Haitian women writers have been able to find their way into print. In a country still fighting for access to the means of self-definition, self-government, and cultural determination, women often find themselves marginalized further than their counterparts in countries with more stable political climates. My own exile from Haiti has enabled me to secure a sense of my history and identity as a woman of African descent, but for the Claires and Roses of Chauvet's trilogy, women still very much alive in my home country, that possibility remains a distant dream.

In *Amour, colère, et folie*, Marie Chauvet illustrates the extent to which access to privilege has become a crucial dimension of Haitian identity. Her middle-class and mulatto characters all struggle to maintain a sense of their identities in a world in which race and color are no longer synonymous with class status. Her female characters in particular, like Michelle Cliff's characters in *No Telephone to Heaven* and *Free Enterprise,* subject to overt sexist brutality on the part of their respective oppressors, are able to bridge the gap between privilege and dispossession, as they work to resist various oppressions and to liberate themselves and their

communities from the clutches of those thirsty for power and wealth. Both authors also demonstrate that fragmentation is an implicit component of Caribbean identity: their characters most often occupy "in-betweenness" due to their color or class, and most attempt to rise above the limitations based on their sex by their societies. For this latter emphasis, Chauvet herself has paid a high price, as her book was banned in Haiti (Shelton 1992, 774), and the cold reception with which her works were received by the Haitian elite led to her exile in New York.

Alienation was not new to Chauvet, who depicted in the marginalization of her female characters the violent dimensions of exile that exist within Haiti itself, as Haitians are forced to distrust or oppress one another to survive or to maintain privilege. Cliff illustrates the same phenomenon, especially in her ending to *No Telephone to Heaven,* while still maintaining that all is not lost. The future can be recovered, before it goes the way of the past, through the acknowledgment of the roots of Africans' survival in the New World: collaboration and insurrection. In their texts, Cliff and Chauvet point out that this tradition can be continued in the present by laying claim to our own histories, however painful or horrific the memories may be. They do so through storytelling. Their words are revolutions in microcosm, inviting us never to forget and to have the courage in our communal consciousness to take up arms again. For oppression and colonization are by no means things of the past: they remain with us, alive and well, waiting to be quelled. Again.

\mathcal{E}pilogue

"Return"

The pleasure and paradox of my own exile is that I belong
wherever I am.
—George Lamming, *The Pleasures of Exile*

The great alchemy is your attitude, who you are, what you are.
When you make a photograph, it is very much a picture of your
own self. That is the important thing. Most people try to be
striking to catch the eye. I think the thing is not to catch the eye
but the spirit.
—Consuelo Kanaga, American photographer

Exile. Home. Return. These three words have been the driving force
behind the writing of this work since its humble beginnings. When I first
sat down to bring together the literature of Afro-Caribbean women in
exile in a book-length treatise, I had few critical resources on which to
rely and wrote in intellectual isolation in the Midwest. I had been in the
United States for all of three years, and it was in that displacement that I
came to realize that the condition of exile had brought me to a greater
understanding of the ways in which imperialism and colonialism have
shaped human relations.

It has become clear to me, as I have moved from one geographical
location to the next, that the key to effective progress is change, constant
movement. This is not a slow progress, it is not one too cautious for its

213

own good. Though it takes time for books to be written, then published, then read, it takes so much less time to react once those words have been discovered. Afro-Caribbean women's literature produced in exile has the ability to reveal both the state of the colonized and the colonizer. The islands they describe are not Shakespearean, the inhabitants thereof are not "Calibans." Their characters are patterned on the real efforts of the formerly colonized to shed the imposition of European languages and cultures, without denying the ways in which that imposition has transformed the ability to reclaim African origins. The state of exile, as reflected in these works, is one in which exiled persons have the privilege of looking both forward and backward—forward to a state of equilibrium wherein alienation from the self and the past will be brought to an end and backward to an understanding of where we have come from and how past generations have sought to prevent the struggles with which we are faced in the present. They reclaim "Sycorax," the dead, silenced, and forgotten mother of Shakespeare's Caliban, to say only that there should be no dead, silenced, forgotten foremothers among us, for it is they who provide us with a guide to a memory that will transform our forward motion. In reclaiming these foremothers, we reclaim ourselves and repair the fissures caused by distrust, economic and political turmoil, as well as the process of emigration. We repair the generational disruptions that have by and large fueled the repetition of the cycles of abuse directed at the youngest and most fragile among us, especially girl children.

Ultimately, what these works show us is the necessity for creating a wider range of coalitions among and beyond ourselves. As I have sought to show in the final chapter in this book, comparative analyses of literature produced by Afro-Caribbean women from different linguistic backgrounds can clarify the points of connection and disconnection among the diverse Caribbean islands. Further research should deal with the wide gulf that appears to separate work bridging the Anglophone, Francophone, Spanish, and Dutch-speaking Caribbean. Though more work has been produced recently dealing with the first two linguistic groups with the emergence of writers from Francophone backgrounds who either write primarily in English (such as Haitian American Edwidge Danticat) or have had their works widely translated (as Guadeloupean writer Marise Condé has), more needs to be done in coming to some understanding of the Spanish Caribbean in the Caribbean context rather than (as is currently done) as the extension of Latin American, Chicano, or U.S.

(Puerto Rico is a case in point) cultural politics. The Dutch-speaking writers appear to be the most alienated of all, but perhaps more attention to comparative studies would alleviate this marginalization. Since progress depends on understanding and not simply on commonality, it is my hope that, although the majority of the women discussed in this work are from the Anglophone Caribbean, the wide range of their experiences and geographical positioning makes its contribution toward that understanding.

At the same time that I have experienced great alienation from my Haitian identity within the United States (for it would seem that the American ideal of the "melting pot" has for its goal that of dissolving rather than celebrating cultural/racial/ethnic diversity), the literature of Afro-Caribbean women has vitally reconnected me to the place of my birth and the geographical nexus of my cultural background. It has grounded me. Even though I have found myself cast in the role of "other" by Euro- and African Americans alike, I nonetheless rediscovered myself through the research completed for the first draft of this text. Then, through revisions, I worked on the manuscript of another book on Haitian women's literature as I moved farther south to Tennessee. Here the major rewriting of this work has taken place after two years of emotional and spiritual drought and a deeper sense of alienation than I had ever thought possible. It is here that I came to realize most completely that the African American experience was not unlike that of Afro-Caribbean people in terms of a sense of alienation from original, African cultures and the search for recuperation of that past. Though not the same (I feel that these differences should always be foregrounded in any responsible comparative study), the cultures are similar and the experiences wrought through slavery and neocolonialism painfully alike. It is my hope that future work in the fields of African American and Caribbean literature and culture will lead us further into the exploration of the nuances that color the African diasporic experience. For though, as descendants of both the enslaved and the enslaving, our legacies run parallel in history, our modes of resistance have taken different expressions (take for example the comparison drawn earlier between the courses of Haitian and Jamaican emancipation) for different ends. In the case of African Americans, the alienation from one's own nation (as James Baldwin has pointed out most pointedly in *The Fire Next Time*) demands different means of survival, different responses to a variety of oppressive power

structures. For, if the exiled West Indian can look back to her or his home island with love and longing while residing in Euro-dominated cultures, certainly the same cannot be said for African Americans exiled in the United States, their nation. Yet, it would seem that the experiences of the impoverished classes and of women as a class in the Caribbean parallel the African American condition in that, as Marie Chauvet and Michelle Cliff's fiction depicts, members of both groups are made to endure the worse indignities within their own home islands. And, for most, this reality cannot be escaped through emigration, it must be confronted and resisted from within.

I was further reminded of the cross-cultural diasporic connections between Afro-Caribbeans and African Americans when I came across a photograph taken in 1948 by Consuelo Kanaga of a young Black girl holding apple blossoms gingerly up to her nose with one hand as she looked resolutely up into the camera lens. The gingerliness of her young and careful hand reminds me of the hopefulness of the characters figuring in the novels of Beryl Gilroy. Her eyes remind me of the eyes of the children I have observed walking through the maze of the *lakou-foumi* in Haiti as if the weight of the world is upon their backs—and sometimes it is, made real and tangible against their toughened skins through the plastic containers heavy with water they carry from the overflowing canals for drinking and bathing. Those eyes remind me of Dionne Brand's poem, "Blues Spiritual for Mammy Prater," as if to say that the eyes of the elderly woman, who has waited patiently to communicate the well of her strength and courage through the ages in a photograph taken of her in old age, are as innocent and immeasurably knowledgeable as the simplicity of a child. I did not see, initially, that the picture was taken in Tennessee in 1948, when this particular girl–child would have had limited access to her innocence. This was a time when "freedom" was simply a word African Americans could one day hope to redefine in this landscape, which, as Billie Holliday has sung, was literally littered with the strange fruit of lynched bodies, of girls and women raped, of horrors now seemingly unimaginable. I have observed while residing here that that legacy hangs thickly in the air, in every interaction. Kanaga's picture reveals the spirit of this young girl without glamorizing her image or romanticizing her past—it is a picture of who we are, what we are, of what we might prevent, of who we might become. In this, it visually captures the essence of what I have termed Afro-Caribbean diasporic feminism: it

reflects a particular person, a young African American girl, in a particular place and time, but remains timeless, a partial symbol of all there is for us to excavate in bringing together the various experiences of people of African descent globally, especially those of Black women. For though assimilation is an undeniable facet of the exile/emigration process, it does not efface the remnants of the culture of origin—this presence is what Said has termed a "contrapuntal" existence, or a sense of double sight on two or more converging cultures.

The paradox of exile has been, for me, then, partially a struggle of coming to terms with the ways in which displacement brings with it the opportunity for a renewed sense of self. Although many exiles lose a sense of who they are (and where they come from) through the condition of exile, still it is possible to transform exile productively to affirm self and origin. For, through exile, we are made to know more clearly how we have become who we know ourselves to be. Thus, as Lamming has observed, the exile has the pleasure (or privilege) of experiencing more than we could have thought possible when still residing in our homeplace, and yet we paradoxically live in the present through the past. Often alienated from the adoptive countries in which we come to live, we are left with the solace of memory; it is in this way that the exile may, to rephrase Lamming, belong wherever s/he is—through memory. For those of us for whom a physical return "home" is rendered impossible for economic and/or political reasons (for example, women "in service" may not have the wages to spare for such a return and those who have fled Haiti's political upheaval and terrorism are not likely to return out of fear or despair), images, both visual and textual, provide us with a reprieve from the hostilities that envelop and embitter our everyday lives.

Literature by women of the African diaspora, then, besides implicitly creating theory, as Carole Boyce Davies has noted, explicitly recreates the intangibles of the Caribbean: laughter, heat, passions, struggle, endurance, the red hues of the flamboyant, the aquamarine of the sea, the sweetness of a bruised and fallen mango, the soft green–yellow of the ripe avocado, the swirls of flying, ocher dust. And all this between the soft covers of a book of which there may exist only fifty, a hundred, or a thousand copies. For this reason, critics intent on discovering and uncovering the meaning behind the words (or "eyes" of the "photographed" subject) must either utilize the theoretical tools the works themselves suggest or those which women of African descent (such as Barbara

Smith, Barbara Christian, Audre Lorde, Carole Boyce Davies, and Molara Ogundipe-Leslie, among others) have themselves articulated and provided for our use.

For me, Afro-Caribbean women's literature is true to life, and in that sincerity it conveys all the nuances, all the palette of human emotions as they have been impacted upon by the force of hate of one race against another, in this instance, the European against the African. But Afro-Caribbean women's literature moves us toward transformation, toward accepting the need for the disruption of those relationships among peoples based on hatred. For words to move, if you would permit me a final return to an analogy explored previously, they must have the quality of a good photograph. They must capture the spirit of the subject in order to move the beholder. They must be concise, the lights and darks exposed in sharp contrast against each other in order to reveal a scene, a portrait, clearly. The literature I have analyzed herein has this quality. It provides, to paraphrase what Consuelo Kanaga has said of photography, the spirit of women of African descent laying claim to their own selves. Their words reflect their own cultural experiences with alienation, displacement, recuperation and, in so doing, create the bridge homeward. Their words create the vibrant images necessary for us to use the imagination in the service of revolutionary actions and discourses, even those which reside in the all too often disengaged theoretical playgrounds of academia where the aim is less often to discover and better our relations to one another and more often to best and obscure. But these word–images are also meant to be heard and, with poetry, spoken aloud. What we can learn from the efforts of the writers discussed throughout this work is the gift of a good ear. If we take to heart the stories these women have had to tell, whether based on personal life experience (as with the women whose oral histories are recorded in Makeda Silvera's *Silenced* and Dionne Brand's *No Burden to Carry*), or autobiographically influenced fiction (as with Beryl Gilroy's *Frangipani House* and Marie Chauvet's *Amour, colère, et folie*), or poetry that seeks to politicize ancestral legacies and claim lesbian and/or women-centered energies (as in Audre Lorde's *The Black Unicorn* and Michelle Cliff's *Claiming an Identity They Taught Me to Despise*), or fiction based on the experience of women of the diaspora (as in Rosa Guy's *Ruby* and Joan Riley's *The Unbelonging*), amid many other forms of writing, we learn to hear their voices rising in concert to proclaim the existence, dignity, and perseverance of Black women

in contemporary societies. In other words, such writing lays claim to the victimization of Black women in order to prevent the repetition of that victimization. In so doing, Afro-Caribbean women create a dense web of voices, which creates a melodious fugue centered on the real lives of Black girls and women.

In hearing the voices of Afro-Caribbean women, in seeing them clearly in everyday life, we have the opportunity to create a transformation that honors their struggles and the expression of these struggles through their words. In the end, those words should move us, not to bloodshed but to self-love and self-awareness, in short, toward a revolution of consciousness, which could one day affirm the beauty and wisdom of Black women and end our alienation. Then, perhaps, the return home will have been achieved.

Notes

Prologue

1. I have written about these experiences in more detail in my essays, "Soul Searching" (*proemCanada* 2:1 [Spring 1990]), and "*Sin Fronteras/Sans Frontières:* Women of Color Writing for Empowerment" (*Frontiers* 13:2 [Spring 1993]).

2. *Harriet's Daughter* was not published in Canada until Philip won the coveted Cuban "Casa de Las Americas" prize in 1988 for the manuscript of *She Tries Her Tongue, Her Silence Softly Breaks* (1989).

3. Ed. Ramabai Espinet (Toronto: Sister Vision, 1990).

4. Ed. Joanne M. Braxton and Andrée Nicola McLaughlin (New Brunswick: Rutgers University Press, 1990). This anthology attempts to be representative not only of the experiences of Afro-Caribbean women but of all women of African descent within the Americas.

5. Ed. Rhonda Cobham and Merle Collins (London: The Women's Press, 1987). *Watchers and Seekers,* as the title suggests, is inclusive of all women of African descent regardless of their geographic origin, although many of the writers included are from the Caribbean.

Chapter One

1. The reader is referred here, by example, to Toril Moi's *Sexual/Textual Politics* of 1985.

2. See Patricia Hill Collins, "The Social Construction of Black Feminist Thought," *Signs* 14:4 (1989): 745–773. She states: "The widespread use of the call and response discourse mode among African-Americans exemplifies the importance placed on dialogue. . . . Many Black women intellectuals invoke the relationships and connectedness provided by use of dialogue" and, thus, the use of dialogue is one distinguishing trait of "an Afrocentric feminist epistemology" (764–765).

3. For further reading, see Hill Collins, *Black Feminist Thought* (1990); and Elsa Barkley Brown, "African-American Women's Quilting: A Framework for Conceptualizing and Teaching African-American Women's History," *Signs* 14:4 (1989): 921–929.

4. It must also be noted that women writers of Afro-Caribbean descent in the United States—Audre Lorde, Barbara Christian, and June Jordan in particular—have been instrumental in formulating the tenets and application of Black feminist criticism.

5. One might remember here that Mary Wollstonecraft's *Vindication of the Rights of Woman* of 1792, like the early feminist texts produced in the United States, gave no thought to the rights of Black women who, as slaves, were deemed inferior. Their rights,

when considered at all, were considered secondary to those of Black men, just as they were by Susan B. Anthony and others of the nineteenth-century suffrage movement in the United States.

6. It is unfortunate that Benoîte Groult's Preface, in an attempt to make readers aware of the revolutionary aspects of Thiam's text (and how they, as Western feminists, will benefit from reading it and coming in close contact with the African women's voices whom Thiam has recorded), undercuts the explicitly feminist intent of Thiam's work, as when she states at the beginning: "It is no longer essential to be a feminist in order to be conscious of the universal oppression experienced by women past and present, oppression which takes many different form from the most vicious, the most visible burdens not always being the most serious" (1986, 1); then she refers to the women interviewed by Thiam as "unpretentious" (1986, 2). Although well-intentioned, these remarks display the remnants of a deep-seated condescension toward African women. Furthermore, they openly contradict both Thiam and Ogundipe-Leslie's later assertions of the impossibility of divorcing a feminist consciousness from the awareness of women's lot globally.

7. The silencing of women in the Caribbean is acute. Although few of the women whose works I analyze in subsequent chapters decry the oppressions suffered by Afro-Caribbean women at the hands of Afro-Caribbean men (Marie Chauvet, Haitian playwright and novelist, is a notable exception), it is clear that their experiences mirror those of African American women. Feminism in the Caribbean, as this discussion reveals, is a recent development. Hence, Afro-Caribbean women's criticism of sexism in the Caribbean context has not yet found its fullest expression and remains a muted component of feminist discussions. It is my belief that the development of a Black feminist consciousness on the part of Afro-Caribbean women will result in the gradual exposure and analysis of sexist oppression in the Caribbean in instances where that analysis has not yet found expression.

8. Note, however, that in Canada, for example, the term "womanist" has gained mainstream acceptance: a free women's paper, *The Womanist* was once distributed throughout the provinces, took its name from Alice Walker's definitions and aimed to "empower and enable women . . . to get back to the basics, the common ground that built the women's movement, while celebrating our differences."

Chapter Two

1. The term "othermothers" is Patricia Hill Collins's (1990, 120); I return to her definition of the term below.

2. Recent novels by African American women have sought to reintroduce this feature of female resistance to enslavement. See, in particular, J. California Cooper's *Family* (New York: Doubleday Anchor, 1991) and Toni Morrison's *Beloved* (New York: Knopf, 1987).

3. Black male leaders and writers known to have made such comments in either speeches or writings include Elijah Muhammad, Imamu Amiri Baraka, Calvin Hernton, Frantz Fanon, and Eldridge Cleaver. Cleaver in *Soul on Ice* (1968), attempts to explain how he was driven to become a rapist. He denounces his acts of violence against white women but does not extend his remorse to acts of violence he perpetrated against Black girls and women. He writes, without remorse, "I started out by *practicing* on black girls in the ghetto—in the black ghetto where dark and vicious deeds appear not as aberrations or

deviations from the norm, but as part of the sufficiency of the Evil of a day" (4; my emphasis). For a fuller discussion and analysis of such writings, consult Paula Gidding's *Where and When I Enter* (1984, 314–324).

4. Although the following discussion emphasizes the work of French artists, it is meant to illustrate how the representation of Black women in "master" works fed the general European response to colonized West Indian women. In this sense, I am attempting to show how such representations cross national borders and inform our understanding of the effect of art and art history upon an artistic and literary imagination that has come to us from various European vantage points.

5. Pollock indicates that, in nineteenth-century Europe, the age of consent steadily rose from the middle to the end of the century. In Britain in particular, she observes that the age of consent rose from the age of twelve in 1861 to the age of sixteen by 1885 (1992, 76). Abigail Solomon-Godeau's essay, "Going Native," also suggests that, given the comments of art critics attempting to justify Gauguin's use of a thirteen-year-old in his Tahiti paintings, the age of consent had risen to eighteen or nineteen years in Europe by 1893 (1989, 127).

6. This included, says Gilman, lesbian sexuality: hence, any and every expression of sexuality that could not be linked to the institutions of wifehood and motherhood were seen as anomalous deviations, which rested on the image of the Hottentot for substantiation (1985, 218).

7. In her essay, "Lady No Longer Sings the Blues: Rape, Madness, and Silence in *The Bluest Eye*," Madonne Miner compares Morrison's novel with "mythic accounts of Philomela and Persephone," in which, "violated by a male relative, a young virgin suffers *sensual loss* of such an extreme that her very identity is called into question" (1985, 184; my emphasis). Miner does an admirable job of conveying how Pecola's rape results in her "madness" and loss of self, but she seemingly forgets during the course of her analysis to define Pecola as a child. Although Pecola is only eleven at the time the story unfolds, Miner refers to her in the opening pages of her essay as "a young black woman" (176). Miner then explains the motivation of the rapist/perpetrator, Pecola's father, as a "belief that he can regain an earlier perception of himself as young, carefree and whimsical by using this girl/woman as medium" (180). A page later, Miner refers to Pecola again as "one young woman" (181). The effect of refusing to identify Pecola as a girl–child and her rape as child sexual abuse, as incest, is an example of the denied presence of childhood sexual abuse in the lives of Black girls; it also masks the connection between the sexualization of Black women and that of Black girls.

Shelley Wong writes that "*The Bluest Eye* emerges as the indictment and the uncrowning of a social and economic order which upholds and implements a metaphysics of isolate unity." This isolation, detrimental to community reform, she finds, is symbolized in the novel's title "where the 'eye' is decidedly singular" (1990, 477). But neither Wong nor Miner interprets the novel as denouncing violence against Black women and girls. According to both, Cholly is as much a victim of circumstance as is the daughter he rapes. Wong interprets Cholly's actions as born of "despair" (476), and she sees Cholly's incest with Pecola as a narrative strategy (by which the rape of Pecola becomes a subtext to the text of

Cholly's despair) utilized by Morrison to mirror the effects of slavery on the Black family: "the disfigurement of human relationships by the marketplace" (476). And Pecola, however victimized, remains an identifiable accomplice to her violation, because, as we shall see, of Morrison's early association of her character with a sexual awareness inappropriate to a girl of her eleven years. Miner thus interprets reciprocity in the rape scene: "Pecola sucks inward, but without positive effect; like a deflating circus balloon, she loses the benefits of lifegiving oxygen and the power of speech" (1985, 180). Miner's own use of language here reflects the alienation imposed on Black girls and women by mainstream society in its refusal to grant that Pecola's silence is an imposition from without. Cholly is the one who in raping her *robs* her life of hope and self-expression, for even when Pecola attempts to speak of Cholly's violation of her to her mother Pauline, she is called a liar and rejected, as has been the pattern of her life and that of her parents.

8. Jacques Cauna, "La Famille et la descendance de Toussaint Louverture." *Le Nouvelliste,* 28 Octobre (1988): 3, 4, 9.

Chapter Three

1. Louis Riel led a rebellion of the Métis (French-Aboriginal Canadians), in 1869, which opposed governmental efforts to annex what are now the Prairie Provinces; the rebellion was successful and, through it, the Province of Manitoba was established in 1870. A similar attempt in 1884 failed, and Riel was executed as a traitor to the Canadian government in 1885.

2. Although the French have endured prejudice in English Canada since their loss of colonial power there, I do not believe that the struggles of the French in Québec and in communities outside Québec (having been a member of both these French-speaking communities) can be seen as equal to those of the First Nations people and numerous other minorities throughout Canada. For one thing, Québec, as most of the articles I have read on the matter of racism in Canada confirm, appears to have participated actively in the oppression of other minorities, especially of their Jewish and Haitian minorities, thus continuing to attempt to end the oppression of the French population by reasserting its lost colonial strength.

3. I must note here that Brand produced her films for the Studio D branch of the Film Board, which was created to provide women filmmakers with the necessary resources to produce their films at a time when the Film Board was made up primarily of male filmmakers and support staff; in 1996, Studio D was dismantled through budget cuts to the Film Board, with the justification that, since women make up almost 50 percent of the board's filmmakers (most of whom, incidently, worked in Studio D), the branch was no longer necessary. It remains to be seen whether women will continue to have access to the resources Studio D provided.

4. The premiere of the twenty-minute documentary, held in Toronto, was attended by fifteen hundred people (Brand 1990a, 51). At the Halifax screening, I was told by other attendees that the premiere had been "standing room only." The film had already made its reputation.

5. A distinction held concurrently by Italian women in Metro Toronto (Brand 1984, 34).

6. Here, I am in agreement with Gay Wilentz, who writes of this passage in Philip's collection that "the silencing of this most primal voice (a mother's words) provokes profound anguish when learning to speak the patriarchal language of the colonial oppressors." On matters of audience, however, our analysis parts ways somewhat. Wilentz concludes that the multiple-choice passages are present to force "us to answer to the physical violence as well as the emotional destruction that has been perpetrated in the name of Western 'civilization'" (1992, 265). This assumes that Philip is only speaking "back to" the imperial forces, which have imposed their tongues among the colonized and enslaved; although this is certainly one aspect of the text, I would suggest that, from an Afro-Caribbean women's perspective, Philip's text provides the evidence for a relationship to language, which as it defies its imposition, actively engages that language in dynamic and transformative ways that divest words of their colonial impact and invest them (as Philip does later on in the text) with revolutionary potential.

7. I articulated the concept of "poelitics" (or *poelitiques*), in the context of finding a language that could accurately describe Haitian women novelists' resistance to naming lesbian and bisexual identities in their works, in a paper presented at the International Caribbean Women Writers Conference of April 1996 (FIU, Miami) entitled, "*Sinm-di ou, oua konn pasé-m:* Masking the Power of the Erotic in Haitian Women's Literature or, the Poelitics of Eros."

Chapter Four

1. The story has since appeared in Silvera's short story collection of the same name published by her Toronto Sister Vision Press (1994).

2. In the present context, this term refers to a Haitian ethnic/racial category, not to a West African Muslim holy man.

3. This work was on exhibit in Canada in *Indigena* (1993), a First Nations/Aboriginal art exhibition, which responds to the "celebrations" held throughout the world in 1992 to mark the quincentennial of Columbus's "discovery" of North America.

4. Although Bertha Rochester is for all intents and purposes a white character in Brontë's *Jane Eyre*, Cliff is suggesting that she might be read as "Black" in her marginalization in ways that are reflective of the experience of the mixed-raced Caribbean woman, at least during the colonial period; such an interpretation is given credence by more recent readings of Jean Rhys's *Wide Sargasso Sea*, in which Bertha is resurrected as a *créole* woman whose racial identity suggests, in veiled ways, the product of "miscegenation."

5. Scholars debate whether or not Cudjoe and Nanny were in fact biologically related. In any case, the two were contemporaries as well as adversaries during this period.

6. The connection between Nanny and Mma Alli is best illustrated by their use of the *abeng*, the conch shell, which slaveholders used to call caneworkers in from the fields, but which Maroons and other revolutionaries used to signal calls to action. Mma Alli, enslaved yet in full command of her past and its resources, keeps an *abeng* "oiled with coconut and suspended from a piece of sisal and a fishhook" (Cliff 1990, 36), ready for use.

7. I am indebted here to the analysis of Roseanne L. Quinn in her unpublished essay, "'The choice is mine, man, is made': Engendering Identities and Cultural Change in Michelle Cliff's *No Telephone to Heaven*." Quinn suggests that Clare "reveals that she has understood Harriet's identity to be encoded as female—when she thinks that Harriet is the

'marvelous woman with endless breasts'" (8)—and is thus moved to renounce her previous masculinizing of Harry/Harriet as a way of denying her own lesbian identity.

Chapter Five

1. In the early nineteenth century, Napoleon sought to restore the institution of slavery in the French colonies and did so in Martinique and Guadeloupe (Plummer 1992, 18). France was never able to reinstate slavery in Haiti, which became an independent state in 1804, but continued to enslave Africans in its other colonies until 1848, when Victor Schoelcher, deputy to Martinique and Guadeloupe drafted the French decree of emancipation. In the United States, emancipation did not occur until 1863, with the Emancipation Proclamation and ratification of the Thirteenth Amendment of the U.S. Constitution in 1865.

2. The Vieux family did, however, publish one of her works posthumously, *Les Rapaces*, in 1984.

3. Michelle Cliff. Personal conversation, 23 July 1993.

4. In his article, "The Sephardim of the Caribbean," Aubrey Newman gives an historical account of the conditions under which Jews lived in different Caribbean islands. Rights granted to Jewish settlers differed according to the laws that governed each colony. For instance, in Barbados, Jews could own estates and cultivate the sugarcane (1989, 447); in Jamaica, where many Jews had come from Surinam, they were by and large restricted in their livelihood to trade and commerce, surtaxed, and barred from holding office and voting (451–459). In all the colonies, Jews were unfairly treated and limited in their access to political, social, and economic equality.

5. "Dunbaring" took its name from a Mr. Dunbar, a white overseer who was killed by female slaves in Jamaica in the early nineteenth century (Dadzie 1990, 25, 38).

6. Female "voodoo" priestess.

7. The translations to follow are my own: "We must learn to submit . . . we must learn to resign ourselves, for nothing is done on earth without the will of God."

8. "You are a virgin, aren't you? You didn't lie to me? I'm going to hurt you, very badly, but you will not say a word, you understand? Not a word."

9. "He drove himself into me in one dreadful blow, brutal and, immediately, grunted with pleasure. I bit my fist, out of pain and disgust."

10. " 'It's my revenge. It's good, isn't it?' he asks me with anguish. And with my eyes closed, I appear to agree. What does it matter! A month goes by quickly. I will be quiet, I will accept whatever he wants. He has made me bleed five times and I have not cried out. My complicity has no limits."

11. "What we are living now is so revolting that we escape our selves only by rehashing dreams of vengeance."

12. "I struggle with the conviction that justice is not on our side. What right do we have to all we own? What right do we have to privilege while others wallow in misery? The misery of those that my peasant of an ancestor must have exploited, the misery of the poor who pilfered from his garden and that he had whipped without mercy, the misery of the beggars who have put on the uniform, the misery of the one who avenges himself on me for having been rejected all his life by the women he desired. If I had to beg also, one day, if I

had to feel myself humiliated, wouldn't I be proud to see Paul in uniform, a gun in his belt? I do not know. It is difficult to put oneself in the skin of others, and I am still too well fed to understand the effects of misery and hunger."

13. Marie-Denise Shelton in her review essay, "Haitian Women's Fiction," states that it "is no doubt the best contructed story of the trilogy" (1992, 774).

14. "I'm instilling principles and I expect to be obeyed. . . . Our race is undisciplined, and our blood of ancient slaves demands the whip, like my father used to say."

15. "rebellion rumbles in me. Already I hated my father for whipping the sons of farmers without reason."

16. "It's starting again. This morning, Calédu bludgeoned some peasants. He is in a rage. I saw the whole thing from behind the blinds of my window. . . . I heard whispering to the right and to the left and from those whisperings, at almost regular intervals, rose Calédu's curses and the peasants' cries of protest, of pain."

17. "We're dealing with a sadist who is perhaps avenging his powerlessness on women . . . he is also an embittered man who is making others pay for his station in life."

18. "It seems that they've crippled her. Have you seen her? I'm still waiting for things to calm down. Eugénie Duclan has seen her. Secretly, but she saw her. She has nothing left, there. . . . It must be terrible. She told Eugénie that she saw her flesh fly in pieces as Calédu flogged her, flat on her back, legs open, kept down in that position by four prisoners, four dirty beggars to whom he then surrendered her. . . . I'm seventy-five years old . . . never have I felt so much horror and malediction hover over this city as today."

19. "Jane Bavière was once my friend and I've decided to reestablish our good relations. I have already sufficiently abandoned her. I have already sufficiently clapped with both hands at the nonsense of our good bourgeois citizens. I am rising against it. There is nothing else to do. Is it because I think of her as unlucky also? In her presence, I always find myself at ease . . . what she teaches me about herself with a spontaneity that I envy constitutes for me the richest lesson I have ever received in my life. . . . I thought that worry, mistrust, and bitterness were the wages of scandal."

20. "In our eyes, a stranger has always represented the best of what can be."

21. "Was it me who uttered those words? Was it me who gently, so gently rebuffed him?"

22. Please note that many *créole* words have various spellings depending on the language that governs the writer. Some words in this section may therefore appear in various forms in quotations; otherwise, I have used the spelling of the word concerned best known to me—usually, the French spelling.

23. In his essay, "Postcards from History," Mark Danner notes that Toussaint, Dessalines, and Christophe each died as a result of rebellions instigated against him by his closest allies (1992); although one might conclude that those allies were not representative of the greater Haitian population, it must be acknowledged that each of these leaders fell because of his need to embrace colonial power, especially Dessalines who crowned himself Haiti's emperor and Christophe who crowned himself King of Northern Haiti and built himself sumptuous palaces in the mountains.

24. Fiehrer estimates that two thousand Haitians were killed when U.S. Marines landed in Haiti in 1915 (1990, 6). This seems a conservative estimate.

25. *Sucre Noir* chronicles the conditions of the sugarcane workers in the bateys of the Dominican Republic, where at least two hundred thousand workers lived, some brought there under false premises (the promise of work, good wages, and the like), others forced at gunpoint (especially children) to abandon Haiti and be enslaved in the Dominican cane fields.

26. Régnier records in his film (1987) that such an agreement was begun in 1952 and continued yearly, even after the death of Papa Doc and the departure of Baby Doc: "workers" are paid, on average, a dollar (U.S.) a day; thirty thousand to fifty thousand workers are brought from Haiti yearly; by age forty, men and women are no longer strong enough to continue to work the cane; Haitians in the bateys receive no food and almost no medical attention except through charitable organizations, most often headed by more fortunate Haitian doctors; Canadian Catholic priests who own buildings and manicured land next to the bateys refuse to visit the Haitians and deny them the use of empty buildings for the storage of medicine. These conditions appear unchanged to date.

27. This doctrine was taken up by other French Caribbean writers, such as Aimé Césaire, in the *négritude* movement.

28. "A corner of tropical blue indigo sky captured my attention as if to mock me; blue indigo diluted by water and dragged by an austere, silent painter, tirelessly, toward the horizon without end. . . . Gunshots whizzing by my ears made me pull back quickly to close the door."

29. "I wrote in French verses on Christophe, Dessalines, Toussaint, and Pétion. I cling like a leech to the colonial heritage. Why not? Did Dessalines believe in its deracination when he cried: 'Decapitate, burn houses!' His speeches on Independence, was it in *créole* that his assistant Boisrond-Tonnerre prepared them? And Toussaint? In what language had he learned to read to match intellect with Bonaparte?"

30. "Serve the *loas* of the family and pray to God so that nothing and no one may have a hold on you."

31. "I scorned the *loas* and ran from the idea of God. I was too often hungry."

32. "What is the use of a religion if it only brings misery instead of comfort? If it brings despair instead of hope? If it diminishes rather than safeguards? André has knelt and prays. From where does he get his mysticism? I saw my mother serve her *loas* tirelessly and I received from her hands, coldly, the sacred heritage. I pray and invoke the *loas* with the conviction that I am playing a comedy."

33. "I do not want to kill or to be killed. I want to drink, I want to write and to make love with the women of Haiti."

34. "Don't bring up this absurd question of skin and race. I am your brother in spirit and heart. You know that."

35. "The commander lifted his club and he struck me. He lifted his feet and trampled me. He spat in my face, called me a mulatto bastard, me, your son. He is Black like you, my negress mother, but he took me for the real thing, an eighteen-karat mulatto as they call the handsome men in this province with flat hair, pretentious, stuffed with prejudices. Is it because of my chicken shit color that they persecute me? Is it because of my rotten coconut color that I cannot find room either to the right or to the left? Simon says that this absurd

question of skin and race must be forgotten. . . . The question of race put aside, since I am Black to the eyes of the whites, why did the commander think he insulted me by calling me mulatto? Do *I* call him nigger?"

36. "Ah! Christ! . . . since they are going to tie us to the stake like they hammered you to the cross and since they are going to riddle our body with wounds, let our death stand for something and prevent our names from sinking into oblivion."

Works Cited

Abbott, Elizabeth. 1988. *Haiti: The Duvaliers and Their Legacy*. New York: McGraw-Hill.

Adisa, Opal Palmer. 1986. *Bake-Face and Other Guava Stories*. Berkeley: Kelsey St. Press.

Alexander, M. Jacqui. 1991. "Redrafting Morality: The Postcolonial State and the Sexual Offences Bill of Trinidad and Tobago." In *Third World Women and the Politics of Feminism*, ed. Chondra Mohanty. New York: Methuen.

Andersen, Margaret L. 1988. *Thinking About Women: Sociological Perspectives on Sex and Gender*. 2nd ed. New York: Macmillan.

Arguelles, Lourdes, and B. Ruby Rich. 1985. "Homosexuality, Homophobia, and Revolution: Notes Toward an Understanding of the Cuban Lesbian and Gay Male Experience, Part II." *Signs* 11:1 (autumn): 120–136.

———. 1984. "Homosexuality, Homophobia, and Revolution: Notes Toward an Understanding of the Cuban Lesbian and Gay Male Experience, Part I." *Signs*, 9:4 (Summer): 683–699.

Atwood, Margaret. 1971. *Survival: A Thematic Guide to Canadian Literature*. Toronto: Anansi.

Balutansky, Kathleen M. 1990. "Naming Caribbean Women Writers: A Review Essay." *Callaloo* 13: 539–550.

Barnett, Alan W. 1989. "Revolution on the Walls." *Art in America* 7:7: 67–75.

Barratt, Harold. 1990. "In Search of the Caribbean Demotic." (Book review/ Philip). *Fiddlehead* 164 (Summer):103–106.

Bass, Ellen, and Laura Davis. 1988. *The Courage to Heal*. New York: Harper & Row.

Blume, E. Sue. 1990. *Secret Survivors*. New York: Ballantine.

Brand, Dionne (ed.). 1991a. *No Burden to Carry*. Toronto: Women's Press.

———. 1991b. *Sisters in the Struggle*. (Film). Toronto: NFBC.

———. 1990a. "Bread Out of Stone." In *Language in Her Eye*, ed. Libby Sheier, Sarah Sheard, and Eleanor Wachtel. Toronto: Coach House Press.

———. 1990b. *No Language Is Neutral*. Toronto: Coach House Press.

———. 1989. *Older, Stronger, Wiser*. (Film) Toronto: NFBC.

———. 1984. "A Working Paper on Black Women in Toronto: Gender, Race and Class." *Fireweed: Theory* 19 (September): 26–43.

Brown, Rosemary. 1991. "Overcoming Sexism and Racism—How?" In *Racism in Canada*, ed. Ormond McKague. Saskatoon, Saskatchewan: Fifth House Publishers.

———. *Being Brown*. 1989. Toronto: Ballantine Books.

Bryan, Beverly, Stella Dadzie, and Suzanne Scafe. 1985. *The Heart of the Race: Black Women's Lives in Britain*. London: Virago Press.

Calliste, Agnes. 1989. "Canada's Immigration Policy and Domestics from the Caribbean: The Second Domestic Scheme." In *Race, Class, Gender: Bonds and Barriers*, ed. Jesse Vorst et al., *Socialist Studies/Études Socialistes: A Canadian Annual*, No. 5. Winnipeg; Toronto: Between the Lines.

Campbell, Elaine. 1990. "The Unpublished Short Stories of Phyllis Shand Allfrey." In *Caribbean Women Writers: Essays from the First International Conference*, ed. Selwyn R. Cudjoe. Wellesley, Mass.: Calaloux Publications.

Campbell, Mavis C. 1988. *The Maroons of Jamaica, 1655–1796: A History of Resistance, Collaboration and Betrayal*. Westport, Conn.: Bergin & Garvey.

Carby, Hazel. 1987. "'Woman's Era': Rethinking Black Feminist Theory." Introduction to her *Reconstructing Womanhood: The Emergence of the Afro-American Novelist*. New York: Oxford University Press.

———. 1982. "Schooling in Babylon." In *The Empire Strikes Back: Race and Racism in 70's Britain*. University of Birmingham: Centre for Contemporary Cultural Studies.

Carey, Barbara. 1991. "Secrecy and Silence." (Interview with Philip). *Books in Canada* (September): 17–21.

Carr, Brenda. 1993. "A Woman Speaks . . . 'I Am Woman and Not White': Politics of Voice, Tactical Essentialism, and Cultural Intervention in Audre Lorde's Activist Poetics and Practice." *College Literature* 20 (June):133–153.

Cartey, Wilfred. 1991. *Whispers from the Caribbean: I Going Away, I Going Home*. Los Angeles: Center for Afro-American Studies, UCLA.

Chauvet, Marie. 1968. *Amour, colère, et folie*. Paris: Gallimard.

Christian, Barbara. 1988. "The Race for Theory." *Feminist Studies* 14 : 1 (Spring): 67–79.

———. 1986. Introduction. In Opal Palmer Adisa's *Bake-Face and Other Guava Stories*. Berkeley: Kelsey St. Press.

———. 1985. *Black Feminist Criticism*. New York: Pergamon Press.

Clarke, John Henrik. 1975. "The Black Woman in History: On 'The Cultural Unity of Africa.'" *Black World* (February): 12–27.

Cleaver, Eldridge. 1968. *Soul on Ice*. New York: McGraw-Hill.

Cliff, Michelle. 1993. *Free Enterprise*. New York: Dutton.

————. 1991. "Caliban's Daughter: The Tempest and the Teapot." *Frontiers* 12 : 2 36–51.

————. 1990. *Abeng.* New York: Dutton.

————. 1987. *No Telephone to Heaven.* New York: Vintage.

————. 1983. "If I Could Write This in Fire, I Would Write This in Fire." In *Home Girls: A Black Feminist Anthology,* ed. Barbara Smith. New York: Kitchen Table.

————. 1980. *Claiming an Identity They Taught Me to Despise.* Watertown, Mass.: Persphone Press.

Clifton, Lucille. 1987. *Next.* New York: Boa Editions.

Combahee River Collective. 1977/1982. "A Black Feminist Statement." In *All the Women Are White, All the Blacks Are Men, But Some of Us Are Brave,* ed. Gloria T. Hull, Patricia Bell Scott, and Barbara Smith. New York: Feminist Press.

Corhay-Ledent, Bénédicte. 1990. "Between Conflicting Worlds: Female Exiles in Jean Rhys's *Voyage in the Dark* and Joan Riley's *The Unbelonging.*" In *Crisis and Creativity in the New Literatures in English,* ed. Geoffrey Davis and Hena Maes-Jelinek. *Cross-Cultures 1.* Amsterdam: Rodopi.

Crean, Susan. 1991. "Taking the Missionary Position." In Racism in Canada, ed. Ormonde McKague. Saskatoon, Saskatchewan: Fifth House Publishers.

Creese, Gillian. 1991. "Organizing Against Racism in the Workplace: Chinese Workers in Vancouver Before the Second World War." In *Racism in Canada,* ed. Ormonde McKague. Saskatoon, Saskatchewan: Fifth House Publishers.

Dadzie, Stella. 1990. "Searching for the Invisible Woman: Slavery and Resistance in Jamaica." *Race and Class* 32 : 2: 21–38.

Danner, Mark. 1992. "Postcards from History." In *Haiti: Feeding the Spirit,* ed. Rebecca Busselle. New York: Aperture.

Daurio, Beverley. 1990. "The Language of Resistance," (Interview with Brand). *Books in Canada* 19:7 (October): 13–16.

Davies, Carole Boyce. 1994. *Black Women, Writing and Identity: Migrations of the Subject.* London and New York: Routledge.

Davies, Carole Boyce, and Elaine Savory Fido (eds.). 1990. "Talking It Over: Women, Writing and Feminism." In their *Out of the Kumbla.* Trenton, N.J.: Africa World Press.

Davies, Charles. 1990. "Pride, Power and Elijah Harper." *The Financial Post Magazine* (September):48–51.

Deren, Maya. 1970. *Divine Horsemen: Voodoo Gods of Haiti.* New York: Chelsea House.

DeShazer, Mary K. 1986. *Inspiring Women: Re-Imagining the Muse.* New York: Pergamon Press.

Desmangles, Leslie G. 1992. *The Faces of the Gods: Vodou and Roman Catholicism in Haiti*. Chapel Hill: University of North Carolina Press.

Dorsinville, Max. 1976. "Senghor, or the Song of Exile." In *Exile and Tradition: Studies in African and Caribbean Literature*, ed. Rowland Smith. New York: Africana Publishing Company and Dalhousie University Press.

Du Bois, W.E.B. 1901/1965. *The Souls of Black Folk*. In *Three Negro Classics*. New York: Avon Books.

Engel, Beverly. 1989. *The Right to Innocence*. New York: Ivy Books.

Farmer, Paul. 1992. *AIDs and Accusation: Haiti and the Geography of Blame*. Berkeley: University of California Press.

Ferguson, James. 1993. "The Duvalier Dictatorship and Its Legacy of Crisis in Haiti." In *Modern Caribbean Politics*, ed. Anthony Payne and Paul Sutton. Baltimore: Johns Hopkins University Press.

Fiehrer, Thomas. 1990. "Political Violence in the Periphery: The Haitian Massacre of 1937." *Race and Class* 32 : 2: 1–19.

Frye, Northrop (ed.). 1969. *The Tempest* by W. Shakespeare. In *The Complete Pelican Shakespeare*, ed. Alfred Harbage. New York: Viking Press.

Gates, Henry Louis, Jr. 1988. *The Signifying Monkey: A Theory of African-American Literary Criticism*. New York: Oxford University Press.

Gaudet, Marcia. 1990. "Telling It Slant: Personal Narrative, Tall Tales, and the Reality of Leprosy." *Western Folklore* 49 (April): 191–207.

Giddings, Paula. 1984. *When and Where I Enter: The Impact of Black Women on Race and Sex in America*. New York: Morrow.

Gikandi, Simon. 1992. *Writing in Limbo: Modernism and Caribbean Literature*. Ithaca and London: Cornell University Press.

Gilman, Sander. 1985. "Black Bodies, White Bodies: Toward an Iconography of Female Sexuality in Late Nineteenth-Century Art, Medicine, and Literature." *Critical Inquiry* 12:1 (Autumn): 204–242.

Gilroy, Beryl. 1989. *Boy-Sandwich*. London: Heinemann.

———. *Frangipani House*. 1986. London: Heinemann.

Glickman, Yaacov. 1991. "Anti-Semitism and Jewish Social Cohesion in Canada." In *Racism in Canada*, ed. Ormonde McKague. Saskatoon, Saskatchewan: Fifth House Publishers.

Gouraige, Ghislain. 1960. *Histoire de la Littérature Haïtienne*. Port-au-Prince: Imprimerie Théodore.

Guy, Rosa. 1976. *Ruby*. New York: Viking Press.

Herskovits, Melville. 1934. *Dahomey*. Vols. I & II. New York: J. J. Augustin.

Hill Collins, Patricia. 1990. *Black Feminist Thought*. London: HarperCollins Academic.

Hine, Darlene Clark. 1989. "Rape and the Inner Lives of Black Women in the Middle West." *Signs* 14:4: 912–929.

Holloway, Karla F. C. 1992. *Moorings and Metaphors: Figures of Culture and Gender in Black Women's Literature.* New Brunswick, N.J.: Rutgers University Press.

Hurbon, Laënnec. 1987. *Comprendre Haïti: Essai sur l'État, la nation, la culture.* Paris: Karthala.

Jordan, June. 1982/1985. "Problems of Language in a Democratic State." In her *On Call: Political Essays.* Boston: South End Press.

King, Deborah K. 1988. "Multiple Jeopardy, Multiple Consciousness: The Context of a Black Feminist Ideology." *Signs* 14:1: 42–72.

Lamming, George. 1959/1960. *The Pleasures of Exile.* Ann Arbor: University of Michigan Press.

Larocque, Emma. 1991. "Racism Runs Through Canadian Society." In *Racism in Canada,* ed. Ormonde McKague. Saskatoon, Saskatchewan: Fifth House Publishers.

Layte, Hollander. 1992. "Women Leaders: Nanny of the Maroons." *Bagdad Café* (December): 8–9.

Lemoine, Maurice. 1985. *Bitter Sugar: Slaves Today in the Caribbean.* Chicago: Banner Press.

Lindsay, Lydia. 1988. "Interracial Relationships: Jamaican Immigrant Women in Birmingham, England, 1951–1971." *Journal of Caribbean Studies* 6 : 2 (Spring): 179–201.

Lorde, Audre. 1992. *Undersong: Chosen Poems Old and New.* New York: Norton.

———. 1984. *Sister/Outsider.* Freedom, Calif.: Crossing Press.

———. 1978. *The Black Unicorn.* New York: Norton.

Lowenthal, David. 1978. "West Indian Emigrants Overseas." In *Caribbean Social Relations,* ed. Bori S. Clarke. Monograph Series No. 8. Liverpool: Center for Latin American Studies.

Mayes, Janis A. 1989. "Mind-Body-Soul: Erzulie Embodied in Marie Chauvet's *Amour, colère, folie.*" *Journal of Caribbean Studies* 7:1 (Spring): 81–89.

McDowell, Deborah E. 1995. *"The Changing Same": Black Women's Literature, Criticism, and Theory.* Bloomington and Indianapolis: Indiana University Press.

———. 1980. "New Directions for Black Feminist Criticism." *Black American Literature Forum* 14:153–159.

McLaughlin, Andrée Nicola. 1990. "Black Women, Identity, and the Quest for Humanhood and Wholeness: Wild Women in the Whirlwind." In *Wild Women in the Whirlwind: Afra-American Culture and the Contemporary Literary Renaissance,* ed. Joanne M. Braxton and Andrée Nicola McLaughlin. New Brunswick, N.J.: Rutgers University Press.

Miner, Madonne. 1985. "Lady No Longer Sings the Blues: Rape, Madness, and Silence in *The Bluest Eye.*" In *Conjuring: Black Women, Fiction, and Liter-*

ary Tradition, ed. Marjorie Pryse and Hortense J. Spillers. Bloomington: Indiana University Press.

Mirza, Heidi Safia. 1986. "Absent Again? No Excuses!: Black Girls and the Swann Report." *Ethnic and Racial Studies* 9:2 (April): 247–249.

Moi, Toril. 1985. *Sexual/Textual Politics: Feminist Literary Theory.* New York: Methuen.

Mordecai, Pamela, and Betty Wilson (eds.). 1989. *Her True-True Name.* London: Heinemann.

Morrison, Toni. 1989. "Unspeakable Things Unspoken: The Afro-American Presence in American Literature." *Michigan Quarterly Review* 28 (Winter): 1–34.

———. 1970. *The Bluest Eye.* New York: Washington Square Press.

Mouré, Erin. 1990a. "A Love That Persists." (Book review/Brand). *Books in Canada* 19:9 (December): 42–43.

———. 1990b. "Insisting on the Questions." (Book review/Philip). *Books in Canada* 19:3 (April): 40–41.

Newman, Aubrey. 1989. "The Sephardim of the Caribbean." In *The Sephardic Heritage,* Vol. II: *The Western Sephardim,* ed. Richard Barnett and Walter Schwab. Grandon, Northants: Gibraltar Books.

Norris, Jerrie. 1988. *Presenting Rosa Guy.* New York: Dell Publishing.

Ogundípe-Leslie, Molara. 1994. *Re-creating Ourselves: African Women and Critical Transformations.* Trenton, N.J.: Africa World Press.

Parkes, Eleanor G. 1991. "Livingstone Presumed." (Letter to the Editor). *Books in Canada* 20 : 8 (November):7.

Payne, Anthony, and Paul Sutton (eds.). 1993. *Modern Caribbean Politics.* Baltimore: Johns Hopkins University Press.

Philip, M. Nourbese. 1992a. *Frontiers: Essays and Writings on Racism and Culture.* Stratford, Ontario: Mercury Press, 1992.

———. 1992b. "Q.E.D." (Letter to the Editor). *Books in Canada* 21:1 (February):5.

———. 1991. *Looking for Livingstone: An Odyssey of Silence.* Stratford, Ontario: Mercury Press.

———. 1989. *She Tries Her Tongue, Her Silence Softly Breaks.* Charlottetown, Prince Edward Island: Ragweed Press.

Plummer, Brenda Gayle. 1992. *Haiti and the United States.* Athens: University of Georgia Press.

Pollock, Griselda. 1992. *Avant-Garde Gambits (1888–1893): Gender and the Colour of Art History.* London: Thames and Hudson.

Pompilus, Pradel, et les Frères de L'Instruction Chrétienne. 1961. *Manuel Illustré d'Histoire de la Littérature Haïtienne.* Port-au-Prince: Éditions H. Deschamps.

Raiskin, Judith. 1993. "The Art of History: An Interview with Michelle Cliff." *Kenyon Review* (Spring): 57–71.

Régnier, Michel. 1987. *Sucre Noir.* (Film). National Film Board of Canada.

Rich, Adrienne. 1980/1986. "Compulsory Heterosexuality and Lesbian Existence." In her *Blood, Bread, and Poetry.* New York: Norton.

Riley, Joan. 1985. *The Unbelonging.* London: The Women's Press.

Roach, Jacqui, and Petal Felix. 1989. "Black Looks." In *The Female Gaze,* ed. Lorraine Gamman and Margaret Marshment. Seattle: Real Comet Press.

Rossbach, Jeffery. 1982. *Ambivalent Conspirators: John Brown, the Secret Six, and a Theory of Slave Violence.* Philadelphia: University of Pennsylvania Press.

Roth, Cecil. 1959. *A History of the Marranos.* New York: Meridian.

Said, Edward. 1990. "Reflections on Exile." In *Out There: Marginalization and Contemporary Cultures,* ed. Russell Ferguson et al. New York, Cambridge, London: MIT Press and New Museum of Contemporary Art.

Sanger, Richard. 1992. "Other Voices." (Letter to the Editor). *Books in Canada* (April): 6.

Scott, Gloria L. N. 1989. "The Aging Female Population in the Caribbean Area: Some Economic Issues." In *Mid-Life and Older Women in Latin American and the Caribbean.* Washington: Pan American Health Organization and American Association of Retired Persons.

Shadd, Adrienne. 1991. "Institutionalized Racism and Canadian History: Notes of a Black Canadian." In *Racism in Canada,* ed. Ormonde McKague. Saskatoon, Saskatchewan: Fifth House Publishers.

Shelton, Marie-Denise. 1992. "Haitian Women's Fiction." *Callaloo* 15:3: 770–777.

Shepard, R. Bruce. 1991. "Plain Racism: The Reaction Against Oklahoma Black Immigration to the Canadian Plains." In *Racism in Canada,* ed. Ormonde McKague. Saskatoon, Saskatchewan: Fifth House Publishers.

Silvera, Makeda. 1992a. "Her Head a Village." In *Voices: Canadian Writers of African Descent,* ed. Ayanna Black. Toronto: HarperPerennial.

———. 1992b. "Man Royals and Sodomites: Some Thoughts on the Invisibility of Afro- Caribbean Lesbians." In *Piece of My Heart: A Lesbian of Colour Anthology,* ed. Makeda Silvera. Toronto: Sister Vision.

———. (ed.). 1989. *Silenced.* 2nd ed. Toronto: Sister Vision.

———. 1983. "How Far Have We Come?" *Fireweed: Writing* 17(October): 39–42.

Smith, Barbara. 1977/1982. "Toward a Black Feminist Criticism." In *All the Women Are White, All the Blacks Are Men, But Some of Us Are Brave,* ed. Gloria T. Hull et al. New York: Feminist Press.

Smith, Rowland. 1976. Introduction. In *Exile and Tradition: Studies in African and Caribbean Literature,* ed. Rowland Smith. New York: Africana Publishing Company and Dalhousie University Press.

Solomon-Godeau, Abigail. 1989. "Going Native." *Art in America* (July): 117–128, 161.

Stasiulis, Daiva K. 1987. "Rainbow Feminism: Perspectives on Minority Women in Canada." *Resources for Feminist Research* 16 : 1 (March): 5–9.

Stepto, R. B. 1986. "Audre Lorde: The Severed Daughter." In *American Women Poets,* ed. Harold Bloom. New York: Chelsea House.

Stokes, John, and Joan Greenstone. 1981. "Helping Black Grandparents and Older Parents Cope with Child Rearing: A Group Method." *Child Welfare* 60: 19 (December): 691–701.

Suárez, Isabel Carrera. 1992. "Absent Mother(Land)s: Joan Riley's Fiction." In *Motherlands: Black Women's Writing from Africa, the Caribbean and South Asia,* ed. Susheila Nasta. London: Women's Press.

Tate, Claudia. 1988. *Black Women Writers at Work.* New York: Continuum.

Tavares de Alvarez, Julia. 1989. "Empowering Older Women: An Agenda for the '90s." In *Mid-Life and Older Women in Latin America and the Caribbean.* Washington: Pan American Health Organization and American Association of Retired Persons.

Thiam, Awa. 1986. *Black Sisters, Speak Out: Feminism and Oppression in Black Africa.* London: Pluto Press.

Thornhill, Esmeralda. 1983. "Black Women's Studies in Teaching Related to Women: Help or Hindrance to Universal Sisterhood?" *Fireweed* 16 (May): 78–83.

Wallace, Michele. 1975/1982. "A Black Feminist's Search for Sisterhood." In *All the Women Are White, All the Blacks Are Men, But Some of Us Are Brave,* ed. Gloria T. Hull et al. New York: Feminist Press.

Wilentz, Gay. 1992. "English Is a Foreign Anguish: Caribbean Writers and the Disruption of the Colonial Canon." In *Decolonizing Tradition: New Views of Twentieth-Century "British" Literary Canon,* ed. Karen K. Lawrence. Urbana: University of Illinois Press.

Wilson, Lucy. 1989. "Aging and Ageism in Paule Marshall's *Praisesong for the Widow* and Beryl Gilroy's *Frangipani House.*" *Journal of Caribbean Studies* 7:1 (Spring): 189–199.

Wong, Shelley. 1990. "Transgression as Poesis in *The Bluest Eye.*" *Callalloo* 13: 471–481.

Zimra, Clarisse. 1993. "Haitian Literature After Duvalier: An Interview with Yanick Lahens." *Callaloo* 16:1: 77–93.

Index